NEW COLLECTING:
EXHIBITING AND AUDIENCES AFTER
NEW MEDIA ART

New Collecting:
Exhibiting and Audiences after
New Media Art

Edited by

BERYL GRAHAM
University of Sunderland, UK

ASHGATE

Published by
Ashgate Publishing Limited
Wey Court East
Union Road
Farnham
Surrey, GU9 7PT
England

Ashgate Publishing Company
110 Cherry Street
Suite 3-1
Burlington, VT 05401-3818
USA

www.ashgate.com

British Library Cataloguing in Publication Data
A catalogue record for this book is available from the British Library.

The Library of Congress has cataloged the printed edition as follows:
New collecting : exhibiting and audiences after new media art / edited by Beryl Graham.
 pages cm
 Includes bibliographical references and index.
 ISBN 978-1-4094-4894-5 (hardback) – ISBN 978-1-4094-4895-2 (ebook) – ISBN
978-1-4724-0643-9 (epub) 1. New media art. 2. Art museums–Exhibitions. 3. Museum
techniques. I. Graham, Beryl, author, editor of compilation.
 NX456.5.N49N48 2014
 709.05'1075–dc23

2013034879

ISBN 9781409448945 (hbk)
ISBN 9781409448952 (ebk – PDF)
ISBN 9781472406439 (ebk – ePUB)

Printed in the United Kingdom by Henry Ling Limited,
at the Dorset Press, Dorchester, DT1 1HD

Contents

List of Figures

Notes on Contributors

Sarah Cook is a curator of contemporary art, a writer, and Reader at the University of Sunderland until 2013, then Reader at University of Dundee. She is co-author of *Rethinking Curating: Art after New Media* for MIT Press (2010) and co-editor with Sara Diamond of *Euphoria & Dystopia* for Riverside Architectural Press (2011), an anthology on art and technology collaborations drawn from research at the Banff New Media Institute 1995–2005. She co-founded CRUMB and for over a decade has curated exhibitions in Canada, the US, New Zealand, Mexico City, and across Europe.

 http://www.sarahcook.info

Heather Corcoran is Executive Director of Rhizome. Her previous posts include Film and Video Umbrella in London where she served as Deputy Director, and Curator at FACT, the UK's leading center for new media. She has held positions at Interaccess Electronic Media Arts, Toronto, SPACE, London, and has produced large-scale projects with the Barbican Centre, AND Festival, and the 2010 Liverpool Biennial, where she was a contributing curator. She holds a BFA from Ryerson University, Toronto, and an MBA from Imperial College, London.

 http://rhizome.org

Steve Dietz is the Artistic Director of Northern Lights.mn. He was the Founding Director of the 01SJ Biennial and is the former Curator of New Media at the Walker Art Center in Minneapolis, Minnesota, where he founded the New Media Initiatives Department in 1996, the online art Gallery 9, and the digital art study collection. His writings have appeared in *Art in America* and *Museum News*.

 http://www.yproductions.com

Rudolf Frieling has been SFMOMA's curator of media since 2006 and previously worked at ZKM Center for Art and Media in Karlsruhe, Germany, where he organized the web project *Media Art Net* and the exhibition and restoration project *40yearsvideoart.de – part 1*. At SFMOMA, he curated among others the survey shows *The Art of Participation: 1950 to Now* (2008) and *Stage Presence: Theatricality in Art and Media* (2012). He is also Adjunct Professor at the California College of Art and the San Francisco Art Institute.

 http://www.sfmoma.org

Beryl Graham is Professor of New Media Art at the Faculty of Arts, Design and Media, University of Sunderland, and is co-founder and co-editor of CRUMB. She curated the international exhibition *Serious Games* for the Laing and Barbican art galleries, her book *Digital Media Art* was published by Heinemann in 2003, and she co-authored with Sarah Cook *Rethinking Curating: Art After New Media* for MIT Press in 2010. She was a member of the AHRC-funded *Research Network on Collecting New Media* at Tate.

 http://www.berylgraham.com

Caitlin Jones is Executive Director of the Western Front Society in Vancouver. Previously she had a combined curatorial and conservation position at the Solomon R. Guggenheim Museum and was the Director of Programming at the Bryce Wolkowitz Gallery in New York. A key member of the Variable Media Network, her writings have appeared in a wide range of exhibition catalogs, periodicals, and other international publications.

 http://front.bc.ca/about

Pip Laurenson is Head of Collection Care Research at Tate and has worked at Tate since 1992. She completed a BA in Philosophy at King's College London before training as an objects conservator at the City and Guilds of London Art School. She is also a member of the advisory committee for IMAP (Independent Media Arts Preservation) and is an accredited member of UKIC.

 http://www.tate.org

Barbara London is Associate Curator in the Department of Media and Performance Art, Museum of Modern Art, New York. She was founder of the video exhibition and collection programs at the Museum. Since the 1970s, she has taken the lead in tracking the development of media art from its raw beginnings. She has curated more than 120 exhibitions, including one-person shows, such as Nam June Paik, Bill Viola, Steina Vasulka, Joan Jonas, Gary Hill, Mako Idemitsu, Valie Export, and Laurie Anderson.

 http://www.moma.org

Lizzie Muller is a curator, writer, and researcher specializing in interaction, audience experience, and interdisciplinary collaboration. She is Senior Lecturer in the School of Design at the University of Technology, Sydney. She holds a curatorial practice-based PhD on the audience experience of interactive art. In 2007 she was researcher in residence at the Daniel Langlois Foundation in Montreal.

 http://www.lizziemuller.com

Louise Shannon is Curator of Digital Design at the Victoria and Albert Museum. Since 2003, she has worked in various collections in the Museum including Furniture, Textiles, and Fashion, and the Word and Image Department. Since 2006, she has been curator in the Contemporary Programmes, where she was involved in the management of the *Friday Late* programme of live events, developed a series of digital commissions, and was co-curator of *Decode*, the first exhibition devoted to digital technologies at the Museum.

http://www.vam.ac.uk/microsites/decode

Lindsay Taylor was Exhibitions Officer at the Harris Museum and Art Gallery in Preston until 2013. She led the contemporary art program from 2004, including exhibitions by Kutlug Ataman, Simon Faithfull, Shezad Dawood, and *A Private Affair: Personal Collections of Contemporary Art* in collaboration with the Contemporary Art Society North West. In 2011 she led the exhibition and collection project *Current: An Experiment in Collecting Digital Art*. Since 2013 she has been Art Curator at University of Salford.

http://www.harrismuseum.org.uk

Foreword

Paying Attention to Media Art's History

Barbara London

Although media art is relatively new, it has a history that deserves attention. The past provides a context and determines which department in a museum might deal with the artwork, or how a private collector might take an interest, and therefore how the work might be understood in the future.

It all began in the early 1960s, when advanced, room-size computers were the focus of collaborations among engineers, musicians, and artists. Under the auspices of technical research or groundbreaking residency programs, artists were invited to such high-tech corporate enterprises as Bell Laboratories in New Jersey and Siemens Studio for Electronic Music in Munich.

In the late 1960s spirit of counter-culture and revolution, artists took up the new portable video camera with its crudest of editing systems for "alternative" practices. Young artists started to thrive in the fertile middle ground between disciplines. In the spirit of counter-culture and revolution, artists experimented with time-based art that was intangible and difficult to commodify and collect. Their seat-of-the-pants approach to process and materials was well suited to the artist-run, rough-and-ready exhibition spaces sprouting up in cities the world over. Unconstrained by the financial expectations of commercial galleries, these nonprofit alternative spaces allowed artists to experiment and benefit from their successes and failures. In these venues, which were frequented by the artists' peers, viewers became participants and assumed active relationships with the new kinds of art (site-specific and/or performance-based) that were then forming.

Many women entered this wide-open field with its clean slate and no old-boys network. Viewers became participants and engaged in a more active relationship with image and sound. Vitality and candor characterize the earliest media projects, which were made as an alternative to and a critique of male-dominated modes of art production.

Artists developed video installations, often with a "live" camera, designed specifically for the particular exhibition space (preferably not a white cube). "Performance art" was not a term used at that time, and so interesting new categories of work were named. Joan Jonas called her early action work "pieces" or concerts, in which she performed with a camera and a "real time" image of herself on a monitor. Critics called Bruce Nauman and Vito Acconci "body artists."

When Joan Jonas, VALIE EXPORT, Nalini Malani, and Mako Idemitsu started out in the 1970s, the contemporary art world was smaller, and media meant video, installation, and interdisciplinary performance. Technology continued to

change and developed two tiers – professional and consumer levels. The first tier, the broadcast industry, used computers for new frame-accurate editing. For many artists, "high end" production values were considered imperative, which meant that the cost of making a video skyrocketed. Slowly the personal computer initiated a wide range of new interactive work that soon morphed into media art, absorbing video.

In the late 1980s, as baby boomers started to reach adulthood and media art and the art market exploded, museums developed larger contemporary shows that routinely included media installations. At each turn, there were more artists, and more museums purchasing contemporary art and producing larger international survey shows. Meanwhile, private collectors built bigger homes to display loft-scale paintings and video projections.

Today, young media artists work with the latest technologies as readily as they sip water, since their tools are affordable. With the economic downturn, collectives are active again. Audiences are ready for content that goes beyond reality TV and responds to the most up-to-date iteration of what originally would have been discovered in underground art venues scattered along the periphery. Now the new settings combine art, technology, and social utilities along with the unfolding of mobile phones and the Internet.

By now museums are more adept at incorporating video and media installations into their programming. Many have specialized technical teams on staff to install and maintain collection and exhibition equipment. This expansion of the range of art shown by museums occurred in the early 1990s, when projectors and personal computers became more affordable and user-friendly. As commercial art galleries embraced media art and developed marketing strategies for it, museums hired media conservators to safeguard and preserve it for the future. This practical step, along with the burgeoning of interdisciplinary art practices, contributed to what is now a widespread acceptance of time-based media installation as a collectable art form. Because the work is collected, whether online, as single-channel videos in a library, or complicated installations preserved in a museum, the work is available to art historians to publish, and to curators to exhibit in new ways – either way, media art reaches audiences and can be interpreted according to future times.

The youngest generation of media art pioneers is poised to reinvent the avant garde. Hackers, programmers, and tinkerer-revisionists draw upon their local culture and upon more international sources. This book explores and explains the challenges facing institutional and private collectors of media art. Get ready and jump in!

Acknowledgments

I would first like to thank all of the authors who contributed to this volume. In order for this book to be most useful to future collectors and curators of art, it was necessary to share the working knowledge of those active in the field. Curators are notoriously busy people and so I'm particularly grateful that they found the time to contribute to this volume – I'm in awe of the expertise collected here and their generosity. I'd also like to thank all of the artists and organizations that donated their images to this book, and of course the artists who make such fascinating art in the first place.

This sharing of knowledge is one of the working tenets of the CRUMB research centre at the University of Sunderland, which provides a resource for those involved in new media art, via events, publishing, and the crumbweb.org website. This book also references some debate from the CRUMB discussion list, where a wider community or artists, curators, and academics can thrash out very current issues and gather knowledge as it emerges. A special theme on collecting was introduced to the discussion list in 2012 in preparation for this book, and I am also grateful to everyone who participated online. Some of the new interviews cited in this book will also be appearing on the CRUMB website.

I'd also like to thank the University of Sunderland for its support of CRUMB as a research centre since 1999, in particular Brian Thompson, Associate Dean for Research for the Faculty of Art Design and Media, and my CRUMB colleague Dr Sarah Cook. For the physical preparation of the book, I'm grateful to Karen Blenkinsop as a freelance proofreader.

I'd like to thank the Arts and Humanities Research Council for a Research Fellowship that paid for half of my time over nine months in order to edit this book, and for research expenses for research in the UK and in China, Taiwan, and Japan. In addition, the KOCIS Korean Culture and Information Service kindly invited me to spend a week in Seoul researching art, which also fed into this book. There were many kind and helpful people who aided me on my travels, and I would particularly like to mention Victoria Bradbury and Professor Fei Jun of the Central Academy of Fine Art in Beijing, Professor Ying-Ying Lai of the National Taiwan University of Arts in Taipei, curator Yukiko Shikata, and Yuka Uematsu of the National Museum of Art, Osaka, Japan, Jinsang Yoo of Mediacity Seoul, and last but not least, Ms Sun-mi Lee, an excellent translator of my whispers when I completely lost my voice due to British Flu, and who introduced me to Korean chicken and ginseng soup.

Finally, thanks go, as always, to my friends and family for tolerating my absences: and to all those who make things in Black Wood with me. This book

is dedicated to warm memories of Newcastle's historic and beautiful City Pool and Turkish Bath, closed down by Newcastle City Council in 2013 due to budget cuts – would anyone care to collect and reanimate it?

Introduction

Beryl Graham

Rafael Lozano-Hemmer's *Pulse Room* from 2006 is a large installation comprising incandescent light bulbs, voltage controllers, heart-rate sensors, computers, and metal sculpture. It involves a complex and subtle interaction with multiple audience members and is of "variable dimensions." A "version" of the work, *Pulse Park* (2008), is intended for outdoor display in non-art locations with unlimited audiences. The work is therefore both object-based and immaterial, difficult to categorize, time-based, highly interactive, and highly variable. The artwork might therefore be considered as "not easy to collect," but nevertheless it *is* collected and is currently in both institutional and private collections, including the Museum of 21st Century Art in Kanazawa, the Colección/Fundación Jumex in Mexico City, the Museum of Old and New Art (MONA) in Tasmania, the Jonathon Carroll Collection in New York City, and the Karin Srb Collection in Munich.

The reason why collectors would go to the trouble of rethinking what might be collectible is, of course, based on a high regard for the artwork. *Pulse Room* is a very visually affective installation showing a sensitive understanding of interaction. When an audience member holds on to the heart-rate sensor handles, the light bulb nearest to them starts to pulse to match their heart rate. As the next person holds the handles, the previous heartbeat moves into the large grid of heartbeats and is surprisingly recognizable as it moves along the grid. The delicate fluttering of many lights reflects the fragility of human presence, and as the work unfolds through time, the tension between individuals and groups becomes apparent: as in many interactive works, people want to track their own "identity," but there is also the awareness that it is the group installation that is the key visual impact and that each new heartbeat pushes somebody else's heartbeat off the end of the grid. The work has been exhibited at the 2007 Venice Biennale and as part of a monographic show at Manchester Art Gallery. The fact that others in the art world also hold the artwork in high regard naturally helps any kind of consideration of collection, but for some new media works, exhibition can be both a test bed for the works and the only way in which the interactive nature of the works can be experienced.

The starting point for this book is therefore the awareness that fascinating works of art involving new media are being collected, but that a certain amount of rethinking of categories, objecthood, documentation and audiences is necessary – as Steve Dietz states in this volume, collecting new media art is "just like anything

else, only different." The awareness of these differences includes not only questions of what is collected, but also the modes or ways of working for those involved in the collecting process. As the example of Lozano-Hemmer suggests, considerations of exhibition and audience are closely connected with issues of collecting, not only for new media art but also for any art form that might be immaterial or involve participatory systems.

Because the book concerns ways of working, the contributors selected are predominantly practicing curators and arts workers. The approach taken is not based on traditional curatorial institutional critique, but seeks to highlight examples of how institutional systems might be changing in response to new art. As Danish Curator Jacob Lillemose states, these changes can provide positive opportunities:

> I often hear Danish museum directors ask for a list of categories because it would make them feel more comfortable with digital art; it frames digital art in accordance with the principles of non-digital art. However, I think they misunderstand the challenges and do themselves an unintentional disservice. Digital art demands new ways of institutional thinking about art works both in terms of curating and preservation; it's difficult, sure, but also a chance for the institution to develop. (Graham 2004)

What this book does not aim to do is to specialize in the conservation or preservation of new media art. There is an excellent body of existing material on this subject and so this book only touches upon the most recent developments in the field that most directly relate to collecting, exhibiting and audiences.

On the timeline of collecting, this book both considers production stages before collection and exhibition and historicization after collection. Again, these aspects are strongly connected to each other. If new art doesn't get produced and collected, then it is less likely to develop provenance, to be re-exhibited, written about, researched and historicized. As Sarah Cook, an author in this volume, has written, commissioning with an eye on collection is a way to "keep the recent memory of art alive," and to look forward to historicization via collection (Cook 2013: 401). This book therefore aims to look forward to the future of new media art within the contemporary arts.

New Media as Art or Educational Tool?

> It is easier to get an entire museum–collection on the Internet than to get a single exhibition of Internet Art in a museum–space. ... In return, the exhibition of traditional art collections ... raises the chance to get a broader audience and a more effective discourse, abstaining from conventional forms of display. (Franz Thalmair in CONT3XT.NET 2007a)

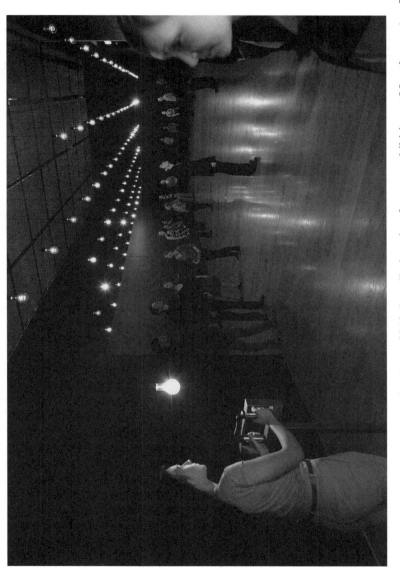

Figure I.1 Rafael Lozano-Hemmer's *Pulse Room*, 2010. Installation view from an exhibition at Manchester Art Gallery, Manchester, UK. Photo by Peter Mallet, courtesy of the artist

One of the most significant differences between new media art and other kinds of art is that the same set of new media are used both for art itself and for art interpretation, exhibition, or collections management. Hence, a net artist will use software and the Internet for making and distributing art, and a museum will use the same media to put digitized documentation of an "entire museum-collection on the Internet" for "virtual museums" or for marketing purposes.

There is a great deal of literature which deals with the significant cultural issues concerning the digitization of objects, museums as repositories of information, and what this means for modes of display and interpretation (Henning 2007: 41; Noordegraaf 2004; Parry 2010). Much of the debate revolves around the tension between the seductive allure of interactive technology's capacity to engage potentially new and bigger audiences balanced against concerns over access, expense and loss of unique objecthood and human contact (DCMS 2005: 11; Graham forthcoming A; Rellie 2010). While this dominant discourse can be useful for furthering debate on audiences in relation to art, new media art is sometimes in the unusual position of being confused with new media as an interpretation tool. Audiences walking into an art institution and seeing a computer can usually safely assume this to be interpretation rather than art, and even curators or funders can sometimes confuse the two. Sometimes this has been a productive confusion for new media art, where staff employed in interpretation areas have come to inform curating, exhibiting and collecting, as was the case with Kelli Dipple's role at Tate, which is mentioned in Chapter 3 (Graham and Cook 2010: 164ff).

Artists too have productively worked across both areas. The People Speak is a group that provides tools which makes it easy for people to talk to each other. Its projects include *Talkaoke*, a mobile doughnut-shaped desk with lights and microphones where a host encourages people to talk about whatever is important to them and to have a conversation with each other. They share knowledge via training so that the skills of hosting conversations can be passed on. The case studies on the web have worked in the contexts of art festivals, creative industries conferences and city-planning campaigns. The co-founders, Saul Albert and Mikey Weinkove, cite their experience as including participatory art and chat-show hosting, but this project can be understood both as social/educational and as art using the particular qualities of the media.

As new media artists and curators are often aware of new media theories of information and audiences, they can benefit from a critical grasp of these areas. As Friedrich Kittler describes in relation to the display of information, two kinds of approaches are emerging: the pedagogic display of "lovingly presorted information" and the open access to databanks of "all available information" (Kittler 1996: 73). The difference between these two approaches lies in the role of the "audience" rather than the curator in selecting the information and leads to a very current debate as to the "openness" of museums in relation to audiences (Graham forthcoming A). In this volume, the case study of the Rhizome ArtBase in Chapter 4 reveals the subtle variations of practice between lovingly pre-sorted selections from an online collection and modes where audiences can do their own curating.

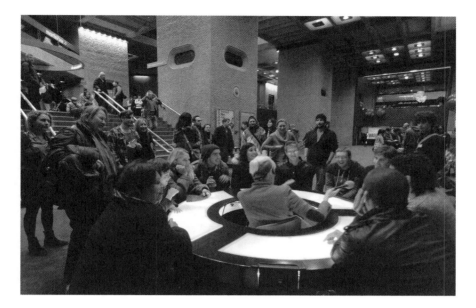

Figure I.2 **The People Speak's *Talkaoke* at the Barbican Centre, 2012. Photo by Hektor P. Kowalski, courtesy of The People Speak**

Defining New Media Art, Audience and Open Source

> We are neither autonomous nor assimilated without pardon. (Druckrey 2007)

The argument concerning whether new media art is just like contemporary art or is different has occupied many positions between autonomy and assimilation. The artworks known as new media art have amassed around them a varied nomenclature, including "born digital," art & technology, art/sci, computer art, electronic art, digital art, digital media, intermedia, multimedia, tactical media, emerging media, upstart media, variable media, locative media, immersive art, interactive art and Things That You Plug In. As discussed in the book *Rethinking Curating*, it was not always the specific media that necessitated a change in the way in which the art was curated, but "medium-independent behaviors" (Ippolito 2003: 48). Steve Dietz identified three characteristics of net art: connectivity, computability, and interactivity. Each behavior, when applied to new media art in general, can be related to different art histories, ranging from installation art or performance art to video (Graham and Cook 2010). Connectivity, for example, might be familiar to curators of live art, or 1960s conceptual art including mail art. Considering "computability," the generative, evolving and algorithmic nature of computer software is sometimes difficult for art historians to differentiate from the instruction sets of conceptual art, but the art historical emphasis on understanding materials

and processes from gouache to bronze casting should offer useful tools for this. It is, perhaps, the third behavior of "interaction" which seems to present the most fundamental problems for collecting (Graham 2007, forthcoming A).

This book therefore uses a broad working definition of "new media art" as artwork that is electronic and shows Dietz's three behaviors either individually or in combination. Rather than using traditional media-specific academic or museological terms, this choice reflects the experience of curators who found that the rethinking necessary was not around digital/analog differentiation, but around these behaviors. In Chapter 3, for example, Pip Laurenson uses the terminology of "significant properties" and "behaviors."

Druckrey's opening quote also highlights another issue of definition for new media art: is it art? Some issues for collecting reflect the strictly "fine art" nature of traditional collecting. The National Museum of Contemporary Art, Korea, for example, acknowledges that its current collecting policy deliberately targets "relatively overlooked genres like print, craft, photography, and new media" (National Museum of Contemporary Art, Korea 2012). Curator Sooyoun Lee acknowledges that young people in Seoul are very familiar with the lively wider technological cultures of social networks, mobile devices, and screens in many public places. The work of Kuen-Byung Yook, for example, includes gallery-based and outdoor installations, and *The Sound of Landscape + Eye for Field* was acquired and installed in the museum grounds in 2006. At the museum, two of the four finalists in the 2012 Korean Artist Prize used video, and Sooyoun Lee is particularly keen to select artworks which move beyond a traditional fine art approach to new media which might be "limited and implemental," and to include more recent works which are conceived with a full understanding of the behaviors of new media (Lee 2013).

Altogether, the particular behaviors of new media art, especially the behavior of interaction, call into question the definition of "audience." Sometimes the audience will be viewing in a conventional sense, sometimes the artwork will react to them, sometimes they will be interacting with an artwork or each other, sometimes they will be participating in the creation of an artwork, or they might be collaborating in artistic or curatorial decision making. Throughout this book, audiences are referred to using the conventional terms for clarity, but with the proviso that they might differ from conventional definitions of a passive audience, in order to acknowledge that audience behaviors are very important. These terms of interaction, participation, and collaboration are often used very loosely and interchangeably, but wherever possible in this book, they are used as per the examples of usage above (Graham and Cook 2010: 112ff).

New media offers a very particular mode of collaborative production – that of "open source" software production, where many people contribute to developing software. The source code is available to all and is written in such a way that the structure (the recipe, if you like) is open to other programmers/users to copy, improve or adapt. "Open source" is a term that is often applied rather loosely to participatory art projects to mean an essentially non-hierarchical collaborative production structure, yet this is not necessarily the case, as there may well be

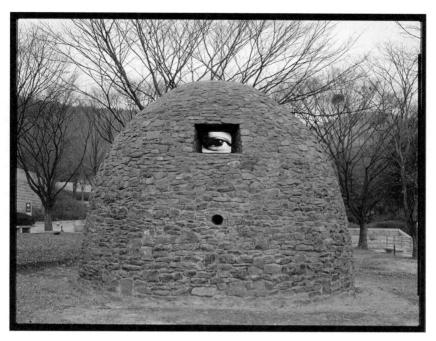

Figure I.3 **Kuen-Byung Yook's *The Sound of Landscape + Eye for Field*, 2006. Installation view in the grounds of the National Museum of Contemporary Art, Korea. Photo by ykb studio. Image courtesy of the National Museum of Contemporary Art, Korea, and the artist**

hierarchies of skill and time involved in open source production systems, but a key characteristic of the systems centers on crediting work.

Definitions and categories are of obvious importance in the field of new media where such things are open to question – Rhizome in Chapter 4, for example, is particularly careful to let its categories and themes be led by the art itself, and Sarah Cook in Chapter 10 also explores categorical problems, which leads on to the importance of taxonomical structures for new media.

Taxonomies, Databases and Search Engines

Whilst most literary portrayals depict collectors of fine and decorative art, much more collecting is devoted to, well, "collectibles". The classification of Collectibles on eBay employs forty-five main headings – such as "Brewerania and Beer", "Disneyana" and "Militaria" – under which are arranged approximately 500 categories. (Altshuler 2009: 38)

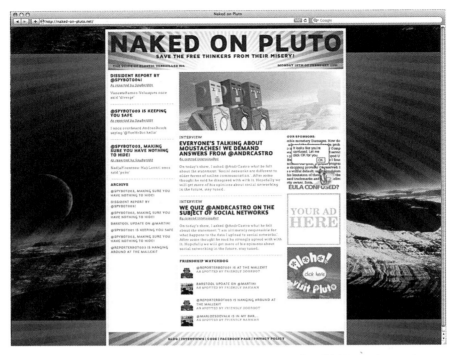

Figure I.4 Screenshot from *Naked on Pluto* website (2012) by Aymeric Mansoux, Marloes de Valk, and Dave Griffiths. Image courtesy of the artists

If the working definitions of new media art might differ from traditional art museum art form-specific departments, then this becomes even more important when considering the importance of definitions, categories and taxonomies in collecting, and in collections using new media databases and Internet search terms in particular. As Lindsay Taylor points out in Chapter 5 of this volume, there was a basic problem for collecting new media art in terms of how to define the work on collection management systems that didn't recognize the terminology. Rudolf Frieling in Chapter 6 also challenges traditional media-specific categories in favor of Dorner's consideration of "practice."

In practice, what this means for online databases of museum collections is that new media art can be difficult to find. Some databases including that of Tate simply do not use terms such as "new media," "digital," or "electronic" at all in their browsable categories. Where "new media" is used, sometimes this can mean dominantly or only video art, as is the case with the Pompidou Centre, FRAC Aquitaine, or the National Taiwan Museum of Fine Arts. Some institutions, including the Queensland Art Gallery, prefer the term "Electronic Media," where that includes works by John Baldessari. Research failed to find any collections

where categories of behaviors such as "participation" existed. Some databases have more unusual categories which are not necessarily mutually exclusive – for example, the Arts Council Collection in the UK includes four categories: Film and Audio, Mixed Media, Installation, and Multiple. Its collection includes the Thomson and Craighead work *Short Films about Flying #1* (2002), which is categorized rather strangely as a "computer game." If the media categories fail to help those searching for new media art, then it is also difficult to fall back on searching by name, unless of course you are already familiar with early career artists rather than household names. In general, it could be argued that the sublime quantity of material in online databases is rather wasted if it is too difficult to find and that the problem here is one of the categories simply not fitting new media art, as Sarah Cook outlines in Chapter 10.

In a study of collecting born-digital artworks in collections in the Netherlands, research discovered several thousand websites, a few games, and a few dozen 3D designs or reconstructions. The researchers suggested that a solution to this slow stagnation of collecting could be to use an Open Archival Information System (OAIS) model, which involves several parties in documenting the work: the producer/maker of the heritage, the consumer/user, and their intermediary, the custodian of the material or heritage institute (van der Graaf and Nauta 2010: 8.4).

This mode of developing more useful categories via many people is one that is picked up in the idea of "folksonomies" developed by many users rather than by individuals or small groups of experts. The website runme.org is a repository of software art, and because software art has very few existing subcategories, the keywords are developed by those who submit artworks and by those who use the site. The most used keywords become more central to the database. The artwork *Naked on Pluto* (2012), for example, by Aymeric Mansoux, Marloes de Valk, and Dave Griffiths, has the self-assigned category of "social software" and the keywords of "social – lisp – Facebook – ascii – Twitter – propaganda – human – criticism – apocalyptic – surveillance – open_source – friendly – community – anachronistic – story – multiuser – free_software – capitalism – 1980s." The site is very useful in terms of finding behaviors as well as content, including the more jokey classifications of "Best Grant Hoover" or "jodi plagiarism" (Goriunova 2012: 73–80).

Some Histories of Collecting

> One myth of photography is of a poor, misunderstood medium that struggled for decades for recognition as an art form, finally achieving that high status in the late twentieth century. In fact the status of photography – nearly always the focus of one aesthetic controversy or another – varied throughout the nineteenth and early twentieth century. At different times and locations, photography's prestige both increased and declined, depending in part on other streams of the culture. (Walsh 2007: 20)

> The utopian vision for archives is of a participative, more representative model,
> which not merely represent the perspective of those in authority but also minority
> groups and interests. (Breakell 2010: 10)

The book *Rethinking Curating* draws parallels between certain kinds of new media
and the histories of other art forms showing similar behaviors, such as the non-object
based, participatory systems of certain conceptual art (Graham and Cook 2010). In
a similar way, certain histories of collecting can inform the collection of new media
art. The history of photography, for example, can be seen as facing similar issues of
acceptance as art, reproducibility, photography as document, and perceived problems
of preservation (Moschovi 2008). New media art and the concept of history have a very
particular relationship in relation to new media's perceived "futuristic" values, but, as
explored by curator Sarah Cook in Chapter 10, histories are of particular importance.
Her exhibition *The Art Formerly Known as New Media*, for example, co-curated
with Steve Dietz, adapted the curatorial modes from the traditional "retrospective" to
something with a more alternative approach to history (Cook 2013).

As Breakell foregrounds in the opening quote, the behavior of participation is
one that is linked to the structure of archives themselves and hence is linked to issues
of access to collections, for audiences and artists alike. In categorical and collecting
terms, many kinds of art seem to fall outside of the most conservative definitions
of "art" and thus become "the other." According to curator Howard N. Fox, in
the 1960s and 1970s, the Los Angeles County Museum of Art (and of course many
other institutions) didn't notably collect feminist art or art by Chicano or African
Americans, despite the currency and presence of such work both locally and nationally
(Fox 2005: 19). Large areas of practice where the work of art itself is participatory,
community-based, or activist are similarly thought to be uncollectable and poorly
served by documentation, and hence historicization (Graham and Cook 2010: 111ff).
Although the conflation of political "others" with art form "others" is to be avoided,
there are certain aspects where both the form and the content of an artwork, such as
artworks using participatory systems, activist content or working with non-artists
might be deemed to be uncollectible because of layers of otherness. In Dewdney,
Dibosa, and Walsh's book on *Post Critical Museology*, they make explicit points
about the "'hard-walled' separation between the values of collection and those of
embodied audience" in relation to the racial origins of audiences, and link this to the
need for institutions to be "distributive not contributive" (2013: 156, 177).

As described in Chapters 1 and 7 of this volume, it is sometimes the socio-
economic systems of new media art which differentiate it from other kinds of
collected art, including radical modes of open source production, and as Steve Dietz
outlines in Chapter 2, there are often very identifiable gaps between art activity and
collecting activity. One history of collecting which new media art can also call upon
is the histories of technology and, to a certain extent, science. As Roger Malina has
said, "every digital appropriation is an act of artistic or scientific translation and the
boundary between the 'natural' and the 'artificial' is good and fuzzy – the nature of
art has evolved continuously over the last few centuries – surely we need to avoid

'backing into the future' when talking about curating new media art" (CRUMB 2012). The lack of awareness of technological history can be a serious disadvantage for those seeking to collect new media art, but the problem is not an insoluble one. As the Rhizome curators found in Chapter 4 of this volume, some curators are very comfortable with technological histories, and at the Harris Museum in Chapter 5, the industrial context of Preston set the scene nicely for the new media work.

Above all, histories of new media art have been cross-disciplinary rather than purely technological and hence can draw from, for example, modes of documentation from music and sound art in the form of a "score," or notions of audience from public art. The Victoria and Albert Museum (V&A), as described in Chapter 8, can draw strength from design-based notions of versioning, prototyping, and mass production. If parallels are considered with performance art, then the debates around collecting documentation in relation to live events are well rehearsed. Rudolf Frieling describes the performativity of collected works every time they are displayed, and Chapter 1 includes useful experiences from the Tate Tanks' curators concerning "reanimating" documentation and considering the audience.

Sometimes the connections with histories of collections can be unexpected. In Chapter 2, Steve Dietz mentions the Wunderkammer or wonder chamber as a historical form of exhibition, but in the twenty-first century, the presence of the individual collector with definite if eclectic tastes has not disappeared. At the Museum of Old and New Art (MONA), Hobart, Tasmania, there is an outdoor Wunderkammer showing some of MONA's "collection of everything," including video art, Yoruba items, and Roman coins. The casket apparently "caused a war: conservators vs curators," and the equally eccentric MONA website shows some very interesting and participatory interpretational strategies for audiences (Muller 2012).

This concern for audiences ranges across many art forms, but is of recurring importance for considering the exhibition of collected participatory or interactive new media artworks. The history of collecting installation art, for example, raises challenges of conservation, documentation, and audience experience that can inform new media art (Reiss 1999). Some authors have stressed the general importance of the audience in considering histories of museums and exhibitions, including the experiential aspects of the performative body as it moves through institutions, and the interesting histories of museums seeking to strictly control the behavior and deportment of visitors (Rees Leahy 2012).

Above all, if audiences are to be taken seriously in relation to collecting, then well-documented histories of exhibition will help in this task. Mary Anne Staniszewski has suggested that the history of exhibition installations is one particularly badly served by art histories to the point of being culturally "repressed" (1998: xxi). However, recently authors have been seeking to address these issues, including a concentration on new media exhibitions in particular (Graham forthcoming B and C). If, as Staniszewski claims, the "sources" of new media practices, alongside installation and site-specific artwork, lie in exhibition installation, then the very nature of what is documented about exhibitions becomes particularly important to these practices if issues of historicization are considered, as described by Sarah Cook in Chapter 10.

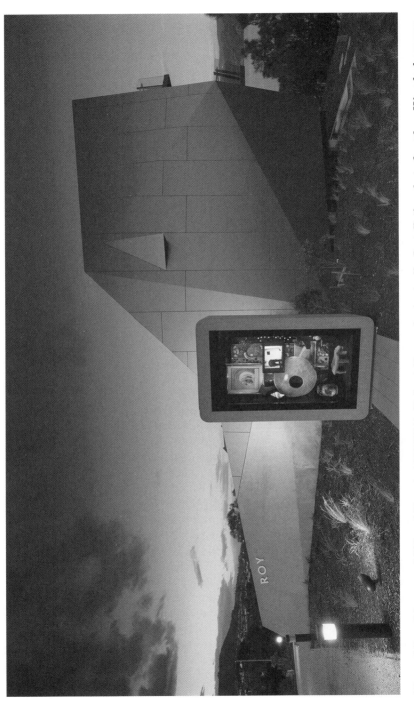

Figure I.5 Museum of Old and New Art (MONA), Hobart, Tasmania, Australia. Installation shot of outdoor Wunderkammer. Photo by Brett Boardman. Image courtesy of MONA

The Structure of the Book

This book is arranged into three parts, each with collecting at its core, but connected to different issues in each part: first documentation, then exhibition, and finally audience. These issues actually form part of an interconnected web and so each part will contain cross-references to the others.

Part I: Documentation, Archive, Collection, Conservation

> Museums traditionally are concerned with selection and unique or specific objects. Libraries are traditionally concerned with access and instances of a generally available object. Many digital artworks are easily replicable, however, and artists are more interested in making them accessible than rare. In this context, some of the differences between a museum collection of digital artworks and a library collection of digital objects begin to converge. ... Whether these collections are called permanent or study or archives makes a difference in terms of what they can ingest and how. (Dietz 2005)

As curator Steve Dietz discusses in this volume, connected to the issue of new media existing both as art media and as tools for collections is the fact that new media artworks might be found in a library or archive as well as in a collection. Barbara London, author of the foreword for this book, has also described how in curating the exhibition *Looking at Music* for the Museum of Modern Art (MoMA) in New York in 2008, she was showing items from the museum collection, from the archive, and also items such as vinyl record covers from the library. The exhibition was the first in a series, and *Looking at Music 3.0* in 2011 also took a very broad approach to the wider context of music, including digital cultures (CRUMB 2009). All of this serves to highlight that a rethinking of modes of collecting and exhibiting might be necessary if curators are to make the most of the wider context of the work, and the importance of equally wide documentation. As Dietz says, "document the context." Since Dietz's 2005 chapter, others have gone on to describe the different modes of documentation that might be most relevant to new media art:

> At present, several types of documentation can be distinguished: first, documentation produced for publicity and presentation; second, for purposes of reconstruction or preservation; third, for describing processual changes in the appearance of a work; fourth, for developing an aesthetical and/or a historical "framework" or reference; fifth, for educational purposes; sixth, for capturing audience experiences; and seventh, for capturing the creative or working process of the artist(s). (Dekker 2013: 153)

Within the seventh category of capturing the creative or working process of the artist, Dekker goes on to describe three phases: "documentation as process,

in which documentation is seen as a tool in decision-making processes during the development of the work; documentation as presentation, or, the creation of audiovisual material about the work; and, documentation for recreation in the future" (2013: 155). This last phase nicely ties in with other themes in this book – having artworks in collections is rather pointless if the documentation necessary for them to be successfully re-exhibited is missing. As Dekker puts it: "The term 'Darwinistic Archiving' was suggested, referring to the survival of the best-documented artworks" (Dekker 2010: 6). Unsurprisingly, it has been artists themselves who have been quickest to see the potential of making their own documentation of practice available. Those artists familiar with open source modes of working, where all working processes are made available to others, are particularly au fait with this idea. Aymeric Mansoux, one of the authors of *Naked on Pluto* (see Figure I.4), was interviewed by Pip Laurenson as part of a workshop on conservation and was asked about the documentation of process, in particular about the comments made by authors attached to parts of computer code. He responded that these were public and available, as with any open source software, but were mostly "stupid jokes between us." When asked whether these comments were nevertheless reflective of working processes, he answered "I'm afraid so!" (Baltan Laboratories and Van Abbemuseum 2012). This admirable openness is rather different from the painstaking attention afforded in institutional archives to every scrap and scribble of famous artists, but nevertheless still could be of serious importance to those wishing to "reanimate" art from documentation, as stated by Stuart Comer in Chapter 1.

In addition to the concentration on roles, whether artistic or curatorial, in Chapter 1, other authors in this volume also necessarily reflect upon roles in documentation. Lindsay Taylor at the Harris Museum, for example, maps out in Chapter 5 the key roles of curators, exhibition organizers, and the greater than usual involvements of artists and technicians. At the V&A in Chapter 8, external consultants were unusually involved and the new media exhibitions demanded a delicate negotiation around the control of websites. At the San Francisco Museum of Modern Art in Chapter 6, the roles of audiences as collectors challenged existing institution structures. There is also the relatively new role for audiences in documentation. As Lizzie Muller explores in Chapter 9, the experience of audiences is at the heart of any interactive artwork and should be documented as much as possible. As Caitlin Jones pointed out in a workshop in 2008, "crowd-sourced" documentation or art events by audience members can complement institutional documentation and can to an extent solve the time burden of such painstaking documentation (Jones 2008).

Although this book does not focus explicitly on preservation or conservation issues, these intricate connections mean that it is part of the network of knowledge around collecting. Many institutions cite anxieties around conservation as a major roadblock preventing new media art from entering collections. Fortunately, some conservation courses are starting to integrate new media considerations into their curricula, including the University of Amsterdam, and

Bern University of the Arts with the Swiss Institute for Art Research Zurich who run the AktiveArchive web resource. The growing body of literature concerning the preservation of new media art has reached a stage where useful modes and strategies can be identified. Concerning roles in conservation for new media art, curator Caitlin Jones has also perceived the "occupationally independent" nature of the preservation skills needed as well as the medium-independent behaviors of the artworks (2003: 61). In the Variable Media Initiative, Ippolito describes four flexible options: store, emulate, migrate, or reinterpret (Ippolito 2003: 48–51). This range of options has been successfully applied to a wide range of contemporary arts and is able to deal with the characteristic new media habit of appearing in highly variable software versions and interface options. Richard Rinehart (2005) of the Berkeley Art Museum and Pacific Film Archive has developed a highly detailed method for conservation based on the metaphor of a "score." The experience of producing large-scale and complex technological works at ZKM in Germany has led to the sharing of preservation knowledge via the Digital Art Conservation Project (Serexhe 2013). Annet Dekker, already cited here, has led many development events and has succeeded in integrating considerations of documentation and exhibition with preservation issues. Recently, Alessandra Barbuto and Laura Barreca have described one mode of the preservation of collections as "intentionist" where the documentation of the intention of the artist for the display of the artwork is of prime importance (Barbuto and Barreca 2013: 184).

Chapter 1 of this book therefore concerns itself not only with questions of what is collected but also who collects and how. The nature of what institutions can "ingest" obviously reflects upon the form of new media, whether as replicable media on DVDs or unique installations, and this has in turn shaped new physical economic modes of collecting for new media art. Concerning the "who" of collecting, the role of each participant becomes important, especially in the case of considering the long-term or short-term roles of producer, patron, or the audiences themselves. Modes of collecting are also identified: museums, after all, can mean various different things when they describe collections of items as "display collection," "archive," or "library," and this affects the status of what and where the material is. The modes include those that might move between definitions of archive as documentation of art, and archive as collection of art, as is the case with Rhizome in Chapter 4.

Chapter 2 by Steve Dietz identifies that important node for new media art sitting on the intersections between documentation, archive, and collection. He examines the modes of operation of three collections. The Guggenheim's approach is described as an "art is art" attitude, where new media artworks are collected and preserved as part of contemporary art. At the American Museum of the Moving Image, a "material culture" mode suits its collection of media equipment, objects, and works including popular culture and design. At the Walker Art Center, where Dietz was curator of new media, the new media collection policy specifically stated that it was "a hybrid Collection that shares similarities with the Permanent

Collection, the Study Collection, and the Archives Collection." He questions notions of authorship for new media art and, importantly, identifies the roles that artists themselves have had in identifying and challenging the boundaries within art institutions, including Jim Campbell and Lisa Jevbratt.

In Chapter 3, Pip Laurenson unpicks in detail the intricate connections between documentation, preservation, and exhibition for "new new media" involving software, rather than the old new media of video, which has more established precedents for conservation. She examines in detail the kinds of documentation needed for such ephemeral works, including a set of questions for artists identifying the "significant properties" of the artwork. She outlines the importance of exhibition in relation to conservation, whether the artwork is based on an existing metaphor of painting, such as Michael Craig-Martin, or the interactive nature of Rafael Lozano-Hemmer's work. Laurenson has described the role of the conservator as that of a "broker" of relationships between the staff of institutions and the artists themselves so that collecting can function fully in the long term.

Part II: Producing, Collecting, Exhibiting

> Yet, what if a link turns into the representative of the artefact, the context and the exhibition at once? (CONT3XT.NET 2007b)

TAGallery, which CONT3XT.NET ran from 2007 to 2010 and "will be maintained as long as Delicious.com allows it," was a gallery run as a collection of tags and links. Each exhibition, with a named curator, is simply a collection of links to online works by named artists and a title. Here new media is calling into question, as it often does, what actually defines an exhibition. The artist Anthony Antonellis has also been able to use this facility to wittily satirize the ambivalent nature of making and curating new media art. His website *put it on a pedestal.com*, for example, enables the user to drag those lowly new media artifacts, animated gifs, on to the equally cheesy art world pedestal of their choice. He has also experimented with seeing how long videos survive on Vine, the Twitter app that supports videos of up to six seconds, and his work has been shown in the exhibition *The Shortest Video Art Ever Sold* instigated by Postmasters Gallery for the Moving Image Contemporary Video Art Fair in New York in 2013.

This part offers examples of exhibitions that are both online and offline, immaterial and physical. Art institutions will tend to utilize whatever format and location of exhibition that suits their needs. The Digital Depot at the Boijmans Van Beuningen Museum, Rotterdam, for example, greets visitors on the ground floor with screens offering extra layers of data on physical objects and a more radial mapping of the museum collection than might be encountered in physical gallery spaces in a more chronological fashion. As Julia Noordegraaf states, there is a "tendency in museums to combine elements from various older scripts and turn them into a new, hybrid script" (Noordegraaf 2004: 205). There are also

other lessons from history concerning modes of exhibition that are particularly appropriate for new media or participatory art. Otto Neurath, Paul Otlet, and Le Corbusier, for example, planned a series of museums intended to include wider cultural contexts called "Mundaneums," and the concept of "open storage display" popular in the 1980s can be seen to relate strongly to the open databases of online collections (Henning 2007: 28–40). More recently, museums have sought to fit the format of exhibition to the nature of the media used. The exhibition *Mediascape, à pas de Nam June Paik*, for example, at the Nam June Paik Art Center in Seoul, is a permanent exhibition intended to form a "road map of the conceptual space of Paikian mediscape." The exhibition includes playful elements and works from contemporary artists such as Jodi, and the use of some of Seoul's huge video walls in public places. The catalog outlines the chronological development of Paik's work, but also states "simply ignore this note if you adopt the Paikian 'random access' to this catalogue." The questions for the curator concerning exhibition strategies were very demanding – would Paik have approved of these playful exhibition strategies and the use of the kinds of media that were not available in his time (Lee and Kim 2011)?

The particular demands of exhibiting new media art to fit its particular nature in relation to time and space have been mapped out by many curators, including Christiane Paul, Steve Dietz, Inke Arnes, Jack Burnham and Jean-François Lyotard (Graham and Cook 2010; Mondloch 2010; Paul 2007). Many of the more recent experiments with exhibition modes have also come from artists. Aram Bartholl, for example, suggests the *Speed Show*, which involves choosing an Internet cafe, renting all the computers they have, and running an exhibition on them for one night. This mode allows performative pieces using pre-installed communication programs, but custom software or offline files are discouraged, hence fitting the exhibition format to the nature of the Internet.

The examples also encompass different ends of the collection timeline: exhibiting to collect and exhibiting from a collection. Exhibiting *before* collection might be simply a way of enabling artworks to be seen by buyers, as Caitlin Jones outlines in Chapter 7, or it can be a way of "testing" artworks in gallery contexts and with various audiences before the long-term considerations of collecting in an art institution, as was the case for Lindsay Taylor at the Harris Museum in Chapter 5, as well as for Pip Laurenson at Tate and Louise Shannon at the V&A. For early career artists or for works in development, festivals and laboratories form accessible kinds of exhibition and, as also outlined in this part, commissioning can be an exciting albeit risky mode of producing new art even before exhibition. In this part, both Rudolf Frieling and Caitlin Jones use the word "production" to indicate a mode of working that owes something to laboratory concepts and that operates around both commissioning and exhibition practice. Exhibiting *from* a collection is a mode increasingly available for new media art and, as Rudolf Frieling describes in Chapter 6, each reproduction of an exhibition from a collected artwork can illuminate that work in different contexts and esthetics. In Chapter 4, Rhizome exhibit from its ArtBase collection online, including audience-curated

selections, and also in physical spaces such as the New Museum. As Caitlin Jones illustrates in Chapter 7, even the behind-the-scenes processes of preservation can be exhibited in the *Seeing Double* exhibition at the Guggenheim, New York.

In Chapter 4, Heather Corcoran of Rhizome explains how ArtBase is described as an archive as well as having been understood as a collection. The archive forms its own public display as a whole, but Rhizome curators also "lovingly presort," in Kittler's terminology, some "collections" from the online archive, with themes such as "Formalism and Glitch" suggested by the artworks themselves and intended to offer a way into the archive. Physical exhibitions such as *ArtBase 101* at the New Museum offer another model of exhibition which functions in a different way for audiences who visit the museum for contemporary art in general. Importantly, the artists and viewers using the archive can curate it themselves, either by selecting "exhibitions" from the artworks or by using keywords that contribute to a "folksonomy."

In Chapter 5, Lindsay Taylor of the Harris Museum and Art Gallery, Preston maps the relationships needed to both exhibit and collect new media art over a long period of time. In her case, the processes need the close involvement of curators, exhibition organizers, collection committees, artists, and technicians. She found that a series of exhibitions and educational events helped to build both institutional and audience confidence in order to build a collection of innovative work. The selection of the work from a larger exhibition involved a panel of experts external to the museum and also audience feedback to the exhibited work. This artwork has since been exhibited again, which tested the efficacy of the documentation strategies, and collecting new media art has led to commissioning new artwork.

Chapter 6 features the San Francisco Museum of Modern Art, one of the institutions with a substantial collection of media art, and regular exhibitions from this collection. Rudolf Frieling has identified four categories of display: staging of the document; the participatory work and acts of translation; the production of a shared public collection; and the artist is absent. Citing examples of artists from Hans Haacke to Harrell Fletcher and Miranda July, Frieling describes the museum as a "producer," able to re-exhibit works via performative strategies, including commissioning other artists to conceive new installations for collected artworks. The exhibition *The Art of Participation* in particular explored modes of exhibition where audiences play active parts in performing, documenting or even collecting. Frieling references Alexander Dorner as a curator who can offer historical insights into exhibiting immaterial artworks.

In Chapter 7, Caitlin Jones explores the objecthood of new media art in relation to exhibiting and collecting, and the key art notions of authenticity and authorship, including the example of Rafaël Rozendaal's strategy of selling websites with unique URL names. Using examples from private collecting, the inherently reproducibility of new media does not appear to deter people from buying packaged versions of artworks which are freely available on the Internet. *Seeing Double*, the exhibition that she curated for the Guggenheim Museum, comprised paired artworks – one from the collection and a newer version that might include

the conservation strategy of emulation. Her chapter reinforces the importance of documentation in an archive and identifies a range of artists' documentation strategies, including Cory Arcangel's "thinly specified" work.

In the opening quote of this part, TAGallery highlights the material/immaterial nature of new media in relation to examining exhibitions and the fact that audiences can be the ones to do the tagging. With the dominant forms of online collections of media being databases such as YouTube or Rhizome's ArtBase where audiences can do their own selecting, it could be argued that the modes of exhibiting which most closely match new media art are those where the audiences are most strongly involved.

Part III: Audiences, Collections, and Exhibitions

> Engagement through moving around
>
> Engagement through temporal and spatial co-presence
>
> Engagement through identification and association.
>
> (Jo, Yamamoto, and Nakakoji 2006: 183)

When artists are engaged in studying audience behavior, they are able to bring their own skills in working with space and time into their research. For example, artist Kazuhiro Jo, together with others, formally studied *The Sine Wave Orchestra* artworks in public places at festivals. Together they were able to identify different styles of participation and share them with other researchers. This part of the book asks the following question: if audiences are so important, then what is known about them?

As established in this Introduction, new media fundamentally questions definitions of "audience" (Graham and Cook 2010: 161ff). What might be known about art audiences is a wide-ranging and contentious issue that is worth a little explanation here. The starting point for audience studies is often quantitative and when it comes to comparing online collections with physical galleries, the former often wins. As Jon Ippolito points out, comparing two New York examples from 2003, the Metropolitan Museum of Art's five million visitors per year (2.5 visits per artwork) is roughly comparable with Rhizome.org's four million visitors per year (7,000 visits per artwork), although the latter has a fraction of the budget (CRUMB 2012). As researcher Rui Guerra of the INTK.com resource says: "Wouldn't it be ironic if in the near future, offline exhibitions would be just a marketing strategy to attract visitors to websites?" (Debatty 2011). New media can, of course, attract not only an art audience but also those interested in new media cultures (Zippay 2006). Beyond mere numbers, however, the "Engagement Factor" of new media can measure the duration and number of return visits to determine the depth of interest from online visitors (Deshpande, Geber, and Timpson 2007: 276).

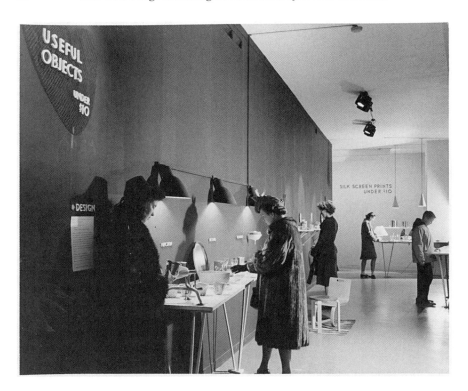

Figure I.6 Installation detail of unidentified visitors at the *Useful Objects of American Design under $10* exhibition at the Museum of Modern Art (MoMA), New York, 1940. © 2013 Courtesy of the Museum of Modern Art, New York/Scala, Florence

For art institutions, a key concern has been the particular demographics of art audiences in terms of class, gender, and race (Dewdney, Dibosa, and Walsh 2013: 126ff; Prior 2003: 59–66). On the subject of more qualitative research on the experiences of audiences, the fields of education and exhibition design have been historically much more active in this than curators themselves (Graham and Cook 2010: 164ff). A 1940 photograph from MoMA New York, for example, shows viewers indulging rather decorously in the unusual notion that audience members are allowed to touch the objects displayed, an early example of how factors of participatory behavior of audiences affect exhibition modes and how these exhibition modes are aimed to reflect the content of the exhibition – if objects are intended to be used, then those behaviors need to be catered for.

Much of the knowledge concerning audiences might lie in education departments. This close involvement of education departments with collecting

and exhibiting is one that is reflected in many museums. At the Van Abbemuseum in Eindhoven, for example, Christiane Berndes, curator of the collection, has described how the *Play Van Abbe* program is planned with a team of curators and education workers rather than being media-specific, and offers understandings of the different kinds of roles that audiences might adopt in relation to their behaviors in an art museum, including those of "flaneur" or "worker" (Baltan Laboratories and Van Abbemuseum 2012). Because of the connection between new media and modes of audience participation, much research concerning interactive media does deal with audience experience rather than just demographics, but predominantly covers commercial or educational products rather than art. The little research that does take art seriously includes Beryl Graham's work on interaction between viewers, Bill Gaver's "cultural probes," and Nadja Mounajjed's work on Rafael Lozano-Hemmer (Graham and Cook 2010: 187). Since artists have been thoroughly exploring the participatory systems of new media, it is not surprising that many have insights into audience behaviors themselves, including Harrell Fletcher, one of the artists behind *Learning to Love You More* (Sanchez 2007). However, what is often missing from the published research is a deeper understanding of audiences as participants in curatorial roles. In this book, however, when arts organizations do take audience views seriously, they are often greatly rewarded. In the case of the Harris Museum and Art Gallery in Chapter 5, for example, it was discovered that the audience's choice for collection was very much in accord with a panel of art experts, and their choice was a complex and slow-burn piece with a minimalist esthetic.

A strong focus of this part is placed on the connections between audiences, exhibitions, collections, and histories. Looking at the nature of the art forms where audiences are clearly important to documentation, art that involves performative or participatory aspects emerges. Bruce Altshuler, for example, discusses the exhibition *When Attitudes Become Form: Works–Processes–Concepts–Situations–Information (Live in Your Head)* in 1969 in terms of Adrian Piper's role as a human interface and the numbers and nationalities of visitors (Altshuler 1994: 239). More recently, the exhibition *bit international – [New] Tendencies – Computers and Visual Research* curated by artist Darko Fritz for the Museum of Contemporary Art in Zagreb took the early computer-inflected "[New] Tendencies" work from around 1968 and presented it in a way that reflected on Tito's Yugoslavia at that time, rather than just in terms of technological or art history (Merenik 2007). In historical terms, therefore, each exhibition from a collection has the potential to reinterpret and add to the work itself.

In Chapter 8, Louise Shannon of the V&A describes how exhibiting contemporary new media art and design can relate to a collection of computer art, and in particular how connections between marketing, education, and collections departments of a museum can help reach audiences. She outlines how previous education-led events, including the *Friday Lates* events, were related to the commissioning of new media works which were able to experiment with

various spaces in the museum, including interactive artwork for the John Madejski Garden. Live audience feedback was part of this work and this in turn helped to develop elements of the *Decode* exhibition in 2010. This exhibition was very popular with audiences, including students and families, and included some highly participatory elements, such as audiences being encouraged to recode an animation by Karsten Schmidt for the marketing campaign for the exhibition. The exhibition tour included some updated versions of artworks at each venue, including new commissions such as that from Feng Mengbo in China. The exhibition and tour was seen as a good way of thoroughly exploring each artwork in different contexts, and led to several new acquisitions for the collection, including Aaron Koblin's *Flight Patterns* and Casey Reas's *Process 18*.

In Chapter 9, Lizzie Muller puts audiences and artists at the center of her research and, in doing so, provides the kind of documentation that would be of significant use to curators seeking to exhibit any kind of art from a collection. She outlines the different incarnations of David Rokeby's *Very Nervous System* over its 30-year life, including suites of software that could be used by other artists. She includes Rokeby's observations on interactivity and her own research on "indeterminate archives" of material including detailed interviews with audience members, some of whom have seen various incarnations of an artwork. Her more recent work studying audiences of Anish Kapoor's sculptural work has been included in a public "living catalog" of an exhibition of Kapoor's work at the Museum of Contemporary Art in Sydney and points toward a future where the kinds of documentation included with collected works could also include audience experience.

Chapter 10 sees Sarah Cook both looking back at what might enter a collection and looking forward to what future histories might make of what has been collected. Starting from the problem of taxonomies which seek to "pin the butterfly" of new media art, she explores the kinds of documentation that might remain from certain works beyond the actual objects, for example, the plans, videos, and diagrams from Norman White's robots. The exhibition *The Art Formerly Known as New Media*, which was curated by Cook and Dietz for a media art histories conference, is discussed in relation to the ways in which technological histories and change can challenge conventional curatorial notions of retrospectives and chronological exhibitions. Commissioning is foregrounded as a way of ensuring that new art is still being produced in order to be collected, and the different "versions" of Thomson and Craighead's commissioned work *A Live Portrait of Tim Berners-Lee* are commented on by Steve Fletcher of Carroll/Fletcher Gallery. Laurence Sillars, a curator at BALTIC, refers to the experience of exhibiting Robert Breer's kinetic sculptures and stresses the need for documentation and critical response to come from several sources in order to reflect enough information for effective exhibiting, rather than relying on a single historian, artist, or curator. Her chapter acknowledges possible dystopian futures for new media art (Cook forthcoming).

Concerning the complex web of how contemporary art might be understood in future histories via what is documented, archived, and collected, others have

also made connections between the importance of high-quality art criticism for new media art and the establishment of a provenance for collecting. As outlined earlier in this chapter, the role of the audience in documenting, archiving, and criticizing is also very important in historicizing current art. As the chapters of this book illustrate, collecting new media art challenges curators, archivists, documenters, artists, educators, historians, and audiences. As Ippolito and Rinehart say: "Only You Can Prevent the End of History" (Ippolito and Rinehart forthcoming).

Collections, Exhibitions, Audiences – Connected Issues

> In my view, new media is most interesting for what it does to the hierarchies of knowledge in the museum, particularly in relation to the division between "front and back regions" of the museum. (Henning 2010: 303)

When Michelle Henning quotes sociologist Erving Goffman's phrase concerning the traditional divisions and hierarchies between "front and back regions" of the museum, it is precisely these conventional divisions that new media art challenges. The divisions between medium-specific art forms and between art and design are challenged by the immateriality and medium-independent behaviors of various kinds of new media art, in particular behaviors of interactivity and participation. Goffman's background in sociology also connects strongly to the importance of understanding social systems and the ways in which those systems use technology. The hierarchies between education and the curating departments of museums are particularly sharply delineated, and yet new media also connects these areas, to the point of new media art being confused with new media as a tool for interpreting art.

As outlined in Chapter 1, the roles of the curators and collectors vary greatly from commissioners and patrons to collaborative curating models. However, the divisions between the roles of who does what in the processes of documenting, exhibiting, and collecting are challenged most significantly when audiences are involved. Audiences are already significantly involved in: documenting art events; curating and exhibiting by collecting links, selecting from online archives such as Rhizome's ArtBase, or participating in folksonomies; and helping in the conservation of software art in particular, through open source methods. The role of the audience is becoming increasingly formalized in some of the basic archival systems – the OAIS model discussed in this Introduction in relation to taxonomies significantly names the consumer/user and the target groups of the system, the so-called designated community, as being key to designating the kinds of documentation in the archive. This central place of the audience also highlights the relative lack of information about audiences beyond simple demographics, a factor that this book starts to address. This is not only a challenge for collecting art but might also be a necessity if enough relevant contextual material for the successful reanimation of artworks from collections is to be archived and made available to future curators.

Factors of documentation, exhibition, and audiences are indissolubly linked for collecting new media art. As outlined in Part II of this Introduction, the histories of exhibitions rather than art are very poorly documented, and yet exhibitions are where artworks meet audiences, while for participative artwork, the work barely exists outside of its exhibited form (Graham forthcoming C; Paul 2007). This then raises the question – can exhibitions be collected? In this book, certain exhibitions such as *Information* in 1970 are returned to as examples of artistic strategy and audience behaviors. Recently, there have been indications that museums' acquisition systems are indeed capable of considering whole exhibitions if the taxonomical structures can be adapted. When the Van Abbemuseum acquired a version of the exhibition *No Ghost Just a Shell*, instigated by artists Philippe Parreno and Pierre Huyghe and including work by other artists, collecting an exhibition rather than an artwork presented some problems. "To be accounted for as an acquisition, it needed to be fragmented into single objects or registered under one entry." This systemic problem was solved by creating special "work sets" in the collections management system that created a link between individual works, while also allowing the person entering the data to designate one inventory number to the project as a whole. In 2007, private collector Rosa de la Cruz donated another version of *No Ghost Just a Shell* to the Museum of Contemporary Art (MoCA) in North Miami and Tate Modern in London. This recognition of the exhibition as a collectible form by both private and public collectors, and the subsequent systemic change, bodes well for the future of a more flexible and integrated collecting mindset (Saaze 2013: 175).

In line with the mindset of crowd-sourced documentation, certain curators have been active in sharing their curatorial research and documentation of their own exhibition processes. Barbara London of MoMA blazed a trail with her *Stir-Fry* website in 1997 (London 1997) and, more recently, Amanda McDonald Crowley has testified that it is useful for her to be able to "share the research I am doing on a particular topic that will lead to curatorial projects," using scoop.it, blogs, delicio.us, or any new media tool designed for sharing (London 1997; McDonald Crowley 2013). This generous sharing of curatorial knowledge is the central aim of this book and I am grateful to all of the contributors for forcing their busy lives of practice into the timescale of publishing, and for smoothing the many radial connections between collecting, documentation, exhibiting, and audience into the form of a book.

References

Altshuler, Bruce (ed.). 1994. *The Avant-Garde in Exhibition: New Art in the 20th Century.* Berkeley: University of California Press.

Altshuler, Bruce. 2009. "Collection: Threads of Chance and Intention," in *A Manual for the 21st Century Art Institution*, edited by Samita Sharmacharja. London: Walther Koenig, 34–45.

Baltan Laboratories and Van Abbemuseum. 2012. *Collecting and Presenting Born-Digital Art Working Conference.* 14–15 December. Eindhoven: Baltan Laboratories and the Van Abbemuseum.

Barbuto, Alessandra and Laura Barreca. 2013. "MAXXI Pilot Tests Regarding the Documentation of Installation Art," in *Preserving and Exhibiting Media Art: Challenges and Perspectives. Framing Film 4*, edited by Vinzenz Hediger, Barbara Le Maitre, Julia Noordegraaf, and Cosetta Saba. Chicago: University of Chicago Press, 183–8.

Breakell, Sue. 2010. "For One and All: Participation and Exchange in the Archive," in *Revisualizing Visual Culture*, edited by Chris Bailey and Hazel Gardiner. London: Ashgate, 97–108.

CONT3XT.NET (Sabine Hochrieser, Michael Kargl, and Franz Thalmair). 2007a. "Virtual/Real Representations in Real/Virtual Spaces," in *Circulating Contexts – CURATING MEDIA/NET/ART*, edited by CONT3XT.NET. Norderstedt: Books on Demand GmbH, 54–59. Also available at: http://cont3xt.net/blog/?p=370 [accessed 14 October 2013].

CONT3XT.NET (Sabine Hochrieser, Michael Kargl, and Franz Thalmair). 2007b. *TAG | TAGallery | THE ART Gallery.* http://tagallery.blogspot.com/2007/02/about-tagallery-ber-tagallery.html [accessed 14 October 2013].

Cook, Sarah. 2013. "On Curating New Media Art," in *Preserving and Exhibiting Media Art: Challenges and Perspectives. Framing Film 4*, edited by Vinzenz Hediger, Barbara Le Maitre, Julia Noordegraaf, and Cosetta Saba. Chicago: University of Chicago Press, 391–405.

Cook, Sarah. Forthcoming. "We're Not Hobbyists or Dabblers Anymore," in *Speculative Scenarios*, edited by Annet Dekker. Eindhoven: Baltan Laboratories, 46–52.

CRUMB. 2009. *Real-Time: Showing Art in the Age of New Media Conference.* 24 September. Abandon Normal Devices Festival, Liverpool and Liverpool John Moores University. Available at: http://www.crumbweb.org/getSeminarDetail.php?id=13 [accessed 14 October 2013].

CRUMB. 2012. *Collecting New Media Art Theme Jul 2012. CRUMB Discussion List Edits.* Available at: http://www.crumbweb.org/discussionArchive.php?&sublink=2 [accessed 14 October 2013].

DCMS. 2005. *Understanding the Future: Museums and 21st Century Life – A Summary of Responses.* DCMS. Available at: http://webarchive.nationalarchives.gov.uk/+/http:/www.culture.gov.uk/images/publications/understanding_the_future_responses.pdf [accessed 14 October 2013].

Debatty, Regine. 2011. "Interview with Rui Guerra about Online Strategies for Cultural Spaces." *We-make-money-not-art.* http://we-make-money-not-art.com/archives/2011/02/interview-with-rui-guerra.php#.USkNuhneNBY [accessed 14 October 2013].

Dekker, Annet. 2010. "Report: Archive 2020 Expert Meeting," in *Archive2020 – Sustainable Archiving of Born-Digital Cultural Content*, edited by Annet Dekker. Amsterdam: Virtueel Platform.

Dekker, Annet. 2013. "Enjoying the Gap: A Comparison of Contemporary Documentation Strategies," in *Preserving and Exhibiting Media Art: Challenges and Perspectives. Framing Film 4*, edited by Vinzenz Hediger, Barbara Le Maitre, Julia Noordegraaf, and Cosetta Saba. Chicago: University of Chicago Press, 151–71.

Deshpande, Suhas, Kati Geber, and Corey Timpson. 2007. "Engaged Dialogism in Virtual Space: An Exploration of Research Strategies for Virtual Museums," in *Theorizing Digital Cultural Heritage: A Critical Discourse*, edited by Fiona Cameron and Sarah Kenderdine. Cambridge, MA: MIT Press, 261–79.

Dewdney, Andrew, David Dibosa, and Victoria Walsh. 2013. *Post Critical Museology: Theory and Practice in the Art Museum*. Abingdon: Routledge.

Druckrey, Timothy. 2007. *Media Art Undone Panel, transmediale.07 Conference.* 3 February. Berlin: Available at: http://www.mikro.in-berlin.de/wiki/tiki-index.php?page=MAU [accessed 14 October 2013].

Fox, Howard N. 2005. "The Right to be Wrong," in *Collecting the New: Museums and Contemporary Art*, edited by Bruce Altshuler. Princeton: Princeton University Press. Available at: http://www.yproductions.com/writing/archives/000764.html [accessed 14 October 2013], 15–28.

Goriunova, Olga. 2012. *Art Platforms and Cultural Production on the Internet.* London: Routledge.

Graham, Beryl. 2004. "Webexclusive: Exhibiting Locative Media: CRUMB Discussion Postings." *Metamute*, 20 May. Available at: http://www.metamute.org/en/Exhibiting-Locative-Media-CRUMB-discussion-postings [accessed 14 October 2013].

Graham, Beryl. 2007. "Redefining Digital Art: Disrupting Borders," in *Theorizing Digital Cultural Heritage: A Critical Discourse*, edited by Fiona Cameron and Sarah Kenderdine. Cambridge, MA: MIT Press, 93–112.

Graham, Beryl. Forthcoming A. "Open and Closed Systems: New Media Art in Museums and Galleries," in *Museum Media: The Handbook of Museum Studies*, edited by Michelle Henning. London: Wiley-Blackwell.

Graham, Beryl. Forthcoming B. "Histories of Interaction and Participation: Critical Systems from New Media Art," in *Performativity in the Gallery: Staging Interactive Encounters*, edited by Outi Remes, Laura MacCulloch, and Marika Leino. Oxford: Peter Lang.

Graham, Beryl. Forthcoming C. "Exhibition Histories and New Media Behaviours." *Journal of Curatorial Studies*, 2(2), 242–62.

Graham, Beryl and Sarah Cook. 2010. *Rethinking Curating: Art after New Media.* Cambridge, MA: MIT Press.

Henning, Michelle. 2007. "Legibility and Affect: Museums as New Media," in *Exhibition Experiments. New Interventions in Art History Series*, edited by Sharon Macdonald and Paul Basu. London: Wiley-Blackwell, 25–46.

Henning, Michelle. 2010. "New Media," in *A Companion to Museum Studies* (Blackwell Companions in Cultural Studies), edited by Sharon Macdonald. London: Wiley-Blackwell, 302–18.

Ippolito, Jon. 2003. "Accommodating the Unpredictable: The Variable Media Questionnaire," in *Permanence through Change: The Variable Media Approach*, edited by Alain Depocas, Jon Ippolito, and Caitlin Jones. New York: Guggenheim Museum. Also available at: http://www.variablemedia. net/e/preserving/html/var_pub_index.html [accessed 14 October 2013], 47–54.

Ippolito, Jon and Richard Rinehart. Forthcoming. *Re-Collection: New Media and Social Memory*. Cambridge, MA: MIT Press.

Jo, Kazuhiro, Yasuhiro Yamamoto, and Kumiyo Nakakoji. 2006. "Styles of Participation and Engagement in Collective Sound Performance Projects," in *ENGAGE: Interaction, Art and Audience Experience. CCS/ACID Symposium*, edited by Ernest Edmonds, Lizzie Muller, and Deborah Turnbull. Sydney: Creativity and Cognition Studios Press, University of Technology, 110–19.

Jones, Caitlin. 2003. "Reality Check: A Year with Variable Media," in *Permanence through Change: The Variable Media Approach*, edited by Alain Depocas, Jon Ippolito, and Caitlin Jones. New York: Guggenheim Museum. Available at: http://www.variablemedia.net/e/preserving/html/var_pub_index.html [accessed 14 October 2013], 61–4.

Jones, Caitlin. 2008. *Documenting New Media Art Seminar*. 5 March. Newcastle: CRUMB. Available at: http://www.crumbweb.org/getPresentation.php?pres ID=44 [accessed 14 October 2013].

Kittler, Friedrich. 1996. "Museums on the Digital Frontier," in *The End(s) of the Museum*, edited by John Hanhardt. Barcelona: Fondacio Antoni Tapies, 67–80.

Lee, Sooyoun. 2013. Re: From Sooyounlee, National Museum of Contemporary Art, Korea. 3 January 2013, 09:12:18 GMT [personal email].

Lee, Souyoung and Seongeun Kim. 2011. *Mediascape à pas de Nam June Paik*. Seoul: Nam June Paik Art Center.

London, Barbara. 1997. *Stir-Fry*. http://www.adaweb.com/context/stir-fry [accessed 14 October 2013].

McDonald Crowley, Amanda. 2013. "Re: [NEW–MEDIA–CURATING] The Way We Share: Transparency in Curatorial Practice." *New-Media-Curating Discussion List*. Available at: http://www.jiscmail.ac.uk/lists/new-media-curating.html [accessed 14 October 2013].

Merenik, Lidija. 2007. "Before the Art of New Media." *Mute*. Available at: http://www.metamute.org/editorial/articles/art-new-media [accessed 14 October 2013].

Mondloch, Kate. 2010. *Screens: Viewing Media Installation Art*. Minneapolis: University of Minnesota Press.

Moschovi, Alexandra. 2008. "Changing Places: The Rebranding of Photography as Contemporary Art," in *Photography between Poetry and Politics: The Critical Position of the Photographic Medium in Contemporary Art*, edited by Hilde Van Gelder and Helen Westgeest. Leuven: Leuven University Press/ Cornell University Publications.

Muller, Lizzie. 2012. Re: Incomplete Draft … 4 July 2012 [personal email].

National Museum of Contemporary Art, Korea. 2012. *National Museum of Contemporary Art, Korea: Overview*. Seoul: National Museum of Contemporary

Art, Korea. Available at: http://www.moca.go.kr/engN/engNCollection.do?_
method=Coverview [accessed 14 October 2013].

Noordegraaf, Julia. 2004. *Strategies of Display: Museum Presentation in
Nineteenth- and Twentieth-Century Visual Culture.* Rotterdam: NAI Publishers.

Parry, Ross (ed.). 2010. *Museums in a Digital Age* (Leicester Readers in Museum
Studies). London: Routledge.

Paul, Christiane. 2007. "The Myth of Immateriality: Presenting and Preserving New
Media," in *MediaArtHistories*, edited by Oliver Grau. Cambridge, MA: MIT
Press, 251–74.

Prior, Nick. 2003. "Having One's Tate and Eating it: Transformations of the
Museum in a Hypermodern Era," in *Art and its Publics: Museum Studies at the
Millennium* (New Interventions in Art History), edited by Andrew McClellan.
London: Blackwell, 51–74.

Rees Leahy, Helen. 2012. *Museum Bodies.* Farnham: Ashgate.

Reiss, Julie H. 1999. *From Margin to Center: The Spaces of Installation Art.*
Cambridge, MA: MIT Press.

Rellie, Jemima. 2010. "Museum Migration in Century 2.08," in *Revisualizing Visual
Culture*, edited by Chris Bailey and Hazel Gardiner. Farnham: Ashgate, 139–50.

Rinehart, Richard. 2005. "A System of Formal Notation for Scoring Works of Digital
and Variable Media Art." *MediaArtHistories Archive Refresh! Presentations.*
Available at: http://hdl.handle.net/10002/307 [accessed 14 October 2013].

Saaze, Vivian van. 2013. "Case Study: No Ghost Just a Shell by Pierre Huyghe,
Philippe Parreno, and Many Others," in *Preserving and Exhibiting Media Art:
Challenges and Perspectives. Framing Film 4*, edited by Vinzenz Hediger, Barbara
Le Maitre, Julia Noordegraaf, and Cosetta Saba. Chicago: University of Chicago
Press, 172–7.

Sanchez, Marisa. 2007. "Tell Me Your Story: An Interview with Artist Harrell
Fletcher," in *Searching for Art's New Publics*, edited by Jeni Walwin. Bristol:
Intellect, 79–90.

Serexhe, Bernhard (ed.). 2013. *Preservation of Digital Art: Theory and Practice.*
The Digital Art Conservation Project. Berlin: ZKM/Springer Verlag GmbH.

Staniszewski, Mary Anne. 1998. *The Power of Display: A History of Exhibition
Installations at the Museum of Modern Art.* Cambridge, MA: MIT Press.

Van der Graaf, Maurits and Gerhard Jan Nauta. 2010. "Cultural Heritage in
Limbo," in *Archive2020 – Sustainable Archiving of Born–Digital Cultural
Content*, edited by Annet Dekker. Amsterdam: Virtueel Platform, 8.4–8.5.

Walsh, Peter. 2007. "Rise and Fall of the Post-photographic Museum: Technology
and the Transformation of Art," in *Theorizing Digital Cultural Heritage: A
Critical Discourse*, edited by Fiona Cameron and Sarah Kenderdine. Cambridge,
MA: MIT Press, 19–34.

Zippay, Lori. 2006. "Conversation with Cory Arcangel." *EAI Online Resource
Guide for Exhibiting, Collecting & Preserving Media Art.* Available at: http://
resourceguide.eai.org [accessed 14 October 2013].

Chapter 1
Modes of Collection

Beryl Graham

Why Collect?

> *Ten Thousand Cents* is a digital artwork that creates a representation of a $100 bill. Using a custom drawing tool, thousands of individuals working in isolation from one another painted a tiny part of the bill without knowledge of the overall task. Workers were paid one cent each via Amazon's Mechanical Turk distributed labor tool. The total labor cost to create the bill, the artwork being created, and the reproductions available for purchase (to charity) are all $100. (Koblin and Kawashima 2007)

New media art *is* collected. It's just that it challenges many of the established definitions, histories, exhibition forms, authorship, economic systems, roles and processes of traditional object-based fine art. Given this factor, this chapter considers different "modes" of collecting rather than a singular "model" intended to be set in stone. Because a deep understanding of authorship, socio-economic systems, and processes is demanded from those working with new media art, artists are able to push these systems as far as they will go, gleefully playing the system to make the form of the artwork reflect the content of what the artists want to say. The artists are not necessarily inserting a monkey wrench into the works to make the machine stop as per the tradition of certain activist or oppositional art (although this is still an option), but developing elegant new spanners that can tweak the machine into doing strange and interesting things.

Ten Thousand Cents by Aaron Koblin and Takashi Kawashima from 2007, for example, is using the existing Mechanical Turk online system whereby many people in different parts of the world do small digital tasks that only humans can do for small amounts of money or credit. By making multi-authored art objects via this system, selling them directly, and giving the money to charity, these artists are making visible a rather complex globalized economic system. The producers and viewers of the work are also carefully tracked on the website, even if they do not buy the work – average times spent and the location of visitors from Egypt to the Philippines are logged. The fact that this is completely outside of the single-authored unique object of the traditional art market doesn't stop the artwork from selling. What better way to shock the bourgeoisie in the twenty-first century than to question the allure of the international art market, online shopping, and the globalization of networked labor?

If the question "*why* collect new media art?" is asked, then one answer could be that it is a default option. As curator and artist Domenico Quaranta points out: "In the cache era, accumulating data is like breathing: involuntary and mechanical. We don't choose what to keep, that is, but what to delete" (Quaranta 2011: 8). It is certainly easy and cheap for individuals to buy immaterial or material artworks such as *Ten Thousand Cents*, and those with more money to spend can obviously develop a taste for the wit, beauty, and complexity of artworks which are dealing with contemporary systems, cultures, and issues, to whit the Carroll/Fletcher Gallery which deals in contemporary art, including new media (see Chapter 10).

Those in charge of institutional collections obviously have an eye for history as well as for more immediate gratifications, but if they deal with contemporary art at all, they can be including new media art depending on the knowledge and taste of curators or even of national government ideology. In examining collecting internationally, it is noticeable that nations that see themselves as young, forward-looking, and technophilic are rather more likely to collect new media art. The National Taiwan Museum of Fine Art in Taichung, for example, has a special category in its collections database for young Taiwanese artists and publishes a lavish catalog each year of only young artists. Collecting new media art is seen as part of this remit, and the Museum as a national collection is actively encouraged by government funding and ideology to do this (Graham 2012a). Although the funding might be enviable, collecting because of government ideology obviously also has its drawbacks, not least because government ideology changes perhaps even more frequently than art world fashions; therefore, what happens when new media art is no longer "timely" (Graham and Cook 2010: 285)? Other conversations in Taiwan revealed a strong "cultural industries" agenda, which might be familiar to those in the UK, where new media appeals to government agendas purely as a commercial product and hence forces the understanding of new media towards design rather than art (Variant 2010).

Given the popular aphorism stating that what is collected is "artists not artworks," a particular interest in young and early career artists might be a good reason why new media art is collected, as many new media artists are necessarily early career. However, as many artists by now have a solid 20 years of new media art practice under their belts, this is not necessarily the case: Rafael Lozano-Hemmer in the Introduction, and Thomson and Craighead in Chapter 10, for example, have substantial bodies of work in various collections. New media art is, unsurprisingly, collected in various ways for various reasons. What this chapter aims to do after clarifying who collects what is to identify different "modes" of collecting, especially where these modes or systems might be adapted to match the nature and systems of the artwork itself. These modes draw on some histories of collecting as outlined in the Introduction and use international examples that are not covered elsewhere in the chapters of this book. Bruce Altshuler's 2005 edited book *Collecting the New: Museums and Contemporary Art* is notable not only for its inclusion of art forms including performance but also for examining *how* the art is collected. This chapter also seeks to do this and hopefully to highlight how the collectors might be the richer for it.

What is Collected?

> Doing *Cities on the Move* was an almost unbearable thing for the institution, the audience, and even the artists because the works had to change. This is a challenging concept to those who think that art is a commodity for the market. The market regards art as a thing that does not change. It's time for us to articulate the importance of immaterialty, fluidity, performativeness, and change as central to our activities. (Hans Ulrich Obrist in Kuoni 2001: 77)

"Immateriality" is sometimes cited as an insurmountable obstacle for collecting new media art. However, as Hans Ulrich Obrist indicates, curators of various contemporary art forms have been dealing with this for some time. For curators of new media art, the levels of materiality are hotly debated and the behaviors of immateriality are seen as their basic "operating system":

> The economics and temporality of net art, software art, database art or any art process that lives online and is formulated through code, presents a distinctive operating environment for the curator of this "immateriality." This sphere of operations lends itself to a more distributed topography of decision-making and evaluation (quick and painless dissemination of work, participatory features, time/space collapse). (Vishmidt 2006: 45)

This code might be materialized or performed in different ways – on a screen or as sound – and the same code might be commercially distributed as a DVD or limited as a small edition. Depending on the museum, it might collect various things: the National Media Museum in Bradford, for example, has a large collection of media objects such as screens and projectors which are not art, but might be necessary to display art, and it is these items which appear in the Museum's online collection database website. It has also commissioned for long-term exhibition artworks such as Thomson and Craighead's *A Live Portrait of Tim Berners-Lee* (see Chapter 10).

Artists who work with new media, however, are very used to the variability of the materialization of their ideas and code in different contexts. The artist Carlo Zanni, for example, has artwork which exists only on screen, but has also worked on objects, sometimes of a temporary nature, which make visual sense in the context of his work: The work *File* from 2000, for example, used small 32-pixels-square desktop icons as "portraits" of people. For an exhibition in New York, he also printed out the images and mounted them on aluminum, but at exactly the same tiny size that they were on a computer screen. Zanni has also produced a series of artworks called *Altarboy*, specially made for screens in metal suitcases, and has actively sought to develop the debate on new media art and material forms for collecting by hosting a forum called

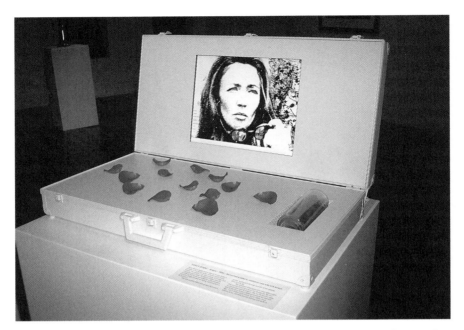

Figure 1.1 Carlo Zanni's *Oriana (Altarboy)*, 2004. Installation view at the Chelsea Art Museum as part of the exhibition *The Passage of Mirage – Illusory Virtual Objects*, 2004, curated by Christiane Paul and Zhang Ga. Photo by the artist. Image courtesy of the artist

"P2P_$: Peer to Peer $elling Processes for net_things" and a mailing list "P2P_. EDU: Peer to Peer Educational for art dealers" (Zanni 2010: 44).

In 2001, Susan Morris' research report on museums and new media art identified three key pre-existing models of "what" exactly was collected: an original, unique work of art; an edition; or a performance (Morris 2001: 9). Museums still understand collection broadly under these headings of object, reproduction, or score/performance rights, and hence deeply influence "what is collected." When examining the actual new media objects that museums have in their collections, it can be interesting from a curator's point of view to see and handle the solutions that artists themselves come up with. The Victoria and Albert Museum (V&A) has a Prints and Drawings Study Room where, admirably, the public can make appointments to handle works from that collection. Searching the online collection for Casey Reas' 2010 *Process 18 (Software 3)* comes up with nine separate items in the collection: two CDs containing software, one documentation print signed by the artist, five other digital prints, and a presentation box. If these are requested for examination, then it becomes clear that the artist has carefully considered how to present the work for a collection. The aluminum presentation

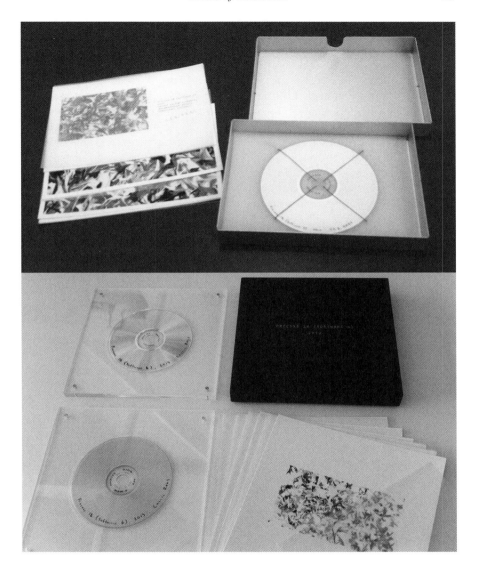

Figure 1.2 **Versions of objects representing Casey Reas' *Process 18*.
(Top) *Process 18 (Software 3)*, as collected by the V&A,
showing signed digital prints, and CD-ROM sewn into
drafting vellum, in an aluminium box. (Bottom) *Process 18
(Software 6)*, in an etched aluminium box. Courtesy of the
photographers and the artist**

box neatly contains the CDs and signed print. The CDs are annotated by hand in pen and are sewn between two sheets of drafting vellum, bringing a certain presence and hand of the artist to highly immaterial software art (see also Chapter 8).

Whilst Morris' three categories are still reasonably flexible, there are some aspects of new media art that disrupt them beyond the general immateriality of conceptual art or performance. First, there is the phenomenon of versioning – common enough in software production where a cycle of improvements is usual, but less so in art. Artists such as Casey Reas, however, are very clear about exactly which version of the software is being considered and which kind of output is obtained from that software. Second, there is a set of socio-economic ethics and systems surrounding certain new media, including open source production methods, free software, copyleft, and multiple authorship, which mean that much work has been done by researchers to integrate details of specific contracts and economics into the consideration of collecting new media art (Dekker and Somers-Miles 2011).

Economic Modes

> Free goods and commercial value creation are not fundamental opposites. On the contrary, it is the specific features of these goods that create entirely new needs. It could be briefly formulated that what is specific about services based on free goods is not the focus on exclusive possession, but rather the stabilization of social relationships. (Stalder 2010: 76)

Like some conceptual art and new media art, the law might deal with material products, but is quite used to immaterial concepts such as patents and trademarks used to "protect" objects. As Caitlin Jones indicates in Chapter 7 of this volume, new media art is sold in various ways, and the artist Rafael Rozendaal has been quick to rationalize the potential of URLs – the necessarily unique domain name of a website – to form a unique sellable item, with a different URL for each of his net artworks. Some economic modes for selling immaterial works, however, are not so elegant, such as [s]edition (seditionart.com), a website selling digital reproductions of art objects including sculptures or paintings and a special Facebook sign in. What the buyer gets is access via a smartphone, computer, or TV to digital images and a certificate of "authenticity," a rather confusing and tortuous mode to those familiar with new media behaviors.

Those important open source and free systems defined in the Introduction to this volume are of obvious importance for economic issues, and Felix Stalder goes on to examine the more difficult questions which challenge traditional art collection more fundamentally. He identifies four different types of "value" that do not involve owning an object: "embodied knowledge, possession through association, privileged access, and symbolic shareholding" (2010: 79). Most of these systems might already be familiar to those working in the art world, including purchasing

access at "premium" times or spaces, or of sponsors choosing to be associated with events of "high social value."

What might be less familiar to the art world are those other systems that specifically attach to open source and free software in particular. Such software is free to use, study, share, copy, and modify, and can be licensed under a General Public License (GPL). As outlined in the opening quote, it can be a source of much puzzlement how any artwork could be bought or collected in this case. Felix Stalder, however, suggests that artists could benefit economically in at least three ways:

Dual Licensing A consequence of the GPL is that all software based on GPL code must be redistributed under the GPL. Not all users want to be restricted to these conditions. This results in the demand for the acquisition of a program under a non-free license as well ...

Customizing Free and Open Source Software, especially when it is developed in formally open networks (which is usually the case), is generic for structural reasons. For it is the generic core of a problem that is shared by many and around which cooperation is organized in larger groups. The application of software, however, is almost always unique, especially if it passes a certain stage of complexity ...

Support Next to customization, the area of support certainly creates the greatest demand for commercial services based on free goods. A central criticism of products produced in open networks is that responsibility and accountability are often unclear. Although most problems can also be solved within the open network (by consulting forums and mailing lists), this can take a great deal of time and effort and may also presuppose a high degree of knowledge on the part of the person trying to solve the problem. (Stalder 2010: 84–6)

As Stalder identifies, "dual licensing" can enable a more flexible sense of ownership or, as Jaime Stapleton has put it, "bundles of rights" (Dipple 2010). Although "open source" is sometimes rather loosely applied to kinds of artwork that rely on process and participatory structures, there are obvious differences between a system that is collectively authored and free, and an art system that is strongly founded on authorship linked to financial value. However, because Creative Commons and GPL licensing retains a strong emphasis on crediting and moral rights to works, there are certain parallels that can be made. As researcher Dominic Smith has discussed, open source production methods do not mean that there are not hierarchies of authorship or ownership of works, but that the hierarchies attach more to levels of instigation, activity, and skill than to the repute of an individual artist (Smith 2011).

"Customization" could involve an artist presenting a solo version based on a larger collective project – with proper credit of course. In a financial sense,

it could be argued that new media is actually *more* sellable because of its "customizable nature":

> Beat Brogle's *onewordmovie* asks visitors only to type in one word. The *onewordmovie* program then searches the Internet for images involving this word and makes a flash movie out of them ... The interaction becomes binding only when it comes to a sale. The object sold is a DVD containing the film made for the word in question. The choice of words will be correspondingly more discriminating. Will the word chosen generate only nice pictures or will it express the client's originality? (Schwander 2010: 34)

"Support" for an artist could mean providing workshops or artist-in-residence activity around a project. Artists Harrell Fletcher and Miranda July, for example, with their online participatory project *Learning to Love You More*, did not find that the multi-authored nature of the work prevented the artists being paid for workshops and exhibitions, solo works based on the material, or the work being collected (see Chapter 6).

Particular new media economic modes can therefore be seen both as a challenge to pre-existing modes of collecting and also as flexible extra modes to be considered and adapted for the future. As outlined in the Introduction, open source production methods could also mean the possibility of "crowd-sourcing" the conservation of art, or software art in particular, and could this provide a possible solution for a long-standing issue for collectors.

Who Collects? Public and Private Roles

> Curators, registrars, audiovisual technicians, and conservators negotiated their roles as collections forced them to make radical change. (Wharton 2012: 19)

Glenn Wharton of New York's Museum of Modern Art (MoMA) describes *The Museum Life of Nam June Paik* in terms of the effect that the artwork itself has on the roles of all those involved in collections. In addition, Sarah Cook has identified in particular the role of the registrar as key to considerations of data-based new media: "the role of the registrar within the museum – someone to create an information system for the data generated by the contemplation and study of the art object, someone to tie fact to artifact ... is the most challenged by new media art. The curatorial and registrarial challenges of new media art run from questions of how to commission and to collect it to how to document and archive it" (Cook 2004: 331).

Certain key roles do form important hubs of information, and the connections between them also become more salient. At the San Francisco Museum of Modern Art (SFMOMA) in 2001, the exhibition *010101: Art in Technological Times* caused changes in the institutional flowchart of work

between staff, including who worked with whom, including collaborative work and new relationships between curatorial, educational, and website staff in particular. In 2012, Layna White of SFMOMA echoed this change of roles when considering what kinds of information were needed from whom in order to collect new media art, including the roles of conservator, artist, and audience (Baltan Laboratories and Van Abbemuseum 2012). These factors all reinforce the importance of roles, and the ability to collaborate between curators and others involved, if new modes of collection are being considered (Graham and Cook 2010: 247ff).

Alongside the question of the roles of those involved in collecting within museums, there is also the question of what kind of museums collect, and the two questions are firmly related. SFMOMA has an eponymous responsibility to collect the modern and contemporary, while the National Gallery of Canada has a responsibility to collect Canadian artists, many of whom happen to be media artists (Gagnon 2001). In both cases, the institutions have employed certain curators who have a special knowledge of media and new media art, a factor that is, unsurprisingly, firmly linked to general art institutions who *do* collect new media art. This is also the case with an example of a collecting organization which is not a museum but which collects art and design, with an eye for national strengths in an international context. It is perhaps because of this emphasis that the British Council has been highly conscientious in informing itself about all new art forms. It has in its collection, for example, works by artists commissioned to make mass-produced items for the home, digital animation, and, importantly, works by Thomson and Craighead, including objects, prints, and the networked data piece *Decorative Newsfeeds* from 2004.

Museums with a specific remit to collect new media art are relatively rare, but where they do exist, they reveal the more subtle variations in what is collected by whom. At ZKM (Zentrum für Kunst und Medientechnologie) in Karlsruhe, there is a very interesting relationship between the Media Museum, with its collection of interactive media art, and the Museum of Contemporary Art in the same building, with its collection of contemporary art. The collection of interactive media art is shown both in physical gallery spaces in a media-object-based approach and via documentation in the media library, some of which is also available online via the website, along with interpretation. The Museum of Contemporary Art is the one physical space that is advertised as offering "selected works from private collections" (Graham and Cook 2010: 204). The ZKM Medialounge also shows single-screen material from the media archives and, importantly, the two production institutes for image and sound have also fed into what was collected, an aspect pointed out by Johannes Goebel: "One would have to look very closely (and deeply) into the politics of ZKM and the directors of these two museums – their relationship and how these museums were placed in the context of the overall ZKM enterprise (which included production institutes" (Goebel 2013). It is not, however, only the roles of those in public

collecting institutions which are brought into question by new art. As explained in the Introduction, the work of Rafael Lozano-Hemmer is in both public and private collections and so this field also needs to be examined.

Private Collectors: Patrons or Collectors?

> The people who buy a work of art they cannot hang up or have in their garden are less interested in possession. They are patrons rather than collectors. (Lippard 1973: xiv)

As Lucy Lippard explained in relation to "dematerialized" art in 1973, private collectors might need to consider differentiating their roles from those who collect objects. Again, new media artwork *is* collected, but using different economic modes and with the collector playing slightly different roles. There has been particular resistance in the first place to thinking of media art as something that people would want to "hang up or have in their garden," but this is perhaps a misconception:

> Like many innovative collections, the Kramlich collection did not get under way in an entirely accepting atmosphere. There were those who were unconvinced of the importance of the medium and Nay Sayers who were suspicious of an art form that could be so effortlessly copied. Still others were sceptical as to whether these artworks could be installed and integrated in a private home. (Thomas Struth in Riley 1999: 171)

Private collectors Pamela and Richard Kramlich do indeed have media art displayed all around their home, and with items such as iPads and large LCD screens being already well embedded in many homes, it could be argued that new media is an inherent domestic set of technologies. The art-selling website softwareartspace.com features single-screen works by artists including Golan Levin and C.E.B. Reas, in editions of 5,000 for around $125, and shows a photograph of the happy customer viewing the work on a nice flat-screen TV in the comfort of their lounge. Although the excitement of the "innovative" in the face of nay-sayers might be something that appeals to some private collectors, others also have an interest in historical works – such as Michael Spalter and his wife Anne Morgan Spalter, who have created one of the world's largest private digital art collections, including many early computer art prints – and move firmly out of the domestic – loaning works to venues such as London's V&A and New York's MoMA. As Caitlin Jones outlines in Chapter 7, private collecting is alive and well.

Art fairs are an obvious place where the art buyer meets the art seller, and there is a growing presence of commercial galleries which include new media, such as Carroll/Fletcher's presence at the Loop Video Art Fair in Barcelona

in 2013. There have been particular initiatives to raise the visibility of new media art. In 2009 and 2010, for example, Domenico Quaranta curated the *Expanded Box* section at the ARCO Art Fair in Madrid, and in 2009 in China, the art fair project *e-Arts Beyond* during the Shanghai Contemporary Art Fair, and the exhibition *base target=new* curated by Zhang Ga, made a point of including media artworks.

So, if Lucy Lippard claims that private collectors of immaterial art might act more in the role of patron, is this also true for new media art? Wolf Lieser, who has been running galleries selling digital art since 1999, stresses the long-term approach to private collecting: "From the beginning I have approached my customers on the basis that first of all: this is the future in art; second, forget about the old concepts of buying a painting and taking it home. Instead consider your acquisition a contribution to the artist, so he can work better and create better art" (CRUMB 2012). The artist Esther Polak concurs with Lieser, albeit in the context of PhD students asking for permission to reproduce images, and who never have any money for reproduction fees: "we give permission under the condition that they promise us to buy a work of art with the first money they earn, based on the grade involved. The work does not have to be ours, as long as it is from one of the artists that truly inspired them" (CRUMB 2012). Artists therefore might be feasibly considering long-term patronage – or rather very long-term altruistic bartering in Polak's case – but this might still be a small amount of money compared to other sources. When European artists Jodi were questioned about income sources, their reply indicated that public funding was still in the majority, with 10 per cent sales, 40 per cent fees commissions, etc., 40 per cent grants, and 10 per cent private funding (Jodi 2010: 144). To gain some kind of idea of what kind of prices are being paid for artworks in a globalized market in 2010, the price for one of the 10 copies of the offline version of the work *Traveling to Utopia* by Young-Hae Chang Heavy Industries was set at $10,000. At the art trade fair Art Basel in 2009, the Vitamin Creative Space from Guangzhou marketed animations by the Chinese artist Cao Fei for €26,000 (Storz 2010: 106).

What the market for new media art has in common with the market for contemporary art in general is that the more famous the artist, the higher the price. The artist Jonas Lund has rather satirized this golden rule by making a website, *The Paintshop*, where people can use a digital painting tool to make a square painting which goes into a bigger patchwork of images. The paintings can be purchased as a digital print online and, importantly, the price of each painting is calculated using the Paintshop Rank™ algorithm and is updated daily. The algorithm calculates the popularity of the painting by online hits and adds the "stature" of the artists as measured by the artfacts.net website. *Et voilà*, an automated art market calculated via artistic fame (Lund 2012).

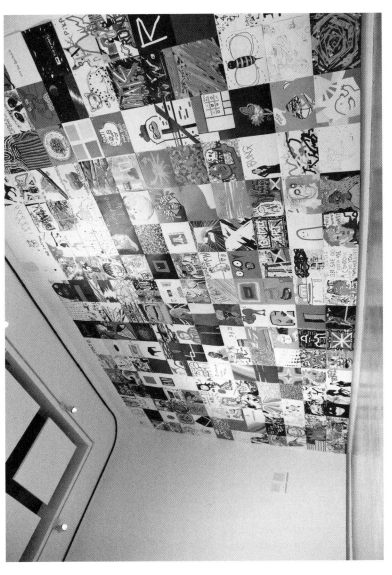

Figure 1.3 Installation detail showing prints from Jonas Lund's *The Paintshop.biz* (2012) from the exhibition *The Paintshow* at the Van Abbemuseum, Eindhoven, 2012. Courtesy of the artist

Artists and Audiences as Collectors

> [T]he artists set certain parameters through software or a server and invited other artists to create "clients", which in and of themselves again constitute artworks. In these cases, the artists begin to play a role similar to that of a curator, and the collaborations are usually the result of extensive previous discussions, which sometimes take place on mailing lists specifically established for this purpose. (Paul 2007: 256)

Art historians may well be familiar with artists using archives and making their own collections: archivist and reference librarian Mark Lombardi, Walid Raad/ the Atlas Group and Susan Hiller to name only three. Some critics, however, have deliberately excluded new media artistic collection strategies from consideration of the "archival impulse" on the grounds of being too "fungible" (Foster 2006: 144). Nevertheless, there are plenty of examples where artists are not only using but are also making collections of media or otherwise, such as Hannah Hurtzig's *FCA – (Flight Case Archive)*, a mobile continuously growing archive. As a dramaturge and curator, she fully considers not only the collection but also its relationship to its audience, whether sitting in a packing case or participating in a live event, such as *Blackmarket for Useful Knowledge and Non-Knowledge* (Hurtzig 2012).

As Christiane Paul states in the quote given above, some new media artists have taken this even further. She refers to Alex Galloway and Radical Software Group's *Carnivore*, where the artists are not only acting as curators but are also offering the users the chance to be curators too – the chance to be in control of the whole system. As established in the Introduction, collections management databases and online interfaces offer audiences the chance to choose their own collection from museum collections, and museum websites abound with such opportunities. Much wider than that, the audience has been quite familiar for some time now with making its own collections from YouTube or anywhere on the broad horizons of the Internet: "Everything I assembled over the years simply accumulated on the computer, and from there on the myriad backup discs with their ever-increasing storage capacity. When, at a later date, I would rummage through that jumble of folders and subfolders, I unfailingly felt like the owner of a medium-sized museum" (Quaranta 2011: 8).

Furthermore, the audience can make its own taxonomies or folksonomies of folders, subfolders, favorites, tags, and keywords, as outlined in the Introduction to this book. The question of the quality of audience curating is always, of course, a key issue, but nevertheless inspired FACT in Liverpool to develop the project *Open Curate It* (http://www.opencurateit.org), and as Mike Stubbs explains:

> Part of the intention was to shift the terrain from classic contemporary art systems and invite people who had not had formal training in curating or theory to take part in a debate and consider new forms nuancing collecting, licensing and curating – informed by a playlist culture and as an experiment in creating

[the] opportunity for people to play and improve their "curating" – thereby
validating a range of practices that might be deemed "folk." (CRUMB 2012)

Audiences are indeed so adept at surfing, tagging, linking, and using those links
to "exhibit" that in "surf clubs" such as Marisa Olson's *Nasty Nets*, there is little
visible differentiation between artists, curators, geeks, or just regular surfers.
Surf clubs such as *Trail Blazers* include performative and competitive elements,
comprising opportunities to "show off your PRO surfing skills" (nm.merz-
akademie.de/trailblazers).

Such breaking down of boundaries and changing roles is a characteristic
behavior of new media, and of course artists have systematically challenged very
basic conceptions of who collects. *Collecting the WWW* was an exhibition curated
in 2011 by Domenico Quaranta and included work by Gazira Babeli whose
Save Your Skin was a collection of "skins" filched from their rightful owners,
smuggled out of Second Life and presented in an independent setting
(Quaranta 2011: 70). *Database Imaginary* was an exhibition curated in 2004 by
Sarah Cook and included work by Alan Currall, whose *CD-ROM Encyclopaedia*
included definitions and information from ordinary people rather than from experts.
As Cook states: "It is this question of the 'where' of art – in the collection, in the
network, in the digital data space – that has led me to an interest in geographical-
sited online database art" (Cook 2004: 332). The existence of such diverse,
culturally specific, and located examples of new media artists' use of archives
and databases might suggest that rather than being merely "fungible" mutually
interchangeable data that can be substituted for other data, these uses show what
can be achieved by a fine awareness of how data and archives behave, and how
both audiences and art experts might use these archives.

Modes of Collection

> I would suggest that a curator especially a net art curator should become an
> instigator of a process that is open ended. To my mind this means setting up a
> loose structure that allows for maximum creativity and then inviting individuals
> to do something. You organize the material after the event occurs. In this way
> you are an archivist more than a curator. This is already somewhat of the
> default process on the web. What has not occurred is the next step which is the
> analysis and presentation of webmaterial in real life. That is the exciting part.
> (G.H. Hovagimyan in CONT3XT.NET 2007)

As Hovagimyan states, modes of collection are indissolubly linked to modes of
display and, for the particular behaviors of new media, highlight a tension between
the roles of collector, curator, and archivist along different points on a timeline.
Modes of collection are therefore strongly linked to the intent of what is to be
collected, by whom, and how.

Most museums do, of course, have a highly structured acquisitions procedure, which proceeds cautiously over time with keen consideration of artistic provenance, quality, and historicization. A large panel of people is often involved and there is frequently some debate over who is included on this panel – which curators, whether academics and artists are included, and in which proportion (Graham 2012a). Conventionally, the artists collected have a long and solid provenance, but if a museum wishes to collect "the new," then how might the artworks become known to those people on a panel and enter a collection?

For new art in general, festivals have been an excellent way of seeing such works. In Seoul, for example, the Mediacity Seoul festival has brought international artists to the city, including the *Spell on the City* project which had gallery-based elements, but used some of the huge video screens to show guest artists' work, and to facilitate input from the audience via Twitter and other social networking tools. Major exhibitions in the Seoul Museum of Art brought local and international curators together, so that the Museum is now familiar enough with new media art to consider bringing it into its permanent collection. The next section therefore addresses what might happen in the period before an artwork is collected, including the creation of art through commissioning or producing.

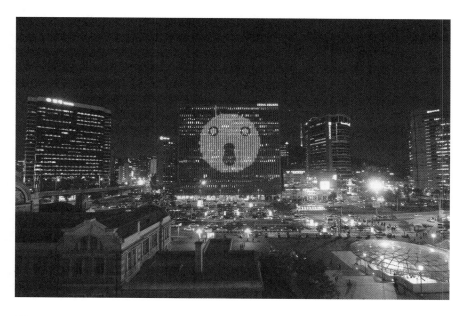

Figure 1.4 **Installation view from the *Spell on the City* project on Seoul Square screen, showing an image by NMARA (New Media Art Research Association). Part of Mediacity Seoul 2012. Image courtesy of the artists, Mediacity Seoul and Seoul Museum of Art**

Modes of Acquisition, Commissioning or Production?

> [F]or me what is really important is to think about how to support that kind of research, and commissioning as being the only solution that we have right at this point. In other words, providing the infrastructure; giving money to artists to produce their work and possibly extending this to being able to put them in touch with people who can help them with technical problems that they can't necessarily solve on their own. Then hosting the project and trying to maintain it, with the obvious caveat that we cannot guarantee that the work's formal integrity will be maintained forever. But with the other caveat that we do not claim ownership of this work, we merely claim the right to display it for as long as we can. (Benjamin Weil quoted in Graham 2002)

When Benjamin Weil was Curator of Media Arts at SFMOMA, he noted that the kind of research and development needed for new art and new media art in particular demanded commissioning, and a particular kind of commissioning if this was to lead to collection. When he commissioned Christian Marclay to make *Video Quartet*, the artist named Weil "executive producer" on the credits because "you found the money, you found the people who helped resolve all the technical problems. You followed the production of the piece; you negotiated a contract with my gallery. You found the right people to stage it in the museum. This is what an executive producer does, in another world" (Weil quoted in Graham 2002). This role of producer is certainly a more hands-on and practical approach than might be expected and could be particularly suited to new media art.

In the UK, the Contemporary Art Society is a body aiming to encourage an appreciation and understanding of contemporary art by a wide audience, and to donate works by important and new artists to museums and public galleries. The aim of their Annual Award for Museums is to support museums to commission new work that, once completed, will remain within the museums' permanent collection. Museums must be able to commit at least £5,000 towards the development of a publication or catalog, which is also an important factor in historicization identified by Sarah Cook in this volume (see Chapter 10). In 2012, the Collection and Usher Gallery, Lincoln won the award, commissioning artist Oliver Laric to use 3D scanning and printing technology to produce sculptural work that can be "distributed" via data. Laric is one of the co-founders of the online platform VVORK and is hence very well informed on the subject of new media and collecting the immaterial in relation to contemporary art (CRUMB 2009). It is encouraging, therefore, to see awards going towards collecting genuinely new art.

Commissions do not, of course, always make it into a collection. Because collecting is a long process administered by a large panel of people, whereas commissioning is often done by an individual curator, certain freedoms and speed of movement are possible, and newer work and ideas are permissible.

There is always an element of risk, however, which was discussed as a prime factor at the *Commissioning and Collecting Variable Media* symposium (CRUMB and CAS 2010). The debate included the importance of defending an artist's "right to fail." This led to discussion of other modes of production that might be familiar to those working with new media – such as that of the "laboratory" mode. There are many good examples of new media labs such as Eyebeam in New York that have excellent "producer" modes of working which fully take account of processes, failures, and versioning, but fewer examples of where this leads to collections (Graham and Cook 2010: 234; Moss 2008).

This element of "risk" is a recurring theme in relation to commissioning and collections – as described in Chapter 5, the Harris Museum selected artworks for exhibition from an open call before selecting from the exhibition for collection, but has moved on to co-commissioning new media art since then. Good connections between museum departments can certainly help spread the risk, and some curators have suggested various adaptations of commissioning and collecting modes that behave in slightly different ways to overcome the caution of some institutions. For example, an artist might be commissioned to make a customized "version" of a new media artwork to suit a particular institution rather than a new unique work. Benjamin Weil has suggested modes where an artist might donate a copy or edition of the work to the archive, and even if not in the permanent collection, that helps to historicize the work (CRUMB and CAS 2010). The DACollection in Switzerland forms another mode of collection: "in its initial phase … [it] comprises long-term loans from private collections and loans from artists" (DACollection 2011). In terms of conservation, there could also be a partical mode solution if that would prevent the work from being collected at all: Benjamin Weil's opening quote only promises to conserve "for as long as you can" on a basis of maintaining the rights to display the work.

For some institutions, a hybrid solution to the demands of conservation is to collect on a small scale. The NTT InterCommunication Center (ICC) in Tokyo is "storaging" only 14 works, which have been on permanent installation in its galleries. These works, however, are often large-scale installations and are complicated to maintain. Woody Vasulka's *The Maiden* from 1997, for example, is an electro-pneumatic construction adapted from a medical diagnostic and surgical table. For its mechanical control, the hand-operating levels and adjustment features have been replaced by the pneumatic actuators, giving *The Maiden* motion control features by MIDI-activated pneumatics.

Therefore, what can be acquired tends to depend on the sum of economic, practical, and conservation factors, and whether hybrid solutions can address the perceived risks. Benjamin Weil's mention of art residing in an archive rather than a collection brings us back to the point instigated by Steve Dietz in this volume – that of the archive considered as a mode of collection … or as a hybrid mode somewhere in between.

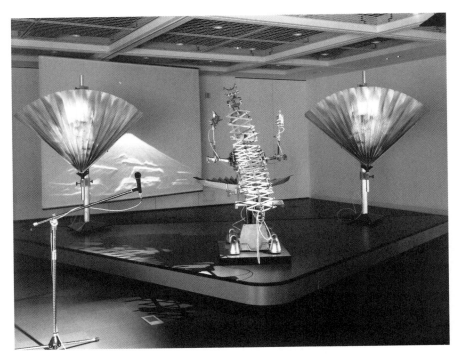

Figure 1.5 **Installation view of Woody Vasulka's *The Maiden*, 1997, from *The Brotherhood* exhibition at ICC Tokyo, 1998. Image courtesy of Steina and Woody Vasulka**

Modes of Archiving/Collecting

> I think all of us are interested in diminishing the hierarchy between the archive and collection for obvious reasons, but those hierarchies still do affect conditions that mean the archive will probably be less accessible to some scholars than the collection – it is certainly not accessible to the public. So I just want to ensure that we engage with that piece somehow through our collection, and that it is really accessible and present in how we're constructing that history. (Stuart Comer quoted in Graham 2012b)

Stuart Comer, Curator of Film at Tate Modern, acknowledges the key tension for "collectionish" strategies that might situate works in an archive rather than a permanent collection. There are hierarchies of power and accessibility involved, so how does the audience then get to access that collection in the form of public display? Museums, after all, can mean various different things when they describe collections of items as "display collection," "study collection," "archive," or "library." In 2012, The Tanks, a new wing of the Tate Modern

building in London, opened to the public. The Tanks opens straight from the main Turbine Hall, has a particular remit to show work from the Tate collections, and the combination of curators tasked with programming the space is of particular interest, comprising Film and Video, Performance, and Education. When showing work such as Lis Rhodes' *Light Music*, it was important that the participative intent was maintained, and Suzanne Lacey's 1987 performance *The Crystal Quilt*, which now exists in the form of a video, documentary, quilt, photographs, and sound piece, was not displayed simply as documentation or as a stand-alone artists' video, but carefully reinstalled, for example, as a sound installation. As Stuart Comer says in the brochure for The Tanks program at Tate Modern: "They are not merely performance documentation that can be played back at [a] whim, but rather rely on a specific set of instructions to reanimate both the existing film or video material and the actions that attend it" (Comer 2012: 42). Mark Miller, Convenor of the Young People's Programmes at Tate Britain/Tate Modern, has also identified a blurring of boundaries between participatory modes for live events, production workshops, and exhibition strategies when it comes to reanimating work from collections (Graham 2013).

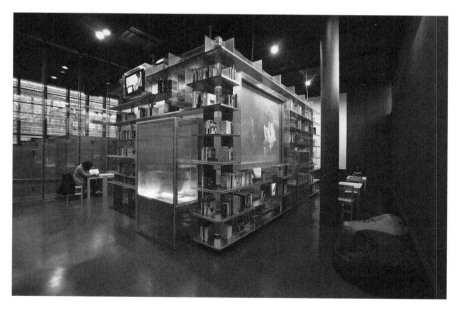

Figure 1.6 **Installation view of the Nam June Paik Library at the Nam June Paik Art Center, Seoul. Designed by Nahyun Hwang and David Eugin Moon (NHDM). Image courtesy of Nam June Paik Art Center**

These instructions are as likely to be in the archive as the collection, and if new media is also often found in the archive, then curators need to be familiar with accessing both systems, and making them accessible to others. At the Nam June Paik Center in Seoul, for example, the library is just off the spacious entrance lobby and is literally transparent: screens provide sheltered corners for reading printed matter, using databases or viewing DVDs, but the translucency beckons the user in with the promise of something interesting around the corner. The stacked shelves give an impression of a large quantity of material and there are helpful people to help the users of this explicitly public library to navigate the relationship between the library, the archive, and the large and very physical collection of Paik's work.

As established in the Introduction, new media are both tools for collections management or archives and media from which to make art. Leaving aside the perceived differences between analog and digital archives in terms of quantity and perceived ephemerality, it is the fact that the means of production is also the means of distribution and exhibition for networked new media that most closely addresses Stuart Comer's concern with access (see also Part II of this book). It might therefore be useful to differentiate two different kinds of archives in relation to collection and then to explore the hybrid examples between those two. As already discussed, each of these types of archives might be more or less open to input or changes by different people:

> **Archive as documentation of art** is perhaps the most familiar type, and of obvious use to curators and others wishing to find information about art. The Database of Virtual Art, for example, was an early adopter of the online database as a way of finding artists whose work was not so easy to find in other art databases. It could be argued that Vimeo, LinkedIn, Flickr, or the Internet itself are the largest, most connected and most participatory archives of documentation of art.

> **Archive as a collection of art** can really only be counted as such if the artwork is fully available in the archive, and in new media art terms, this means that this tends to be restricted to single-screen digital media, net art, or software art. The website Turbulence, for example, shows the net art that they commission, and keep it publicly available, with the usual "catalogue information" of date, media, etc. Turbulence do not name this as a collection, but it appears to function as one. (Dekker and Somers-Miles 2011)

What then about examples where in true new media fashion, an archive might contain both art and its documentation? As described in Chapter 4, Rhizome's ArtBase has at various points in time been described as either an archive or a collection, depending on the levels of conservation and display feasible for various works. Likewise, Pad.ma has elements both of documentation and collection. The actual video works on the website are available to the audience to watch,

but anyone can also annotate the video works via open source software. Lots of information is available about the works and the contexts, and Pad.ma has sought to animate the archive by hosting research fellowships for "experiments with video archives."

The unassuming but long-running runme.org "software art repository" is open-submission and moderated/selected, and also happens to have an interesting set of folksonomy strategies (see the Introduction). Artworks include, for example, Graham Harwood's (from William Blake) *London.pl* from 2001, a Perl poem that translates William Blake's nineteenth-century poem 'London' into program code. The webpage for each work includes links to project homepages and features about the work, and the work itself is there on the website for download. The archive could therefore be argued to be an archive of linked documentation and also a collection of art, because the art is present in the archive. Although some might argue that runme.org is not a collection because runme.org does not own the artworks, they are nonetheless a selected collection and the economic modes discussed earlier in this chapter could suggest that the audience owns the collection as much as anyone else. If a conventional art museum is publicly funded, it could be suggested that in that case too, the audience owns the work as much as the museum – it's just that they are not usually allowed to take the artworks home.

It is therefore very useful to be able to combine the information of the archive with the embodied knowledge of the art object. However, when Stuart Comer of Tate Modern talks about an "archive," then that is the repository where exhibition files containing correspondence, installation photographs, and audience studies and budgetary information is kept – information of great value to those wishing to exhibit that work again. Crowd-sourced archives do not really replace the painstaking institutional archives, but the latter do have their disadvantages – they might not be available outside the organization, even to scholars. In new media terms, the most valuable kind of combination of archive and collection would be one in which there is "all available information," an "open source" collection/ archive if you will. Although runme.org certainly has written and published very openly about it processes, and input data is available on the website, the processes of curation are not really made available so that others could do the same. The NODE.London network, which organized a "no-curator" mode of new media art festival, is admirably open about its processes, but does not have a collection (Graham and Cook 2010: 261ff):

> Although "the open museum" is sometimes discussed in rhetorical terms, there is little critical differentiation between kinds of openness, or indeed hybrid modes of working ... (Graham forthcoming)

Those working around art collections need to be familiar with both archives of documentation and collections of art, how to extract material from both, and how to make them available to audiences. The question remains as to how this might be

achievable, early investigation points towards collaboration, and early indications point towards the collaborative connections made between roles, including the roles of audiences.

Integrated Modes of Collection, Exhibiting, and Audience?

Recently, "Net Art" changed from being an art form in new media to a subject in contemporary art. I see several preconditions for this transition:

1. Big audience. If yesterday for net artists it made sense only to address people in front of their computers, today I can easily imagine to address visitors in the gallery – because in their majority they will just have gotten up from their computers. They have the necessary experience and understanding of the medium to get the ideas, jokes, enjoy the works and buy them.

2. Mature medium. Maturity for a medium means that users are really busy and the medium became totally invisible. If I want to attract attention of users to their online environment and create works about the World Wide Web, I'll better do it offline. Net art today is finding its way out of the network.

3. Slim computers. They look exactly like picture frames and they come with only one button. You press this button and the art piece starts. Reducing a computer to a screen, to a frame that can be fixed on the wall with one nail, marries gallery space with advanced digital works. Wall, frame, work of art. And the art world is in order again.

4. Geek Curators. To name some with whom I had the pleasure to work – Paul Slocum, And/Or Gallery (Dallas), Marcin Ramocki, VertexList (New York), Maxim Ilyukhin, ABC (Moscow). They are not only knowledgeable about the online world and free from the media art prejudices of the 1990s, but also technically competent and innovative. They can offer truly unexpected solutions for materializing, objectifying and preserving works that were born to live in the browser. (Lialina 2010: 38–9)

Artist Olia Lialina rather pithily summarizes a list of factors which she sees as important in integrating net art into the contemporary art scene. She also chimes with some recurring themes of this book: those of audience, historicization, exhibition/objects, and roles. In terms of considering modes of collecting, these in turn relate to what is collected, who collects, and how the collecting happens.

In considering what exactly is collected, it is clear that there is a range of material options for artworks that might be considered "immaterial," not

least those springing from the inventive minds of the artists themselves. For works that are resolutely immaterial, modes from other immaterial art forms such as conceptual art or performance art can be adapted to a certain extent, but, conversely, some new concepts directly from new media production and economic systems could in the future inform many art forms which concern process rather than product. In particular, the systems of Dual Licensing, Customizing, and Support could offer economic options for which artists can get paid for immaterial art.

These economic modes mean that private collectors can also collect in various ways, including taking on the roles of long-term patrons as well as in the development of an existing market for new media artworks from both public and private collectors. Concerning who collects, collection by artists and audiences is clearly the mode that differentiates new media art most. As Lialina said, many members of the audience might "just have gotten up from their computers" where they might have been busily tagging, developing their curatorial skills, or surf clubbing. Perhaps less of a case of "geek curators" than geeks who are curating as part of their social lives, or just regular audiences who are merrily tagging, liking, and making favorites as usual. These various modes need to integrate the questions of how and who, because the systems of new media, whether economic or social, necessarily behave in different ways when linking things and people.

Overall, what is particular about "modes of collecting" for new media art is perhaps more of a combination of different systems and working in the spaces between existing modes. Commissioning, for example, which is important for any new art, may involve more of a lab production approach or may involve commissioning a "version." Collecting and acquiring might entail different economic modes of licenses to exhibit for limited periods of time.

Rethinking systems and modes in this way obviously demands gathering knowledge not only about the art but also about the different behaviors of the technology, and the roles of those involved, from artists to audience. In the case of developing knowledge about the preservation of new media art, many organizations have come together in partnerships such as the Variable Media Network and Matters in Media Art to share knowledge and test out new modes. Perhaps this could also happen for collecting, with encouraging signs from the British Council and Contemporary Art Society (CRUMB and CAS 2010). This would certainly help with the significant rethinking needed for institutional change. As Steve Dietz cites in the next chapter, Jon Ippolito envisions a future of interesting times for museums: "For museums to acquire open-licensed art would require them to transform from collecting institutions to circulating institutions" (Ippolito 2002).

References

Altshuler, Bruce (ed.). 2005. *Collecting the New: Museums and Contemporary Art.* Princeton: Princeton University Press.

Baltan Laboratories and Van Abbemuseum. 2012. *Collecting and Presenting Born-Digital Art Working Conference.* December 14–15. Eindhoven: Baltan Laboratories and the Van Abbemuseum.

Comer, Stuart. 2012. "In Context: Projecting Memories of the Future," in *The Tanks Programme Notes*, edited by Charles Danby. London: Tate, 42–3.

CONT3XT.NET (Sabine Hochrieser, Michael Kargl, and Franz Thalmair). 2007. "Visualising Workflows and (Filtering) Processes," in *Circulating Contexts – CURATING MEDIA/NET/ART*, edited by CONT3XT.NET. Norderstedt: Books on Demand GmbH, 54–59. Available at: http://cont3xt.net/blog/?p=370 [accessed 14 October 2013].

Cook, Sarah. 2004. "You Can Find Me Here: Geographical Relevant Database Art Online," in *Obsession, Compulsion, Collection: On Objects, Display, Culture, and Interpretation*, edited by A. Kiendl. Banff: Banff Centre Press, 330–45.

CRUMB. 2009. *Real-Time: Showing Art in the Age of New Media Conference.* September 24. Abandon Normal Devices Festival, Liverpool and Liverpool John Moores University. Available at: http://www.crumbweb.org/getSeminar Detail.php?id=13 [accessed 14 October 2013].

CRUMB. 2012. *Collecting New Media Art Theme Jul 2012. CRUMB Discussion List Edits.* Available at: http://www.crumbweb.org/discussionArchive.php? &sublink=2 [accessed 14 October 2013].

CRUMB and CAS. 2010. *Commissioning and Collecting Variable Media Conference.* March 5. BALTIC Centre for Contemporary Art, Gateshead. Available at: http://www.crumbweb.org/getSeminarDetail.php?id=14 [accessed 14 October 2013].

DACollection. 2011. *The DACollection.* Available at: http://www.digital-art-collection.net/collection/information1_e.html [accessed 14 October 2013].

Dekker, Annet and Somers-Miles, Rachel. 2011. *Virtueel Platform Research: Archiving the Digital.* Amsterdam: Virtueel Platform.

Dipple, Kelli. 2010. Research network meeting 5, Social Architectures, February 22. "New Media Art Network on Authenticity and Performativity." London: Tate (unpublished personal notes by Beryl Graham).

Foster, Hal. 2006. "An Archival Impulse," in *The Archive: Documents of Contemporary Art*, edited by Charles Merewether. London: Whitechapel Gallery.

Gagnon, Jean. 2001. "Consumption: Jean Gagnon Presentation." Curating New Media Art/La Mise en Espace des Arts Mediatiques conference. Available at: http://crumbweb.org/getPresentation.php?presID=19 [accessed 14 October 2013].

Goebel, Johannes. 2013. Re: [NEW–MEDIA–CURATING] What's (Really) Specific about New Media Art? Curating in the Information Age, in *New-Media-Curating Discussion List*. January 9. Available at: http://www. jiscmail.ac.uk/lists/new-media-curating.html [accessed 14 October 2013].

Graham, Beryl. 2002. "An Interview with Benjamin Weil." *CRUMB*. Available at: http://www.crumbweb.org/getInterviewDetail.php?id=13 [accessed 14 October 2013].

Graham, Beryl. 2012a. "Collecting at National Taiwan Museum of Fine Art." *CRUMB*. Available at: http://www.crumbweb.org/getInterviewDetail.php? id=39 [accessed 14 October 2013].

Graham, Beryl. 2012b. "Interview with Stuart Comer. Tate Tanks and Collecting." *CRUMB*. Available at: http://www.crumbweb.org/getInterviewDetail. php?id=38 [accessed 14 October 2013].

Graham, Beryl. 2013. "Interview with Mark Miller." Tate Tanks, Educational Programme, and Collecting. *CRUMB*. Available at: http://www.crumbweb. org/getInterviewDetail.php?id=40 [accessed 14 October 2013].

Graham, Beryl. Forthcoming. "Open and Closed Systems: New Media Art in Museums and Galleries," in *Museum Media: The Handbook of Museum Studies*, edited by Michelle Henning. London: Wiley-Blackwell.

Graham, Beryl and Sarah Cook. 2010. *Rethinking Curating: Art after New Media*. Cambridge, MA: MIT Press.

Hurtzig, Hannah in conversation with Beatrice von Bismarck. 2012. "Space, Presentation, Possibility," in *Cultures of the Curatorial*, edited by Beatrice von Bismarck, Jörn Schafaff, and Thomas Weski. Leipzig: Academy of Visual Arts Leipzig and Sternberg Press, 151–66.

Ippolito, Jon. 2002. "Nettime-bold: Why Art should be Free 2/3: The Digital Sanctuary", in *Nettime-bold*. Available at: http://amsterdam.nettime.org/Lists-Archives/nettime-bold-0204/msg00403.html [accessed 14 October 2013].

Jodi. 2010. "Artists' Statements: Jodi," in *Owning Online Art: Selling and Collecting Netbased Artworks*, edited by Markus Schwander and Reinhard Storz. Basel: FHNW, 142–45. Available at: http://www.ooart.ch/publikation/02. php?m=1&m2=2&lang=e [accessed 14 October 2013].

Koblin, Aaron and Takashi Kawashima. 2007. *Ten Thousand Cents*. Available at: http://www.tenthousandcents.com [accessed 14 October 2013].

Kuoni, Carin (ed.). 2001. *Words of Wisdom: A Curator's Vade Mecum*. New York: ICI/Independent Curators International.

Lialina, Olia. 2010. "Aluminum Sites, Geek Curators and Online Conservators," in *Owning Online Art: Selling and Collecting Netbased Artworks*, edited by Markus Schwander and Reinhard Storz. Basel: FHNW, 37–42. Available at: http://www.ooart.ch/publikation/02.php?m=1&m2=2&lang=e [accessed 14 October 2013].

Lippard, Lucy. 1973. *Six Years: The Dematerialization of the Art Object 1966 to 1972*. Berkeley: University of California Press.

Lund, Jonas. 2012. *The Paintshop*. Available at: http://thepaintshop.biz [accessed 14 October 2013].

Morris, Susan. 2001. *Museums and New Media Art*. Research report commissioned for the Rockefeller Foundation. New York: Rockefeller Foundation. Available at: http://www.rockfound.org/display.asp?context=3 &collection=0&subcollection=0&DocID=528&SectionTypeID=16&Previe w=0&ARCurrent=1 [accessed 14 October 2013].

Moss, Ceci. 2008. "Interview with Sarah Cook: Eyebeam's Curatorial Fellow Discusses 'Untethered' Exhibition." *Rhizome*. Available at: http://rhizome.org/ editorial/2008/sep/25/interview-with-sarah-cook [accessed 14 October 2013].

Paul, Christiane. 2007. "The Myth of Immateriality: Presenting and Preserving New Media," in *MediaArtHistories*, edited by Oliver Grau. Cambridge, MA: MIT Press, 251–74.

Quaranta, Domenico. 2011. "Collect the WWWorld: The Artist as Archivist in the Internet Age," in *Collect the WWWorld: The Artist as Archivist in the Internet Age*, edited by Domenico Quaranta. Brescia: Link Editions, 4–23.

Rattemeyer, Christian (ed.). 2010. *Exhibiting the New Art: "Op Losse Schroeven" and "When Attitudes Become Form" 1969*. Exhibition Histories series. London: Afterall.

Riley, Robert. 1999. *Seeing Time: Selections from the Pamela and Richard Kramlich Collection of Media Art*. San Francisco: SFMOMA.

Schwander, Markus. 2010. "Package Deal – On the Materiality of Net-Based Art," in *Owning Online Art: Selling and Collecting Netbased Artworks*, edited by Markus Schwander and Reinhard Storz. Basel: FHNW, 29–36. Available at: http://www.ooart.ch/publikation/02.php?m=1&m2=2&lang=e [accessed 14 October 2013].

Smith, Dominic. 2011. "Models of Open Source Production Compared to Participative Systems in New Media Art." PhD thesis, University of Sunderland.

Stalder, Felix. 2010. "Property, Possession and Free Goods: Social Relationships as the Core of a New Economy of Immaterial Culture?" in *Owning Online Art: Selling and Collecting Netbased Artworks*, edited by Markus Schwander and Reinhard Storz. Basel: FHNW, 75–88. Available at: http://www.ooart.ch/ publikation/02.php?m=1&m2=2&lang=e [accessed 14 October 2013].

Storz, Reinhard. 2010. "Internet-Based Art in Museums, Private Art Collections and Galleries," in *Owning Online Art: Selling and Collecting Netbased Artworks*, edited by Markus Schwander and Reinhard Storz. Basel: FHNW, 97–114. Available at: http://www.ooart.ch/publikation/02. php?m=1&m2=2&lang=e [accessed 14 October 2013].

Variant. March 2, 2010. Re: [NEW-MEDIA-CURATING] Three Questions about Commissioning Variable Media. *New-Media-Curating Discussion List*. Available at: http://www.jiscmail.ac.uk/lists/new-media-curating.html [accessed 14 October 2013].

Vishmidt, Marina. 2006. "Twilight of the Widgets," in *Curating Immateriality: The Work of the Curator in the Age of Network Systems*, edited by Joasia Krysa. London: Autonomedia, 39–62.

Wharton, Glenn. 2012. "The Museum Life of Nam June Paik Media Sculpture," in *Nam June Paik Art Center Man–Machine Duet for Life*. International Symposium Gift of Nam June Paik 5. Program of events. October 12. Seoul: Nam June Paik Art Centre, 19–21.

Zanni, Carlo. 2010. "329,95 Euro – A Ten Years Investigation," in *Owning Online Art: Selling And Collecting Netbased Artworks*, edited by Markus Schwander and Reinhard Storz. Basel: FHNW, 43–50. Available at: http://www.ooart.ch/publikation/02.php?m=1&m2=2&lang=e [accessed 14 October 2013].

Chapter 2

Collecting New-Media Art:
Just Like Anything Else,
Only Different

Steve Dietz

[New-media art] questions everything, the most fundamental assumptions: What is a work? How do you collect? What is preservation? What is ownership? All of those things that museums are based upon and structured upon are pretty much thrown open to question.

(Jeremy Strick, Director, Museum Of Contemporary Art, Los Angeles)

In this comment, Jeremy Strick is both correct and being rhetorical.[1] Lots of contemporary art raises these same questions. New-media art, particularly in its network-based incarnations, does so perhaps more consistently, but none of the questions raised is radically new. In fact, the Variable Media Initiative, one of the results of institutions' early investigations of collecting new media, is significant precisely because of its cross-medium applicability.[2] Nevertheless, there is a kind of crisis of collection – and hence of cultural memory – because of the paucity of new-media art in museum collections and because of the nature of such work, both of which make it difficult at best to create an adequate collection of new-media art.

Even among the few museums making relatively active curatorial efforts in new media, none has a collection that even approaches the scope of its holdings in other media. Yet at the same time – since at least 1977, when Kit Galloway and Sherrie Rabinowitz first presented their *Satellite Arts Project*,[3] and certainly since the invention of the World Wide Web in the early 1990s – there has been an

1 The quotation is taken from Susan Morris, *Museums and New Media Art: A Research Report Commissioned by the Rockefeller Foundation*, October 2001, 4. Available at: http://www.rockfound.org/Documents/528/Museums_and_New_Media_Art. pdf (accessed October 28, 2013).

2 For more about the Variable Media Initiative, see the Variable Media Network website at http://www.variablemedia.net/e (accessed October 28, 2013). See the website for the exhibition *Seeing Double: Emulation in Theory and Practice* (2004), organized by the Solomon R. Guggenheim Museum in New York in partnership with the Daniel Langlois Foundation for Art, Science, and Technology at http://variablemedia.net/e/seeingdouble/home.html (accessed October 28, 2013).

3 Kit Galloway and Sherrie Rabinowitz, "Satellite Arts Project," 1977, http://www.ecafe.com/getty/SA/index.html (accessed October 28, 2013).

explosion of new-media artistic activity, which is well documented on websites such as Rhizome.org and in the archives of the Ars Electronica Festival, which celebrated its twenty-fifth year in 2004.[4] What accounts for this discrepancy between artistic activity and institutional collecting?

What is New-Media Art?

In order to understand the issues involved in collecting new-media art, it is reasonable to ask what new media is. Photography and video were both new media at one point and, in the near future, the Weisman Art Museum in Minneapolis will accession a transgenic work of art by Eduardo Kac, which is synthesized, in part, from his own DNA – a new media of a different sort.[5] This suggests that *new* is simply "too broad a term to he truly useful," as Lev Manovich writes in his influential book, *The Language of New Media*, about the terms digital and interactivity.[6]

The flipside of nearly generic terms such as *new*, *digital*, and *interactive* is the attempt to define new media as a set of unique properties – "the formalist rap," as David Antin refers to the hermeneutical process in his seminal essay "Video: The Distinctive Features of the Medium."[7] Formalism, as Rosalind Krauss has pointed out, is too often "abusively recast as a form of objectification or reification, since a medium is purportedly made specific by being reduced to nothing but its manifest physical properties."[8]

New-media art remains an evolving reference with no permanent definition. In the context of this chapter, I use it to refer to artworks that use computation as more than just a production tool and/or use the Internet as more than merely a means of delivery. The model I prefer is new-media art as a process, as the artist Jim Campbell has usefully abstracted in this diagram (Figure 2.1), which he refers to as a "formula for computer art."[9]

4 The Rhizome Artbase is accessible to members at http://www.rhizome.org/artbase. The Ars Electronica archives for the Prix Ars Electronica are available at: http://www.aec.at/en/archives/prix_einstieg.asp (accessed October 28, 2013).

5 Correspondence with Shelley Willis, Curator of Public Art, Weisman Art Museum, University of Minnesota, February 16, 2004.

6 Lev Manovich, *The Language of New Media* (Cambridge, MA: MIT Press, 2001), 55.

7 David Antin, "Video: The Distinctive Features of the Medium," in *Video Art*, edited by Ira Schneider and Beryl Korot (New York: Harcourt Brace Jovanovich, 1976), 174. See my "Beyond Interface: Net Art and Art on the Net II," 1998, for further analysis of the idea of distinctive features in relation to new media: http://www.yproductions.com/writing/archives/beyond_interface_net_art_and_a.html (accessed October 28, 2013).

8 Rosalind Krauss, *A Voyage on the North Sea: Art in the Age of the Post-Medium Condition* (New York: Thames & Hudson, 2000), 7.

9 Jim Campbell, "Formula for Computer Art," 1996/2003, http://www.jimcampbell.tv (accessed October 28, 2013).

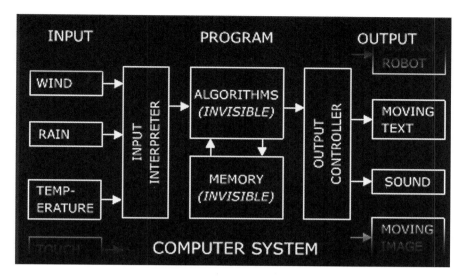

Figure 2.1 Jim Campbell (American, born 1956), "Formula for Computer Art," http://www.jimcampbell.tv, 1996/2003

This diagram can be read as a narrative: first, there is some kind of input. It can be the click of a mouse, the striking of a key, or the weather. With the necessary interpreter, the input can be literally anything. What the interpreter does is convert, or "quantize," the input into a number, usually expressed to the computer in the language it can read – a series of ones and zeros. Once quantized, the input is inside the black box of the computer and algorithms instruct the computer how to process it. Algorithms, for our purposes, represent the set of instructions that the artist provides about how the computer software and hardware – which also invoke various algorithms – should act upon the external input. It is at this level that the artist is making important choices, although they are not always observable. Once the algorithms are executed, they are reconverted to the specified output, whether that is an image on a screen or some other stimulus perceivable by the human sensorium, such as a sound or a puff of air.

A few things should be noted about this diagram of new media. First, it is recursive. Any output can become input, and in regard to network-specific art, or net art, the Internet can constitute the input and/or output of an artwork and even act as a kind of distributed computer system itself. Net art, as perhaps the most virtual form of new-media art, helps identify boundary issues in terms of collecting new-media art, but network-specific art is not coterminous with new-media art, nor is new-media art always networked. Second, output that is homologous to the input is not new-media art. For example, to digitize a photograph of a painting and post it on the Internet is not new-media art, even though it technically conforms to the diagrammed process, because it simply and faithfully re-presents the source

material without any esthetic intentionality. Finally, the digital art process is not about purity or exclusivity and is best considered in light of anthropologist Gregory Bateson's definition of information as a "difference that makes a difference."[10] If one can make the argument that the computational process makes a difference to the work as art, then it is arguably new-media art.

One of the ongoing debates in the institutional art world is whether new media should be thought of as a distinct field or whether it is best to consider it as "just art." There are valid points of view on each side of the debate, but for the purposes of collecting, it doesn't matter. Some institutions have departments of photography or video curators and others don't, but both types may collect photographs and video art. Regardless of institutional structure, it is important to consider how to integrate new-media art into the museum's collection practices as well as to consider the conceptual issues and pragmatic concerns raised by its distinctive features.

There are many new-media artists and artist groups for whom the museum is a specific site of contestation. Work by Knowbotic Research, Critical Art Ensemble, Graham Harwood, and others often uses the museum context to make its point, and in this sense it is similar to the socially and politically engaged practice of Hans Haacke, Andrea Fraser, and Fred Wilson, each of whom engages the institution of the museum with at least some of their work.

Many network participants, however, would agree with Australian artist Melinda Rackham that there is a more general issue at stake, which she articulated in an online discussion: "[T]he reasons people started making net art … to connect on a network and route around the censorship of the institutional and corporate world, mean that they (museums) will never want to treat it seriously – it's still in opposition to their structure."[11] Whether or not these are the reasons that many museums don't collect new-media art as conscientiously as other art forms is debatable, but there is a fundamental tension between the wide-ranging and open structures of the Internet and the traditional role of the museum as gatekeeper. One example of this gap in practice is that often an institution collecting new-media art is in fact collecting a production platform or set of algorithmic parameters with constantly changing content rather than a fixed entity.

Mark Napier was commissioned by the Solomon R. Guggenheim Museum in New York to create *Net.Flag* (2002), a dynamic online work that allows viewers to modify the look of a virtual flag in real time. The Guggenheim also acquired the work – the software with its dynamically changing content – for its permanent collection. In addition, as part of the purchase agreement, Napier insisted that the

10 Gregory Bateson, *Steps to an Ecology of Mind* (Chicago: University of Chicago Press, 2000), 457.

11 Melinda Rackham, April 17, 2002, "[-empyre-] Forward from ippolito re gift economy vs art market #1," [-empyre-] listserv, http://lists.cofa.unsw.edu.au/pipermail/empyre/2002-April/msg00046.html (accessed October 28, 2013).

work "always be on view."[12] This is a condition that could never be accommodated for any physical work of art, but that, though still ambitious, is not unattainable online.

The primary issue regarding collecting "anti-institutional" net art ultimately isn't its content, but the general desire by many new-media artists for their work to continue to be freely and easily accessible – and appropriately displayed. Potentially, the museum can help enable this, especially over the long term, by taking on some of the burdensome support functions, recognizing that such freely available and often easily replicable work may also impact the museum's traditional insistence on uniqueness or limited availability for objects in its collection.

A lot of new-media art is ephemeral. Generally this issue can be divided into two separate categories: time and materiality. Stelarc's classic *Ping Body*, which allows remote participants to actuate his body by "pinging" it via the Internet, causing his limbs to involuntarily twitch through remotely activated electrical stimulators, is a performance that first took place on 10 April 1996.[13] Like Jean Tinguely's *Homage to New York* (1960), it can have a cascading influence on the field, but even when repeated, it would still be classified as a performance, like any musical event, and its documentation would generally become part of an archive or study collection. The performance itself is unlikely to go into a museum's permanent collection.

The distinction between art and the documentation of an artistic event begins to blur a bit, however, when the art is instruction-based. For instance, Sol LeWitt's *Four Geometric Figures in a Room* was commissioned by the Walker Art Center in Minneapolis in 1984. Technically, the artwork is the following set of instructions: "Four geometric figures (circle, square, trapezoid, parallelogram) drawn with four-inch (10 cm) wide band of yellow color ink wash. The areas inside the figures are blue color ink wash, and the areas outside the figures are red color ink wash. On each side of the walls are bands of India ink wash."[14] As the contextual information states, LeWitt's instructions are something that "anyone may execute, in any location, any number of times." The parallels to new-media art are striking. In a sense, the input is the room's dimensions, the algorithms are LeWitt's instructions, and the output is the drawings on the walls.

Lisa Jevbratt's *Stillman Project* (Figure 2.2) was also commissioned for the Walker Art Center but for a virtual "room" – the online Gallery 9.[15] Jevbratt, too, wrote a set of instructions, only they were in a computer language known as JavaScript. These instructions were placed on every page of the Walker

12 Interestingly, the contractual agreement between the Guggenheim and Napier does not guarantee that *Net.Flag* will always be on view, but if it isn't via the Guggenheim, Napier has the right to re-host the work (correspondence with Jon Ippolito, February 16, 2004).

13 Stelarc, "Ping Body," April 10, 1996, http://www.artelectronicmedia.com/document/stelarc-ping-body (accessed October 28, 2013).

14 Sol Lewitt, "Four Geometric Figures in a Room," 1968, http://www.walkerart.org/collections/artworks/four-geometric-figures-in-a-room (accessed October 28, 2013).

15 Lisa Jevbratt, "A Stillman Project for the Walker Art Center," 1998, http://www.walkerart.org/gallery9/jevbratt (accessed October 28, 2013).

Figure 2.2 Lisa Jevbratt (Swedish, born 1967), *The Stillman Project for*
 the Walker Art Center, **http://projects.walkerart.org/stillman/**
 documentation/stillman/error.html, 1998

website (in the source code, not visible to the visitor) and caused a number of things to happen when a visitor viewed the website. On the first-viewed page only, they generated a set of simple questions (each in a different color). Based on how visitors answered, they were "tagged," and as they viewed different pages throughout the website, those pages were also tagged with a color linked to the visitor's answer. Over time, pages of the website acquired a profile based on who was looking at them: 30 per cent of the people looking at this page believe the Internet is primarily informational, etc. The point is that with all net art and significant aspects of all new-media art, as with the LeWitt, the artwork that is collected is the instruction set and the artwork that is experienced is its execution.

A lot of new-media art, especially network-based work, doesn't have spatial dimensions per se, but nodes and levels of connection. Maciej Wisniewski's *Jackpot* (Figure 2.3), for example, is an online slot machine that randomly displays URLs (web addresses) contained in a pre-existing database. In 1998, the Walker Art Center acquired this work as part of its acquisition of the website äda'web. The web pages that *Jackpot*'s database of URLs pointed to were not saved at the time, and now when you play it, the majority of results are missing pages. Even though the piece is technically "correct" – the instructions still work – much of the magic of the original experience is gone.

To some extent, this is a potential hazard for any work that relies on external input. Calvin Tomkins tells the story of the first time that John Cage presented *Imaginary Landscape No. 4* (1951), a composition that involves operating 12 radios according to a particular script. By the time Cage and his performers took the stage, it was after midnight and the radio spectrum was practically silent. There were no sound streams for the radios to manipulate. The performance was not a great success.[16]

16 Calvin Tomkins, *The Bride and the Bachelors: Five Masters of the Avant-Garde* (New York: Viking Press, 1965), 113–14.

Figure 2.3 Maciej Wisniewski (Polish), *Jackpot*, **http://adaweb.walkerart. org/context/jackpot, 1997**

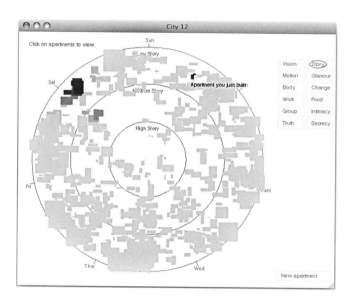

Figure 2.4 Marek Walczak (British, born 1957) and Martin Wattenberg (American, born 1970), *Apartment*, **http://www.turbulence.org/ Works/apartment, 2001**

I would argue it is not enough just to say that *Jackpot* is technically intact and that it simply has become a marker of how the World Wide Web has changed. That was not the artist's intent. On the other hand, how *Jackpot* should be collected is not obvious. One could simply save its initial set of pages in the database, but when a future user clicks on a link within such a page, it will return an error message because the links are no longer "live." One could create a script that periodically refreshes its database of URLs, so that more of them are accessible. One could modify the script to use only URLs that are still operational. Whatever the decision, it is important to make such future decisions an explicit part of the acquisition process, not an afterthought. This is one function of the Variable Media Initiative project, – to have the artist specify, in a more systematic way, which aspects of a given project can be changed and which must remain for the project to retain the artist's intent.

One constant refrain about the promise of new-media art is that it allows the viewer to become a participant and even, for many works, a producer. The artist is creating the context, the platform, the set of rules by which the "viewer" participates and produces. With a work such as *Apartment* (Figure 2.4) by Marek Walczak and Martin Wattenberg, users enter a string of words in order to create the floorplan of an apartment. The truth is some users are better than others at generating results that are of interest to other viewers. How are we to judge works where the input is the user's? For Kynaston McShine's acclaimed *Information* exhibition (1970), Dennis Oppenheim created a system for visitors to write a secret on a note card and put it in a slot. In return, they received someone else's secret. After the exhibition, all 2,000-plus of the secrets were published, without editing. One would be hard-pressed, however, to argue that the quality of this essentially conceptual work was dependent on what people wrote.

Many new-media artworks are inherently performative. It is important to judge them on the basis of the performance that is possible, not on every person's rendition of *Moonlight Piano Sonata* (1801), so to speak.

There are plenty of ephemeral, instruction-based works in museum collections, from Jana Sterbak's *Vanitas: Flesh Dress for an Albino Anorectic* (1987)[17] to LeWitt's *Four Geometric Figures in a Room*. There are plenty of "anti-institutional" artists collected by museums, from Hans Haacke to Andrea Fraser. There are certainly examples of unbounded and open works, from Ray Johnson's correspondence art to Yoko Ono's *Scream* score.[18] Why is there so little new-media art in museum collections?

There is no single answer, of course, but push senior curators on this point and beyond the issues of new-media art being non-collectible, ephemeral,

17 Jana Sterbak, "Vanitas: Flesh Dress for an Albino Anorectic," 1987, http://www.walkerart.org/collections/artworks/vanitas-flesh-dress-for-an-albino-anorectic (accessed October 28, 2013).

18 Yoko Ono, "Voice Piece for Soprano," 2001, http://sonicflux.walkerart.org/ono/index.html (accessed October 28, 2013).

decontextualized, open-ended, and difficult to preserve; beyond frustration with not having the right plug-in or the computer being "down" when they were at an exhibition; they will finally admit two things: never having seen new media they thought was really great art, and not knowing anyone who collects (buys) new-media art.

These are not trivial issues by any stretch of the imagination, but as Linda Nochlin pointed out in her seminal essay "Why Have There Been No Great Women Artists?" (1971), the question, if answered adequately, can "challenge the assumptions that the traditional divisions of intellectual inquiry are still adequate to deal with the meaningful questions of our time, rather than the merely convenient or self-generated ones."[19] It is not my goal with this chapter to attempt to answer the question adequately – in Nochlin's sense – of why there have been no great new-media artists, but I do believe that doing so is fundamental to reversing the situation.

One brief speculation, however: with LeWitt's instructions for *Four Geometric Figures in a Room*, a curator, even though she may not be a trained preparator, can get a pretty good sense of the results of the instructions just by reading them. And, of course, there is a 1,000-year history of drawing that can be referenced in evaluating the experience of the actual work. With Jevbratt's JavaScript instructions, however, most curators, including myself, have a hard time reading the code in any meaningful way. I don't think this means that curators must become coders, but a different level of familiarity and accessibility is needed. In terms of the resulting web pages – Jevbratt's "rooms" – the conceptual nub is not the visual experience, but the interactive experience. The history of such interactivity is much more truncated, and most of it is borrowed from different forms, such as the theater, or based on usability studies that may be more appropriate for E-commerce sites than works of art. In the words of Leo Steinberg: "One way to cope with the provocations of novel art is to rest firm and maintain solid standards … A second way is more yielding. The critic interested in a novel manifestation holds his criteria and taste in reserve. Since they were formed upon yesterday's art, he does not assume that they are readymade for today … He suspends judgment until the work's intention has come into focus and his response to it is – in a literal sense of the word – sympathetic; not necessarily to approve, but to feel along with it as with a thing that is like no other."[20]

Sympathy isn't necessarily the best criterion for make a lasting commitment, but neither is mere similarity to one's previous relationships.

19 Linda Nochlin, "Why Have There Been No Great Women Artists?" *Artnews* (January 1971): 22–39. See also Steve Dietz, "Why Have There Been No Great Net Artists?" 1999, http://www.yproductions.com/writing/archives/why_have_there_been_no_great_n.html (accessed October 28, 2013).

20 Leo Steinberg, "Other Criteria," in *Other Criteria: Confrontations with Twentieth-Century Art* (New York: Oxford University Press, 1972), 63.

Collecting New-Media Art

The distinctive features of new-media art do challenge many of the conventional notions about art, but many respected – and collected – non-new-media artists have used these same strategies in their work. I have no doubt that eventually new-media art will be as much a part of institutions' collections as photography, video, and installation art have become. In the meantime, however, there is a crisis at hand. We are in danger of losing 30 years of new-media art history. It is important to learn how to collect new-media art now, if there is to be any hope of preserving its recent past.

If magnetic tape has a half-life of approximately 30 years – the point at which it starts to significantly deteriorate – the half-life of digital media can be days. In 2002, the average lifespan of a web page was just 74 days. In addition, the software that drives many new-media applications may change every six months – and it is not always backwards compatible. The artist duo Jodi's famous *404-object* page can still be displayed, but only by looking at the source code can you tell that hundreds of the words on the page are supposed to create a virtual Times Square of blinking.[21] Current web browsers, however, no longer support the blink tag, so the experience of the work is radically different from what the artists intended.

Museums traditionally are concerned with the selection of precious, rare, or unique objects. Libraries are traditionally concerned with expanding access to generally available objects. Many digital artworks are easily replicable and artists are more interested in making them accessible than rare. In this context, some of the differences between a museum collection of digital artworks and a library collection of digital objects begin to converge. As Jon Ippolito, progenitor of the Variable Media Initiative, provocatively put it in regard to the non-uniqueness of certain digital artworks: "For museums to acquire open-licensed art would require them to transform from collecting institutions to circulating institutions."[22]

According to the National Information Standards Organization's framework for digital collections: "A good digital collection is created according to an explicit collection development policy that has been agreed upon and documented."[23] While this may seem obvious, it is not always true. To date, several approaches have been taken at US museums.

The clearest process may be to place new-media works in the museum's permanent collection, under whatever existing mission that collection has. According to Ippolito: "the Guggenheim is bringing a particularly long-term vision to collecting online art, acquiring commissions directly into its permanent

21 Jodi website, n.d., http://404.jodi.org/bcd (accessed October 28, 2013).

22 Jon Ippolito, April 12, 2002, "Nettime-bold why art should be free 2/3: the digital sanctuary," nettime-bold listserv. See http://amsterdam.nettime.org/Lists-Archives/nettime-bold-0204/msg00403.html (accessed October 28, 2013).

23 National Information Standards Organization, "A Framework of Guidance for Building Good Digital Collections," November 6, 2001, http://www.niso.org/publications/rp/framework3.pdf (accessed October 28, 2013).

collection alongside painting and sculpture rather than into ancillary special Internet art collections as other museums have done. The logic behind the Guggenheim's approach, known as the Variable Media Initiative, is to prepare for the obsolescence of ephemeral technology by encouraging artists to envision the possible acceptable forms their work might take in the future."[24]

The Guggenheim is focused on the important issue of lasting stewardship and the particular requirements of new-media art, and it takes the position that works should not be segregated by medium. This is a principled position. At the same time, Ippolito acknowledges that he is constrained, with such a policy, in what he can show and especially acquire because it must "succeed." As Steinberg warned, however, judging such success – or failure – is too often based on the norms of existing media.[25]

The American Museum of the Moving Image (AMMI) has a material culture collection. In the digital realm, it has collected sound-effects files, video games, and the dancing-baby animation. For AMMI's collection, "artistic merit is one among many characteristics that make something worthy of being collected. There are many others as well, such as considerations of its importance and influence at the time, or being part of a chain of influence for later developments and innovations, or even that it was an intriguing dead end." As curator Carl Goodman puts it: "We as a museum are free to recognize artistry and artistic achievement but are not tyrannized by it – it is not the singular characteristic uniting all of our objects."[26]

At the Walker Art Center, where I was curator of new media (1995–2003), the new-media collection policy specifically states that the Walker's is "a hybrid Collection that shares similarities with the Permanent Collection, the Study Collection, and the Archives Collection" and is intended "to provide a permanently and publicly accessible record and context for understanding the telematic and new media artwork of our time, document major tendencies in the field, and increase local and remote visitors' appreciation of new media art."[27]

There was a two-step process for collecting new-media art at the Walker. It could be acquired for the Digital Arts Study Collection and then later accessioned into the Permanent Collection. This allowed me to collect work that I felt strongly about, but that the institution was not necessarily fully equipped to deal with at that point. More important, however, the Study Collection allowed me to preserve work that provided a context for the artwork I was collecting, such as the *Art Dirt* webcasts, which included interviews with many of the artists in the Digital Arts Study Collection.[28]

24 Jon Ippolito, "Ten Myths about Internet Art," 2002, http://three.org/ippolito/writing/ten_myths_of_internet_art (accessed October 28, 2013).

25 Jon Ippolito, correspondence with the author, February 16, 2004.

26 Carl Goodman, correspondence with the author, February 16, 2004.

27 Walker Art Center Digital Arts Study Collection Policy.

28 G.H. Hovagimyan, "Art Dirt," http://www.walkerart.org/gallery9/dasc/artdirt (accessed October 28, 2013).

Friedrich Kittler, in his essay "Museums on the Digital Frontier" (1995), argues strongly that one of the significant opportunities for museums in the digital age is to create digital collections that are the artworks *and* the context for the artworks, from related cultural artifacts to contextual materials to the technical notes that underpin the creation and presentation of the work. Whether these collections are called "permanent" or "study" or "archives" makes a difference in terms of what they can ingest and how, but in terms of access, integration, and hybridity are practically a mandate for Kittler – with whom I agree: "What looms ahead or rather what has to be done is the reprise of the wonder chambers. Johann Valentin Andreä, the founder of the Rosicrucians, once advocated an archive that would include not only artworks, tools, and instruments, but also their technical drawings. Under today's high-tech conditions, we have no choice but to start such an archive or endorse millions of anonymous ways of dying."[29]

Museums are moving toward such integration of their collections, archives, and libraries, at least intra-institutionally. It remains a goal to expand accessibility inter-institutionally.

Preserving New-Media Art

Collecting a work of art brings with it the core responsibilities of research, presentation, and preservation. There are many reasons why preservation is problematic for new-media artworks, primarily having to do with the variability of both their input and output, the fast pace of change for underlying hardware and software, and the physical deterioration of components. At the moment, there are very few solutions to these issues, but a number of interesting approaches are being attempted. For the time being, some combination will be necessary until there is common conceptual agreement as well as the supporting technical capabilities. In the meantime, collecting this important cultural heritage is a critical and necessary first step.

For many media-based acquisitions, museums will purchase the equipment necessary to run them as protection against the equipment not being available at some future date. This approach has generally been downplayed for digital art because the potential variations boggle the mind. On the other hand, given the very few number of works actually collected, and given their cost compared to works by similarly established artists in parallel fields, I believe that equipment purchase, broadly defined, is worth considering.

If, for instance, a project requires Netscape 4.01 or later with the Flash 5.0 plug-in, there is no reason it wouldn't be possible to store a computer with this and its related configuration. If it also requires a server running Apache 3.02, Perl 4, etc., I don't think it is unreasonable to have a separate server running for

29 Friedrich Kittler, "Museums on the Digital Frontier," in *The End(s) of the Museum* (Barcelona: Fundació Antoni Tàpies, 1996), 78.

this project that maintains this configuration. Other projects requiring the same configuration could also, in theory, be served from the same machine, but once a new acquisition requires a setup that requires changes to the existing setup, then a new server is purchased ($1,000 plus installation of mostly free software). Eventually, of course, the hardware itself will fail and it may not be possible to replace it, but at least one has bought anywhere from five to 30 years until more robust solutions need to be implemented.

Because media fail physically and because software and hardware systems change radically, preserving digital media is an eternal migration at this point. There are two main components to the process: Refreshing and migration.[30]

Refreshing

Like paper, film, magnetic tape, or any other physical substrate, the media that digital files are stored on, such as CD-ROMs, floppy disks, and hard drives, will inevitably fail. Before this happens, it is important to refresh their contents to new storage media – even if the physical format remains the same (i.e., hard drive to hard drive).

Migration

Refreshing moves a particular file – and the format it is encoded in – from one physical storage medium to another. But that is no guarantee that the file itself can be read or executed. Very few institutions can still read WordStar word-processing files, even if they have been refreshed from their original $5\frac{1}{4}$ in. floppies to brand new DVDs. Migration involves not only refreshing these files but also converting them to currently readable formats. Migration is time-consuming and it doesn't guarantee that the formatting from one software format is preserved in the next (for example, current browsers can read and display Jodi's page, but they ignore the blink formatting). Nevertheless, migration is critical for the content of files to remain readable.

Emulation is perhaps best known as a way to use contemporary software, such as a Java applet, to emulate the way older software and/or hardware ran, such as a video arcade game. It is possible to download an applet that allows one to play

30 Three excellent articles on the preservation of new media are: Richard Rinehart, "The Straw that Broke the Museums Back? Collecting and Preserving Digital Media Art Works for the Next Century," posted June, 14 2000, http://switch.sjsu.edu/web/v6n1/article_a.htm (accessed October 28, 2013); Howard Besser, "Longevity of Electronic Art," submitted to International Cultural Heritage Informatics Meeting, 2001, written February 2001, http://besser.tsoa.nyu.edu/howard/Papers/elect-art-longevity.html (accessed October 28, 2013); and Peter Lyman, "Archiving the World Wide Web," in *Building a National Strategy for Preservation: Issues in Media Archiving; Library of Congress*, April 2002, http://www.clir.org/pubs/reports/pub106/web.html.

the very first video game, *Space War* (1962), more or less as it would have been played at MIT, where it was invented, on a time-sharing mainframe computer. The idea with emulation is that if you can encode a way for a contemporary machine to run older software – including a computer's operating system – then you can skip migration, as the original software will always be playable, as long as it has been refreshed and hasn't physically deteriorated.[31]

Documentation, of course, is a critical part of any collection. There are three important strategies regarding documentation of new-media art.

Print it Out

We know how to preserve paper. Although it is not common, and we did not do it at the Walker Art Center, if I had to do it again, I would print out all of the software instructions, especially the artist's code. It may not be possible to actually print out the source code of Flash or other proprietary software, but it is definitely possible to print out the lingo script the artist used in Flash. It is not a difficult process and it adds an extra layer of security.

Document the Context

As discussed above regarding Wisniewski's *Jackpot*, there is legitimate debate over how much context to try to preserve for any given project. Having collected several pieces that have now lost their original context, I regret not having been more assiduous in documenting, by whatever method possible, materials that might have been linked to the work. This would never be the same as a contemporaneous experience, but it would be far better than another "404 Not Found" message. It is also part of the cultural heritage that institutions can and should preserve to help provide a context so that future generations can better understand and, one hopes, experience this important work.

The Variable Media Initiative

One of the most promising reconceptualizations of collecting, which affects collecting contemporary art in general, not just new-media art, is the Variable Media Initiative (VMI) originated by Ippolito at the Guggenheim Museum and now the work of a consortium of institutions and funders.[32] At the core of VMI are the twin assumptions that the nature of much contemporary artwork is variable and that it is important to document the artist's intentions regarding that variability

31 Jeff Rothenberg, "Avoiding Technological Quicksand: Finding a Viable Technical Foundation for Digital Preservation," January 1998, http://www.clir.org/pubs/reports/rothenberg/contents.html (accessed October 28, 2013).

32 "Archiving the Avant-Garde: Documenting and Preserving Digital/Variable Media Art," http://www.bampfa.berkeley.edu/about/avant-garde (accessed October 28, 2013).

as clearly as possible at the time of acquisition. Museums have interviewed artists about their work before, but the VMI is radically explicit about the mutability of much contemporary art and attempts to provide a standard framework for both artists and museum personnel to understand what really matters to the artist for any particular work of art.

To what degree do knowledge formations and institutions (museums, universities) transform in relation to the unfolding of their emergent subjects (new art) and alter their relationship to all that went before in the history of art and the collections that sediment that history?[33]

Abstract Expressionist painting changed the size of museum galleries. Video installation introduced the black box to the white cube. Examples abound of how contemporary art practice has changed institutional practice at both pragmatic and conceptual levels. Even as institutions begin to collect new-media art more diligently and to concern themselves with its preservation, it is unlikely that every museum will have the resources necessary to fully support its collections. However, because networked new-media art is not dependent on physical location for viewing, it is possible for institutions to share infrastructure, such as servers, technical staff, and hosting. It is imperative for museums to find a scaleable, sustainable solution to issues of preservation if they are going to feel confident in building collections of new-media art. Finding such a solution is unlikely to happen at the level of the individual institution.

Collecting new-media art is first and foremost a curatorial issue. The medium poses challenges to traditional notions of collecting, but not that much more so than other contemporary art. Ultimately, the ability to preserve and conserve new-media art will be irrelevant – at least for museums – unless curators take the first step and begin to collect, critically and assiduously.

33 Barbara Kirshenblatt-Gimblett in "Museums of Tomorrow: An Internet Conference," 2003, sponsored by the Georgia O'Keeffe Museum, http://www.okeeffe museum.org/symposia.html (accessed October 28, 2013).

Chapter 3

Old Media, New Media?
Significant Difference and the
Conservation of Software-Based Art

Pip Laurenson

Sharing a taxi recently with a museum curator of new media, our conversation turned to software-based art, which we jokingly referred to as the "new" new media. My colleague cited the lack of established documented practice for the conservation of software-based artworks as the main reason for the small amount of collecting activity in this area by museums. Put simply, software-based art is perceived as a risky area. What was interesting about this view was that it was voiced by a curator with many years of experience in the conservation of media-based artworks, and demands answers to the question: "What is so different (and seemingly alarming) about the conservation of software- or computer-based art?"

In this chapter we will consider software-based art from the perspective of time-based media conservation within a museum context in order to explore whether there is something fundamentally different in the conservation challenges presented by software-based art compared to traditional time-based media. Here I use the term "traditional time-based media" to refer to works of art whose primary medium is video, film, 35 mm transparencies, or audio. The primary mode of these media is playback and the technological environment upon which they depend moves through major changes, which destabilize these systems every 50 or so years. Even specific formats used for video archiving such as Digital Betacam have been current for almost 20 years. In contrast, software is a more diverse, non-standardized, and fast-moving technological environment, and the systems which make up software-based artworks are often more diffuse and less well defined than we find in traditional time-based media works of art. In addition to the technological environments on which these works depend, this chapter asks whether there are any significant properties that are specific to software-based artworks and, if so, how these might impact the work of conservators with regard to notions of artistic medium, change, risk, and expertise.

I will draw upon research carried out on Tate's collection and on the results of two research initiatives: the collaborative research project *Matters in Media Art* and the *New Media Art Network on Authenticity and Performativity*.

Funded by the New Art Trust, *Matters in Media Art* has, since 2004, brought together staff from Tate, the Museum of Modern Art in New York and the San Francisco Museum of Modern Art to build a consensus regarding the care and management of technology-based works within the three museums. The *New Media Art Network on Authenticity and Performativity* was led by Kelli Dipple, the Tate curator of Intermedia Arts, and was funded by the UK Arts and Humanities Research Council (AHRC) from September 2008 until September 2010. Over a series of five meetings at Tate Modern, the network brought together a range of different voices including artists, academics, curators, and conservators to identify the key research questions pertaining to the contemporary art museum's response to new media artworks and to examine specific questions around authenticity and performativity.

The Museum Context

The museum context from which this chapter is written is that of Tate. Software-based artworks have been displayed at three of Tate's four museum sites and Tate Online, and software-based artworks have, since 2003, also begun to come into Tate's collection in numbers that are broadly akin to live performance-based works, which have also only recently begun to be collected. Tate does not have a new media curator, but then nor does it have a curator of painting or sculpture. Traditionally, Tate curators have a mixed portfolio that is broadly organized around geographic region and historical period. Exceptions have recently been made for a curator of performance, a curator of photography, and a curator of film. Whilst identified by Tate as strategic priorities, these posts have also come about in response to specific funding opportunities. Whilst in some quarters this is considered a less progressive way of organizing curatorial responsibilities, the advantage of curatorial posts dedicated to a particular artistic medium is not only in the additional resource and attention this brings but also in the often medium-specific awareness of artworks and forms of practice which, either now or at a particular point in history, were or are not distributed through the art market or exhibited in mainstream art spaces. Unlike the curators, Tate does organize its conservators around media, with specialisms in paintings, frames, sculpture, works on paper, and time-based media. Starting at the turn of the millennium, Tate is not unusual in having commissioned software-based artworks for its website, a practice that at Tate was the responsibility of Tate Online (now Tate Media) rather than the curatorial department. Tate Media also hosted the post of Intermedia Arts Curator held by Kelli Dipple (now Kelli Alred) from 2003 to 2011, a post associated with commissioning works rather than bringing works into the Tate collection (www2.tate.org.uk/intermediaart). Works that are commissioned are not automatically acquired, and these two processes represent very different levels of responsibility on the part of the museum.

The Conservation of Media Artworks

Within contemporary art conservation, the challenges are twofold: first, those related to loss of a distinct, defined, and bounded material object as product in some areas of contemporary artistic practice; and, second, the technical challenges posed by non-traditional artistic media. The potentially contingent nature of the material object for some areas of contemporary artistic practice has opened up the possibility that the conservation of the work will not involve the conservation of any particular material instantiation of the work, for example, in the wall drawings of Sol le Wit, or an installation such as *This is Propaganda* (2002) by Tino Sehgal. A related but separate challenge is presented by works which take the form of ongoing projects where the artist is uninterested in the idea of a work reaching its final form, but instead sees the artwork as moving between phases within the potentially open-ended life of the work or providing the focus for a cluster of activities. Take, for example, Heath Bunting's *Status Project* (2004–14), which explores how our official identities are constructed according to different profiling systems, whether governmental or commercial. The *Status Project* incorporates a number of events, maps, personal portraits, and other outputs, such as a zine and an identity kit called by Bunting "Synthetic off-the-shelf (OTS) British natural person." This work is not in a museum collection and it is not clear whether it would make sense for such works to enter collections; however, it serves to illustrate the point that no longer can the conservator assume that the correct object of their attention is simply the material objects which are used in the display of an artwork or its particular iteration at any particular time. This has reiterated for conservation the need for a firm understanding of the significance and context of different aspects of a work, both tangible and intangible, to underpin any approach to its conservation and also the need for a clear understanding of whether a work is conceived of as complete or whether it is intended to evolve. With regard to the second challenge (the technical difficulties posed by non-traditional media), the Head of Conservation at the Museum of Modern Art (MoMA) in New York has made the clear and simple point that the use by artists of ephemeral materials does not mean that those artists did not want their works to last (Coddington 1999). Many materials used by contemporary artists are challenging to conserve – whether they be made from bread, plastic, butterfly wings, or software, they all have their specific vulnerabilities. The difference for software is that it is not chemical instability that is the focus of conservation, but rather instability in the technological environment upon which they depend.

In a recent paper I identified a set of key questions for the conservation of traditional time-based media works of art, where traditional time-based media is used to refer to works where the primary artistic medium is video, audio, film, and 35 mm slide (Laurenson 2013). Here, I will revisit these questions and consider if and where the conservation of software-based art requires a different approach or set of questions. The central questions for the conservation of any work coming into a museum collection are "What are we acquiring?" and "What do we need to

preserve?" The questions below aim to contribute an understanding of what the work is from a conservation perspective. The answers to these questions form the basis of a conservation strategy for a particular work:

1. *Significant properties*: are there significant properties for software-based works that are distinct from those associated with time-based media works of art more generally?
2. *Artistic medium*: is there anything different in understanding the relationship between the medium and the work of art for software-based artworks?
3. *Parameters of change*: is there anything unique to software-based artworks that challenges the way in which we understand the parameters of acceptable change for more traditional time-based works of art?
4. *Risk*: is there anything specific about the way in which risks are identified and mitigated for software-based artworks?
5. *Expertise*: what are the relevant notions, locations, and scope of the expertise needed to support software-based artworks?

Significant Properties

The concept of significant properties has been adopted from the archive community where it has been defined as follows: "The characteristics of digital objects that must be preserved over time in order to ensure the continued accessibility, usability, and meaning of the objects, and their capacity to be accepted as evidence of what they purport to record" (Grace, Knight, and Montague 2009). However, the way in which the term is used in conservation is more closely aligned to the phrase "work determinative properties," as developed by the philosopher Stephen Davies in his discussions of authenticity and the identity of musical performance (Davies 2001: 20). A rich examination of an artwork's properties is particularly useful for software-based art given that software is a very versatile tool that is capable of being deployed in a variety of ways to produce a broad range of behaviors and characteristics. An exploration of significant properties is therefore a means of identifying where, for any particular work, to focus attention in order to answer basic questions about the work and what it is that is important to its conservation. Questioning at this level is designed to help develop an understanding of the specific artwork and to lay the foundations for a more detailed conservation strategy for that work.

In research conducted as part of the *New Media Art Network on Authenticity and Performativity*, Kelli Dipple, Frederico Fazenda Rodrigues, and this author identified a number of areas of focus for different types of significant properties relevant to networked artworks. Although the original focus was on networked artworks, such as Internet-based works, the results were found to work well for a broader range of software-based artworks and also traditional time-based works of art. Drawing upon the description provided by Kelli Dipple in her final report

on this network (Dipple 2010), I have described these categories of significant properties in Appendix 1 of this chapter. I have chosen not to list these in the text, but instead to focus on the two areas of significant properties which I consider to be indicative of the distinction between software-based art and more traditional time-based media artworks.

The first of these are properties associated with "function." For software-based artworks, it makes sense to ask the question "What is the software designed to do?" in a way that it does not for a traditional time-based work whose primary mode is linear playback. It is central to the identity of software-based artworks that they are inherently transformative, that they *do* something in real time, something more than playback, so that the input is different from the output. Hence, it makes sense to ask whether these artworks analyze data or create visualizations. Whether they retrieve or select information, whether they sense presence, record events, produce or animate or translate content. Although it is beyond the scope of this chapter, it is in this link to liveness that lie interesting connections to the conservation of live performances.

The second most significant difference between software-based artworks and traditional time-based works of art relates to what has been described as "diffusivity." This concept, developed in 2009 by Ceci Moss, the then senior editor of Rhizome in a discussion about Internet-based works, concerns not only the external dependencies of software-based artworks but also the way in which, in many cases, they do not exist in one location, but over a series of locations or platforms (Moss quoted in Fino-Radin 2011: 8–9).

Many software-based artworks depend on external links or dependencies. This might include links to websites, data sets, live events, sculptural components, or interfaces. It might also refer to technical dependencies such as those related to web browsers, plug-ins, codices, a software or hardware environment, or human action or intervention.

Unlike the majority of time-based works, those software-based works which exist in distributed networks, such as the Internet, can exist in real time beyond the gallery walls and can also always be on and always accessible. Questions about the spatial and environmental parameters of a work relate to where physically or virtually the work resides – for example, is it screen-based or presented within a browser window? Is it embedded within a social networking site or in some other way connected over the Internet? Is it installed within a gallery or does it relate to a particular geographic location outside the gallery? Is it staged live? Works can exist simultaneously or at different times in different forms.

Both the capacity of software-based artworks to *do* something in real time, and their dependencies, point to an understanding of these works as systems. Of course, all time-based media works of art can also be seen as systems (Laurenson 2005), but the systems used in traditional time-based media works of art are far more regulated and standardized. In video, the data is decoded into sound and image according to the standard used by the manufacturer in the design of the equipment used by the artist to create the work, whereas for a software-based work, the artist

has often either created or designed the way in which the input is transformed. Take, for example, the work *Subtitled Public* (2005) by Rafael Lozano-Hemmer. At the core of this work are many thousands of lines of bespoke code written in Delphi, which operate in an environment produced by the commercial software, including the operating system and the libraries and drivers required for communication between an array of hardware and software components. Distinguishing between the functions created by the bespoke software and those determined by the commercial software is difficult as they meld together to create the desired behaviours of the system. Elements of this software are designed to calibrate the cameras used to map the space in which the work is installed. Additional software takes the output from the cameras, which provide coordinates of any members of the public entering that space and tracks them. Further software components then randomly selects a word from a list and sends the word to a video projector, which projects the word onto the torso of the person being tracked. The system will also detect whether there is contact between two of the people and pass words from one person to another. The complexity of the system is created by the number of elements, its array of functions, the mix of bespoke and commercial software, and ultimately its ambition. Changes in the system threaten to undermine its ability to do what it is designed to do, and change over time and between spaces is inevitable. This makes the display and conservation of this work, in the form of an essentially experimental system, challenging. It is highly likely that in the future replicating the behaviour of this work will be simpler than the means available when the work was made; whether this is ethically appropriate is a dilemma that preoccupies conservation and the museum.

There are fundamentally two ways in which a software-based artwork will fail once on display; either because it is presented with a previously untested situation or because a component which it is dependent on is lost, changes in some critical way, or fails. Artworks are not industrially produced objects, so in many ways they often function as a prototype, with scenarios having gone untested. The more a specific function is critical to the identity or presentation of the artwork, the more critical any lack of robustness becomes. The more complex the system, the higher the probability of failure, as there are more things that can fail. If you have no control over an element of the system, then you may not be able to maintain it and it may cause a failure at any time.

Whilst other categories of significant properties may be equally as important in understanding a specific software-based artwork and its conservation, properties associated with the function and dependencies of software-based artworks often point to key elements in the identity of these works as well as specific challenges in their conservation. Steve Dietz cites interactivity, computability, and connectivity as the three distinctive characteristics of net art (Dietz 2000). In considering the significant properties of software-based artworks, properties which related to the ability of software to "do" something computational or interactive, and their diffuse and connected nature, supports the identification of these characteristics as defining features of software-based art. I will therefore consider these significant properties as they play out in ideas of artistic medium, change, risk, and expertise.

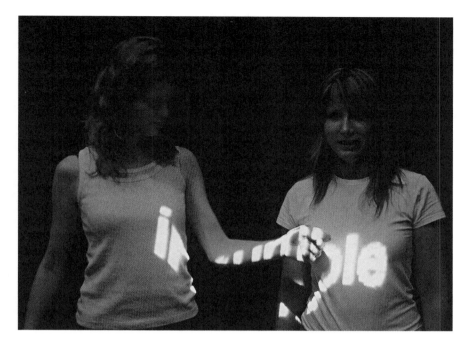

Figure 3.1 **Installation detail of Rafael Lozano-Hemmer's *Subtitled Public*, 2005, exhibited at Sala de Arte Publico Siqueiros, Mexico City, Mexico. Photo by Alex Dorfsman. Courtesy of the artist**

Artistic Medium

> Paint is a medium and the brush is a tool. (Paul 2001)

In the introduction to this chapter, I stated that one of the greatest challenges in the conservation of contemporary art lies in addressing the potential contingency of the material used in the creation and manifestation of the artwork. Given that in the contemporary art museum the artist is the most significant stakeholder in defining what is important about a work in terms of what is preserved, their views about the notion of a medium are often highly significant in determining the conservation strategy of a work.

In writing about the notion of the medium in art, the philosopher David Davies has identified both the vehicular medium and the artistic medium, both of which are distinct from the idea of a "tool" (Davies 2004). According to Davies, the artistic medium is to be understood in terms of artistic intentionality. It is therefore the way in which the medium is used to articulate an artistic statement, but also takes into consideration the influence of that medium in the final form of the work.

In contrast, the vehicular medium is simply the physical stuff that was used in the making or realization of the work. It is possible for physical materials to be used in the creation of the work without them being significant as an artistic medium. We see this clearly in the decisions made around equipment that is used in the display of a time-based work in that sometimes elements will be considered contingent and in other cases they will be seen as essential. For example, the use of a Walkman in Angus Fairhurst's work *Gallery Connections* (1991–96) is seen as essentially a sculptural (albeit functioning) object, referencing not only the time when the work was made but also the technology used to make the work. In contrast, the video projector used in the presentation of Frances Alÿs's *Railings* (2004) has already changed many times for different displays depending on what was available. In these works the Walkman has become part of the artistic medium for *Gallery Connections* in a way that the video projector for *Railings* has not. Similarly, many artists have no qualms about transferring works from film to video and also from video to film for the presentation of the work. These original media may leave their traces, but the medium itself is not considered significant to the final form of the work, just as wax might be used in the casting of a bronze (Laurenson 2005, 2009). This, of course, presupposes the idea of a work having a "final form," a concept that is currently under pressure by some contemporary art practices.

Artist's views on the nature and importance of the medium in which they create their works can run the gamut from the position taken by Croce and Collingwood where the medium is only contingently related to all artworks and its execution is simply a matter of craft skill (Collingwood 1938; Croce 1922), to the view attributed to Wollheim and Margolis that the medium enters in an important way into the artistic process, to ideas of the purity of the medium where certain media are best suited to conveying certain things, a line of thought that led to the modernist notion of "truth to materials" and broadly attributed to Lessing and Greenberg (Greenberg 1961; Lessing [1766] 1984; Margolis 1980; Wollheim 1968).

From a conservation perspective, understanding what is to be treated as part of the artistic medium matters because this identifies the medium as constitutive of the artwork and therefore as something that needs to be preserved. For software-based artworks, whether the code is considered as a key artistic medium or simply as a means of enabling certain functions to be performed will determine what are considered appropriate conservation strategies for that work. The way in which decisions are made regarding the artistic medium of a work and its significance is similar for both software-based artworks and traditional time-based works. For example, re-coding may be acceptable for a work where the value is considered to lie in the behavior or functions of the code rather than any inherent value it may have as part of the artist's esthetic medium. For example, for Michael Craig-Martin's *Becoming*, although the program was written by Daniel Jackson specifically for the piece, the code is not seen as "the work." This means that the artist is open to the work being re-coded in order to keep the behavior the same. For another artist, the bespoke code may be key to the meaning and identity of the work and fundamental to the artistic medium of the work. For example, in an

interview conducted in the context of the AHRC research network *New Media Art Network on Authenticity and Performativity*, concerning his work *The Giver of Names* (1991–), the artist David Rokeby remarked: "in a work like this there is philosophy, esthetics, phenomenology, in the code" (Dipple 2011). Recognition of the significance of the code for his work has led to Rokeby changing his working practice to separate out the code which he considers part of the identity of the work and part of what is to be preserved from software which is not essential, for example, the commercial software which forms the operating system, etc.

Tate is currently exploring the impact of both re-coding works where this is appropriate and also emulation where this better suits the significant properties of a work. There is a suggestion that emulation might provide an approach where it is important that the code is preserved in its original form. There are also indications that exploring these strategies early in the life of a work mean that they can be useful diagnostics indicating where the risks and dependencies of a work lie. For example, Michael Craig-Martin's *Becoming* runs on a standard Windows XP operating system. The computer program was originally written by Daniel Jackson of AVCO in the programming language Lingo using Macromedia Director. The program serves to randomly call up any one of the 15 Craig-Martin line drawings and adds them to the composition, fading them up or down, and using degrees of transparency to create a constantly changing composition on the screen. In an experiment where the work was re-coded by the original programmer Daniel Jackson, it became clear that the way in which Lingo originally managed the sequence of steps over time was different from how this was managed in ActionScript 3. In ActionScript 3 the program would jump steps in a sequence in order to complete the action in the allotted time, whereas in Lingo it would complete the steps regardless of the time that had been allotted to the task. This simple difference has the potential to have an effect on the behavior of the piece if the processing speed of the hardware is changed. In this example the re-coding of the piece not as a recovery tool, but as a diagnostic tool was valuable in producing a better understanding of its vulnerabilities and dependencies over time.

Whilst the status of the code may be different for these works by Rokeby and Craig-Martin, the maintenance of what the software does in determining the behavior of these works is highly significant in both cases and is essential to their conservation.

Many software-based artworks are designed to be installed in a gallery setting where the hardware may or may not be a significant component of the work. For example, *Becoming* by Michael Craig-Martin functions in many ways visually as a painting would – it can be hung on the wall and requires no interactivity. The piece is essentially a computer-generated animation. *Becoming* was part of a wave of software-based works which were designed to be framed and hung on a wall in a way akin to more traditional art forms exploited by artists such as Julian Opie and Michael Craig-Martin around 2002. Building on ideas that he had developed for his own work, Daniel Jackson not only worked with Opie and Craig-Martin on the programming side of their works but also worked with Torch Computers to produce a way of presenting them. Torch specializes in design solutions for artists. I quote from their website:

Just because the artwork is realised on a computer and computer display screen doesn't alter the fact that the item is an artwork. It's a complete piece where the details of the platform also matter, although secondary to the visuals of what appears on the screen. Just as with the frame on a painting, the platform should complement the art, but not distract from it. Our screens are designed to hang on the wall like a painting. (Torch Computers 2012)

In an interview with Michael Craig-Martin in August 2010 whilst discussing the significance of the visible hardware, Craig-Martin reiterated the references to the conventions of framing: "what was important to me was that it could hang on the wall exactly like a painting," the emphasis being on the significance of being able to hang this work on the wall so that it "is referencing painting as much as technology" (Craig-Martin 2010). During this discussion, it was agreed that the scale of the work, the aspect ratio, and the references to painting (being framed, hanging on a wall) were all-important to the identity of the work.

Figure 3.2 Installation detail of Michael Craig-Martin, *Becoming*, 2003. Photograph © Tate, London 2013

The original screen was 18 inches, employing a 3:4 aspect ratio. There is some flexibility in terms of the size of the screen (it could be as large as 21 inches if necessary), but it is important that the piece maintains its intimate quality. The artist is aware that the hardware marked a particular moment and therefore has historical value; however, there is some ambivalence concerning the way in which the technology dates the work.

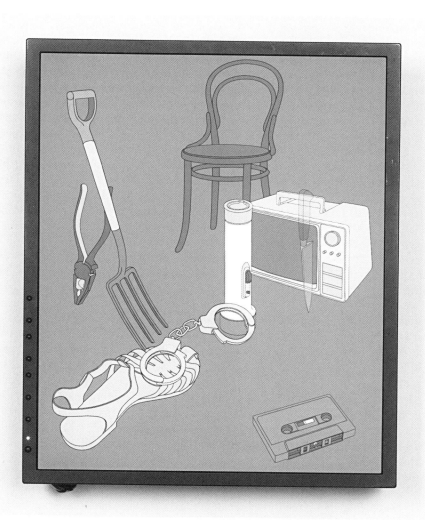

Figure 3.3 Installation detail of Michael Craig-Martin, *Becoming*, 2003. Photograph © Tate, London 2013

The way in which value is assigned to the hardware used in software-based art is broadly similar to other time-based media works of art. Interestingly, it is in the gaming community that a high premium is placed on the historical authenticity of the interface between the gamer and the game. In many ways the response within this community is more conservative than in the arts. In the arts the artist is commonly taken as the primary determiner of value, whereas in the gaming community the value assigned by the user is primary – this is of course partly because of the anonymity of the creators of games (Guttenbrunner et al. 2008).

As with other time-based media works of art, visible hardware used in a sculptural way or which determines the way in which the viewer engages with the work is valued more highly than purely functional hardware which is not visible or accessible and therefore does not feature in the way the public encounters the work. Hardware that is visible within a sculptural context may have been chosen for very pragmatic reasons, but over time may become associated with the identity of the work. Artists may or may not consider the hardware or the software used to constitute the piece essential to the identity of the work. In works that depend on a fast-changing technological environment, this is important, as there will be pressures to remove the work from dependency on natal technologies. Artists may also value hardware for connections to the way the work was made, or other references to the time in which it was made or a social or political context.

Another software-based work in Tate's collection is Jose Carlos Martinat Mendoza's work *Brutalism: Stereo Reality Environment 3* (2007). This work is a sculptural installation that utilises the Internet to search for the term "brutalismo/brutalism." Phrases from the resulting searches are printed onto thermal printers, the printouts then falling to the floor, accumulating over the course of the show. The thermal printers are a practical choice, given their robust nature, but also add to the pared-down esthetic of the work. Here, in an interview with the artist conducted by the conservator Patricia Falcão, the significance of the liveness of the search and the changing nature of the results is an important part of the work, referring not only to the idea of research carried out using a search engine but also the sense in which it is possible to create a research organism which searches and selects from the sea of information which has increasingly become difficult to absorb (Martinat Mendoza 2010). Hence, for this work, there is significance in the use of the Internet, which makes it part of an artistic medium explored in the work rather than simply a tool used in the return of phrases to be printed. When listening to this interview, the distinction between discussions of elements that form part of the artistic medium of the work and those that, although visible, are more functional is striking. For example, the printers are largely valued for their reliability.

Works such as *Brutalism: Stereo Reality Environment 3* (2007) rely on a constantly changing input of data, and although it is possible to use a previously populated database to feed the piece, the idea of liveness is evoked as a significant or work defining property of the work. This dependence on a live data feed also points to the diffuse nature of the work as a key property of the medium employed. This sense of liveness is not present in traditional time-based works and is also a

distinctive aspect of the medium. In a meeting at Baltan Laboratories in Eindhoven in December 2012, the artist Aymeric Mansoux remarked in the context of the work *Naked on Pluto* (2010–) that to rely on a previously populated database would be equivalent to the work being on "life support" (Baltan Laboratories 2012). The significance of liveness also links these works to performance-based artworks.

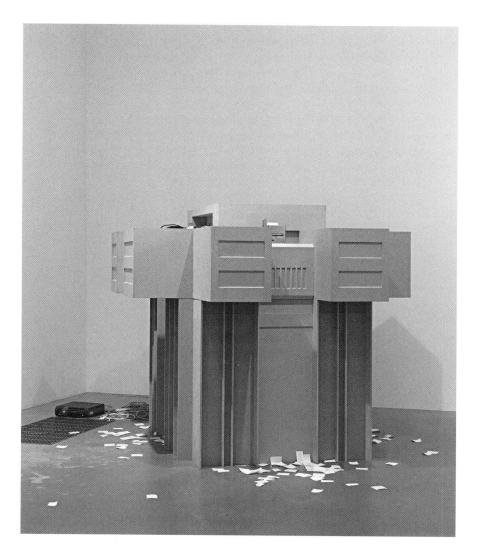

Figure 3.4 Installation view of Jose Carlos Martinat Mendoza, *Brutalism: Stereo Reality Environment 3*, 2007. Photograph © Tate, London 2013

**Figure 3.5 Installation detail of Jose Carlos Martinat Mendoza,
Brutalism: Stereo Reality Environment 3, 2007. Photograph ©
Tate, London 2013**

In this discussion of artistic medium we have considered how in contemporary art museum practice the artist is the main arbiter of what is defined as part of the artistic medium and the value it is assigned. Different artists have different notions of the significance of the artistic medium. In this section we have looked at two different artists with different notions of the value of their original code developed for their works. We found that in both cases, maintaining the ability of the code to *do* what it was designed to do was an essential part of the conservation of both works. We have also in this section considered a work that depended on the Internet to provide a live feed. Here the live and diffuse nature of the work was again something that the artist felt was a significant or work-defining property. Whilst the process of establishing what is an important part of the artistic medium is similar for traditional time-based media works of art and software-based works, we find that these examples support the hypothesis that the properties of the software considered the most important to preserve

were those linked to the transformative behavior, liveness, and diffuse nature of the works.

What is valued in a work determines not only the focus of conservation activity but also the judgements regarding what is considered acceptable treatment and how loss is defined. In the next section I will consider whether there is any difference in the way in which we understand the parameters of acceptable change within software-based artworks and traditional time-based media works of art.

Parameters of Change

There are strong forces for change in any artworks that are dependent on a fast-changing technological environment. The degree to which technology-based works embrace or resist this varies. How these changes are managed is determined by the significance that is assigned to different aspects of the work.

Sandra Gamara's *LiMAC Shop* (2005) is both a sculpture referencing a museum shop and a website for the imaginary museum of contemporary art of Lima, Peru (http://li-mac.org). The website is designed to perfectly mimic that of a generic contemporary art museum. The sculptural component of the work remains static and unchanged, whereas the web-based aspect evolves and changes, much as a real museum website might, with an exhibitions program, new acquisitions to its collection, new products in its shop, and major website redesigns. Here the conservation of the work involves the ability to keep the work live and also to create an archive or history of the changes to the work over time.

In contrast, Martinat Mendoza exhibits a far more ambivalent relationship to change with regard to *Brutalism: Stereo Reality Environment 3*. This is the case both in terms of how the future of the Internet might affect the work and also how the different geographic contexts will impact what is returned from the searches and how that might be managed. In an interview at Tate in the context of the *New Media Art Network on Authenticity and Performativity*, the artist David Rokeby gave an interesting account of the dilemmas he feels in response to the questions of change in his work. In this interview he talks about the difficulty of resurrecting the work in the future in that "there is no specification except that it should work like it used to work and there are things that may not seem like good programming practice which are there on purpose." This statement suggests a degree of anxiety about how the work might change, whereas later in the same interview he considers his attitude to how the different editions of his work *The Giver of Names* (1991–) might change over time:

> I am sure that if all six versions get sold and they are still around in a hundred years they will all be quite different and I am very open to that. It reminds me of a story about John Cage where a friend of mine was conducting a piece of Cage's and Cage came the day before the performance and he smiled and

watched the whole thing and said "It has nothing to do with my work, it is very nice but it has nothing to do with my work." I don't know if I would feel that way if I saw the work in a hundred years but that is the risk you take. I feel that there is a pretty clear course that is the only course that will offer it a chance of survival and that has an openness to it. Through documentation … I can guide that process but that process is going to be out of my hands. (Dipple 2011)

In this quote we can see an example of an artist who is managing the inevitable impact of rapid technological change on his work. This is distinct from the position of an artist who has designed a work that is either open-ended or intentionally comprised of different phases. An example of an open-ended work is found in the web-based element of Sandra Gamarra's *LiMAC Shop*. It is in the artist's use of the trope of the museum website rather than the use of the Internet itself which makes *LiMAC Shop* a work that is not only designed to evolve and change over time but which also references a form for which this is to be expected. However, many web-based works have at least an element which evolves over time, whether by inviting visitors to generate new content (for example, Mark Napier's *Netflag* (2002)) or by evolving in phases (as in Yael Kanarek's *World of Awe* (2000, 2002, 2006) which, in referencing the idea of a travelogue or journal, exists as three chapters produced at different times).

Contemporary artistic practices that are participatory are increasingly bringing works into collections which are designed to change and be open-ended or which exhibit distinct phases, for example, from live event to archive. These works challenge the notion of the static and timeless museum object. Some of these works are software- or Internet-based artworks, but many are not. However, software and the use of the Internet is one of the ways in which it is possible to invite and orchestrate participation or access in a non-geographically fixed way. In some cases the Internet may simply be a tool of engagement, as in Heath Bunting's *BorderXing* commissioned for Tate Online in 2002–03. This work consists of the "documentation of walks that traverse national boundaries, without interruption from customs, immigration, or border police" (http://www2.tate.org.uk/intermediaart/borderxing.shtm). The work is not accessible to everyone and one has to apply to view the work or travel to one of many designated locations. In a meeting in August 2010 as part of the *New Media Art Network on Authenticity and Performativity*, Bunting commented that the work was not in his view tied to the Internet, but could in fact in the future be presented in another form, for example, a book. Hence, in this case, the Internet would become part of the history of the presentation of the work rather than being seen as an essential component of the work itself.

Although change is perceived similarly by many software-based artists and traditional time-based media artists, it does appear that for Internet-based works, there may be a greater association with forms of practice that are ongoing or evolutionary in nature and hence evoke a very different relationship to change over time.

Risk

One of the purposes of assessing value and significance is so that one can judge the significance of risks as they are identified. In considering the expertise that conservators bring, it is useful to remember that conservators are fundamentally trained to assess risk over time. Within time-based media conservation, the dependence on particular technologies presents a very specific magnifying factor, namely obsolescence. In a paper published in 2007 regarding software obsolescence for military and aviation systems, the author identifies three types of software obsolescence: functional, technological, and logistical (Sandborn 2007). Functional obsolescence refers to obsolescence prompted by a change in hardware or another piece of software within the system. Technological obsolescence is when support ceases – for commercial software, this often coincides with the termination of security patches. Finally, logistical obsolescence is when the means of distributing the software is no longer supported or the software used to build, test, and integrate the software is no longer supported, making it difficult to port to a different technology (Bartels et al. 2012). Sandborn states that the most challenging software obsolescence management project is often found at the interfaces between the applications, operating system, and drivers where work has to be done on each specific system to ensure that the complete system operates effectively. In the case of a technology-based artwork, if a part of the system fails and is obsolete, then this will make the ability to repair the fault and recover from the failure far harder. As Patricia Falcão wrote in her MA thesis on risk assessment in software-based art: "Obsolescence is one of the main magnifying factors affecting software-based artworks. Unlike other types of magnifying factors that tend to be constant over time (or until action is taken) the effect of obsolescence actually increases over time" (Falcão 2010: 27). Whilst all time-based media works of art are dependent on their underlying technologies, for software-based works, the boundaries between the technological infrastructures that underpin the work and those elements that are to be preserved as part of the artwork are sometimes difficult to distinguish. The dependencies of the work are less transparent than for traditional time-based works and often the technological context changes more rapidly than in traditional areas of media arts because of the lack of a requirement for manufacturing. The diffuse nature of software-based artworks and the systems of which they are made mean that obsolescence is often more difficult to monitor than in traditional time-based media works of art and the risk of failure in these works is harder to predict.

Because of the complexity involved in predicting failure in some software-based artworks, display is a useful conservation strategy. It is widely recognised that unlike traditional objects, the relationship between conservation and display for software-based works is reversed. Whereas for traditional fine art objects, display means exposure to agents of deterioration such as light, physical wear and tear, or fluctuating humidity, for software-based artworks, display helps to conserve the work. Although it is no substitute for a proactive conservation plan, regular display creates an opportunity to ensure that everything is running properly and to

deal with any changes in the software and hardware as they occur, and before such changes create failures that are difficult to recover from. One of the tasks central to the conservation of software-based artworks is the practice of monitoring particular file formats or technologies for obsolescence. Because of the difficulty of doing this effectively, frequent display or testing of the system is very useful. Unfortunately, for gallery-based works, this can be difficult; however, many web-based works have the benefit of being on constant display online and hence any problems with broken links or failures of plug-ins can be picked up and dealt with immediately, just as one might maintain any website. An example is *adaweb* (http://adaweb.walkerart.org/ home.shtml), a site designed to bring contemporary artists into contact with users of the Internet and which is hosted by the Walker Art Gallery and has been online since 1995. Despite its age, the fact that it has always been online and maintained has meant that it is still accessible and functioning well. In museum terms, it is of course notable that a site that is not yet 20 years old is considered aged.

Expertise

Software-based artworks have demanded different collaborations both within and outside the museum. Just as in recent years the value of communication and collaborative working between those responsible for the environmental conditions within the galleries and those responsible for the museum collections has been recognized, so too are we seeing an increased recognition of the importance of collaborative working between those responsible for digital storage and the information infrastructure within the museum and those responsible for digital collections. Also significant is the access of the arts community to the larger archive community. Whilst artworks are often far more complex than the majority of objects in digital repositories, much can be learnt from the approaches that have been taken with regard to managing storage and the expertise in preservation within these digital repositories.

For any artwork there exists a network of those who can support the technical needs of that work. This is particularly apparent for time-based works where the essential support network extends to laboratories, artists, artists' technicians, hardware manufacturers, and retired individuals whose rare skills are no longer as highly valued commercially as they are by the art world. However, for software-based works, often the skills we need belong to younger generations and it has proved difficult to interest this generation directly in questions of conservation. As Rokeby noted in an interview for the *New Media Art Network on Authenticity and Performativity*, artist's code is often "gnarly" (Dipple 2011). It is not written in the same way as a commercial piece of code might be constructed. The challenge is therefore to find those who have the skills and also the empathy, patience, and sensitivity to work with an artist's material.

In this new environment, the role of translator between these different areas of expertise is emerging, although where this role sits will depend on the specifics of different institutions. Conservators of software-based works will need to learn

how to access the mechanisms for community support that already exist around software and gaming, and find ways to build and maintain these networks.

Within the project *Matters in Media Art*, it has also been recognized that some of the traditional analytical strategies within conservation are ineffectual when dealing with these complex artworks. Hence, within this project, we are experimenting with drawing, in a looser way, on the expertise within the small community that is engaged in the conservation of software-based artworks to help develop strategies in the conservation of software-based artworks. The types of things that emerge from this community are often common-sense ways in which the museum can engage with these works – for example, relating to documentation and a growing awareness of what it is that is important to secure when a work enters a collection. However, there is another level of engagement needed, a deeper technical familiarity with specific computer languages and platforms that are often specific to a particular work. Here the artist and the programmer may be able to provide the first layer in a support network for a work, but we need to also grow these networks, which means finding ways to reach out to communities we have not accessed in the past.

Conclusion

At the beginning of this chapter I described a taxi ride with a colleague who expressed the view that the reason that software-based artworks were not collected in larger numbers was a sense of their riskiness in terms of conservation. In this chapter I have considered the question of whether the conservation of software-based artworks differs significantly from traditional time-based media works of art. Whilst there are many areas of similarity in the conservation of traditional time-based media works of art and software-based artworks, particularly in the processes used within the museum to identify the value and significance of particular components and properties, this chapter has argued that there are two distinct areas where software-based artworks present specific challenges in their conservation. The first is in the way in which software-based artworks "do something" and the second is in the "diffusivity" of software-based artworks, as defined by Ceci Moss (2010), both in terms of dependencies and their potentially distributed nature. But perhaps these properties alone do not fully explain the nervousness expressed. However, add to these the speed of change in the technological environment underpinning software-based artworks and the need to reach out to an unprofessionalized expert community that the museum has yet to build a relationship with and perhaps the sense of unease becomes clearer. There seems a general move towards performative or participatory artistic practices that demand greater and often deeper ongoing engagement by the museum. For this to be sustainable, what may be required is a shift which acknowledges our dependency on new networks and communities in order to sustain a broad range of artworks; how we enlist the support of these communities may require different ways of operating for the museum, something which may well be invigorating, but will also inevitably bring with it a degree of anxiety.

Appendix 1:
Significant Properties

In a meeting held as part of the AHRC research network *New Media Art Network on Authenticity and Performativity*, we specifically looked to map the significant properties of networked art. However, these properties are in fact applicable to the exploration of all time-based media works of art.

Areas of Focus for Significant Properties for Software-Based Art that Equally Apply to Traditional Time-Based Media Works of Art

Content and Assets

Both traditional time-based media works of art and software-based works share significant properties associated with content and assets. This might be video, audio, animation, graphics, images, or text.

Appearance

Significant properties associated with the appearance of the artwork are common across old and new media artworks. Although appearance can include non-visual properties, the visual remains dominant, with display being a defining characteristic of the fine art museum. Properties associated with appearance include layout, color, resolution, design, and whether a work is representational or abstract.

Context

This might be social, cultural, political, technical, or artistic.

Other Versions

Does the work exist in other versions? This may include editions of the work but also installations, events, workshops, websites, or other forms of publishing. Are these different versions considered as different moments in the development of the work or as different works?

Formal and Structural Elements

What are the formal and structural elements of the work? This might include code, databases, navigation, architectural elements, or a performative element.

Behavior

How does the work behave or respond? Are there generative elements? Does the work involve on-off interaction? Does it involve linear playback? Does it have a static or dynamic default state? Does it replicate, appropriate, accumulate, or transform material?

Time

What are the different ways in which time operates in the work? What is the duration of an encounter? What are the durations of the different processes involved? Does the piece have start and end times? What is the pace of the work? And how is that determined?

Areas of Focus for Significant Properties for Software-Based Art that are Distinct in a Significant Way from Traditional Time-Based Media Works of Art

What are the Spatial or Environmental Parameters of a Work?

This relates to where physically or virtually the work resides – for example, is it screen-based or presented within a browser window? Is it embedded within a social networking site, connected over the Internet? Is it installed within a gallery or does it relate to a particular geographic location? Is it staged live? This might also include any acoustic or lighting conditions for the work, as well as whether there are any scale requirements that need to be maintained or architectural elements which are important to the piece. Unlike the majority of time-based works, those software-based works which exist in distributed networks such as the Internet can exist in real time beyond the gallery walls and can also always be on and always accessible.

External Links or Dependencies

Does the work contain any external links or dependencies? This might include links to websites or data sets, live events or sculptural components, or interfaces. It might also refer to technical dependencies such as web browsers, plug-ins, codices, software or hardware, or human action or intervention. Whilst all technology works are dependent on technology, for software-based works, the boundaries between the technological infrastructure that underpins the work and the content in terms of media are blurred. The dependencies of the work are less transparent than for analog works and often the technological context changes more rapidly given the lack of a requirement for manufacturing.

Function

What is the work designed to do? Does it analyze data or create visualizations? Does it retrieve and select information or sense presence, record events, produce, or animate content or translate? The majority of more traditional time-based works are based on linear playback, whereas there is something inherently transformative about many software-based works.

Processes

What are the processes that are enacted by the work? For example, does it gather data or compute data and is it made up of participatory events?

Artist's Documentation of Process

What type of documentation has the artist produced related to the work, for example, photographic, audio, video, written, manuals, diagrams, or contact information? What is the status of this documentation? What is its relationship to the work? How does this change over the life of the work? The increased significance of the documentation of the process is also visible in participatory performance-based art.

Rules of Engagement

Are there any particular rules that need to be followed in order to engage with the work? This might include permissions or instructions or also might refer to a reliance on cultural or social patterns of behavior.

Visitor Experience

How are people intended to interact with the work? How do people interact with the work? This might include their ability to contribute. The philosopher Dominic Lopes has identified interactivity as the defining feature of what he would call "computer art" (Lopes 2010).

Legal Frameworks

Does the work incorporate third party copyright? Who owns the domain name? Does the piece include reusable content? Is the work dependent on any particular software licenses to run?

References

Baltan Laboratories. 2012. "Collecting and Presenting Born Digital Art: A Matter of Translation and (Historical) Knowledge." Discussion workshop, Baltan Laboratories, Eindhoven, December 14–15, 2012.

Bartels, Bjoern, Ulrich Ermel, Peter Sandborn, and Michael G. Pecht. 2012. *Strategies to the Prediction, Mitigation and Management of Product Obsolescence.* New York: Wiley.

Coddington, James. 1999. "The Case against Amnesia," in *Mortality Immortality?: The Legacy of 20th-Century Art*, edited by Miguel Angel Corzo. Los Angeles: Getty Conservation Institute, 19–24.

Collingwood, R.G. 1938. *The Principles of Art.* Oxford: Clarendon Press.

Craig-Martin, Michael. 2010. Unpublished conservation Interview with Pip Laurenson, Patricia Falcão, Daniel Jackson. London: Tate.

Croce, Benedetto. 1922. *Aesthetic as Science of Expression and General Linguistic*, 2nd edn. Translated from Italian by Douglas Ainslie. London: Macmillan and Co. Ltd.

Davies, David. 2004. *Art as Performance.* Oxford: Blackwell.

Davies, Stephen. 2001. *Musical Works and Performances: A Philosophical Exploration.* Oxford: Clarendon Press.

Dietz, Steve. 2000. "Why Have There Been No Great Net Artists?" Available at: http://www.walkerart.org/archive/5/B473851A45B7748A6161.htm [accessed 14 October 2013].

Dipple, Kelli. 2010. *Final Report for the New Media Art Network on Authenticity and Performativity.* London: Tate.

Dipple, Kelli. 2011. "David Rokeby on Interactive Media," *Tate Media.* Available at: http://www.tate.org.uk/context-comment/video/david-rokeby-on-interactive-media [accessed 14 October 2013].

Falcão, Patricia. 2010. "Developing a Risk Assessment Tool for the Conservation of Software-Based Artworks." MA thesis, BFH, Hochschule der Künste Bern (HKB).

Fino-Radin, Ben. 2011. "Digital Preservation Practices and the Rhizome ArtBase." Available at: http://media.rhizome.org/artbase/documents/Digital-Preservation-Practices-and-the-Rhizome-ArtBase.pdf [accessed 14 October 2013].

Grace, Stephen, Gareth Knight, and Lynne Montague. 2009. *InSPECT Final Report.* King's College, London. Available at: http://www.significant properties.org.uk/inspect-finalreport.pdf [accessed 14 October 2013].

Greenberg, Clement. 1961. *Art and Culture: Critical Essays.* Boston: Beacon Press.

Guttenbrunner, Mark, Christoph Becker, Andreas Rauber, and Vienna Carmen Kehrberg. 2008. "Evaluating Strategies for the Preservation of Console Video Games." Paper presented at the international Conference on Preservation of Digital Objects (iPRES), Vienna University of Technology, Austria, iPRES.

Laurenson, Pip. 2005. "The Management of Display Equipment in Time-Based Media Installations," in *Tate Papers*, Spring. Available at: http://www.tate.org. uk/download/file/fid/7344 [accessed 14 October 2013].

Laurenson, Pip. 2006. "Authenticity, Change and Loss in the Conservation of Time-Based Media Installations," in *Tate Papers*, Summer. Available at: http:// www.tate.org.uk/download/file/fid/7401 [accessed 14 October 2013].

Laurenson, Pip. 2009. "Vulnerabilities and Contingencies in Film and Video Art," in *Film and Video Art*, edited by Stuart Comer. London: Tate Publishing, 145–51.

Laurenson, Pip. 2013. "Emerging Institutional Models and Notions of Expertise for the Conservation of Time-Based Media Works of Art." *Techne*, 37.

Lessing, Gotthold Ephraim (translated by E. Allen McCormick). [1766] 1984. *Laocoon: An Essay on the Limits of Painting and Poetry*. Baltimore: Johns Hopkins University Press.

Lopes, Dominic. 2009. *A Philosophy of Computer Art*. London: Routledge.

Margolis, Joseph. 1980. *Art and Philosophy*. Brighton: Harvester Press.

Martinat Mendoza, Jose Carlos. 2010. Unpublished conservation interview with Patricia Falcão. London: Tate.

Moss, Ceci. 2010. "The Diffusion of Current Internet-Based Art and the Problem of the Archive." Master's thesis, New York University.

Paul, Christiane. 2001 Re: FEED Article – The Demise of Digital Art in *New-Media-Curating Discussion List*, 29 March. Available at: http://www.jiscmail. ac.uk/lists/new-media-curating.html [accessed 14 October 2013].

Sandborn, Peter. 2007. "Software Obsolescence – Complicating the Part and Technology Obsolescence Management Problem." *IEEE Trans on Components and Packaging Technologies*, 30(4), 886–8.

Torch Computers. "Computers for Art." Available at: http://shop.torchcomputers. co.uk/information.php?info_id=14 [accessed 14 October 2013].

Wollheim, Richard. 1968. *Art and its Objects. An Introduction to Aesthetics*. New York: Harper & Row.

Chapter 4

Self-Collection, Self-Exhibition?
Rhizome and the New Museum

Heather Corcoran and Beryl Graham

Introduction

Rhizome's ArtBase is one of the largest and longest-running online collections of self-submitted artworks. Rhizome has also had a long-running relationship with the New Museum in New York and so has also exhibited works in physical spaces.

This combination of the online and the physical relates to many aspects of Rhizome's work. The preservation strategies of ArtBase are well developed (Fino-Radin 2011; Rinehart 2002; Smith 2008) and obviously affect what can be collected – as Ben Fino-Radin, Digital Conservator at Rhizome, states: "While the ArtBase cannot currently support a physical collection, there are certainly elements of variable media that can be archived and preserved for restoration in the future" (Fino-Radin 2011: 13).

The relationship with the physical space of the New Museum means that the museum has had to understand new media in various ways. For example, the exhibition *Unmonumental: The Object in the 21st Century* in 2007–8, was curated by New Museum curators Richard Flood, Massimiliano Gioni, and Laura Hoptman in three sequential parts, and the last part, "The Sound of Things: Unmonumental Audio," was designed to coincide with the online exhibition *Montage: Unmonumental Online* (February 15, 2008–March 30, 2008) at http://rhizome.org/exhibitions/montage-unmonumental-online. Online elements were in this way integrated by wider considerations of objecthood in contemporary art. Since 2012, the New Museum website has featured *First Look: New Art Online*, which is a monthly series of innovative online projects and new commissions curated by Lauren Cornell, who was Executive Director of Rhizome from 2005 and in 2012 became adjunct curator at the New Museum. *First Look* highlights one artist's work per month, often features emerging artists, and includes interpretative material and a link to the artwork's URL.

Because conservation at Rhizome is already covered by existing publications, this chapter therefore builds on the existing analysis of Rhizome's ArtBase collection and goes on to consider audiences both for the online collection and physical exhibitions related to Rhizome and the New Museum. It takes the form of written questions asked by Beryl Graham and replies written by Heather Corcoran, Executive Director of Rhizome, in consultation with Ben Fino-Radin.

ArtBase as a Collection

BG: Rhizome's ArtBase is an online collection/archive of art, with more than 2,000 artworks included since 1991. I'm particularly interested in how the artists and the audience play more active roles than might be usual in other kinds of art. Submission of works, for example, is open to all artists, but Rhizome curators do select works from the submission. Could you describe how this selection process works?

HC: Ben Fino-Radin acts as the main filter for ArtBase submissions. When works are submitted, he checks them first and foremost to discard submissions that fall outside our collection scope – works that don't engage with technology culture or that aren't artworks. Second, he considers whether the work is engaging, challenging, or of particular social or historic value in the context of our collection. Finally, he considers what we can feasibly commit to stewarding in the long term – each selection is a commitment to caring for the piece, which takes resources, and some great works would just be too difficult for us to conserve.

ArtBase was open submission, and largely unfiltered, until the mid-2000s. They filtered for relevance, not for quality – so only new media art, but all new media art. Art that didn't involve new media would be rejected, as would new media that wasn't art. Mark Tribe explained the rationale to me as this: philosophically, they were opposed to filtering for quality because they felt they might end up rejecting works that would later be deemed important. Especially in the early years of this new art form, it seemed arrogant to them to assume they had an objective sense of what would be historically significant. That is also why they framed it as an archive rather than as a collection.

Inversely, we can now filter and curate the ArtBase because as our field has matured we are able to judge which works are and will be significant, in terms of their contribution to the field and culture more broadly. And of course this is a good thing, as we could never dedicate the resources needed to archive all the works that come through now. So the growth of the field necessitates the filtering, but also gives us the knowledge and the insight necessary to do it. There is still a good range of artwork on ArtBase, including different kinds of new media, such as Richard Vijgen's *The Deleted City* from 2011, which is an interactive visualisation of the 650 gigabyte Geocities backup made by the Archive Team on October 27, 2009. It depicts the file system as a city map, and plays nearby MIDI files whilst browsing.

BG: Since 2010 people viewing the collection online can also select from the collection to make "ArtBase Member Exhibitions" pages. About 240 of these pages are viewable currently on the site, typically have around 12 artworks selected, and range from artists selecting their own artworks to themed exhibitions. As a curator yourself, what is your opinion on these exhibitions and do you have information of what kind of online audiences view these exhibitions?

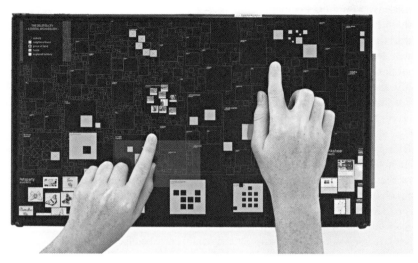

Figure 4.1 Installation shot from Richard Vijgen's *The Deleted City*, 2011. Image courtesy of the artist

HC: When the website was relaunched, I think it was important to Nick Hasty, Rhizome's Director of Technology at the time, and Lauren Cornell for it to reflect the new, more engaged ways that people were interacting on the web. The concept of curation on the web – not just art, but images, music, texts – was also rising to public prominence as a concept. Web users were becoming more comfortable and even expecting to be able to act as a kind of "curator." The ArtBase was growing and it was clear that Rhizome needed to find new ways for people to explore and experience it.

That is to give some context when I say that I think the value of Member Exhibitions lies in the process of putting them together – of exploring works in the ArtBase and using the exhibition as an educational, research, or learning tool. We know of several professors who have assigned the task of curating a Member Exhibition to their students, or seed-stage curators who are testing out what it is like to think about work in a curatorial way for the first time. So for that reason I think the most important audiences for those exhibitions and that feature are the Members themselves. But we do keep an eye on them, and our site visitors do see those pages, and sometimes you get stuff that is really interesting and surprising.

BG: Since 2012, Rhizome curators have also offered their own "Collections" from ArtBase: Formalism & Glitch; Code; Digital Archivalism; Tactical Media; Net.art and Hypertext; and Rendered Reality. Who selected these themes and why?

HC: Ben selected these themes to highlight trends and themes he found apparent in the ArtBase, for the purpose of providing more entry points, access, and context for

those who might not be familiar with the history of such creative practices. He chose them based on topics that he saw coming up frequently in the ArtBase itself – so starting with the artwork and looking at what kinds of stories it was telling, rather than trying to come up with categories that could act as a more fixed container for all possible work that may come in. I hope in this way that they read as just one set of collections rather than fixed categories – unlike the metadata categories that we use, like medium, artist name, technology type, et cetera, the collection's categories aren't fixed to the artworks themselves. They will probably change over time.

BG: Since the early days of ArtBase, artists submitting works have also chosen their own keywords, which can help to form a "folksonomy" of categories of art rather than a taxonomy more usually developed by curators. In 2007, an ArtBase folksonomy appeared alongside a keyword list developed by a group of experts. To quote Ward Smith on ArtBase's *Challenges for the Cataloging of New Media Art*:

> Tagging can generate basic recall terms. It can often lack precision, though, and only be useful for personal use. Alternatives, or modified practices like 'expert tagging' may be better in terms of accuracy (though it may also reflect debates within a field of study and still lack precision), but may not be useful for the general audience in terms of recall. Ultimately the so-called "wisdom of crowds" may not manifest beyond the most basic terms. Folksonomies can generate recall terms, but lack precision for satisfying the needs of expert communities. Faceted tags hold some promise for the disambiguation of homonyms, but as more complication is introduced into the process, familiar problems arise. Specifically, the need for expertise – not just in subject matter, but also in metadata – becomes increasingly necessary. Experiments with game contexts for describing images (for example, the Google image labeling game, http://images.google.com/imagelabeler) are interesting as a user interface and data collection method, but do not necessarily produce information that escapes the problems outlined above.
>
> Tagging strategies have been attempted as a way to catalog collections of New Media art. Rhizome.org's ArtBase, for example, has a large collection of works available to members online. Besides basic categories such as artist, date of creation, title of work, etc., Rhizome chose to let [each] artist describe their work with tags. Even with "expert tagging," however, search has become difficult because of the issues raised here earlier." (Smith 2008)

Could you describe the current position of ArtBase re tagging, keywords and who taxonomizes? Are audiences and artists still involved?

HC: Currently, artists can assign tags to the descriptive record of their work. This is augmented by tagging done by Rhizome's curatorial assistants, referring also to a collection of tags that have been deemed particularly useful and are given greater weight in search indexing.

Tags really are limited, however, and the issues raised by Ward are all salient. While the value of tagging in the context of museum collections is well established, we believe, through Ben's work and research, that this can't be the sole backbone of searchability and browsability. We are building a new management system for the ArtBase that introduces several new facets of findability, including work type (web, software, moving image, image, etc.), geolocation (birthplace of the artist), or materials/technologies (like browser version or operating system – information we currently have but isn't yet browseable), just to name a few. Tagging and folksonomies are, in 2012, completely standard features that have been debated in the information science community years ago in terms of their cost, benefit, and risk. So it is clear and proven that they are valuable. But our position is that they shouldn't be the backbone of cataloging and findability.

BG: Ben Fino-Radin (Owens 2012) describes ArtBase users as comprising primarily academics, and other artists, and he also describes some "popular" and perhaps more overlooked artworks. Who uses ArtBase and how?

HC: We don't have detailed usability reports on the ArtBase specifically, but anecdotally we can say a few different types of people use it. First, academics: students, professors, and researchers. They get in touch asking for more information on works or to interview us about pieces. They are using the ArtBase as a primary research tool for their research projects.

Second, curators: they use Rhizome more generally as a way to stay in touch with new artists working in the media arts field, and ArtBase in order to find works first-hand that they may include in their shows. We get them asking us for contacts for artists sometimes or for more info on a piece.

Third, artists: they use it wherever they need institutional affiliation, such as grant proposals or artist visa applications. They also use it to support or double up the archive efforts of their work, relieved they don't have to do it themselves, and send people to view the work on Rhizome.

Of course, we know that lots of general Rhizome site visitors also check out the ArtBase to explore this art form. Recently we've been posting images of works in the ArtBase to our Tumblr with link backs, and from this gained over 20,000 followers to our account in just over two months. So those people are viewing the ArtBase, with a different kind of entry point.

BG: Ben Fino-Radin has described how his role as Digital Conservator of an online collection of new media art has caused him to question the different roles of conservator, curator, and exhibitor (where the new media need to be both conserved as art media and understood as a means of exhibiting a collection) (Owens 2012). Would you agree from your own experience? Are there examples where you think this has worked particularly well?

HC: My own curatorial career has spanned different roles, yes, though from a slightly different perspective. I did a fine art degree with a specialization in New Media and learned a lot of hands-on technical skills – coding, electronics. I also started out working in organizations that had media lab cultures – InterAccess in Toronto, Space Media Arts in London, and to a lesser degree, FACT in Liverpool. Working hands-on with media artists was how I came to curating.

In the early part of my career as a curator I found myself drawing on these technical skills more frequently. In earlier days of new media, the early 2000s when I was starting out, I think it took a bit more familiarity with technologies to feel confident in putting them into an exhibition. On a very practical level, I can imagine it would have been daunting to approach an exhibition using technologies that you didn't really understand – to have to overcome that barrier as well as all the other tasks and thinking that goes into exhibition making – so my technical familiarity helped in that regard. I was more fearless of technology. Also, being able to facilitate a conversation between artist, installation technician, and myself as curator was made much easier by my level of knowledge – I could challenge things that people might say were impossible or make informed decisions. It also meant I was able to identify significant artworks, while they were still in the early production or idea formation stage – I could understand the significance of what artists were working on before they had the chance to articulate it outside of largely technical terms. Often I would hear about something interesting or see it in the lab and help them to articulate it in a more accessible or engaging way.

But I've seen this dual role change over time and I don't use specialist technical skills as much anymore. My role has become a more singular, curatorial one, as both artists and audiences are more interested in talking about technology culture in ways that don't necessarily involve presenting on complex technologies themselves. We – artists, audiences, curators – are all at a level of media fluency across the board that is pretty comfortable and reasonable with technology so woven into everyday life, different than five or 10 years ago. I'm not saying all our knowledge levels are the same, but the common denominator is pretty adequate for understanding this work, when it's communicating at its best. I feel the role I can play as a curator outside of the specialist technical process is a more valuable one – it keeps me a bit closer to the audience perspective and therefore the feedback is more likely to challenge an artist's thinking process in a useful way.

New Museum as Exhibition

BG: So, Rhizome has a collection (ArtBase), and the New Museum is explicitly *not* a collecting organization, as part of its concern with the contemporary. Can this be conceptually resolved?

HC: It's probably helpful at this point to explain the relationship between Rhizome and the New Museum. We are an affiliate organization, in that our office is at the

Museum, we share some administrative functions and services, and our staff is relatively integrated into the culture of the Museum itself. Yet we're independent – we have separate boards, separate mission statements, separate finances. This is to say that everything we do does not always have to be conceptually resolved with the New Museum's work – though of course generally, Rhizome's work does support the Museum's goals as an innovative, future-facing organization.

And yet I do think it can be resolved. The New Museum was founded as an organization challenging the very idea of a museum by focusing on the contemporary. That remains true today, but many other museums let alone galleries are also incorporating contemporary artists and practices into their work – everyone is chasing the contemporary. So the Museum looks at contemporaneity in other, deeper ways too – exhibition formats, archives, or museum relationships. The ArtBase sits well within that desire to examine the contemporary in all aspects of museum work. As a collection it is challenging the definition of what is a collectable object in a free and open web, and the practices and protocols that we are developing are really at the cutting edge of born digital art conservation. It sits well within the Museum's interest in innovation.

ArtBase artworks have been shown at the Museum – for example, Joel Holmberg's *Legendary Account*, where he asks unusual, profound, or existential questions in Yahoo! Answers to subvert the simple Q&A system, was shown in the *Free* exhibition. That piece is an interesting one for both the ArtBase and the New Museum gallery space, as it's essentially a performance work on the Yahoo! Answers platform. By nature it's quite ephemeral, as the questions he asked were only open for people to respond to for a limited time before they are resolved and become essentially documentation. The artist himself preserved it as a series of screen captures on his website, but when we took it into the ArtBase, we did a web archive (or "scrape") of it from Yahoo! Answers. Then in the Museum it was presented as a simple series of screen capture printouts, mounted on the wall. In some ways, seeing the screen captures on the artist's website and seeing the screen capture printouts in the gallery are not that different of an experience.

BG: In 2005, an early physical show from ArtBase was *ArtBase101*. In an interview with Caitlin Jones, Lauren Cornell talks about the challenges of translating into the physical, and how ArtBase systems such as contracts are aimed at facilitating physical and well as online exhibition (Jones 2006). Seven years later, are the issues similar?

HC: The issues are similar, but different. What has changed is that artists, curators, and audiences are more comfortable with the online/offline dynamic. People understand that projects can have iterations in both spheres and are more comfortable with each situation. A project can exist exclusively online, or can have an offline iteration, where people more readily understand the reasons why an artist or curator may want to bring a project into physical space – different contexts, prestige, economic models, different audiences, to express something new.

Figure 4.2 Screen capture of Joel Holmberg's *Legendary Account*, 2008–10, showing the page "How do you occupy space?" in "Military"

I always liked and agreed with this quotation by Olia Lialina, talking about the changes in audience perspectives over time:

> Yesterday for me as an artist it made sense only to talk to people in front of their computers, today I can easily imagine to apply to visitors in the gallery because in their majority they will just have gotten up from their computers. They have the necessary experience and understanding of the medium to get the ideas, jokes, enjoy the works and buy them. (Lialina 2007)

That is a difference between then and now – audiences. That affects how you can present work, whether that means less didactic material needed to understand the work or interfaces, which are more intuitive because they are more familiar.

BG: When selecting new media art for exhibitions, where do *you* look? Apart from ArtBase of course, do you look at other collections, festivals, online?

HC: I think a more interesting question would be where do all the Rhizome staff look, or how does Rhizome get its information about artists and works to feature online or in exhibitions? We're more and more becoming a gateway for wider contemporary art curators and audiences, or technology world audiences, to learn about our area of media art. So it's important that we're looking in the right places, or enough places, to represent the best of what is happening out there.

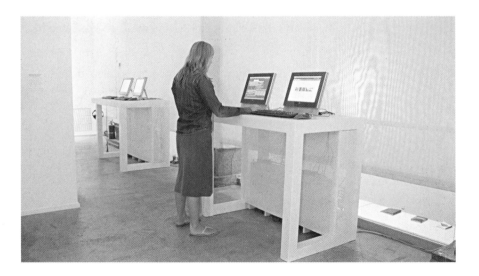

Figure 4.3 **Installation view of the *Artbase 101* exhibition at the New Museum, 2005. Image courtesy of the New Museum, New York**

Our staff is all highly engaged in online conversations, even more so than other media arts organizations I've worked with. It's the nature of being a primarily online organization, with that history and culture. We follow many artists or writers on Twitter and pay attention to conversations they're having with other people we might not follow yet; we watch what's happening on Tumblr with younger artists engaging with that platform's image language; there is a group for women net artists on Facebook set up by Kari Altmann that's kind of interesting, to give one example of a conversation on that platform. We've really inserted ourselves into these kinds of informal networked conversations happening around the Internet. Between the five of us, we spend a lot of time online and this deeply informs our culture and the artists we feature.

However, of course we need to be sure we've got enough diverse sources feeding in. I try to be sure to attend at least a couple of the European media art festivals every year – Transmediale, Ars Electronica, AND Festival, Futuresonic, Impakt. I attend contemporary art fairs and biennials to contextualize our work and advocate for our field. Traveling and conducting good old-fashioned studio visits helps. Talking or listening to other curators – for example, there is a curator named Samantha Culp, based in Hong Kong, whose writing I've been enjoying a lot lately and has kept me in the loop on some things happening in Asia. Checking out exhibitions from peer organizations, reading art magazines. I really just see as much as possible from as wide a pool as I can to augment the research we do online.

BG: New Museum has had exhibitions concerning technological history such as *Ghosts in the Machine* (Fino-Radin, Rhizome). Does this help a critical understanding of new media art? Does the New Museum make an exception in its contemporaneity for histories of technology?

HC: Again in terms of the New Museum's contemporaneity, their definition is expansive and challenging, not just about chasing the contemporary. There was a polemic position running through the *Ghosts in the Machine* show that does resonate strongly with the Museum's mission – to show artists who aren't often shown (in that case, because they are somewhat outsider to the art world) and to bring in new perspectives and new information. The show concentrated on positions in recent and contemporary art history that have not quite been represented mainstream historical narratives, such as o ptical or kinetic art. It is contemporary for that reason.

But yes I think it does help with a critical understanding of new media art. It's great to see our histories and pre-histories included in museum shows like that, and technology in art being discussed in terms of its impact on culture. The exhibition was decidedly pre-digital so perhaps didn't make the links as explicit as we would have to artists working today in Rhizome's networks. I am also slightly wary of what I perceive as a boom of interest in the kinetic and early computer art of the 1960s and 1970s, without a joined-up interest in contemporary practitioners working in this vein after 1970, pushing the edges of technology and examining technology culture.

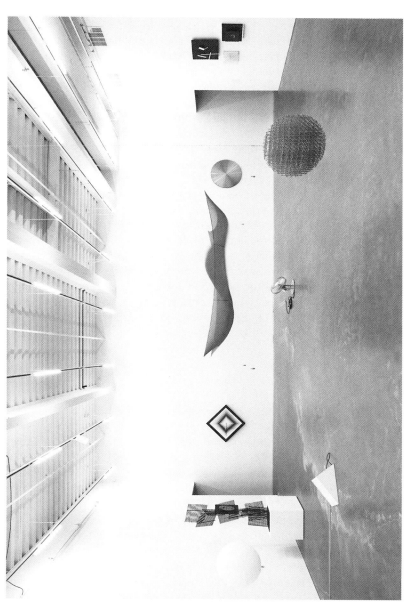

Figure 4.4 Installation view of the *Ghosts in the Machine* exhibition at the New Museum, 2012. Image courtesy of the New Museum, New York. Photograph by Benoît Pailley

I hope that new media artists don't have to be dead or finished with their careers in order to be understood. But shows like this do help public understanding of our field for sure.

BG: In some museums, including Tate, new media art has entered through "educational" departments. What has been the Rhizome experience at the New Museum in relation to this?

HC: Well, our office is on the same floor as the education department! I have deep respect for what they do, but we don't work with them often yet, except for some public programs and events coordination. We host a regular public program event at the Museum called *New Silent Series* and work with them to coordinate it. We also get their input on what programs work best for the Museum's audiences.

Our entry point to the Museum was with the Director, Lisa Phillips, who is quite active on our board, and our most prominent collaborations have been with the curatorial team, such as on the exhibitions mentioned previously and Lauren's work as adjunct curator while still at Rhizome. We also informally consult on exhibitions – for example, for their upcoming exhibition *NYC 1993*, the curators came to ask us what was happening in technology at that time and we happened to be working on a big project to conserve *The Thing BBS*, which of course originated in New York and was very active in that year. We facilitated its inclusion in the exhibition as we felt it was significant to the narrative they were creating.

References

Cornell, Lauren. 2011. "Down the Line. Technology: In the Nostalgia District." *Frieze*, September (141).

Fino-Radin, Ben. 2011. *Digital Preservation Practices and the Rhizome ArtBase*. New York: Rhizome.

Jones, Caitlin. 2006. "Conversation with Rhizome," in *EAI Online Resource Guide for Exhibiting, Collecting & Preserving Media Art*. Available at: http://www.eai.org/resourceguide [accessed 14 October 2013].

Lialina, Olia. 2007. "Flat Against the Wall." *art.telportacia*. Available at: http://art.teleportacia.org/observation/flat_against_the_wall [accessed 14 October 2013].

New Museum. 2007–8. *Unmonumental: The Object in the 21st Century* [exhibition]. Available at: http://archive.newmuseum.org/index.php/Detail/Occurrence/Show/occurrence_id/1509 [accessed 14 October 2013].

New Museum. 2012–. *First Look: New Art Online* [exhibition]. Available at: http://www.newmuseum.org/exhibitions/online [accessed 14 October 2013].

Owens, Trevor. 2012. "ArtBase and the Conservation and Exhibition of Born Digital Art: An Interview with Ben Fino-Radin." *The Signal: Digital Preservation*, May 1. Available at: http://blogs.loc.gov/digitalpreservation/2012/05/artbase-and-the-conservation-and-exhibition-of-born-digital-art-an-interview-with-ben-fino-radin [accessed 14 October 2013].

Rinehart, Richard. 2002. "Preserving the Rhizome ArtBase." Available at: http://archive.rhizome.org:8080/artbase/preserving-the-rhizome-artbase-richard-rinehart [accessed 14 October 2013].

Smith, Ward. 2008. "Research Issue: Challenges for the Cataloging of New Media Art." Available at: http://rhizome.org/artbase/about [accessed 14 October 2013].

Whitewall. 2009. "New Museum's Lauren Cornell." May 6. Available at: http://www.whitewallmag.com/2009/05/06/lauren-cornell-adjunct-curator-at-the-new-museum-speaks-with-wws-sascha-crasnow [accessed 14 October 2013].

Chapter 5

From Exhibition to Collection:
Harris Museum and Art Gallery, Preston

Lindsay Taylor

The Harris is a municipal museum and art gallery, which opened to the public in 1893. The neoclassical Grade 1 listed building houses significant permanent collections of fine and decorative art and local history, and offers a contemporary visual art program in the large temporary exhibition galleries. In 2011, the Harris presented *Current: An Experiment in Collecting Digital Art*, a collaboration with the digital arts organization folly. The project was created as a practical case study for the collection and integration of digital artworks into existing museum collections.

Current was developed as a response to artistic, political, and funding issues affecting the wider visual arts sector, and also occurred at a pivotal point in the history of both organizations. During the project, the importance became clear of the continual development of strong relationships between artists, individuals, and organizations, and a desire to work collaboratively to benefit the sector and engage the public. It is therefore a case study intended to demonstrate how working in collaboration, a medium-sized, regional local authority museum and gallery has the potential to impact on sector developments, whilst delivering public-facing programs that are accessible to wide audiences. However, first it is necessary to rewind to consider and to understand the background context of the organization.

Background and History

The intentions concerning collections and audiences can be seen from the very origins of Harris Museum and Art Gallery. It is a grand building that reflects the ambitions of the town in the Victorian era; the scale of the building far surpassed the size of the town as it was then. In line with the philanthropic attitudes of the time, the Museum and Art Gallery were for the benefit of the public and there is an inscription in the stone of the building, which although written in traditional language remains apt today: "The mental riches you may here acquire abide with you always."

Today, Preston has changed significantly, gaining city status in 2002, but audiences continue to remain at the heart of the Harris. Over the last 25 years, the Museum has gained a reputation for its ambitious and high-quality contemporary visual art program, which complements the permanent historic collections.

In the early 1990s, support and investment from Arts Council England's "Glory of the Garden" scheme and the Contemporary Art Society's "Special Collection Scheme" enabled the parallel development of the contemporary art exhibition program and the collecting of contemporary artworks, including a particularly strong British photography collection including Hannah Starkey, Keith Arnatt, Boyd Webb, and Helen Chadwick.

At around the same time, Preston Polytechnic was expanding to become the University of Central Lancashire (UCLan) and a strong mutually beneficial relationship developed between its Department of Fine Art and the Harris.

Of course, the Harris has acquired artwork contemporary to the time throughout its history, with curators regularly purchasing work from the Royal Academy summer shows until the 1960s. Many of these works have become local favorites, such as the 1944 *Pauline in the Yellow Dress* by Sir James Gunn. The Harris has also been a member of the Contemporary Art Society since 1910, which encouraged a more robust approach to collecting "avant-garde" work – from an early 1949 Lucian Freud painting *Still Life with Squid and Sea Urchin* acquired in 1952 to Lucy Gunning's *Climbing Round My Room* dated 1993 and gifted to the Harris in 2000. This was the first moving-image piece to enter the Harris collection.

A critical element in the development of contemporary programming at the Harris has been the relationship with UCLan. Artists including Professor Lubaina Himid MBE, Professor Christopher Meigh-Andrews, Professor Charles Quick, and others started teaching Fine Art at UCLan in the 1990s, forming strong relations with staff at the Harris which resulted in collaborative exhibitions, projects, conferences, and research opportunities. Most relevant within the context of influencing exhibiting and collecting new media is the relationship with Christopher Meigh-Andrews and the Electronic and Digital Art Unit. In 2001, Meigh-Andrews and the Harris Exhibitions Team conceived *Digital Aesthetic*, a relatively small-scale exhibition, conference, and website. Amongst others, it included the pioneering artists Steina and Woody Vasulka and, via a (patchy) video link from New Zealand, Sean Cubitt.

The context of the historic building and museum collections provided an interesting facet to the exhibition – different from presentations in a purpose-built white cube or black box space. Furthermore, *Digital Aesthetic* demonstrated that specialist audiences would travel nationally and internationally to see this type of exhibition, raising the profile of the Harris, UCLan, and the city, but crucially there was also a local, more general appetite for digital artwork.

The project was considered so successful that a second version was developed for spring 2007. *Digital Aesthetic 2* was more ambitious and international in outlook, and with financial support from Arts Council England included newly commissioned work by boredomresearch (*Wish (Edition no 2)* developed with folly), Bill Seaman (USA), Simon Blackmore (UK), and eBoy (Germany), existing work by Gary Hill (USA), Robert Cahen (France), and Thomson and Craighead (UK), and speakers including Sean Cubitt (Australia), David Garcia (the Netherlands), and Lori Zippay (USA). The exhibition included interventions

around the building, plus offsite venues including UCLan and Preston Minster – encouraging audiences that wouldn't normally engage with contemporary art to attend. At this time, museums were benefiting from "Renaissance in the Regions" funding, which, in this instance, particularly enabled some audience development and access work around the project – examples include digi_club workshops for teenagers run by folly, and basic ICT training offered to the Harris Community Consultation Group and subsequent talks and discussions in the exhibition.

Steina and Woody Vasulka also contributed to *Digital Aesthetic 2*, with Steina performing on the opening night. Later that evening at the conference dinner, an informal conversation took place that proved instrumental in informing the thinking about collecting contemporary art and specifically new media at the Harris. At that time Steina and Woody were based at ZKM in Germany documenting their vast back catalog of work. In conversation it became clear that two of the twentieth century's most pioneering artists were heading toward the end of their careers with very little of their work in museum collections.

The background and history of collecting new media art at the Harris can be seen to have slowly built local audiences for media art through integrating the exhibition of new artwork with talks, events, and workshops aimed at engaging different communities, coupled with a growing personal concern for the historicizing of current international art through museum collecting.

The Catalyst for Collecting

In summer 2007 the Art Fund launched a funding initiative to encourage UK museums and galleries to build outstanding collections of international contemporary art. At that time the Harris was showing digital work by Ori Gersht and Julian Opie as part of a group show called *Static: Contemporary Still Life and Portraiture* and was planning the installation of a major international co-commission with Turkish artist Kutluğ Ataman. *Paradise* had premiered at the Orange County Museum of Art in the USA and was due to be presented in Preston with two other installations in January 2008.

The earlier conversation over dinner with Steina and Woody sparked an idea.

An application was submitted to the Art Fund International scheme with a view to developing a collection of international new media art. The application reached the final shortlist, although ultimately it was unsuccessful. However, the process of getting to the final shortlist had involved consultation with a wide group of regional artists and arts organizations such as FACT (Foundation for Art and Creative Technology) in Liverpool and folly. The cross-sector consultation presented clear evidence that there was an urgent need to address the issues of collecting new media, with or without Art Fund backing. As a result, in 2008 Arts Council England supported the Harris with further funding to scope out and develop a collecting new media policy to sit as an appendix to the Harris Collections Development Policy, which was in the process of being revised.

The Collections Development Policy outlines potential areas for collecting for all disciplines within the Harris, including looking for opportunities to fill gaps in the historic collections. The scoping process for the collecting new media policy was important in that it developed a wider network of expertise to draw on and raised further awareness of issues and barriers to collecting ephemeral work. Significantly, it also developed thinking about the relationship of the contemporary art exhibitions and the long-term legacy of this program in terms of collecting. Of course, the Harris does not claim to be the only museum to be collecting new media work at this time, but significantly was a regional local authority-run organization that wanted to consider and address the issues.

Many museums and galleries were happy to exhibit moving-image and new media artwork; however, the barriers to collecting the work permanently included the following:

- Appropriate space for permanent display – some but not all new media relies on a large area of wall and darkened space for projections. This is easy to accommodate on a temporary basis, but is difficult to incorporate in a "traditional" fine art gallery hung with historic paintings and sculpture.
- Cost – there are concerns regarding the cost of acquiring and maintaining display equipment, particularly if the equipment is expensive or specific to an artwork.
- Conservation – there are concerns regarding the "future proofing" of work – that is, maintaining or upgrading technical knowledge/ability and software/ hardware.
- Storage – lack of knowledge about how and where to best store artwork.
- Definitions – there were concerns regarding editions (some are not unique objects, but this is hardly different to prints or cast sculpture) and how to define the work on collection management systems that did not recognize terminology.

This work was led by the Exhibitions Officer, who had the knowledge of contemporary art, supported by the Fine Art Curator, who had a stronger knowledge of historic painting and sculpture. It is important here to mention that, historically, the job titles and staff structures in local authority-run organizations don't necessarily accurately represent responsibilities or lend themselves to contemporary collecting. The evidence presented here is anecdotal; however, it would be an interesting area to research further. At the Harris, the Exhibitions Officer is interested in pushing boundaries, challenging artists and audiences, developing ambitious exhibitions, and bringing the latest in artistic practice to Preston. The Fine Art Curator, however, has a responsibility to care for a vast historic collection and knows that in future this will be judged by any new acquisitions made during his or her custodianship.

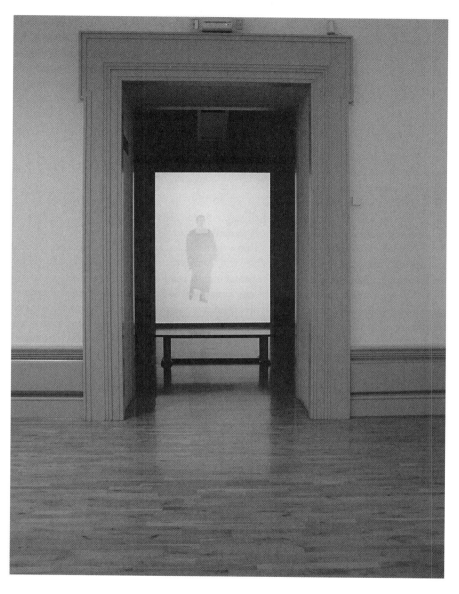

Figure 5.1 **Robert Cahen's *Traverses*, 2002, in the *Digital Aesthetic 2* exhibition, 2007, at Harris Museum and Art Gallery. Image courtesy of the artist © Harris Museum and Art Gallery**

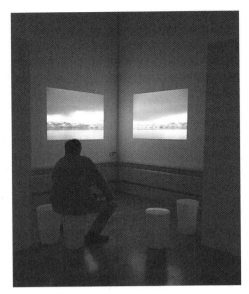

**Figure 5.2 Robert Cahen's installation *Paysages d'Hiver*, 2005, in the
 exhibition *Passages*, 2009, at Harris Museum and Art Gallery.
 Image courtesy of the artist © Harris Museum and Art Gallery**

The research acknowledges the detailed work undertaken by Tate and other
international partners called *Matters in Media Art* (New Art Trust 2005–), which
recommends dialog with artists about preserving the artwork for the future. As
the Exhibitions Officer routinely works with artists on planning an exhibition,
this inevitably means a relationship has already developed between artist and
curator, which in turn enables improved communication and documentation of an
acquisition process.

During the research period for the Collecting New Media Policy, the exhibitions
program continued with *Passages*, the first British solo show by pioneering
French video artist Robert Cahen. Cahen was invited to stage a solo show after
the popularity with audiences of his single-screen projection *Traverses* (2002) in
the *Digital Aesthetic 2* exhibition. *Passages* presented work from over 25 years
of his practice, including two large video installations and new piece made in
collaboration with Guido Nussbaum.

Visitors responded thoughtfully to the exhibition in the comments book, with
responses such as:

"The Robert Cahen videos were like moving watercolours – absolutely brilliant."

"Robert Cahen exhibition – amazing! Beautiful. Best contemporary exhibition
I've seen in years."

"Robert Cahen exhibition/installation inspiring, absorbing and thought provoking. A sensory experience well worth a second visit."

This exhibition coincided with the reinvigorated Acquisitions Scheme of the Contemporary Art Society (CAS), which in 2009 had a specific focus on moving image artwork. As such, *Traverses* was acquired for the Harris, partially funded by the CAS scheme, with the remainder coming from the very modest Harris Acquisitions Fund. Respecting the ambitions of the Museum and the relationship developed between Cahen and the staff during the planning and installation of the exhibition, the artist generously offered to gift a second work to the Museum. Through discussion with curatorial staff, front-of-house staff (who reported back on visitor engagement), and the artist, the double-screen installation *Paysages d'Hiver* (2005) was selected. These were the first acquisitions made directly as a result of the Collecting New Media Policy.

Building Relationships

folly, a digital arts organization based in Lancaster, was one of the stakeholders interviewed as part of the consultation process for the Art Fund International initiative. It was an organization that worked in partnership with cultural and non-cultural organizations across the UK to deliver an artistic program using technology that engaged artists and the wider community. Successful projects include *Portable Pixel Playground*, *Digital Artists Handbook*, and most recently as founding partners of the Abandon Normal Devices (AND) Festival with FACT in Liverpool and Cornerhouse in Manchester.

folly had been invited to manage a co-commission for the *Digital Aesthetic 2* exhibition – boredomresearch's online artwork *Wish (Edition no 2)*. Through the successful delivery of the co-commission, a strong working relationship between the organizations developed, particularly between Creative Director Kathryn Lambert and Exhibitions Officer Lindsay Taylor. As partners in the establishment of the AND Festival, folly led the program across Lancashire and Cumbria, providing a further opportunity for collaboration; the Harris presented an exhibition of new work by British artist Simon Faithfull, and for the opening included a site-specific performance of *Fake Moon* on top of Preston Bus Station car park, much to the bemusement and interest of visitors to the local bingo hall and drivers on the ring road. Reaching new and different audiences remains a priority for many cultural organizations. folly engaged with an online audience through its website, and *In Certain Places*, a further collaboration between the Harris and UCLan, presents a programme of public realm projects and events that examine how artists can contribute to the development of the city of Preston (www.incertainplaces.org). Following further discussions, the Harris and folly were keen to develop a bespoke collaborative project which was ambitious and unique, as well as within the remit of both organizations.

The Case Study – *Current: An Experiment in Collecting Digital Art*

The *Current* project had four main aspects – an "open call," exhibition, acquisition, and public debate – and was conceived as a pilot that had the potential to become a regular scheme for collecting digital art. It was seen very much as a partnership project, with both organizations learning from each other's expertise and benefiting a wider audience than if each organization had worked separately.

The aim of *Current* was twofold: to celebrate innovative and creative use of new media technology and to undertake a practical case study for the collection and integration of digital artworks into existing permanent collections. In turn, this would further the Harris' mission to establish a nationally significant collection of new media art.

In addition to exhibiting the best in digital art at the time, the objectives of *Current* included the following:

- Supporting artists working with technologies in innovative and inspiring ways.
- Increasing public engagement with new media work as well as increasing the understanding and accessibility of it.
- Further developing existing professional knowledge of new media and museum collecting through a meaningful collaboration.
- Sharing findings with colleagues in both visual arts and museum sectors through a public debate.

Funding

Both the Harris and folly committed core funding to the project. An application was also submitted to Arts Council England, but was unsuccessful; although it had been recommended for support, it was an unfortunate casualty of the Grants for the Arts competitive process. At this stage both organizations agreed that the project was so strategically important they would proceed anyway, albeit scaled down and with a national rather than an international focus. This decision was a risk and was made in a rapidly shifting political and economic climate, but is testament to the strength of the relationship between the Harris and folly and their shared ambition to strengthen the understanding and appreciation of digital art.

Open Call

An "open call" was put out in autumn 2010 through digital media and visual art networks inviting artists to propose work for public exhibition and acquisition. The application process was only open to artists living in the UK and the expectation was that they would have previously exhibited or distributed their work publicly (in museums, galleries, online, etc.). The open call was designed to encourage a wide range of artists to submit work.

Artists were asked to propose new work (produced in the last two years) that demonstrated innovative use of technology in the making, display, or distribution. They were also asked to articulate how the work might be presented in the gallery environment. This was important, as there had to be a manifestation of the work within the exhibition, even if the work itself was not made for that environment – that is, documentation of site-specific work.

Furthermore, artists were expressly asked to consider how the suggested work might be displayed in a gallery environment in 20 years' time. This was to encourage artists to think about the long-term plans and sustainability for their work, and also to help inform the decision-making process. This didn't mean that time-limited work wasn't considered, just that the jury was aware of the artist's long-term intentions for the work.

In total, 200 applications were submitted, of which 147 were considered eligible. Those discounted included artists not based in the UK or whose applications were incomplete.

A selection panel was convened to shortlist work for the exhibition. This panel included:

- Lindsay Taylor (Exhibitions Officer, Harris Museum and Art Gallery).
- Kathryn Lambert (Creative Director, folly).
- Mike Stubbs (CEO, FACT).
- Ruth Catlow (co-director, Furtherfield).
- Beryl Graham (co-editor of CRUMB and Professor of New Media Art at the University of Sunderland).

This panel was selected to ensure a broad range of expertise and experience from different types of organizations, and was chaired by Lindsay Taylor. The brief was to select up to six artworks that fulfilled the selection criteria and that represented a broad range of art forms within the field of digital art. The panel was clear from the start that they needed to try and represent a variety of practice within the final selection and to be mindful that one of the works would be selected for acquisition into the Harris' permanent collection.

Although artists were encouraged in the promotional material to interpret the brief broadly, the panel were surprised that many entries were not very ambitious or innovative. This may have been incidental, or possibly artists felt they wanted to play safe: perhaps the idea of an artwork being in a permanent museum collection influenced the decision over which artwork was submitted.

Every application was considered by the panel and relatively quickly whittled down to 18. If one panel member felt particularly strongly about a work, it was put through. Work was discounted for a number of reasons, but mainly because it hadn't met the stated criteria – that is, it wasn't judged to be innovative (digital photographs), it was more than two years old, there wasn't enough information supplied, it was site-specific to another location, or the artist hadn't considered how the work would be shown in a gallery environment.

The remaining 18 were examined in more detail collectively by the panel and a healthy and lively debate ensued, with some panel members championing particular artists or artwork. The panel ensured that the merits of each work were discussed critically from both an artistic and a technical perspective. As the shortlist became smaller, the considerations of what would make a good exhibition and how complicated the installation would be were necessarily factored in – input was sought from the Harris' technician. Whereas these technical considerations didn't strongly influence the final decision, they were important to consider in terms of audience engagement, health and safety, and in light of limited funding.

The Exhibition

Five artworks were selected by the panel:

- boredomresearch – *Lost Calls of Cloud Mountain Whirligigs (view 2 left and right)*, 2010. Thin Film Transistor (TFT) screen display with custom-built software.
- James Coupe – *The Lover*, 2011. Video cameras, software algorithms, and projection.
- Harwood, Wright, Yokokoji – *Tantalum Memorial – Reconstruction*, 2008. Installation ("Strowger" electromagnetic telephone exchange connected to computer database).
- Michael Szpakowski – *House and Garden*, 2009. Animated GIFs with original soundtrack.
- Thomson and Craighead – *The distance travelled through our solar system this year and all the barrels of oil remaining*, 2011. Networked gallery installation; projection.

Having selected the artwork (of which interestingly three were collaborative projects themselves), the artists were invited to Preston to undertake a site visit. They each came to see the space and to discuss the logistical, technical, and budgetary requirements with the *Current* project team. The location of the work in the gallery and how that might relate to the other artists' work, both visually and audibly, was agreed. At that point the final shortlist was publicly announced.

Working in a historic Grade 1 listed building and as part of a local authority has many benefits, but also brings challenges that new purpose-built contemporary spaces don't generally suffer from. This project demonstrates the importance of having excellent technical staff who understand what an artist is trying to achieve, know how to make it happen in such a complex context, and how to work with the artist to successfully deliver his or her vision. In this instance the project benefited from the different expertise of the technicians from both organizations (John Critchley and Steve Wade).

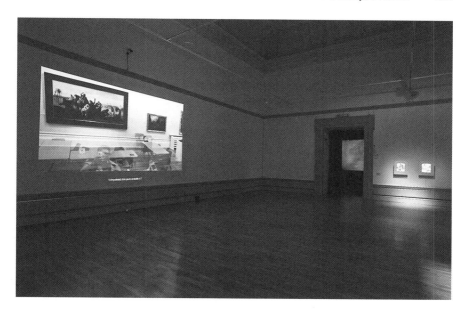

Figure 5.3 **Installation image from *Current* exhibition, 2011, at Harris Museum and Art Gallery, showing from left to right: James Coupe's *The Lover*, 2011; Michael Szpakowski's *House and Garden*, 2009; boredomresearch's *Lost Calls of Cloud Mountain Whirligigs (view 2 left and right)*, 2010. Image courtesy of the artists © Harris Museum and Art Gallery**

boredomresearch's Vicky Isley and Paul Smith did not feel it necessary to undertake a site visit, first as they knew the Harris through *Digital Aesthetic 2* and second as the *Lost Calls of Cloud Mountain Whirligigs* were self-contained units. The location of the work was agreed in advance and the install was relatively straightforward, although additional speakers were required due to the size and acoustics of the gallery.

The artists use computer-game technology to create "life studies that move" – a world populated with mysterious flying forms called "Whirligigs." These unusual creatures are inspired by birds of paradise, flower petals, and mechanical flying machines, and live, move, sing, and die in an intimate and imaginary world. As old Whirligigs die, new ones are randomly generated, bringing new forms, patterns, and songs, and suggesting the diversity of nature and species over time.

In terms of collecting, the two works would have been relatively straightforward. The white frame around the screens is bespoke to the work, but the artists expected the screens and hardware to be updated as and when necessary. The programming and software could be transferred to newer hardware relatively easily.

James Coupe's *The Lover* entailed installing six high-definition robotic cameras, with face recognition software, in three different parts of the building. The nature of doing this in such a large building was complicated and involved running significant lengths of cable from the ground-floor entrance to the galleries on the top floor. Once the cabling and PC were installed, the rest was left to the artist and his technician to install the software and complex programming.

However, the practical issues were only part of a very complicated picture. The work relies on filming and selecting images of visitors to the Harris building, and reusing them in a large-scale projection in the gallery. The Harris is run by Preston City Council for the people of Preston as well as housing the main city library, which is run by Lancashire County Council and has a similar "access for everyone" ethos. The recording, use of, and public display of CCTV footage is covered by strict data protection laws which are important to abide by but difficult to manage in a multi-occupancy building. Conversations ensued with the City Council Data Protection Officer and Legal Services, resulting in carefully worded signage to warn the public that their image may be re-appropriated.

The cameras were positioned strategically to allow the public the option to enter and leave the building without participating, which was considered essential as the Harris is for the benefit of all local residents. The software was already programmed to differentiate between age and gender and to only pick up certain demographics. However, as a precaution, the Learning Team were also consulted and informed to ensure that school visits or children's workshops did not take place directly in front of the cameras.

The resulting film was algorithmically constructed based on the 1962 play *The Lover* by Harold Pinter. Over the period of the exhibition, the film evolved with increasing variations depending on the growing database of CCTV footage of visitors. At first the balance of obligation to inform visitors over the random generation of new footage was difficult to gauge, but ultimately the work was successful – after some initial uncertainty, the installation was engaged with by staff and public alike.

Data protection issues aside, the fact that this was technically the most challenging piece also made it the most interesting in terms of collecting. First, it was site-specific, although Coupe agreed that it could adapt to different locations providing the sense of the three camera locations was within the artist's intent. Second, there were questions about the face recognition software and the equipment, which is still in its infancy and would need replacing/updating regularly. Furthermore, the programming was very complex and required the artist or specialist technician to install it. It worked and certainly engaged visitors, but it was felt that some of the technical issues needed further resolution.

Harwood, Wright, Yokokoji – *Tantalum Memorial – Reconstruction* explores issues of globalization, migration, and our addiction to constant communication; paying memorial to the more than four million victims of the Coltan Wars in the Congo since 1998. Tantalum, derived from coltan, is an essential component of everyday modern technology – including mobile phones – and its export to Western markets is cited as helping finance the conflicts in the Congo.

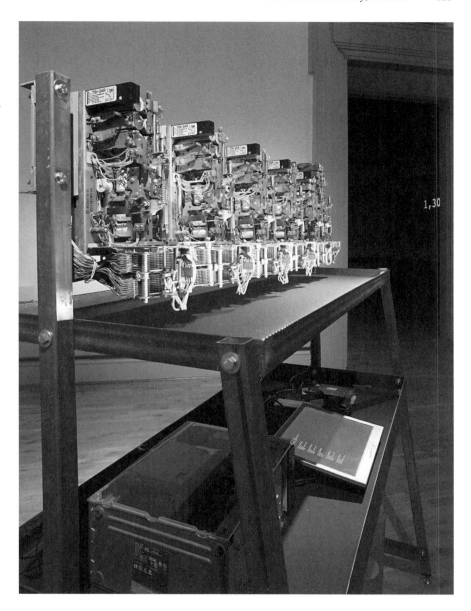

Figure 5.4 Harwood, Wright, Yokokoji's *Tantalum Memorial –*
Reconstruction, **2008. Installation ("Strowger" electromagnetic
telephone exchange connected to computer database).
Installation image from** *Current* **exhibition, 2011, at Harris
Museum and Art Gallery. Image courtesy of the artists ©
Harris Museum and Art Gallery**

The piece consists of an imposing rack of electromagnetic "Strowger" telephony switches, which are triggered by an archived database of calls from the "Telephone Trottoire" (2006–09), a social telephony network designed for use by the international Congolese diaspora.

This was the only sculptural element to the exhibition and, contrary to first impressions, caused a number of health and safety concerns. The Strowger switches sit on a bespoke metal framework, which also housed an uncovered PC. The Harris works hard to develop new audiences for its programs as well as encouraging existing visitors and, despite every effort to explain why visitors should not touch artwork, sometimes it is difficult to prevent this happening. In most instances this is for the long-term preservation of the artwork, but with much contemporary practice there are also issues regarding the safety of the visitor. In this instance there was a concern that a child could trap his or her fingers in the Strowger switches or that a visitor could get a nasty (or fatal) electric shock from exposed wires in the PC.

This is not the first occasion on which the Harris has had to negotiate safety issues and it is important to strike a balance between the artist's intention, what visually works, and what is reasonable behavior in a gallery environment. Whilst not wanting to underestimate other contemporary galleries' health and safety assessments or overemphasize the Harris' commitment to this area, it is important to reduce the risk to staff and visitors to an acceptable level. In this instance it meant earthing the framework and covering the exposed internal working of the PC with clear perspex, thereby reducing the risk of an electric shock should there be an incident. "Please do not touch" signs were displayed and the work was sited in direct view of the front-of-house staff, who were briefed to ensure no one touched the work.

This work would have been relatively straightforward to collect. The database is transferable and the PC is replaceable; however, the artists maintain that viewing the internal working is integral to the work. The Strowger switches are already obsolete technology, but are currently maintained by expert volunteer telephony enthusiasts. Storage of such a large object would be a difficulty, though, as storage space in most museums is very limited.

Michael Szpakowski's *House and Garden* was probably the most simple to install. It consisted of a large-scale projection of an apparently looped movie with original accompanying music. It was made up of a seemingly endless sequence of visual and musical clips, randomly generated so that no two viewers experience the same film. Based on the artist's own house and garden, the content was both ordinary yet beautiful and captivating – one visitor likening the imagery to that of a Seurat painting.

The artist made use of commonplace modern technology such as compact digital cameras, animated GIF files, and JavaScript in the making of the artwork. The database is all that would be acquired if the work was collected and the artist anticipated this was transferable. However, Szpakowski's work is freely available to download from the Internet to anyone who wants it.

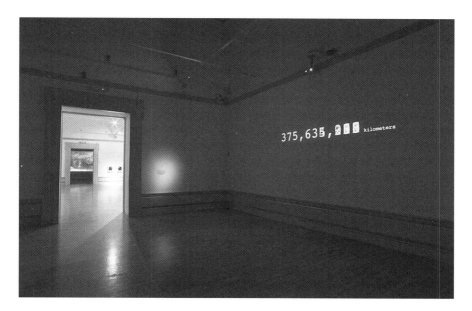

Figure 5.5 **Thomson and Craighead's *The distance travelled through our
solar system this year and all the barrels of oil remaining*, 2011.
Networked gallery installation; projection. Installation image
from *Current* exhibition, 2011, at Harris Museum and Art Gallery.
Image courtesy of the artists © Harris Museum and Art Gallery**

Thomson and Craighead's *The distance travelled through our solar system
this year and all the barrels of oil remaining* consists of two wall-based gallery
projections, which display the two figures counting up/down, respectively. The
data is streamed from the online Real Time Statistics Project and uses an algorithm
to check and display the figures. There is an accompanying soundtrack of the
magnetosphere in the earth's solar system.

Technically the work is quite simple, consisting of two projectors and two
Mac mini computers connected to a live Internet feed and speakers. The resulting
installation was powerful, with visitors commenting on how it made them feel
very small and insignificant in the world. One of the questions repeatedly asked by
visitors is: what will happen when the number of barrels of oil is zero? Obviously
this worrying global problem is one the artists want to bring attention to. They
responded in one of two ways – either it remains at zero or an archived copy from
a time when there was still oil is displayed instead.

As with Szpakowski, there is nothing physical to collect as the soundtrack
and figures are provided directly from an online source. The equipment required
is procured locally. Further issues surrounding the collection of this work are
presented below.

Further information about each of the artists is available on the *Current* website (Harris 2010–).

Building an Audience

The Harris has worked hard to build a reputation as a leading regional museum and gallery with a strong contemporary program, in particular for moving image and digital work. In February 2011 it was described as a "centre of excellence" in an article in the *Museums Journal* about displaying, collecting, and preserving new media art in the UK (Ali 2011: 32).

We know that digital art is well represented in festivals, including the AV Festival, ISEA, Futureeverything, or Liverpool Biennial, and in temporary exhibitions in dedicated spaces such as FACT and Furtherfield. Expertise is at the heart of these organizations and rightly so – they provide high-quality experiences for the specialist audience – and aim to attract wider audiences through, for example, their excellent community engagement programs or cinema programming.

Museums like the Harris already have the wider audiences that have come to see local history or the paintings already in their collections by eminent artists such as Joseph Wright of Derby, Lucian Freud, or L.S. Lowry. It is their responsibility to encourage these audiences to make connections between the painting and sculptures, and to understand that the digital artwork is part of a very long and continually evolving history of art.

Clearly presented interpretation is part of the solution. With more resources, this could include material for many different audiences; however, capacity and funding dictate a simple approach. For *Current*, the Harris provided a black-and-white printed interpretive leaflet containing information about the artists and the artwork in plain English. Front-of-house staff and volunteers were trained to provide further information to visitors and several curator guided tours of the exhibition were offered.

As with many exhibitions that involve the commissioning or display of new work, it is difficult to plan formal learning sessions for schools, particularly as school trips inevitably involve National Curriculum subjects. However, the dedicated Learning Team endeavor to include contemporary shows as part of the "sculpture" or "portraiture" tours offered to Key Stage 1 and 2 students. With *Current*, however, both they and front-of-house staff noted some school group leaders not engaging confidently or positively with the exhibition. Although this is only anecdotal evidence, the feeling is that teachers and parents/carers are often less skilled in digital media than children and young people, and therefore avoid digital artwork. Children and young people, however, are used to mediating the world through digital media and are therefore more likely to give it a go.

Visitor comments cards and a touch-screen questionnaire at the exhibition allowed visitors to rate and comment on *Current*. Seventy-nine per cent of

respondents rated the exhibition as "ok" to "excellent" and selected positive comments included the following:

> "Thought provoking – how to keep/preserve digital art. I agree a whole generation of exhibits will be lost otherwise. I like innovative works. They are important, just as more traditional art forms are – they have a place too. Thank you."

> "Very ambitious, awe-inspiring and interesting. An eye opener."

> "It was great, and I never thought it would be this interesting. 10 out of 10, it was fantastic."

> "Very compelling and challenging."

Negative reactions collected mostly revealed the lack of acceptance of digital art as an art form, confirming the concern of *Current* about the perception of digital art within the wider visual arts sector and audience – and also suggesting that the exhibition was provocative, experimental, and challenging.

The Acquisition

The acquisition element was strategically the most important element of the project. A second expert panel of judges was convened with different areas of expertise compared to the exhibition selection panel:

- Alexandra Walker (Head of Arts and Heritage, Preston City Council).
- Taylor Nuttall (CEO, folly).
- Paul Hobson (Director, Contemporary Art Society).
- Sarah Fisher (Chair of Axis and FACT).
- Gavin Delahunty (Head of Exhibitions, Tate Liverpool).

As head of the Museum and having substantial knowledge of the Harris collections, the panel was chaired by Alexandra Walker. Taylor Nuttall represented folly, Paul Hobson was invited in respect of the long-term and well-established relationship with the Contemporary Art Society and knowledge of contemporary collecting nationally, with Sarah Fisher bringing an excellent knowledge of new media and visual arts practice, and Gavin Delahunty representing national collections. The panel was given exclusive access to the exhibition, followed by further information provided by the *Current* curatorial and technical team. The final decision took several hours to reach.

The panel finally chose Thomson and Craighead's artwork for acquisition into the Harris' permanent collection. Comments from the panel of judges highlight the particular contexts from collecting new media art:

When new media works are infrequently the focus of contemporary collections – selection is weighted with layered considerations. Not least of which is the history of the institution itself. The Harris came about through the Victorian drive to create free public access to the library and philosophical collections. At that time industrial exploitation of the workforce went hand in hand with "betterment" via education. Across the north, information and ideas were pored over in new cathedral-like public spaces of learning and reflection.

In the Internet age the experience of surfing for information and ideas is self-directed, speedy and perhaps not commonly reflective. Standing in the room watching the counters change slows time and one is forced to consider what these incomprehensibly vast numbers mean. I found myself thinking about the impossibility of the Victorians comprehending either the philosophical implications of the *Distance travelled through our solar system this year*, or the industrial and ecological import of *all the barrels of oil remaining*. Sarah Fisher, panel member (Harris 2010–)

The panel selected the piece based on its "experimental and innovative" qualities and as both a complement and contrast to the Museum's current collection:

The work is a completely new departure for the Harris Museum and Art Gallery. It's very much of the twenty-first century and could only be produced now. It … deals with the big issues of the environment, which are of concern to everyone. It may not initially have obvious connections with the Harris' collections, however, artists have always been concerned with helping us to understand and relate to the world we live in. Alexandra Walker, Chair of the panel (Harris 2010–)

Notably, this piece also proved to be the visitors' favorite, receiving almost 34 per cent of votes in visitor feedback by the end of the exhibition. This is interesting because in some ways it is the least familiar medium (data pulled from Internet sources and fed into a display via software programming). However, it demonstrates that a strong artwork, regardless of the medium, can be understood and enjoyed by audiences from all backgrounds, not just the specialist. It also demonstrates that the audience development work around new media at the Harris seems to be working.

In their acceptance speech, Thomson and Craighead acknowledged the importance of the work being collected in the context of a museum:

Jon Thomson: "It's really delightful and exciting for us, because it's new work … and it's been great to be able to show it in such beautiful galleries. I think one of the things about the Harris that we are so impressed by is that it has such a particular reputation for having a really good collection. We've been lucky to visit here a few time over the years, and we showed here in another exhibition a few years ago and we were always impressed by the fact that recent acquisitions were not only being made by a collection like this, but that they

were also being shown amongst the collection as well, and that's a distinctive feature of this museum."

Alison Craighead: "And a very brave thing … to be doing, especially at the moment, the current moment." (Thomson and Craighead 2011a)

The acquisition fee was deliberately set at £10,000 to both attract established artists and to reflect the significance of the art form. Without external funding, core funding had necessarily been diverted to the exhibition and the Friends of the Harris Museum and Art Gallery generously agreed to help support the acquisition. This is significant as it was the first time that they had contributed to a contemporary art purchase. The remaining funds came from the last of the Harris Acquisitions fund – a small pot of funds that previously enabled major leverage of match funding to support acquisitions.

Greta Krypzyck-Oddy, Chair of the Friends of the Harris, stated: "The Friends, who have always been the Harris' main supporters, were delighted to help purchase the Thomson and Craighead work because we feel it is important that the Harris continues to collect contemporary works and this piece is a thought provoking and exciting example" (Krypzyck-Oddy 2012).

Collection Issues

One of the difficulties for the Museum, and indeed the museum sector, is "what" is actually collected. With any one of the selected artworks there are elements of the work that are not physical but are data-driven. Paradoxically this causes complications for the collections management databases used by museums within the UK, as there is not a classification for data/software like there is for oil on canvas or bronze sculpture, for example. This is a sector-wide issue, with Tate encouraging museums to lobby producers of cataloging systems to revise their software (New Art Trust 2005–).

Previously this has been dealt with in an ad hoc manner, relying on the common sense of whoever is inputting the data, but this relies on the person later searching for information using the same intuitive terminology. For example, the Lucy Gunning video, acquired by the Harris in 2000, is classified as "betacam video," which relies on future researchers already knowing the precise format. Working with the Harris' Collections Officer, we are agreeing a set of bespoke descriptions until the issue is solved nationally.

In terms of *The distance travelled through our solar system this year and all the barrels of oil remaining*, the initial information provided by Thomson and Craighead included the following:

- Software on a USB memory stick: a PHP script, mathematical algorithm.
- Documentation of the piece – e.g. drawings and photographs.

- Text/instructions for set-up and maintenance.
- A URL of the work to be archived.
- A physical representation of the piece to sit in the collection, e.g. a drawing.

Thomson and Craighead already have work in the Arts Council and British Council collections, so they are better informed than some digital artists when it comes to thinking about the longevity of their work. Whilst the final artwork for exhibition only actually exists as data on the USB stick, the subsequent items help to explain, archive, and support the work, and so may also be considered a part of the final "piece." When interviewed about the work before knowing that it was the selected acquisition, Jon Thomson said:

> In terms of a work like this persisting in the longer term I probably favor the tank running empty, and the work existing as a zero, but we continue to move around the planet. However it's this sort of work that could be simulated, it could be documented, it could exist in different types of ways. It's something we were talking about as we were developing the work. (Thomson and Craighead 2011b)

This multi-faceted nature is not necessarily unique to new media and digital arts (it is also used in, for example, live art), but it does overcome some of the challenges of positioning the work alongside other art forms in the current collecting system. Importantly, the inclusion of documentation and a physical representation (for example, the drawing) allow an intangible work to have a physical presence within the collection. Thomson and Craighead were keen that the drawing will sit amongst other works on paper within the collection so that future curators can come across it physically rather than just relying on the collections management database.

What the artists made clear from the outset was the importance to them of establishing and maintaining a relationship with the museum once a work is collected; this relationship will be the most important key to preserving the artwork, allowing both artist and collector to:

- periodically ensure that the piece continues to function correctly;
- make the work available for lending as appropriate – for example, through an "exhibition copy" URL;
- agree on possible different formats for exhibition;
- discuss any possible technical alterations or updates – the piece could adapt to new software, for example, when current technologies cease.

In order to test some of the issues regarding the redisplay of this work, it was included in a later exhibition *A Public Affair: 130 Years of Collecting Fine Art at the Harris* in the summer of 2012. As the title suggests, the exhibition examines the formation and development of the fine art collection from its Victorian origins to

The distance travelled through our solar system this year and all the barrels of oil remaining. Due to the nature of the exhibition, there was much less space than was previously the case to present the work. The curator, Claire Corrin, contacted the artists to discuss alternative display options. It became clear that the artists wanted to retain the theater of the work by having an enclosed space. This meant building a false wall to divide the gallery in half. In close consultation with the artists and technical staff, an appropriate level of "black out" was achieved and the work was successfully reinstalled in the smaller space. Displaying the work in such a varied exhibition seems to have divided visitor opinion in the comments book:

> "The Newsham/Miller/Haslam collections are excellent and I would like to see them on permanent display. Giving over a large amount of gallery space to some projected numbers seems pointless and the sound being played spoiled the atmosphere in the rest of the gallery."

> "Exquisite museum – fantastic exhibits. Photography and mixed media were my favourite."

> "All the paintings are exquisite and the oil remaining and space in our solar system is shocking. Thank you."

The importance of maintaining this relationship with the artists will be tested most when the current curatorial staff have left the Harris; however, by that time there will be a substantial body of unique supporting material within the artists' file which will inspire and instruct future generations of curators in the installation and preservation of the artwork.

The Debate

A debate took place on May 24, 2011 to present both the *Current* project and to discuss the perception and future of digital arts within the wider visual arts sector. Delegates included representatives from galleries, museums, arts organizations, and universities, as well as Friends of the Harris and members of the public.

Wanting to draw upon existing relationships, the event was developed with the help of Beryl Graham and Sarah Cook from CRUMB (Curatorial Resource for Upstart Media Bliss) and Professor Christopher Meigh-Andrews from the Electronic and Digital Arts Unit at UCLan.

Following a number of presentations from the key curatorial team were breakout discussion groups. A number of key points and issues around the perception and collection of digital art today were addressed. These points were collectively assembled and shared as "action points" to help support, develop, and increase the collection of digital and new media art, and to provide starting points for further action and research. The key points are as follows:

- *That individuals and institutions can improve the perception of digital art within the wider visual arts sector by:*
 - confidently collecting digital art and sharing best practice;
 - engaging in critical debate about digital artwork, but also wider digital collecting – for example, music and images;
 - making, exhibiting, and collecting very high-quality work;
 - engaging with and providing funding opportunities.
- *That museums and galleries can better support and collect digital artwork by:*
 - communicating and collaborating across institutions;
 - touring digital exhibitions;
 - commissioning with a focus on high-quality production/display;
 - collaborating better internally across departments;
 - understanding and providing better interpretation for audiences;
 - improving the narrative of art history;
 - lobbying for good art, whether digital or not.
- *That education plays a key role in the understanding of digital art through:*
 - better resources and fewer restrictions for teachers;
 - wider acceptance of digital art as a valid art form;
 - teaching art as a way of thinking and looking at the world – not just a skill of doing;
 - targeting primary education as younger learners are growing up in a heavily technology-orientated society and are often keen to engage with media and new media experiences.

The Future

Although this case study covers a very particular environment – a regional local authority-run museum and art gallery – it does demonstrate the power of collaborative working and the importance of strong relationships.

Current came about because of relationships between individuals and organizations, and relied on the collaboration and support of a number of individuals from other organizations who wanted to start to address some of the issues affecting artists and organizations working in the digital realm. Sadly, in August 2011, folly became the first of a number of arts organizations to close due to a lack of funding. The relationship with artists was also tested – through the delivery of the exhibition, then through the acquisition process, and the subsequent redisplay of the work.

The project was part of a trajectory that the Harris had chosen to take and lessons have been and no doubt will continue to be learnt and shared. Now, as a matter of course, the Harris thinks about the long-term legacy of commissioning new work for exhibition, as demonstrated by the acquisition of two works by Shezad Dawood later in 2011 – one a commission and one a direct gift from the artist.

The Harris also developed *Digital Aesthetic 2012* – the third and final of the series of exhibitions, conferences, and websites with UCLan. The learning and relationships developed in *Current* informed the planning of the exhibition and conference chaired by Sarah Cook and Sean Cubitt. Some of the issues from the *Current* debate were directly addressed – such as providing an INSET training session for teachers in the basics of digital art. Two new works were commissioned: *The Museum of Glitch Aesthetics*, an online artwork by Mark Amerika with physical glitches occurring in the Harris (in collaboration with the AND Festival); and *DIYVBIED* by Harrison and Wood, who are gifting an Artist Proof of the work to the Harris. In addition, works by Terry Flaxton and Lee Yongbaek were installed in the fine art galleries. Flaxton has subsequently offered to gift his work to the Harris collection.

However, as implied earlier in this chapter, the existing infrastructures and perceived hierarchies do not support audience development as well as they could. If artists, curators, and academics feel that building a wider audience for digital art is important, they could stop trying to define what they do by the media and concentrate on making, exhibiting, and writing about high-quality, innovative, and challenging contemporary art. If the role of the museum is to reflect or tell a narrative of history, it needs to ensure that what it collects reflects what artists are making now, which includes work made in new media. Of course, there is an element of subjectivity and risk in developing any museum collection, but a clear vision can lead to exceptional collections, such as Wolverhampton Art Gallery, also run by a local authority, which has strong collections of Pop Art and work that explores the troubles in Northern Ireland.

Like most public museums and visual arts organizations, the Harris also faces deep financial cuts which are significantly affecting the capacity to plan and deliver the ambitions of the organization. However, the Harris has been around for 130 years and is working toward different business models and ways of working. It is vital that the ambition and vision of the organization remain and that high-quality exhibitions that include digital art are regularly programmed in order to further develop its audiences and its reputation for collecting and exhibiting new media. As such, early discussions are taking place with FACT about presenting a second version of the *Current* experiment.

The subject of this chapter may be new media; however, we need real relationships with artists and audiences, and collaboration with individuals and organizations, not only to survive but also for the long-term success of both the Harris and contemporary art practice.

References

Ali, Abbas. 2011. "Digital Futures." *Museums Journal*, 111(2) (2011), 32–5.

Harris. 2010–. *Current*. Available at: http://www.harrismuseum.org.uk/our-work /74-current-an-experiment-in-collecting-art [accessed 14 October 2013].

Krypzyck-Oddy, Greta. 2012. 15/11/2012 *Current* [personal email correspondence].

New Art Trust. 2005–. "Matters in Media Art." Available at: http://www.tate.org. uk/about/projects/matters-media-art/acquisitions/frequently-asked-questions [accessed 14 October 2013].

Thomson and Craighead. 2011a. "Current Experiment: Acquisition Announcement at Private View." *YouTube*. Available at: http://www.youtube.com/watch ?v=3FVRr-OxUhs [accessed 14 October 2013].

Thomson and Craighead. 2011b. "Current Experiment: Thomson and Craighead." *YouTube*. Available at: http://www.youtube.com/watch?v=VX9Q7bdJwMo [accessed 14 October 2013].

Chapter 6

The Museum as Producer:
Processing Art and Performing a Collection

Rudolf Frieling

> The next type of art museum must be not only not an "art" museum in the traditional, static sense, but, strictly speaking, not a "museum" at all. A museum conserves supposedly eternal values and truths. But the new type would be a kind of powerhouse, a producer of new energies.
>
> (Dorner 1947: 232)

Technically speaking, the museum has always produced catalogs, educational materials, public programs, and exhibitions. These obvious readings of the title "Museum as Producer"[1] are not my concern here, although they do play a fundamental role in framing every exhibition display. But an exhibition of contemporary art with a large portion of media works doesn't come into the museum as a series of discrete objects to be exhibited. The introduction of the edition and the multiple already allows an artwork to be physically present at various places at the same time, or not, depending on the contract: Felix Gonzalez-Torres' work *"Untitled" (Golden)* (1995) is exhibited as a site-specific installation of golden plastic beads with dimensions customized to the specific gallery dimensions. The work is co-owned by three American museums (the Art Institute of Chicago, the Guggenheim Museum, New York, and the San Francisco Museum of Modern Art (SFMOMA)), but the artist stipulated that it is only ever shown in one location at a time. It is an instruction with a choice of specific materials, but it is above all a contractual affair of co-ownership and unique experience. The unlimited or limited editions of time-based works have forced artists, gallerists, curators, and museum technicians to deal with what are usually called "exhibition copies." Yet in all of these cases the semantic preferences avoid carefully the term "production." The museum typically pretends to be on the receiving end, preferring that the artists or their representatives from the galleries simply send whatever might constitute the exhibition copy, even assuring contractually that these get destroyed after the exhibition. Art, in these cases, is obviously not tied to a unique object anymore.

1 This chapter is an enlarged and deepened reflection on topics first addressed in my text "The Museum as Producer" in the anniversary catalogue *75 Years of Looking Forward* (Frieling 2010) as well as on thoughts related to an exhibition by all curatorial departments at SFMOMA entitled *The More Things Change* from November 20, 2010 to November 6, 2011.

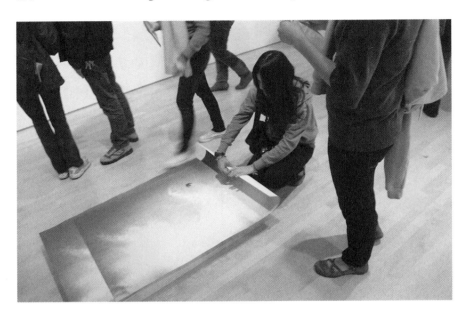

Figure 6.1 Felix Gonzalez-Torres, *"Untitled,"* 1992/93. Installation view from exhibition *75 Reasons Looking Forward: The Anniversary Show*, SFMOMA, 2010. Offset print on paper; 8 in. x 44½ in. x 33½ in. (20.32 cm x 113.03 cm x 85.09 cm). San Francisco Museum of Modern Art, Accessions Committee Fund: gift of Ann S. Bowers, Frances and John Bowes, Collectors Forum, Elaine McKeon, Byron R. Meyer, and Norah and Norman Stone, 94.431. © Felix Gonzalez-Torres Foundation. Photo: James Williams, courtesy of SFMOMA

This is a well-told story ever since Conceptual and Minimal Art introduced the temporary object as a display or intervention into an exhibition. Miwon Kwon, however, cites the example of Donald Judd and Carl Andre protesting against the production of exhibition copies of their work not because they did not meet the specifications in their materiality, but rather because they were made without their specific authentification. The artists wanted to be very much present in this outsourced production, but were fighting the demons they evoked by embracing the industrialization of their process (Kwon 2004: 39ff). While these examples still pertain to a canon of difficulties that emerge in the dealings of artists with institutions, a larger question looms: when is a museum entitled to become the producer of an artwork? Put differently, how can a museum be a producer when we all operate with the implicit assumption that it does not produce but collects objects? Who gets to make decisions in the production process?

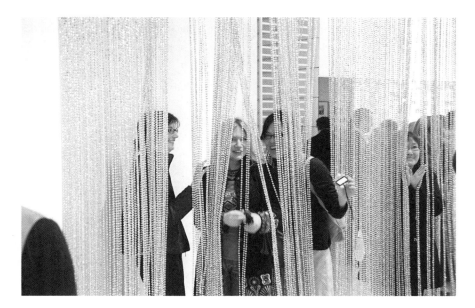

Figure 6.2 Felix Gonzalez-Torres, *"Untitled" (Golden)*, 1995. Installation view from *75 Reasons Looking Forward: The Anniversary Show*, SFMOMA, 2010. Strands of beads and hanging device, variable dimensions. SFMOMA, through prior gifts of J.D. Zellerbach, Gardner Dailey, and an anonymous donor; the Solomon R. Guggenheim Museum, New York, through prior gift of Solomon R. Guggenheim; and the Art Institute of Chicago, through prior gift of Adeline Yates; partial gift of Andrea Rosen in honor of Felix Gonzalez-Torres, 2008.109. © Felix Gonzalez-Torres Foundation. Photo: Winni Wintermeyer, courtesy of SFMOMA

With a set of variables, dramatically enhanced when these include media such as technical recording or playback devices, the outcome is different each time. Media art is relative in that it is as "good" or "bad" as its performance based upon a specific configuration of historic or contemporary technologies, objects (tools), and scripts. The museum as a context and the audience as a contributor to these time-based conditions play a more and more productive role in a metaphorical but also in a literal sense. The following text will thus address a trajectory from the performativity of variable objects to the performance of the museum and audience as agents in this process with a specific focus on works from the SFMOMA collection that involve a fundamental role of production. Finally, the question will be how a collection can be "performed" and what specific kind of experience this

might constitute when the museum produces art, the audience participates, and the artist is absent.[2]

On Objects and Products

The notion of the museum as producer is not quite unknown. Every museum with a collection of objects also has products manufactured that are sold in its designated location, that is, the museum's shop. When objects get sold in proximity to the galleries, the blurry boundary between these distinct domains draws criticism of commercializing the core business of the museum, which is the display of art objects and not the sale of products. So, in the logic of the museum, a product is not considered an art object. It seems to be a rather exclusive juxtaposition: products leave the museum in exchange for hard currency, whereas art objects enter the museum and are acquired for its collection. The collected item that is sold again clearly runs counter to the ethics of most museums and each attempt at selling assets to help strained budgets is generally met with public outrage. The museum, in its most fundamental mission, is there to safeguard valuable objects produced by cultural producers such as artists.

One contemporary artist that has inspired me to think about the status of the contemporary, media-based object in today's museums' collections is Bay Area artist Stephanie Syjuco. In order to characterize her sculptural practice, let me start by quoting the definition of one of her exhibition titles from 2010: *Particulate Matter: Things, Thingys, Thingies*. The Urban Dictionary defines "thingy" as a "noun used to describe an object on the spur of the moment when you have a sudden brain fritz and forget exactly what you were gonna say" (Anonymous 2003). Whatever Syjuco produces, the viewer, user, or collector is left puzzled by an object that has a fuzzy edge, a blurry concept, and a questionable value. Her website states:

> [My] projects leverage open-source systems, shareware logic, and flows of capital, creating frictions between high ideals and everyday materials. This has included starting a global collaborative project with crochet crafters to counterfeit high-end consumer goods; presenting a parasitic art counterfeiting event, *COPYSTAND: An Autonomous Manufacturing Zone* for Frieze Projects, London (2009); and *Shadowshop*, an alternative vending outlet embedded at SFMOMA exploring the ways in which artists are navigating the production, consumption, and dissemination of their work. (2010–11)

2 I use the term "performance" in its most general form as someone or something being acted out over time and not as a reference to the historic genre of performance from the 1970s, typically body-related actions. For a more in-depth discussion of the notion of "participation," see my essay "Towards Participation in Art" (Frieling 2008).

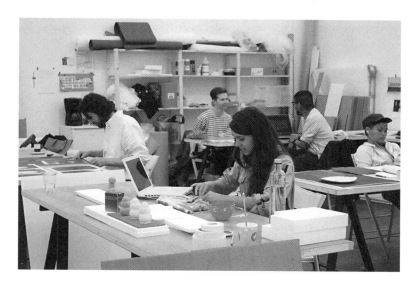

Figure 6.3 **Stephanie Syjuco, *COPYSTAND: An Autonomous Manufacturing Zone*, 2009. Installation view of Gallery Area from a five-day performative counterfeiting event at Frieze Projects. Image courtesy of the Catharine Clark Gallery, San Francisco © Stephanie Syjuco**

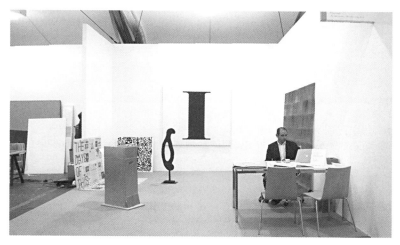

Figure 6.4 **Stephanie Syjuco, *COPYSTAND: An Autonomous Manufacturing Zone*, 2009. Installation view of the shop. Image courtesy of the Catharine Clark Gallery, San Francisco © Stephanie Syjuco**

The objects that come out of her studio are contemporary, things that she calls "thingies" pointing to their derivative status and the precarious nature of her sculptural practice where all "thingies" are retranslations of a digital artifact into something tangible. *Particulate Matter: Things, Thingys, Thingies* displayed:

> handmade versions of over seventy objects designed by users of the free 3-D modeling program Google SketchUp [which] exist somewhere between the bootleg, the copy, and the translation. Modeled from online designs that seem to lack value or utility, these strange objects explore the handmade in the digital-era of design, uniqueness found even within the copy, and collaboration's relationship to outsourcing, as well as labor, authorship, and value. (Syjuco 2012)

Thingies, in Syjuco's terminology, infiltrate the thingness of an object; they act as a remainder of a double translation from the original analog book to a digital version and back to an analog reprint of the digital. What is lost in translation is precisely the confidence in the materiality of the object that the reader is holding in his or her hand. A thingy is clearly disposable, possibly not to be trusted even, akin to an old VHS copy that once had a use value but is now simply sitting in a box while we have discarded the old VHS player in exchange for an ephemeral collection of files on our hard drives. A collector of Syjuco's thingies values this reflective conceptual process without buying into the re-emergence of the handmade as a value.

I will come back to discussing Syjuco within the context of our collection. At this point it is sufficient to point out that artists' hybrid practices not only challenge the notion of value but also reflect on the way in which a collection is produced, displayed, and even redistributed. Looking at the actual practice of exhibiting contemporary art as well as outlining the inherent challenges of exhibiting media art is a step towards an understanding of things collected as things "produced and performed." We will see that artists have been the ones to complicate matters in the first place, turning collectors and museums into producers.

The Museum as a Living Thing: The Emergence of Non-Permanence

Alexander Dorner, former Director of the Niedersächsisches Landesmuseum in Hannover, Germany, in the 1920s and 1930s and then in his US exile in the 1940s, had spearheaded the experimentation with changing displays and visitor participation to establish the museum as a "powerhouse, a producer of new energies," as quoted at the beginning of this chapter. He was alone for many years, but artists eager to challenge the museum in a fundamental way were more successful ever since a "practice" had replaced the traditional definition of the artist's activity by genre or media. This became a defining force in contemporary art in the 1960s through the conceptualization of artists like David Lamelas. In 1968, he made 10 definitive statements on his artistic practice, among them #4 on his works – "They are not

art objects, they are products" – and #6 on the process – "They do not exist as final products, because they never reach completion" (Lamelas [1968] 2004: 247). From performance and concept art to post-studio practice, artists have since de-emphasized the discrete objecthood and stressed the open, experiential aspect of installations, immersive environments, or performative situations. These may or may not involve objects, but whatever is exhibited in the museum galleries is largely the result of a collaborative effort between the artist, the gallery, and the museum's administrative, curatorial, and technical staff. An installation is thus never a given fact, but the result of many agents in this process. We can summarily say it is produced each time it is installed. The degree to which the museum has to interpret instructions by the artist is the subject of debate in conservation and collection management.

"Recent art is hardly a passive object ... sometimes its expanded dimensions alone have prompted the transformation of dis-used warehouses and factories into galleries and museums," claims Hal Foster (2011: ix). The call for a different museum had always been paralleled by a modernist call for a different, more contemporary mode of production. Acknowledging this major shift in artistic production over time, producing large-scale artworks has become a field for highly specialized agencies such as Creative Time in New York. They meet contemporary art's demand to enlarge its impact in terms of scale, complexity, and technological sophistication. The most successful artists employ workshops in order to keep up with the demand for production (for example, Olafur Eliasson). The idea of the workshop (or studio) introduced the idea of collaborative production overseen and authenticated by the master who delegated parts or even a whole work. Initially, it seemed to be the exclusive right of the artist to delegate the process of manufacturing a work – see, for instance, László Moholy-Nagy's *Telephone Pictures* that were industrially manufactured and ordered by phone around 1922, or Marcel Duchamp's "signing" of a work remotely by communicating an instruction:

> Take this bottle rack for yourself. I'm making it a "Ready-made," remotely. You are to inscribe it at the bottom and on the inside of the bottom circle, in small letters painted with a brush in oil, silver white color, with an inscription which I will give you herewith, and then sign it, in the same handwriting as follows: [after] Marcel Duchamp. (Duchamp [1916] 2000: 44)

The collector became the co-producer of an artwork as a multiple or a replica with the artist's consent, but without his presence.

Over the course of the twentieth century, this studio practice expanded and was gradually taken over by other agents in this process. Ever since curator and critic Lucy Lippard started to produce the works of conceptual art for her two seminal exhibitions, *557,087* (Seattle) and *995,000* (Vancouver),[3] curators, public

3 In 1969/1970, Lippard, who curated *557,087* (Seattle) and *995,000* (Vancouver), two iterations of a show of conceptual art, literally manufactured many of the pieces

agencies, and museums have taken on the burden of negotiating the complexities of producing art in public sites, of operating with replicas, exhibition copies, or, as one might call them, new originals or original copies[4] with or without the artist's consent. The art is not permanently present; it emerges as a temporary act of presentation.

Some Assembly Required: Consequences for the Museum

When, in Lamelas' terms, the process is never finished, there is hardly a clearly defined object to be acquired. "What are we getting?" is thus a standard question in every acquisition process today. The question is relevant because things are unclear by default. What the object in the collection *is* is often a question that cannot be answered in a standardized way. Media art has specifically pushed the boundaries of what is generally considered an art object. Archival sub-masters, dedicated equipment, instructions or manuals, reference prints, exhibition copies, more recently emailed or downloaded files, compressed or uncompressed – the institution has to painstakingly define in the first place what constitutes the specific conditions of the artwork to then produce a concrete display, which by the way rarely looks like what is in storage. In other words, some assembly is always required and the collected object is dependent upon a set of variables of hardware and software that need to be executed and performed on a daily basis. Not only the inherent performativity of a machine or script constitutes the experience of a display, but also the curatorial, administrative and institutional factors that condition how the "object" performs, that is, how it constitutes itself as a presence over time. Michael Fried called anything that could only be perceived over time "theatrical" and with that a link to the influence of the performing arts is certainly given. But to distinguish the performance of the object from this tradition, it helps to speak of the "performativity" of the work. Our understanding of performativity in relation to a collection needs to embrace not just the operative assembly of parts, as in an assembly line where all the components have been decided by the artist; assembly in our context here refers to a production that is not merely executing a score, script, or code, but that is performing under variable conditions.

An object that can be touched, used, performed, and even changed does not fall under the "jurisdiction" of the museum registrars, who simply label these objects "not art." Anything that can be replaced and disposed of at the end of an exhibition is in this technical sense not art. Then we should ask: where is the art when there is

or had them done following instructions by the artists without being able to have their final approval. This issue of approval and authentication is also reflected in the example previously mentioned of Donald Judd and Carl Andre protesting against the production of exhibition copies of their work without their specific authentication (Kwon 2004: 39ff).

4 On a related note, see the exhibition and publication: *The Original Copy: Photography of Sculpture, 1839 to Today* (Marcoci 2010).

nothing else but the production of new objects to be exhibited? The art, we could propose, is then an experience based on the performativity of a work. But how can one collect experiences? I will come back to this question when discussing collecting performances. On the other hand, we need to acknowledge that the emphatic stress on the producer in its specific semantic relation to industrialization might be a factor that is fading into history in light of our "post-production" age, as diagnosed by Bourriaud and others (Bourriaud 2002). In the course of the 1990s, the universal category "artist" not only replaced the painter, photographer, and film-maker but now also includes practices that were traditionally unrelated to the creative process, such as programmer, scientist, librarian, anthropologist, politician, etc.:

> [The artist] acts as a cultural analyst (Hal Foster describes the artist as an ethnographer in his book, *The Return of the Real*), a communication agent, an activist, a social worker, an educator, or a service provider. Quite often an artist's physical presence is at the core of what can't really be called an exhibition anymore, but "the project." (Rollig 2003)

Today, this applies not only exclusively to experimental exhibition spaces but also to museums which have begun to exhibit projects, platforms, performative situations, and sites of production. Duchamp's radical approach hasn't quite been absorbed by institutional practice, though. Museums are applying a new approach predominantly in the presence of the artist in this process and are focusing on the challenges brought about by temporary installations and interventions, clearly marking a difference from any objects to be collected. Joseph Beuys' vitrines as relics of performances or Christo's graphics and designs as representatives of his large-scale outdoor works come to mind. But what we are looking at now is a shift in the site of the production: works are not merely made for the museum but also in the museum. The notion of production is not only tied to a temporary exhibition or documentation, but also to the staging of a collection as an experiential, open-ended process.

The art museum has emerged from fundamental debates about its obsolescence, ruin, or status as a mausoleum. Today, a contemporary institution is to a much larger degree responsive and flexible, and, much like capitalism, it has proved to be much more flexible than anticipated, becoming more inclusive without denying its formative role in framing and promoting a specific vision of artworks as objects and facilitators of experiences. Ultimately, we encounter in almost every museum of contemporary art a series of exhibition displays that does not rely upon unique objects anymore but on original copies and unique experiences. The museum has become a productive site at a time when many industrial production sites have become invisible, receding into the domain of the computer. With a nod to the famous critical writing by Douglas Crimp (1993), we could maintain that, on the museum's ruins, many new museums have been built – or, to adapt this notion to my topic, on the ruins of the object, many new objects have been produced.

The More Things Change

In order to clarify what exactly has changed over the last 40 years, let me point to three distinct challenges that have emerged since the 1960s. In the context of this chapter, four aspects emerge as key factors in the process of producing works of art with or in the museum: first, the museum had to learn to cope with the fact that it was often reduced to a secondary role of exhibiting documents while the actual experience of an artwork lay outside its localities. In these site-specific works, as Miwon Kwon summarizes, the site of production becomes non-transferable and the museum thus becomes the site of documentation and related production.

A second challenge was prompted by the introduction of electronic and time-based media in film, slide, video, sound, and computer-based installations which all use an ever-changing configuration of hardware and software, posing enormous problems for conservation. A media-based work of art is inseparable from its technical setup and yet is often conceived as a continuously shifting series of technological upgrades and changing exhibition copies. We take for granted that we experience a video projection in a possibly compromised way with regard to the quality of its display. How often have we seen a burst of sunlight cast a diagonal line over a projected image? How often have we seen contemporary widescreen plasma displays disrespect the original aspect ratio of a video? We also know many examples of degraded imagery or artifacts in poorly transferred or digitized copies. We accept almost all of that as second nature in media art. In addition, we imagine how a work looked different when shown in its first manifestation some 20 or 30 years ago, which leads some conservators to believe that historic displays need to be preserved to allow that specific experience of, for example, a low-resolution electronic image. Embracing the variability of media art, its relativity and changing manifestation is a necessity that disrupts the established procedures and approaches in collection management. Each time a media-based work gets shown, it is the effect of a series of decisions, performances, and available technologies. It is thus changing constantly, and challenges the institution and the viewer with the question of how it can still stay the same.

A third aspect evolved parallel to the rise of media art in the early 1990s and introduced relational art that exhibited situations, temporal acts, and social relations, from David Lamelas' claim to embrace open-ended processes and unfinished works to Rirkrit Tiravanija's cooking, which is possibly internationally the most acknowledged artistic position of relational esthetics.

A fourth aspect comes into play when a relational work is not only gesturing toward a social use of its environment or tools but is also actually activated by producers, performers, or simply participants. Producing a situation that needs to be activated or "performed" by different agents in this process is, however, one of the most challenging parts for any collecting institution.

These four aspects – staging documents, configuring media, producing as well as performing relational works – can be considered acts of dramatization that require a different institutional approach to the very idea of collecting. I will review these four aspects by examining the recent exhibition history of my practice as curator of media art at the San Francisco Museum of Modern Art, exemplified by works that highlight the complexities of finding an institutional approach to the notion of constant change. My interest is not in examining established routines such as museum display, but in exploring the specific aspect of "producing the art object" and "performing the collection" with an emphasis on experience.

I. Staging of the Document: Kit Galloway and Sherrie Rabinowitz

Site-specificity, as stated above, results in a work that cannot be physically or conceptually removed from its given location. Site-specificity was embraced by artists as one crucial way of avoiding the commodification of the art market. It was also embraced by institutions as a practice that enhanced the uniqueness of place. Typically, actions, events, or performances were then documented via photography, film, text, and other ephemera, and consequently represented the work in the exhibition context. In media art, a large portion of seminal historic work, however, has never been documented properly and certainly has never been experienced again by the public.

Kit Galloway and Sherrie Rabinowitz made media art history by realizing *Hole in Space* in 1980, linking two public sites in New York and Los Angeles over three evenings via a live video transmission and public projection. The artists call it a "public communication sculpture." The performative event had been exhibited in the past only as a black-and-white documentation of highlights or a 30-minute installation from a total of three x two hours of video recording. For *The Art of Participation: 1950 to Now*, an exhibition in which SFMOMA explored the museum's public role in light of the contemporary social and technological context of the twenty-first century from November 8, 2008 to February 8, 2009, the museum produced a first complete digitized file of all six hours from both sites as a synchronized video installation on opposite walls, referencing the two windows at the original sites. The audience in the museum was thus looking at two audiences in 1980 facing each other. A new space was constructed, where two real-time events collapsed into one public arena made out of four sides of standing audiences. The museum visitors were mostly watching two "historic" audiences who were as much audience as direct participants. At the same time, the visitors in 2008 were also looking at other visitors across the room, an oblique replication of the dialogical nature of the historic performance. *Hole-in-Space*, like many others works in *The Art of Participation*, exhibited an action and its audience.

While the staging of *Hole-in-Space* made it possible for the first time to experience the unfolding of this dramatic encounter in real time, the site of the

experience had obviously been shifted from the Lincoln Center for the Performing Arts in New York and the Los Angeles Broadway department store in the Century City Shopping Center to a gallery inside SFMOMA. The staging went far beyond the presentation of documentary footage. A new hybrid work was produced based on the historic recordings with a new set of digital files that were returned to the artists after the exhibit. No work was acquired as it was still an open question as to what exactly would constitute the work in question, but a model was tested about how to exhibit performative events of the past and make an experience that one could consider "non-transferable" not into an objectified series of related documents such as photos, texts, and video excerpts, but into an experiential re-staging under different terms.

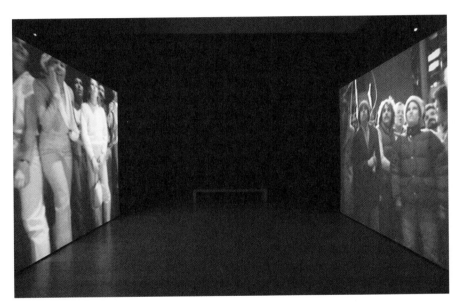

Figure 6.5 Kit Galloway and Sherrie Rabinowitz, *Hole-in-Space*, 1980/2008. Installation view from the exhibition *The Art of Participation: 1950 to Now*, SFMOMA, November 8, 2008–February 8, 2009. Two-channel black-and-white video projection with sound, approx. 360 minutes (re-creation using original footage from a live two-way telecommunication event at Lincoln Center for the Performing Arts, New York, and Century City Shopping Center, Los Angeles, November 11, 13, and 14, 1980); variable dimensions, each screen: 157½ in. x 118 ⅛ in. (400 cm x 300 cm). Image courtesy of the artists. Photo: Ian Reeves, courtesy of SFMOMA © Kit Galloway and Sherrie Rabinowitz

II. The Participatory Work and Acts of Translation: Harrell Fletcher and Miranda July, and Stephanie Syjuco

It has been argued many times that the presentation of media art fundamentally hinges upon the changing parameters of hardware and software configurations. No work, whether analog or digital video, will ever look the same. This might be a subtle difference, but a difference it always is. For my purposes here, however, I will push this assumption into a field where we understand the term "production" not just as an emergence of something that is not a "given," but as the emergence of something that is "changed." The question implicit in this proposal is obviously to what degree a change is producing a "new" work, who would have the authority to do that, and to what degree this might be something new within the parameters of the work. To exemplify this aspect of collection display, I will address a work that takes us from the expanded field of sculpture and media to the "social practice" that has risen to prominence over the last two decades.

Harrell Fletcher and Miranda July's *Learning to Love You More* is an online platform that provided 70 unique assignments between 2002 and 2009 from #1 "Make a child's outfit in an adult size" to #70 "Say Goodbye." The "Hello" section of this participatory project states:

> *Learning to Love You More* is both a website and series of non-web presentations comprised of work made by the general public in response to assignments given by artists Miranda July and Harrell Fletcher. Yuri Ono designed and managed the website. Participants accepted an assignment, completed it by following the simple but specific instructions, sent in the required report (photograph, text, video, etc.), and their work got posted on-line. Like a recipe, meditation practice, or familiar song, the prescriptive nature of these assignments was intended to guide people towards their own experience. Since *Learning to Love You More* was also an ever-changing series of exhibitions, screenings and radio broadcasts presented all over the world, participants' documentation was also their submission for possible inclusion in one of these presentations. From 2002 to its close in 2009, over 8,000 people participated in the project.

SFMOMA acquired the website and all related ephemera in 2010 with the understanding that the museum or any lender could exhibit the work in any format, excerpt, or representation, electronically or physically, but that it would provide the contextual information on all 70 assignments and ideally would always reflect the collaborative nature of the work by engaging an artistic collaborator. We embraced this proposal for a number of reasons: it allowed for the exploration of new avenues beyond the usual curatorial problem of presenting a media-based work in the format that it was originally produced in and for, here the online access on a computer; it offered a more productive approach than a configuration of media technologies that would simply enlarge the visibility of a work by projecting it in a gallery; and it signaled a shift in context – from the online access at home to a

public presentation as part of a museum collection. Configuring media thus meant not a technical or curatorial decision on means of representation, but a conceptual decision to continue the participatory foundation of the work without continuing to add assignments. For the first presentation at SFMOMA as part of the collection show *The More Things Change* in 2011, we decided to ask local artist Stephanie Syjuco to propose a concept and produce a display version. She opted against a typical representative sample and instead for a display of all submissions from all 70 assignments. To that end, she transferred all files to 70 video-based files, thus compiling video, audio, or slide shows sequentially and transferring text to a spoken or read text. To facilitate a more dialogical perception, two assignments were presented side by side each day, thus totaling a series of 35 consecutive pairings to show the totality of all 70. In select cases the sheer wealth of the material requested multiple days to perform a single assignment. This translation of the original material and online format into basically a home TV setup and time-based performance aligns with the intent of the work to provide a variety of opportunities besides the online access to engage the visitors. The presentation had a mesmerizing effect in that it offered daily surprises of parts of the work that had never surfaced before in a random and superficial browsing. It deepened the understanding of what the museum had acquired.

Configuring media was an act of translation into a new context, indicating that something fundamental had changed: the open work had come to a close with assignment #70 "Say Goodbye." The display, however, mirrored the dialogical nature in allowing two assignments to be perceived side by side. The transition from the active contribution to an assignment to the passive consumption as an audience in the museum was another shift signaling a transition, although not a final form. Obviously, the participatory aspect of this work was not foregrounded, but is very much alive in the larger community that took inspiration from the artistic approach or even individual assignments to produce related works elsewhere online. The work is also one of the most frequently loaned from the SFMOMA collection, indicating its continued resonance with a global artistic and educational community.

From a curatorial perspective, this was a productive interpretation and translation into a new format that was also communicated to the artists Harrell Fletcher and Miranda July in the spirit of an ongoing dialog about the activation of this archive in the future. However, the new production complicated matters in terms of collection management since the status of these newly produced display files was and is unclear. Previous exhibitions of *Learning to Love You More* had produced ephemera and exhibition copies that were included in the acquired volume of materials in 2010. But the artists and the museum agreed at the same time that this body of material would be considered final and would not be added to in the future. A previous exhibition file thus belongs to the work; a recent one does not. This is clear in terms of making practical but conceptually somewhat confusing decisions, and confusion is not coincidentally at the heart of Syjuco's practice. In that respect, she was a perfect match.

What the above-mentioned Stephanie Syjuco has openly embraced is the devaluation of the object in this process while insisting on the work staying object-based. Thomas Demand is clearly an early and lasting influence, and so is the so-called Picture Generation of the 1980s. Demand's masterful illusion effect of cardboard scenarios and stop-motion animation is furthered by artists who reference the obvious bootlegging, from Geoffrey Farmer to Stephanie Syjuco.[5] What Michael Fried called back in 1967 the "relational character of almost all painting" (1967: 12) is now revisited through the relational character of contemporary sculpture to images, memes, and digital artifacts.[6]

Syjuco makes the case for making stuff, actual objects, and as such she is a traditional artist. Yet her works indicate the degree to which all objects have been transformed by the digital context and production. However, a hybrid objecthood that is based in total or in part on a digital provenance defies the rarefied value attrition and addresses implicitly or explicitly the most challenging notion in relation to art now: the sharing and redistribution of visual objects.

III. The Production of a Shared Public Collection: Jochen Gerz and *The Gift/San Francisco*

When artists and the public produce and share art, the museum is challenged to become actively engaged in a culture of participation informed by the rapidly changing mass-media context, technologies of networking, and do-it-yourself publishing. This places an emphasis on the gallery as a studio space for the public. Occupied by different concerns than Stephanie Syjuco, the German artist Jochen Gerz nevertheless promoted a similar strategy of folding the two sites of studio and gallery into one exhibition site to address the public's desire to see themselves represented in the museum. For *The Gift/San Francisco*, exhibited as part of *The Art of Participation: 1950 to Now* (2008/09), Gerz agreed to the museum producing a local version of his participatory work *The Gift*, which had originated in 2000 in Dortmund, Germany. He provided a concept and some general guidelines for this production of ultimately 1,900 framed, black-and-white photographic

5 Claire Barliant recently wrote about a younger generation of artists who are mostly producing objects only to be photographed (Barliant 2012).

6 With a specific reference to Object-oriented Ontology, founded by Graham Harman (http://en.wikipedia.org/wiki/Graham_Harman), in his 1999 doctoral dissertation "Tool-Being: Elements in a Theory of Objects," Richard Jackson critically addresses some of the implications for an esthetic philosophy: "One of the main stipulations of being an Object-oriented Ontology advocate is the realist eruption of what counts as a thing, and how that thing contingently relates to different types of entities. This ... emphasises the multitude of things that escape the physical/digital divide ... Under these terms, aesthetics only leads to a banal drudgery, where everything melts together into a depthless disco. Any depth to the works themselves are forgotten" (Jackson 2012).

portraits onsite and during museum opening hours. The museum organized a fully functioning photo studio with volunteer photographers, which was open when visitors arrived, and free participation was on a first-come, first-served basis. The photos were then processed, printed, framed, stored, and exhibited all in the same gallery.

In 1947, André Malraux, while compiling the images that made up his "museum without walls," posited that art history, especially the history of sculpture, had become "the history of that which can be photographed" (quoted in Johnson 1998: 2). With Gerz, the operative photo studio allowed visitors not only to insert themselves into the museum physically as portraits, but also to come back to the museum to claim a framed portrait of another participant at the end of the show. While the public completed the work by lending their faces to this work and thus co-producing it, the nominal "artist," that is, Jochen Gerz, was absent in this process and only returned to the museum for the final act of giving away the pictures to 800 returning visitors, thus reversing the museumification process of objects by distributing to its participants what the museum had originally produced. While the work's relationship to its producers was initially one of identification and recognition, individual participants even came back during the exhibition and took pictures of themselves in front of their framed portrait, the relational character of *The Gift* then changing to a subjective dialog with "the other," a personality that was only known in cases of chance encounters.[7]

The level of engagement necessary to operate an ongoing production onsite is obviously exceptional and thus in all likelihood only temporary. The fact that it does happen more and more is promising. SFMOMA took on a proposition that provided many unknown factors. It required a state of alertness to various states of productivity, gaps, failures (technical or organizational), and procedures such as weekly rehangings of a new set of photos onto the designated exhibition wall. The museum not only produced a work, it also exhibited the performance of producing this work for the public to witness and participate in. One could pointedly say that the artist reverted the notion of the museum receiving and potentially collecting what has been produced elsewhere. At the end, the museum acquired all digital files and a series of exhibition prints that were unclaimed. The artist agreed that the museum could exhibit an even smaller excerpt of at least 20 samples as part of the collection that would, however, respect the diversity of participants, arguably a subjective choice. For Gerz, the important shift lies in the recognition that the work is constituted by an act of sharing a public collection, which turns the museum into one of its shareholders without any right of exclusivity. In fact, the work is constantly in a state of circulation.

7 I personally happened to meet the participant who was given my portrait, which he then "exhibited" by carrying it through the streets of San Francisco and sending me digital pictures via email. On sharing sites like Flickr, participants posted pictures, looked for the unknown collector of their portrait, offered swaps, etc.

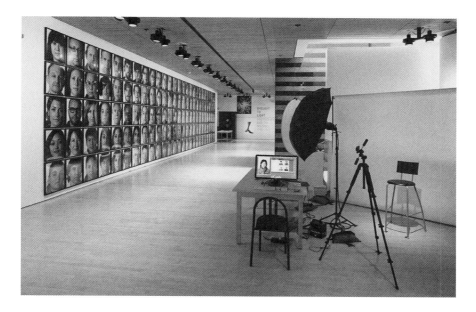

Figure 6.6 Jochen Gerz, *The Gift*, 2000/08. Installation view from the
exhibition *The Art of Participation: 1950 to Now* at SFMOMA,
November 8, 2008–February 8, 2009. Digital photography
studio, production lab, digital pigments prints, newspaper
advertisements, portrait exchange; each photograph: 20 in.
x 24 in., each print 50.8 cm x 60.96 cm; overall dimensions
variable. Courtesy Gerz Studio. Photo: Ian Reeves, courtesy
of SFMOMA © Jochen Gerz and Artists Rights Society (ARS),
New York / VG Bild-Kunst, Bonn

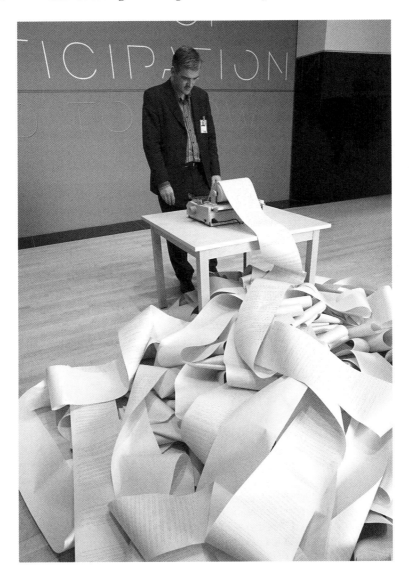

Figure 6.7 Hans Haacke, *News,* **1969/2008. Installation view from**
The Art of Participation: 1950 to Now **at SFMOMA,**
November 8, 2008–February 8, 2009. SFMOMA, purchase
through gifts of Helen Crocker Russell, the Crocker Family and
anonymous donors, by exchange, and the Accessions Committee
Fund, 2008.232. Photo: Don Ross, courtesy of SFMOMA ©
Artists Rights Society (ARS), New York / VG Bild-Kunst, Bonn

IV. The Artist is Absent: From Hans Haacke to Tino Sehgal

Contemporary artistic production is often centered round the presence of the artist without ever producing a final object, for example, Rirkrit Tiravanija, whose presence is essential to the performing of a communal kitchen as the artwork. *The Gift* by Gerz highlights a parallel motion, and that is the absence of the artist from the open-ended project. The artist's role has thus considerably changed over the last few decades from an exemplary producer to an exemplary consumer.[8] In this sense, the museum becomes the producer of a work that the artist then curates, judges, criticizes, etc. The artist's consent to what is being produced is still fundamental to the museum's policies. In our age of post-production and our post-media society of the twenty-first century, the artistic authorial position today is not to be creative, but to be critical, a position that resembles a curator, planner, administrator, leader, organizer, judge, etc.

When the artist can take on any role, and the visitor/participant tries to assimilate the role of the artist in actively participating in the production of a work, the museum is also freed from any pre-defined notion of a receptive partner. When it is able to respond across departmental divisions and territories such as "curatorial" and "education," it can successfully become a producer of art and operate temporarily as a studio, laboratory, office, school, workshop, platform, lounge, etc. The early visionary Alexander Dorner was arguably the first museum director to envision a permanently changing display of objects.[9] Following the ideas of his "living museum," we can now assess more fully that a collection offers a multitude of opportunities to activate and "perform" histories, visions, and media that are resilient to the immediacy of the mainstream media. "Performing the collection" then includes a series of acts such as the temporary configuration of media, embracing change and process in the gallery, including staff and the public to contribute, and engaging in a critical dialog with the artist on the manufacturing of experiences. Whatever happens in a museum is thus a complex configuration of different times, so much so that one can argue:

8 "These days, not production but consumption is the prime civic duty" (Groys 2003: 47, translation by the author).

9 In 1927, Dorner collaborated with the artist El Lissitzky on the realization of the famous *Abstract Cabinet*, whose walls appeared to change according to the works on display and the movements of visitors. "Lissitzky placed these unframed, self-transforming compositions by Picasso, Léger, Gleizes, Lissitzky, Gabo, Mondrian, Baumeister, and Moholy-Nagy on walls striated with miles of vertically aligned metal strips. The strips, painted in three different colors, white, black, and gray, produced a cool shimmer that changed with the slightest movement of a visitor's head. To multiply this effect, the colors were applied in a different order in different wall areas …Inserted in these vibrating, living walls were sliding panels. These, when moved, revealed more pictures underneath." Later, the *Room of Our Time*, designed by Dorner and Moholy-Nagy in 1931, conceptualized a more active role for visitors, proposing that they view films by activating rolling screens and push buttons to activate the projections; however, this room was never functional (Cauman 1958: 103–4).

"Perhaps the single most important task for the field in the twenty-first century is not to find more money, or more objects, or even more visitors, but to find the courage to embrace complexity in museums" (Silverman and O'Neill 2009).

This complexity, though, is one that is not given, but constitutes itself over and over again when an exhibition is not only opened but is also performed in every single instant. Objects that help to activate these experiences and facilitate these presences are temporal and contextual, analog as well as digital. What the museum owns is thus in the end the right to interpret and perform a work. And this is precisely where all performative works by Tino Sehgal are situated. SFMOMA acquired the performance *This is New* (2003) as a contemporary work that would resonate with a historic performative sculpture by Hans Haacke, *News* (1969), acquired in 2009 when exhibited in its updated version as part of *The Art of Participation*. Both works highlight the display of daily news items as their conceptual core. Haacke has them printed out on a dot matrix printer, ultimately producing a sculptural heap of weeks of news, but also updated his historic version based on the incoming wire of a single news agency to a curated selection of online news sources from all over the world. Sehgal in turn lets the museum staff, in this case the ticket-taker, select a headline of the day which is then "interpreted," as Sehgal coins it, by speaking it to the visitor and by possibly engaging in a conversation about it. Sehgal's radical abstinence from any kind of visual or factual document has earned him international recognition. What is less known is that he also insists on attaching monetary value to the performance, asking the museum to pay an additional fee to the staff since they are performing additional duties; creating real value out of an immaterial situation is thus a key concept of his performative practice.[10]

Producing Experiences of Wrong Places

When an art object in a collection is based on performative conditions, such as media or participants, it is only logical that performances themselves become collectible. From Ann Hamilton's *Indigo Blue* (1991/2007), where a performer erases letters in a printed book as part of an installation, a stack of blue cotton clothing, to the recent exhibition of Dora Garcia's *Instant Narrative* (2006) as part of the exhibition *Descriptive Acts* (2012) where more than a hundred individual performers were observing and writing in real time what was happening in the gallery, the museum has become the co-producer of a work following a set of specific instructions. It was a very specific, non-obtrusive, and silent performance

10 During his widely popular exhibition at the Guggenheim in 2010, he also exhibited an older work entitled *The Kiss* (2002), which had two interpreters perform a continuous act of kissing on the ground floor of the museum rotunda. As the artist related to me in a personal meeting, he did have to step in during some rare cases when a performer would not show up on time. Thus, the artist is present when the institution fails to guarantee its continuous performance display of the work during opening hours.

in Ann Hamilton's piece, but a rather open and diversely interpreted situation in Dora Garcia's work. The "instant narrative" became a subjective interpretation of the word "observation," also resulting in a series of unpredictable feedback loops with visitors playing up to the writer and trying to influence the narrative. The museum has taken on a live aspect that is unprecedented in the tradition of collection display. Not only is the museum producing and instigating the process of experiencing a work, it is performing it as much as the public is participating in that performance. Ideally, a walk through the permanent collection could then become an experience of variation and change. Obviously, change is a factor that is inherent to every single experience, as we will never see the same on a second or third visit. But under the conditions of contemporary art, change is openly addressed. It is happening not just in the eye of the beholder, but on the institutional side and the public's side as well. The artist can step back and watch. And while change is not a value per se, it is important to acknowledge how institutions have to adapt and operate differently. A flexible and responsive work environment is needed to be able to fulfill the core mission of a collecting institution, and that is to reflect upon the state of the art.

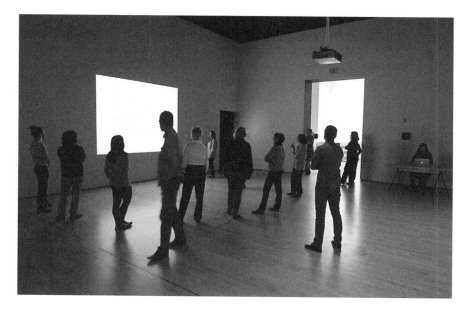

Figure 6.8 **Dora García, *Instant Narrative*, 2006–08. Installation view from the exhibition *Descriptive Acts* at SFMOMA, Act I: February 18–April 15, 2012. Performance with software and video projection; variable dimensions. SFMOMA, Accessions Committee Fund, 2011.14. Photo: Johnna Arnold, courtesy of SFMOMA © Dora García**

Boris Groys was the first to ask what happens when the artist becomes the first consumer of what is produced by the museum. Does that make the museum an artist as well? Or, as a variant of that question, what if the public produces and consumes its own production with the museum being the site of production and interaction – the studio as it were? "The museum remains of interest to the media and the public at large specifically as a site of the strange, divergent, and inexplicable" (Johnson 1998: 2).

It makes sense to keep in mind one of the multiple beginnings of making the museum come alive: Dorner's vision of the museum, rooted in the industrial age of the early twentieth century, still provides a valid foil for our contemporary museum experience. The museum as "powerhouse" in Dormer's terminology or as a producer now emerges as an agent of complex narratives, based in the production not of commodities, but of "wrong places," to pick up Miwon Kwon's term. It responds to its specific place within a geographic location but also a social and discursive situation. It actively seeks to produce unsettling questions and "to pressure the definition and legitimation of art by locating it elsewhere, in places other than where it belongs" (Kwon 2004). This "elsewhere" has often been stipulated and perceived as a place beyond the walls of the museum, but at a time when artists conceptualize and realize temporary and tactical interventions, it need not exclude the traditional site. Any place even inside the museum can become a "wrong place" when it is perceived as the locus of change. The "elsewhere" can thus also be the site where I, the visitor, play a determining, active role.

In 2008, I concluded that the museum, if successful, "becomes a producer of and an arena for social and aesthetic experiences, temporarily interrupting singularities through the presentation of participatory art that actively generates a discursive public space" (Frieling 2008). Let me now add that the museum potentially provides a discursive space with the inclusion of and confrontation with "wrong" places, forgotten visions, rejected, marginal, and obsolete practices as well as temporary objects/things that are "productive" in their different and unexpected agency. What counts in the end is if the art can unsettle the dominant discourse and introduce a difference and heterogenous place into what is too often perceived as a homogenous entity. In the past (and of course still very much in today's art market), a finite object was granted the status of "art" by virtue of being produced by the artist. What is emerging is a series of temporal experiences that are granted the status of "art object" by virtue of the museum's collaboration with the artist.

Rosalind Krauss coined the phrase "the expanded field" to suggest how sculpture had exceeded its own limits, while Gene Youngblood's "expanded cinema" took on the structures and material processes of cinematic conventions. With these precedents in mind, we can now think about the process of exhibiting a collection as an "expanded performance" where the artist, the institution, and the public are co-producers of a singular experience based on variable objects – be they sculptural components, digital files or participatory contributions. And this reality of a performed collection can extend beyond the walls of the museum. The most poetic moment of *The Art of Participation* was in fact the last day, when all

the pictures of *The Gift* left the museum to form a distributed public collection, with the museum being its central node and place of production.

References

Anonymous 2003. *Urban Dictionary.* Available at: http://www.urbandictionary. com [accessed 14 October 2013].

Barliant, Claire. 2012. *Objects to be Photographed.* Available at: http://www. artinamericamagazine.com/features/photography-objet-manque [accessed 14 October 2013].

Bourriaud, Nicolas. 2002. *Postproduction: Culture as Screenplay: How Art Reprograms the World.* Translated by Jeanine Hermann. New York: Lukas & Sternberg.

Cauman, Samuel. 1958. *The Living Museum: Experiences of an Art Historian and Museum Director, Alexander Dorner.* New York: New York University Press.

Crimp, Douglas. 1993. *On the Museum's Ruins.* Cambridge, MA: MIT Press.

Dorner, Alexander. 1947. *The Way Beyond "Art": The Work of Herbert Bayer.* New York: Wittenborn, Schultz.

Duchamp, Marcel [1916] 2000. Letter to Suzanne Duchamp, January 15, 1916. Reprinted in *Affectionately, Marcel: The Selected Correspondence of Marcel Duchamp*, edited by Francis M. Naumann and Hector Obalk, translated by Jill Taylor. Ghent: Ludion Press, 44.

Foster, Hal. 2011. *The Art-Architecture Complex.* London and New York: Verso.

Fried, Michael. 1967. "Art and Objecthood," *Artforum*, 5 (June), 12–23.

Frieling, R. 2008. "Towards Participation in Art," in *The Art of Participation: 1950 to Now*, edited by Rudolf Frieling. London and New York: Thames & Hudson.

Frieling, R. 2010. "The Museum as Producer," in *75 Years of Looking Forward.* San Francisco: San Francisco Museum of Modern Art.

Groys, Boris. 2003. *Topologie der Kunst.* Munich: Hanser Verlag.

Jackson, Richard. 2012. "The Banality of the New Aesthetic." Available at: http://www.furtherfield.org/features/banality-new-aesthetic [accessed 14 October 2013].

Johnson, Geraldine A. 1998. "Introduction," in *Sculpture and Photography: Envisioning the Third Dimension*, edited by Geraldine A. Johnson. Cambridge: Cambridge University Press, 1–19.

Kwon, Miwon. 2004. *One Place after Another: Site-Specific Art and Locational Identity.* Cambridge, MA: MIT Press.

Lamelas, David. [1968] 2004. "Mi sistema de trabajo en 1968." Published in *Listen Here Now! Argentine Art of the 1960s: Writings of the Avant-Garde*, edited by Ines Katzenstein, translated by Eileen Brockbank. New York: Museum of Modern Art, 247.

Marcoci, R. 2010. *The Original Copy: Photography of Sculpture, 1839 to Today.* New York: Museum of Modern Art.

Rollig, Stella. 2003. "Contemporary Art Practices and the Museum: To Be Reconciled at All?" in: *Beyond the Box: Diverging Curatorial Practices*, edited by Melanie Townsend. Banff: The Banff Centre. Available at: http://transform. eipcp.net/correspondence/rollig-cp01en [accessed 14 October 2013].

Silverman, Lois H. and O'Neill, Mark. 2009. "Change and Complexity in the 21st-Century Museum." Available at: http://www.aam-us.org/pubs/mn-change-and-complexity.cfm [accessed 14 October 2013].

Syjuco, Stephanie. 2012. "Stephanie Syjuco." Available at: http://www.stephanie syjuco.com [accessed 14 October 2013].

Chapter 7
Objects, Intent, and Authenticity: Producing, Selling, and Conserving Media Art

Caitlin Jones

"Inconsequential" is the term billionaire art collector Steven A. Cohen used to describe the estimated $100,000 cost to preserve a recent acquisition – Damien Hirst's *The Physical Impossibility of Death in the Mind of Someone Living* (Vogel 2006). The sculpture, a 14-foot tiger shark floating in a glass vitrine, is one of the most iconic artworks of the 1990s, but the ravages of time have radically altered it from the work Hirst originally produced. During the course of the sale, the artist, the dealer, and the collector thus made a decision to restore the work (the shark was decomposing in a murky formaldehyde bath) to its original state – not through traditional conservation efforts, but by entirely re-creating it. With a new shark, a more advanced preservation process, and a new enclosure, the sculpture is now, in a physical sense, completely altered from the original. We can read Cohen's "inconsequential" remark as a reference to the restoration costs vis-à-vis the artwork's $8 million price tag, but perhaps the inconsequential remark also refers to a shift of emphasis from the preservation of the "physical original" to the more nebulous notion of a "conceptual original." In this case, the original object was not preserved, but the artist's original intent for the work was.

In the high-stakes world of contemporary art collecting, where value is often based on the promise of originality and the even more complicated idea of authenticity, this highly publicized preservation project marks a significant shift in thinking. Even though the dematerialization of the art object has been an enduring trope for artists and theorists since the 1960s, many artists, galleries, and collectors have, for a variety of reasons, striven to keep that which has been dematerialized very much material. In doing so, the link between authenticity and the object, rather than authenticity and the concept, is given primacy in discussions of authenticity. Although decidedly an object, Cohen's effort to re-create Hirst's sculpture illustrates the complexity involved in collecting work and retaining both its object and its conceptual values. Hirst and Cohen's re-created *The Physical Impossibility of Death in the Mind of Someone Living* is, according to both artist and collector, an authentic artwork in both an object and conceptual sense.

In no medium is this tension between object, original, and authenticity more apparent than media-based art. While conservators have long dealt with issues of authenticity and variability in painting and sculpture, these questions took on increased relevance with the popularization of video installation in the 1980s.

If we traditionally think of artworks as discrete physical objects and our judgment of their authenticity as predicated on the degree of loss or change to this object, how can authenticity be judged when an artwork is a moving image with no intrinsic object presence? As artists have continued to work in this non-objective way, these questions and challenges continue to grow. This chapter therefore considers a range of issues for collectors of media-based art and in particular how an artwork's authenticity is no longer tied simply to the object, but also to a nuanced understanding of the artist's intent in production and exhibition, and the collector's vision for its preservation.

Consider the work of New York artist Cory Arcangel. His first well-known installation *Super Mario Clouds* (2002–) is a hacked version of the iconic Nintendo video game *Super Mario Bros*. The installation is a large projection of a brilliant blue sky with fluffy, albeit pixelated, clouds moving slowly across the wall. With all evidence of the original game play removed – there is no hard-working Mario, no blocks to hit, no coins to gather – the viewer is presented with a meditative, albeit humorous landscape. In the corner of the gallery you can see the old Nintendo system that plays the visibly hacked cartridge. This hardware is deliberately not hidden from sight, but is fully present in the space, giving the viewer a visual clue as to how the work was made. Editions of this work have been collected by both private collectors and institutions as objects that consist of a Nintendo game machine, a projector, and some computer code contained on a Nintendo game cartridge. Collectors of the work receive this, along with installation instructions. There is another iteration of *Super Mario Clouds*, however, which also exists online, one that the artist himself freely distributes, along with instructions as to how one can make one's own version. The work is both object and idea, collectable and networked. Even if a collector preserves the work as an original art object, what does that mean when the artist himself endorses instructions as to how one can make one's own? *Super Mario Clouds* and many other of Arcangel's works, as well as many other works of media-based art, exist in these multiple versions, distorting traditional notions of authenticity. Which version is authentic? Is there an authentic version? Are there multiple authentic versions? How we define authenticity in an era of multiplicity and versions is a central focus for artists, conservators, and collectors.

Assessing Authenticity

While a potential minefield of interpretation, the role of the artist and the notion of "artist intent" is a question that must be addressed in any discussion of authenticity in contemporary art. In her elucidating essay "Authenticity, Change and Loss in the Conservation of Time-Based Media Installations," conservator and Head of Time-based Media Conservation at the Tate in London Pip Laurenson notes that "in conservation the prevalent notion of authenticity is based on physical integrity and this generally guides judgments about loss. For the majority of traditional art

objects, minimizing change to the physical work means minimizing loss, where loss is understood as compromising the (physical) integrity of a unique object" (Laurenson 2006). According to this traditional reading of authenticity, Hirst's shark is far from authentic. However, Laurenson is quick to point out that the "notion of authenticity based in material evidence that something is real, genuine or unique is no longer relevant to a significant portion of contemporary art." She argues that today authenticity should be judged by different criteria. Looking outside traditional art conservation, she turns to the field of musicology for this new perspective; she cites the work of Stephen Davies, musicologist and philosopher at the University of Auckland in New Zealand. When describing how composers address the inevitable changes and interpretations of their works, Davies employs the terms "thickly" and "thinly." Thickly is used to describe works which are highly prescribed by the composer or artist, and thinly is used to describe works for which interpretation by the performer or curator is welcomed.

Art conservators have long looked to artists to set guidelines for the proper treatment of their works over time (for when the artist is no longer available to install the work themselves) and need to work together closely to map works somewhere along this "thick-thin" continuum. Deviation from the artists' articulation of their own works thus becomes the criteria for judging authenticity. Laurenson cites Stan Douglas as an artist who thickly specifies his work, because in his highly precise video installations very little is open to interpretation. An installation such as *Nu*tka* (1996) is one that uses the unique characteristics of early analog video to create image, sound, and meaning – the equipment used, the playback source, and the location of the video image and speakers within the exhibition space are all carefully expressed by the artist. Deviation from the artist's specifications would change the meaning of the work considerably. This kind of tightly controlled expression is more in keeping with what we traditionally associate with conservation processes.

In contrast, Cory Arcangel could be seen as an artist who more thinly articulates his work. *Super Mario Clouds* is, in comparison to Douglas, far less prescribed; however, there are still some parameters. For example, in the gallery installation the original Nintendo hardware must be visible in the gallery as the presence of the hardware itself helps to create the meaning – without it, the artwork would be less authentic. Arcangel himself learned how to hack the Nintendo cartridge from an online "homebrew" context – gamers who hack into a range of gaming platforms to create their own game interfaces. That Arcangel gives away the code for free stands in opposition to the very concepts of uniqueness and ownership within the art market context, but is completely in keeping from this original production context.

Selling Authenticity

For an artist or gallerist attempting to sell a work of art created in a medium-like video, conveying a sense of authenticity and value has resulted in a number

of conventions. "Certificates of Authenticity" have long been in use to impart a sense of permanence to transitory objects, even going back to the fluorescent light sculptures of Dan Flavin (Jones 2006). While these certificates do nothing to preserve the object value of an artwork, they cannot (or rather should not) be re-sold without them – thus, they ensure some sense of monetary value for the collector. The artist-signed DVD (and earlier laser disc) was another means employed to confer uniqueness and value on a work that, in a purely object sense, is not much more than a 10-cent piece of plastic. Likewise, galleries have developed gorgeous and extravagant boxes in which to house these signed DVDs, videotapes, and certificates in order to further impart a sense of objecthood to the non-objective.

For so-called "born digital" works (materials that originate in a purely digital form), in particular works with computer code as their source material, similar tactics have begun to emerge. Olia Lialina, an early and influential Internet artist and media theorist, describes an emerging trend in the media art world – "flat computers" (Lialina 2007a). These all-in-one units (computers, hard drives, and monitors) are increasingly being used to contain works of computer-based art in convenient (and highly saleable) modules – giving a sense of permanence and commodity to digital art once thought unmarketable. Torch Computers, a UK-based manufacturer of what it refers to on its website as "Computers for Art," is one of the larger suppliers of these integrated units and has been marketing them for many years. Framed, a Japan-based company, touts its all-in-one unit as "bringing digital art into the everyday" – you can even buy work from its online gallery and control the unit from your iPhone (Framed 2012). While perhaps institutions or serious art collectors won't be buying work from iTunes anytime soon, these units have become more commonplace with the proliferation of art fairs – a context where easy saleability is a primary concern.

In 2006, the Bryce Wolkowitz Gallery took to selling work by Lialina and fellow net.art pioneer Vuc Ćosić via these computers for arts. Lialina's *Online Newspapers* (2006) and Ćosić's *ASCII History of Moving Images* (1998), both originally Internet-specific artworks, were a few of the works of net.art that sold particularly well in this new package. Significantly, these units don't contain the original context of the web – the desktop computer, the slow 56k modem, or the not-yet-ubiquitous nature of the Internet – and thus in many essential ways the original meaning of the work is radically altered. The artists, aware of the significance of this shift – from ephemeral and network-based to object-based – felt that the loss of the network context did not jeopardize any notion of authenticity and that it was the code, not the frame (Internet browser or "computer for arts"), where the authenticity was contained. As Lialina drolly suggests, "so, experienced audiences, artists and gallery-friendly computers make the transition of Net Art from New Media to Contemporary Art very explainable. The audience recognizes and values internet aesthetics. Artists make works about the internet, gallerists see a nice way to present and sell. Everything works smooth and comfortable" (Lialina 2007a).

Figure 7.1 **Installation view of Vuk Ćosić's *ASCII History of the Moving Images (Psycho)*, 1998, in the exhibition *On & Off* at Bryce Wolkowitz Gallery. Image courtesy of the artist and Bryce Wolkowitz Gallery**

Ensuring Authenticity

Once a work is sold, ensuring authenticity and value becomes the concern of the collectors. In the past decade, institutional conservators have been formulating strategies that go beyond transforming works into immutable objects and have instead proposed procedures that ensure that works of ephemeral art stay true to their original form and intent. While these strategies often vary in their perspectives and approaches to issues of technological obsolescence, artists' intent, and deteriorating materials, most agree, as Pip Laurenson suggests, that artists should play a major role in conferring authenticity on their sometimes evolving works of art.

Laurenson was a lead researcher in a major research project devoted to precisely this topic, Matters in Media Art, a collaboration between the Museum of Modern Art, the San Francisco Museum of Modern Art, Tate Modern and the New Art Trust. The New Art Trust is a non-profit organization created by noted media collectors Pamela and Richard Kramlich that is a brilliant example of how collectors should be proactively engaging with these changing conditions to preserve their own collections.

The Kramlichs have one of the world's largest private collections of video- and media-based art in the world. Collecting this work since the 1980s, their collection includes both single channel and complicated video installations by early video visionaries such as Bruce Nauman, Dara Birnbaum, and Gary Hill as well as artists like Matthew Barney and Fischli/Weiss. Recognizing the need to preserve the integrity of their own collection of video art, the Kramlichs, through the New Art Trust, have partnered with the institutions to which their massive collection is promised to fund research in the field. They created a massive and highly regarded program that funded research initiatives, preserved countless works of art, and raised awareness of the issues at hand. Case studies, with illuminating interviews with artists, extensive artwork documentation, and hardware specifics, on works by artists such as Hill and Nauman have been made public through the Matters in Media Art website and have provided guidance to numerous other institutions and galleries.

Another inter-institutional collaborative conservation initiative, the Variable Media Network, was a consortium of institutions including the Guggenheim Museum, the Daniel Langlois Foundation for Art, Science and Technology, the Walker Art Center, Franklin Furnace, the Berkley Art Museum, and Rhizome.org that sought to develop new strategies for preserving works of what they referred to as variable media (video, conceptual, installation, performance, and media art). The Variable Media Network developed an original way to talk about these issues by looking at the challenges faced by a range of mediums and shifting the language to address "behaviors" rather than medium-specific descriptions. A questionnaire was designed to elicit information directly from artists regarding the behavior and variability of their works, and to envision what their work might look like once it is no longer viable in its current form. Emerging from discussions between artists, curators, conservators, and technicians, the guiding principle was that artwork should be described by the way it behaves, in addition to its physical components, as a way to draw on the artist's creativity and vision, in combination with traditional conservation practice, in order to help preserve the original intention once the current form is no longer viable.

Like Matters in Media Art, the work done by the Variable Media Network was made public via its website, a publication, and through a number of major conferences. Perhaps most significant was the exhibition *Seeing Double: Emulation in Theory and Practice*, which took eight important works of media art from the 1960s through 2004 and paired the original versions with what they might look like in the future if their original components were no longer available. These works were "emulated" in the pure computer science definition – running old software on new hardware by emulating old operating systems – but emulation was also used in a more general sense. Works by Cory Arcangel, Mary Flanagan, Jodi.org, Robert Morris, Nam June Paik, John F. Simon Jr., and Grahame Weinbren were displayed with their possible future iterations, and the questions of obsolescence and authenticity were tested in a tangible context.

In addition to *Super Mario Clouds*, Cory Arcangel created a number of works with Nintendo game cartridges. The work *I Shot Andy Warhol* (2002), a hacked *Hogan's*

Alley game, was included in *Seeing Double* without a future iteration. Although the work was created with the use of an emulator, Arcangel felt that in his case the replacement of the original NES with new hardware would remove the work so far from its original context that it would be rendered meaningless in a gallery context. He stated that this was "because the public doesn't necessarily understand an emulator. The reason I make works based on game consoles is that all you have to do is see the cartridge to understand what happened … In 30 years a laptop running that game is going to mean nothing to the public. So I want *I Shot Andy Warhol* to be exhibited with a real light gun, the Nintendo and preferably a period TV" (Arcangel 2004). Simple storage (and buying up old equipment on eBay) is therefore for the time being considered the strategy for preservation of this incarnation.

But as with *Super Mario Clouds*, there is a complimentary strategy. For Arcangel, "other people have already been porting my work to other versions. Somebody wrote me and was like, hey, I got it to work on a Game Boy emulating the Nintendo … Because I also participate in behind-the-scenes emulation culture. Everything I learned about programming comes from the homebrew culture, and it's important to me to give the code away so someone else could learn from it." Placing an NES in a crate in a warehouse may save the installation attributes of the work, but releasing it over the network ensures an equally important attribute of it, which is its place in a network context – preserving the artwork beyond its object value.

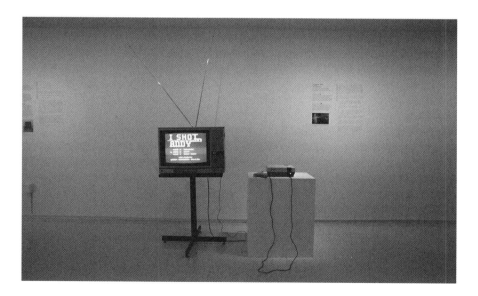

Figure 7.2 **Installation view of Cory Arcangel's *I Shot Andy Warhol* (2002) in the exhibition *Seeing Double: Emulation in Theory and Practice*, 2004. Photograph by David Heald, © The Solomon R. Guggenheim Foundation, New York**

Another work in the exhibition was Grahame Weinbren's and Roberta Friedman's *The Erl King* (1982–85) – a work of interactive cinema. As a major preservation case study, for over a year, in tandem with the artists, the Variable Media Network took part in numerous discussions with technicians, conservators, and computer programmers to identify the components and their functional relationship to the work of art itself. As stated by Grahame Weinbren, "physical limitation of the components of the early 80s was embedded in the program of *The Erl King* to such an extent that they became determinants of the way it produced meaning" (Weinbren 2004). Although the physical equipment itself held no particular importance for the artists, its limitations needed to be clearly understood. In addition, the original code was written by the artists and their collaborators, and was therefore deemed critical to preserve the authenticity of the work – the code carried the authorship. The necessity of preserving these two elements of *The Erl King* drove the decision to emulate this artwork rather than migrate it to newer components. A program was written to interpret the original source code, the video and audio files were all digitized, and all other hardware devices (excluding monitors and the touch screen) were emulated (Dimitrovsky 2004).

During this process, many times a line had to be drawn between where to modify the original system's behavior and where to replicate the system "warts and all." For instance, the original system had errors that would cause it to crash. Is this something that is necessary to emulate? Would it compromise the authenticity of the work if we eliminated potential system failure? In other cases, improvements to the system were unacceptable. For example, the new system had a considerably faster response time from when the viewer touched the screen and the cut in the film was made. According to the artist, "it was so fast that one could not believe that one's action had had an effect on the system, and the power and complexity of the piece dissolved into an arbitrary porridge with no distinction between the viewer-caused changes and those built in" (Weinbren 2004). The artist advised that the speed degraded the viewer's experience, so the system was slowed to match the original speed, replicating the right balance of delays and waits, and "distinguishing between those caused by disc search time and the time required for the computer to communicate with the laser disc players and the touch screen" (Weinbren 2004).

These two major projects – Matters in Media Art and the Variable Media Network – were part of a groundswell in the international conservation community. In recent years many other organizations and projects have been developed to look closely at conditions for collection and conservation. Among them are the International Network of Conservators of Contemporary Art (INCCA), a network of professional conservators whose prime mandate is the sharing and distribution of knowledge within the international conservation community. One of their projects, Inside Installations: Preservation and Presentation of Installation Art, involved more than 25 European institutions and a multitude of case studies (many of them media-based) on installation artworks. Though predominantly installation-based works including work by artists like Olafur Eliasson and Thomas Hirschhorn, there are also very media-specific case studies

including work by film-maker Tacita Dean and video artists Pierre Huyghe and Philippe Parreno among many others. To date, 33 case studies have been made public through its website – an invaluable resource for the field. And what these multimedia case studies tell us is that collectors and institutions are dealing with issues of ephemerality, obsolescence, and authenticity in almost every medium of contemporary art production. Works of media art, while challenging in their particularities, are not unique in the broader challenges of preserving authenticity.

Other initiatives have focused specifically on the realm of Internet Art. A number of organizations tried to capture some of the ephemeral history of art online, notably Rhizome.org's ArtBase. A founding member of the Variable Media Network, Rhizome established the ArtBase to be an online archive of Internet Art. Not a collecting institution in the formal sense of the term, artists upload their projects to the ArtBase voluntarily and Rhizome stores a "copy" of a work with its metadata, works to repair links when broken, and provides constant access to works once they are included. In relation to issues of artists' intent and authenticity, Rhizome declares: "While we fervently believe in taking the necessary steps to make these works viewable, we simultaneously understand that it may be the intent of the artist that these works degrade in time and we fully respect these wishes. When artists agree to have their works rehabilitated, we work directly with them to select the best means of representing their work in a sustainable format." In recent years there has been a renewed focus on the ArtBase, and their newly modified collection policy and preservation documents are all available online, as are a number of other related publications.

These are only a fraction of the research projects in this area (Jones 2007). As a result of all this research and international collaboration, the conversation around the collection and preservation of variable and media-based work is as varied and open as much of the work itself.

New Conditions for Production and Collection

Attitudes and practices towards so-called "new media," contemporary art, and the art market are changing. The relationship between online and offline is becoming a more fluid one and in terms of authenticity, mutability, and openness is as important as any object. Instead of denying the realities of media art by simply transforming work into objects, or the opposite, staunchly defending the ephemeral quality of an online work by denying any object forms, many artists are working creatively within these new realities. In her work *Net Art Generations*, Lialina outlines this generational shift from artists "working with the Internet as a new medium," through those who "studied jodi at university," to the current generation of "artists working with the WWW as mass medium, not new medium" (Lialina 2007b). This shift is also reflected in collection and preservation practices.

An artist who has created a market for his Internet practice is Rafaël Rozendaal. Deeply committed to the non-objective nature of his chosen medium,

he ironically takes a more traditional approach to questions of authenticity. His works are single-page, flash-based websites with very simple interactive features. An image of Jello jiggles when your pointer hits it (jellotime.com) or a flower simply opens and shifts colour (likethisforever.com). After selling a number of web-based works, Rozendaal created his "Art Website Sales Contract" that clearly outlines how works of non-objective nature can be collected. In the preamble to his contract, he states: "I think in moving images, and I don't think moving images are objects. I place these moving images in domain names. Each URL is the title and the location of each art piece. These websites are public, their ownership is exclusive. Domain names are one of the internet's few scarcities. They are unique, they can't be forged or copied" (Rozendaal 2012).

While successful with outlining the terms of selling, Rozendaal's contract doesn't ensure long-term viability and authenticity. Within the contract, he transfers, along with the domain name, all responsibility for the work to the owner. For example:

a. Renew the domain, being part of the Artwork, always in time in order to have the Artwork accessible.
b. As long as it is technically feasible, keep the website, being part of the Artwork, online and accessible to the public.

While Rozendaal has outlined what the work for sale is, he leaves any future iterations up to its new owner. While this does nothing to solve questions of authenticity, ultimately, the banality of his contract normalizes the selling of such digital objects.

Another example of the authenticity shift in contemporary art is a body of work created by the artist Oliver Laric – *Versions* (2011–12). This multi-faceted work is an ongoing art project that involves a number of videos, "a series of sculptures, airbrushed images of missiles, a talk, a PDF, a song, a novel, a recipe, a play, a dance routine, a feature film and merchandise" (Quaranta 2012). The visually and theoretically rich *Versions* takes as its thesis that our digital reality is infinitely mutable and changing, borrowed and exchanged. In an always-updating and mutating form, Laric draws examples from classical sculpture, Disney, and North Korean propaganda to make the point that defining originality and authenticity are illusive and ultimately uninteresting goals. Versions of *Versions* are for sale, freely available, and distributed in a wide range of forms.

From Hirst to Rozendaal, from institution to private collectors, there is an acceptance that sometimes radical change and loss are part of the process of collecting contemporary art. From creation, through exhibition, sale and collection, a recognition and willingness to work with all of art's malleable forms is becoming a necessity. And that this process of an artwork's inevitable change should be managed in tandem with the artists who create it is of central importance. Terms like authentic, original, and unique, while perhaps not "inconsequential," have shifted from absolutes to gradients of managed change. The newly restored *The Physical Impossibility of Death in the Mind of Someone Living* is not the same object that it was in 1992, but that it is the same artwork should not be in question.

Figure 7.3 Oliver Laric, 2012, from *Versions* (an ongoing body of work). Image courtesy of the artist, Tanya Leighton Gallery, Berlin, and Seventeen Gallery, London

References

Arcangel, Cory. 2004. "Proceedings of *Echoes of Art: Emulation as a Preservation Strategy.*" Solomon R. Guggenheim Museum. Available at: http://www. variablemedia.net [accessed 14 October 2013].

Dimitrovsky, Isaac. 2004. *Final Report, Erl King Project.* Solomon R. Guggenheim Museum. Available at: http://www.variablemedia.net/e/seeingdouble/report. html [accessed 14 October 2013].

Framed. 2012. *Framed.* Available at: http://frm.fm/en [accessed 14 October 2013].

Jones, Caitlin. 2006. "Object and Behavior: Variable Media Preservation" in Joan Gibbons and Kaye Winwood (eds), *Hothaus Papers: Perspectives and Paradigms in Media Arts.* Birmingham: VIVID/Article Press, 187–92.

Jones, Caitlin. 2007. *State of the Art of Documentation.* Daniel Langlois Foundation for Art, Science and Technology. Available at: http://www.fondation-langlois. org/html/e/page.php?NumPage=2125 [accessed 14 October 2013].

Laurenson, Pip. 2006. *Authenticity, Change and Loss in the Conservation of Time-Based Media Installations.* Tate. Available at: http://www.tate.org.uk/research/ publications/tate-papers/authenticity-change-and-loss-conservation-time-based-media [accessed 14 October 2013].

Lialina, Olia. 2007a. "Flat Against the Wall." Art Teleportacia. Available at: http://art. teleportacia.org/observation/flat_against_the_wall [accessed 14 October 2013].

Lialina, Olia. 2007b. "Net Art Generations." Art Teleportacia. Available at: http://art. teleportacia.org/observation/net_art_generations [accessed 14 October 2013].

Quaranta, Domenico. 2012. "The Real Thing/Interview with Oliver Laric." *Artpulse Magazine.* Available at: http://artpulsemagazine.com/the-real-thing-interview-with-oliver-laric [accessed 14 October 2013].

Rozendaal, Rafaël. 2012. "Art Website Sales Contract." Available at: http://www. newrafael.com/art-website-sales-contract [accessed 14 October 2013].

Vogel, Carol. "Swimming With Famous Dead Sharks," *The New York Times,* October 1, 2006. Available at: http://www.nytimes.com/2006/10/01/arts/design /01voge.html?pagewanted=1 [accessed 14 October 2013].

Weinbren, Grahame. 2004. "Navigating the Ocean of Streams of Story." Solomon R. Guggenheim Museum. Available at: http://grahameweinbren.net/GW_ Papers/NavigatingOcean.html [accessed 14 October 2013].

Chapter 8

Curating Emerging Art and Design at the Victoria and Albert Museum

Louise Shannon

This chapter gives an overview of the exhibition *Decode: Digital Design Sensations* held at the Victoria and Albert Museum (V&A) from December 2009 to April 2010. I must start by placing the exhibition within a broader context of the Museum and of Contemporary Programmes, the curatorial unit from which many of these initiatives grew. The chapter describes some of the early curatorial strategies of the Contemporary Programmes unit and relates *Decode* to the broader context of the Museum's collections. An exhibition such as *Decode* was possible due to collaboration with a large number of departments and people across the Museum, and was often a testing ground for a number of alternative ways of working within the institution. The V&A holds the national collection of art and design. It interoperates these collections through an interest in process and materials of which digital is an emerging part of these collections.

The Museum of Manufactures was established in 1852 following the success of the Great Exhibition in the previous year. The founding principle of the Museum was to make works of art available to all, to educate and inspire contemporary British designers, and to boost British manufacturing both at home and abroad. Profits from the Exhibition were used to establish the Museum of Manufactures, with objects from the exhibition forming the basis of the V&A's collection (Baker 1999). The Museum moved to its present site in 1857 and was renamed the South Kensington Museum. Its collections expanded rapidly as it set out to acquire the best examples of metalwork, furniture, textiles, and all other forms of decorative art. It also acquired fine art – paintings, drawings, prints, and sculpture – in order to tell a more complete history of art and design. It was subsequently renamed the Victoria and Albert Museum in 1899 by Queen Victoria (Baker 1999).

The V&A holds collections divided primarily into materials and techniques, with the exception of the Asian collections. The Word and Image department collection includes prints, drawings, paintings, photographs, and digital art, plus the National Art Library and the Museum's archives. The Contemporary Programmes department was established in 1999 as a non-collection-based curatorial department (Lambert 2000). The Programme was a series of exhibitions, events, and interventions positioned in and around the permanent galleries. Early projects included the first solo exhibition of designer Ron Arad's

furniture in 2001 which was not "to be shown as we used to do these things in the traditional contemporary white box of the Boilerhouse exhibition space but as an intervention in our Medieval Treasury" (Lambert 2000). This signaled an early desire for the activities of the Contemporary Programmes to be at the heart of the Museum's activities, something that continued throughout the lifespan of the Programmes. The Programme explored a diverse range of contemporary practice, including architecture, graphics, product design, fashion, and digital media. The remit of the Programme was to showcase the work of contemporary artists and designers, reminding visitors to the V&A that it had always concerned itself with contemporary design practice. It was to introduce new and emerging design processes to the V&A's visitors through ways and means beyond a traditional exhibition (V&A 2005). The Programme has since had two permanent galleries to call home, the most recent of which – the Porter Gallery, which opened in 2007 – is positioned in the heart of the Museum adjacent to the Grand Entrance.

Digital art and design has been at the core of the curatorial strategy of the Contemporary Programmes unit since its inception in 1999. As the then Keeper of the Prints, Drawings and Paintings department, Sue Lambert, stated shortly after the Programme began, "engaging with contemporary culture in the same spirit as at the outset of the Museum means engaging with new types of products and practice" (Lambert 2000). As digital processes are becoming inextricably linked to the development of creative practice, from new forms of coding languages to new production and manufacturing methods, it became part of our role to explore these in the Museum context. Two early exhibitions that looked at these were *Designing in the Digital Age* (1999) and *Digital Responses* (2002), the latter having a microsite which can still be accessed via the Museum's website. According to Susan Lambert, then Chief Curator of Contemporary, the former of these exhibitions looked at how digital technologies had "transformed the process of design," while the latter showed digital "media as a medium specifically for original artistic expression" consisting of "a series of interventions by artists who will explore their responses to objects in the permanent galleries through digital means" (Lambert 2000).

Shhh ... Sounds in Spaces, an exhibition co-curated by Lauren Parker in 2004, featured 10 audio commissions, each responding to a geographical area or collection in the Museum. This audio was created by a range of practitioners, from musicians such as David Byrne to the Japanese duo Cornelius, as well as visual artists such as Jeremy Deller and Gillian Wearing (V&A 2006). Visitors to the exhibition were given a pair of headphones and a map, leaving them to create their own journey through the Museum. Infrared sensors would detect the visitors' MP3 players in the gallery and the audio would begin to play. Each person would experience the commissioned audio and the exhibition in a different way; conditions in the galleries would alter and the routes chosen by the visitors would change.

Audience and visitor experiences were at the core of much of the intention of the Contemporary Programmes from inception (Parker 2007). Historically, as a

non-collection department, the Contemporary Programmes department was able to experiment with objects and have more flexibility and license to test ideas or methodologies, trialing display strategies without having the same restrictions as objects held in the permanent collection would. From 2006, the V&A embarked on a series of digital-based commissions. Initially intended to be a yearly commission program, for three consecutive years it helped to establish a growing interest in engaging visitors with emerging art and design, reflecting the growing use and interest in digital technologies across a broad rage of art and design disciplines. The first of these commissions, *Volume*, an interactive lighting installation by United Visual Artists (UVA), was commissioned in 2006 for the John Madejski Garden. The Contemporary Programmes department invited UVA to create an interactive installation. The brief was to experiment, to utilize and highlight parts of the Museum that were typically underused by visitors in the winter months. *Volume* consisted of an interactive installation that transformed the John Madejski Garden over the winter with an array of light columns positioned dramatically in its center. The LED columns responded to movement, creating a series of audiovisual displays. The work was a collaboration between design collective UVA and Robert Del Naja (aka 3D) of Massive Attack, together with his long-term co-writer Neil Davidge (as part of their music production company, one point six). The commission brief developed out of discussions between the curatorial team and UVA with the aim to create an innovative visitor experience. The Garden became like a performance space, the platform became stage-like, with visitors moving in amongst the LED towers, each one of which responded to human presence. The project was almost wholly supported by corporate funding from PlayStation, something that has been fairly typical of the Museum's digital initiatives.

Universal Everything created the *Forever* commission in 2008, which was a series of generative animations. Animations were created in real time, responding to a generative electronic orchestra. The generative design system would self-podcast, releasing a film during each day of the commission run for visitors to download via iTunes. The piece was inspired by the solidity and fixed nature of much of the V&A's collection (Pyke 2008). Creative Director Matt Pyke wanted to highlight the fluid and transient nature of digital design, juxtaposing the sculptures of the Hinze Galleries with the large ever-changing work visible through the windows in the John Madejski Garden.

These commissions provided a space for experimentation. As with most museums, once an object has been acquired by the V&A, it becomes part of a rigorous and thorough collections management procedure. This is part of the well-documented challenge of acquiring variable media works into a collection of traditionally static objects. Commissions, however, can sometimes work outside of the full constraints of the institution and their status as a 'non-objects' can be used to advantage; curators can adapt the work in collaboration with the artist or designer to the surroundings, changing and shifting if needed during the course of the commission. The *Friday Late* program offers another occasion for experimentation. Created in 1999, *Friday Late* is a short window of three and a

half hours of programming that takes place across the Museum's galleries. Since the conception of the Contemporary Programmes unit, the *Friday Late* program has sought to enhance the exhibitions agenda whilst exploring creative practice. It provides a space for visitors to encounter new design practices in a very hands-on way. Planned approximately six months in advance, it allows for flexibility and an ability to reflect current trends within contemporary design practice. Installations can be created testing out experimental technologies with a live audience and prototypes developed over the course of one event using live visitor feedback. In February 2006, the V&A hosted one of its most popular *Friday Late* events to date, attracting very close to 6,000 visitors over three and a half hours. The night featured over 30 digital works, including interactive installations, film screenings, and a series of commissions that responded to the V&A's collection.

Decode

Staged from December 2009 to April 2010, *Decode* was the first large-scale exhibition at the V&A dedicated solely to digital art and design. The exhibition featured a broad range of work and included loans, existing works, and new commissions. It featured over 30 internationally based artists with over 35 works, ranging from prototypes borrowed directly from the artists to exhibition pieces loaned by contemporary galleries. The works were centered in the Porter Gallery, the Contemporary Programmes unit's temporary exhibition space, and at various points throughout the Museum. As previously mentioned, exhibitions hosted by Contemporary Programmes have often used the galleries around the Museum to encourage relationships between historic and contemporary practice. In *Decode*, objects were exhibited in the Garden, en route to the National Art Library, the Grand Entrance, and on the Exhibition Road façade. Part of the appeal of this was to increase the amount of works in the exhibition, as the gallery space would only allow around 30 works, as well as to exploit the potential of exhibiting digital-based works. The Exhibition Road façade was undergoing a thorough cleaning scheme during 2009 and the hoardings used to protect the Aston Webb Screen provided a surprisingly convenient surface to inhabit. Working with the Science Museum, which allowed the use of part of its building to project from, we were able to "plant" digital seeds that transformed in to Simon Heijdens' *Lightweeds* at the base of the hoarding. These seeds grew into weeds in real time over the course of the exhibition, inhabiting the whole of the hoarding at the end of the exhibition. The weeds would react to environmental conditions in the South Kensington area, responding to rain showers with blooms and blowing gently in the wind when it was blustery. It is hard to measure the impact of this work on the public as it was impossible to monitor audience response. It was on the outside of the building and would be switched on from dusk until dawn, free for visitors to observe throughout the night. A small label indicated that it was part of the exhibition, but it was most important that people would have a chance encounter with the work.

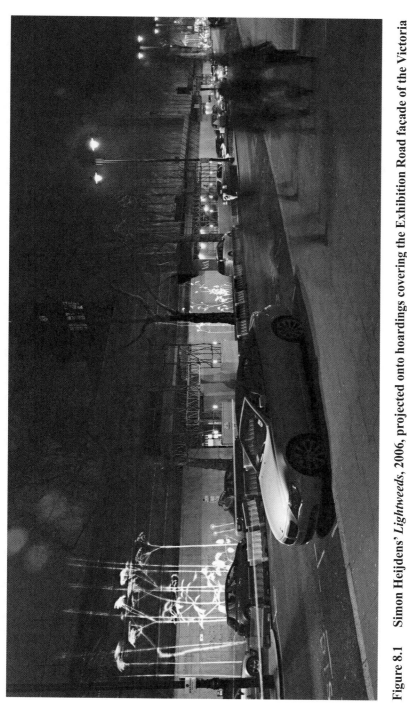

Figure 8.1 Simon Heijdens' *Lightweeds*, 2006, projected onto hoardings covering the Exhibition Road façade of the Victoria and Albert Museum as part of the *Decode* exhibition in 2009. Image courtesy of the artist © Simon Heijdens

Decode, supported by the business-to-business software company SAP, featured works ranging from screen-based animations to large-scale interactive installations, investigating three themes within contemporary digital art and design. *Code* looked at works using innovative programming, bespoke systems, or interesting open-source projects. *Interactivity* comprised works that responded to human movement and touch, either within the space or remotely. *Network* featured works that reflected upon the increasingly connected world, collecting and interpreting our digital tracks and residues left behind in our ever more connected worlds and translating these into data visualizations or graphic representations.

The exhibition, which was co-curated by myself and Shane Walter, Director of the digital arts organization onedotzero, was a collaboration that developed largely due to the success of the *Friday Late* program in 2006. When planning the exhibition, the team was acutely aware of the importance of the architecture of the exhibition space. A balance had to be sought between a relatively small exhibition space of 325m^2 and curators who were keen to show enough work to give a representative feel of the field in 2009. It is quite usual for the Museum to contract an external audiovisual (AV) consultant to position and program projectors, ensure timings are correct, and plan and produce audiovisual guides when needed within exhibitions. However, in the case of *Decode*, every piece of work in the exhibition would need some sort of specialist AV support. It was therefore key that a specialist contractor was appointed very early in the process of the exhibition design in order to create a space where nearly 30 works could live and breathe together for the duration of the exhibition. The 3D designer Francesco Draisci was contracted by the V&A to create the exhibition design. Aztec were contracted as the AV supplier for the exhibition as well as being on hand to maintain the works in the exhibition. Aztec worked hand in hand with Francesco Draisci to develop an AV map of the space, liaising with artists and designers directly so as to be able to scope out the needs of the works, realizing the impact of temporary exhibition walls on infrared technologies, or light bleed into other works on display. Although careful planning took place, the nature of the exhibition meant that some works had to change position during installation, wall positions had to be tweaked, and infrared cameras had to be shifted.

The projected visitor figures for *Decode* were 40,000. The Contemporary Programmes agenda targets visitors from the creative industries, those in education, and those belonging to the age range 18–34. Visitor surveys carried out throughout the exhibition show a slight shift in the demographics of the expected Contemporary Programmes exhibition-goer. The research was benchmarked against another contemporary exhibition, *Hats: An Anthology by Stephen Jones*, and two headline exhibitions, *Baroque: Style in the Age of Magnificence* and *Maharaja – The Splendour of India's Royal Court*. *Decode* had the highest proportion of male visitors of all the exhibitions during the period. The exhibition also attracted a markedly higher proportion of male visitors than the V&A overall: 43 per cent of males visited *Decode* compared with 35 per cent at the V&A overall in the period 2008–09 (Morris Hargreaves McIntyre 2010).

Figure 8.2 Installation view of the *Decode* exhibition at the Victoria and Albert Museum, 2009. Courtesy of the Victoria and Albert Museum © Victoria and Albert Museum

The age range of visitors was markedly different from those visiting other exhibitions and those visiting the V&A's permanent galleries. Fifty-seven per cent of the exhibition visitors were aged 18–34 compared to 29 per cent of all visitors to the V&A. Equally, the number of students visiting the exhibition was significantly higher for *Decode* than the other exhibitions during the period, including that of *Hats*. The comparison was 6 per cent for *Maharaja*, 8 per cent for *Baroque* and 12 per cent for *Hats*, whereas 24 per cent of *Decode's* visitors were students. Visitor research has also illustrated that *Decode* was successful in attracting visitors to the Museum for the first time, with 28 per cent of visitors to *Decode* not having visited the Museum before. Families were a surprise audience group: 16 per cent of audiences interviewed identified themselves as part of a family group, again significantly higher than other exhibitions at the time, with only 9 per cent of visitors to the *Maharaja* exhibition identified as being part of a family group during their visit.

The V&A commissioned Karsten Schmidt, one of the artists appearing in the exhibition, to create an animation that would also be used for the marketing campaign for the exhibition. The outcome, a project entitled *Recode Decode*, has become to be a very successful legacy for the exhibition. Developed in collaboration with Karsten Schmidt, the brand agency RKCR/Y&R, and the media provider CBS Outdoor, the animation was screened both on the London Underground and the exhibition microsite. Visitors were encouraged to recode the marketing campaign and upload their own versions, and the most interesting

would be screened. Visitors to the microsite could download instructions and use basic coding to "recode" the animation, the best of which being chosen to run as the lead image for the campaign. These are still available to see on the archived *Decode* microsite accessible via the V&A website. In attracting the audience, we employed a moving image campaign that enabled us to think differently as to how we attract audiences. However, in terms of converting potential audience to visitor figures, the research indicates that visitors to the website and word of mouth were the most effective in bringing people to the exhibition.

One of the greatest challenges was to represent both the exhibitions virtually. Early hopes of having an online exhibition space were very difficult to achieve. The Museum was in the process of redeveloping its website and timing became an issue with the two projects, meaning that it was not possible to achieve both the *Decode* publicity site and the online exhibition space at the same time. Initial plans for the microsite were to develop and host works created specifically for an online environment, only online. We had ambitions for an online commission, but in this case, it was not achievable due to timing issues relating to the relaunch of the V&A's main website.

Figure 8.3 Installation view of the *Decode* exhibition at the Victoria and Albert Museum, 2009. Courtesy of the Victoria and Albert Museum © Victoria and Albert Museum

Final visitor numbers to *Decode* in South Kensington reached approximately 95,000, plus a further 108,298 at the three international tour venues. The V&A has an extensive touring schedule and *Decode* visited the Central Academy of Fine Arts, Beijing, the Garage Centre for Contemporary Culture, Moscow, and the Design Museum, Holon. As part of the tour, we felt it important to keep the exhibition updated, commissioning works as the show progressed. This enabled the exhibition to continue to be updated as well as offering an opportunity for new responses from practitioners based in the host venue country. In China we commissioned Feng Mengbo and in Israel a number of smaller commissions were possible due to the support of the Porter Foundation.

Institutional Collaboration

The most fruitful institutional collaborations came from marketing, education, and the collections. During the run of the exhibition, we trialed and piloted numerous digital art and design workshops and formal courses. The legacy of these is still felt, with a very impressive digital strand run by colleagues in our Learning Team. Over the course of the *Decode* exhibition, we worked together on a digital weekend, combining our usual *Friday Late* activities with the learning weekend activities.

Certainly, one of the most meaningful collaborations came from discussions with colleagues from the Word and Image department: the curators of our computer art, and digital art and design collection, Douglas Dodds and Honor Beddard. As plans for *Decode* were developing, colleagues were working on a collaborative project with Birkbeck that ran from 2007 to 2010 entitled *Computer Art and Technocultures*. Funded by the AHRC, part of their research included examining the broader art historical, social, and technological contexts of recent computer art acquisitions at the V&A. Outcomes included publications, study days, and a display in the Museum. Working together with Douglas Dodds and Honor Beddard, the V&A curators and researchers on the project, we ensured that the exhibitions opened concurrently and combined efforts to guarantee a collaborative symposium, in which contributors from the *Digital Pioneers* exhibition were in conversation with contemporary practitioners from *Decode*, encouraging debate and the sharing of knowledge between practitioners such as Roman Verostko, Casey Reas, and Karsten Schmidt.

We worked to ensure that new works on display in *Decode* were offered a historical context that was not possible within the exhibition space. Visitors to each exhibition were encouraged to visit its counterpart, hoping that one would inform the other and vice versa. The *Digital Pioneers* exhibition, drawn from the UK's emerging collection of computer art and design, ran concurrently from December 2009 to April 2010 in the Julie and Robert Breckman Prints Gallery. The V&A has been collecting computer art since the 1960s, with substantial collections donated to the Museum in the early twenty-first century (V&A 2011). The collection comprises predominantly, although not exclusively, works on

paper, including prints, original plotter drawings together with photographs and exhibition posters, books, and other ephemera stretching from the 1950s to the present day. The collection represents the development of computer art as a discipline, tracing the early experimentation work of artists like Ben Laposky, Harold Cohen, and Paul Brown.

The collection, based in the Word and Image department, was added to with two large donations from the Computer Arts Society Collection and the Patric Prince archive. Acquired by the V&A in 2007 and 2008, respectively, these two important collections added to the initial objects in the collection. The V&A's holdings range from early experiments with analog computers and mechanical devices to examples of contemporary software-based practices that produce digital prints and computer-generated drawings. Several acquisitions were made from *Decode* into the permanent collection. These were mainly those that have a resonance with the existing computer art archive. A decision was taken that possible acquisitions would be discussed after the run of the exhibition and tour. This ensured that the objects have been assessed by curators, exhibition organizers, and conservation staff a number of times, both here and on the international tour. These meetings included myself, Douglas Dodds, and Melanie Lenz, together with information from Clair Battison in Conservation and members of the Exhibitions Team who had traveled the most to install and de-install the works on the tour. The objects acquired were mainly software-based pieces that have the flexibility of being displayed in a number of ways. Aaron Koblin's *Flight Patterns* and Daniel Brown's *On Growth and Form* were relatively easy to collect and do not depend on a large amount of hardware for support. *Recode Decode* was also acquired by the collection and is housed in our in-house data repository. Further acquisitions to the collection since *Decode* include rAndom International's *Study for a Mirror* and Casey Reas's *Process 18*. These more recent acquisitions by contemporary practitioners have signaled an ongoing commitment to collect and document emerging art and design practices. These acquisitions mean that the V&A now holds one of the world's largest collections of digital art.

Since entering the Museum, these objects have formed part of the permanent collection held by the Word and Image department. They join an active collection that is drawn upon for research, exhibitions, publications, and events. They are curated by Douglas Dodds and Melanie Lenz, who ensure they are cataloged and accessible for both the public and academics via exhibitions, displays, and publications.

Some works in the collection, such as Casey Reas's *Process 18*, are on permanent display and some are loaned out for temporary exhibitions. *Study for a Mirror* by rAndom International appeared alongside a broad range of art and design during the 2012 V&A exhibition, *British Design 1948–2012: Innovation in the Modern Age*, and in February–May 2013, Barbara Nessim was the subject of a temporary exhibition of which some of the works on display were drawn from the emerging collection of digital art. There have been a number

of publications that have drawn upon the collection, including the V&A's own *Pattern Book* series, illustrated with 64 works from the collection (Beddard and Dodds 2009). *British Posters: Advertising, Art and Activism* (Flood 2012) featured the *Recode Decode* project, and the collection has formed the basis of a number of lectures and teaching seminars, appearing as a module part of the V&A–Sussex University exchange program at both BA and MA levels. In addition, many of these works can be accessed by the public via the V&A's Study Rooms. Collecting art and design at the V&A therefore involves many different processes and people, with curators involved in commissioning and educational events as well as exhibiting, publishing, and distribution. The exhibitions themselves have included audiences in ways suggested by the digital media, and exhibiting has both helped to develop works before collection and tested ways of showing works from the collect in new ways. Digital art and design in V&A collections can therefore not only benefit from the historical background of early computer art, but can also look forward to future audiences and understandings.

References

Baker, Malcolm. 1999. "Museums, Collections, and their Histories." From *A Grand Design: The Art of the Victoria and Albert Museum*. Available at: http://www.vam.ac.uk/vastatic/microsites/1159_grand_design/essay-museum -collections-histories_new.htm [accessed 14 October 2013].

Beddard, Honor and Douglas Dodds. 2009. *Digital Pioneers (V&A Pattern series)*. London: V&A Publishing.

Flood, Catherine. 2012. *British Posters: Advertising, Art and Activism*. London: V&A Publishing.

Lambert, Susan. 2000. "Contemporary V&A," *Conservation Journal*, 34. Available at: http://www.vam.ac.uk/content/journals/conservation-journal/ issue-34/contemporary-v-and-a [accessed 14 October 2013].

Morris Hargreaves McIntyre. June 2010. "*Decode*: Digital Design Sensations. V&A Visitor Profile." Unpublished internal report.

Parker, Lauren. 2007. "Statement of Intent 2007–2012". V&A. Unpublished internal document.

Pyke, Matt. [Universal Everything] 2008. *Forever*. Available at: http:// universaleverything.com/#clients/va-museum, http://www.vam.ac.uk/content/ articles/f/garden-installation-forever [accessed 14 October 2013].

V&A 2005. V&A Strategic Plan 2005–2010. London: V&A. Available at: http:// media.vam.ac.uk/media/documents/legacy_documents/file_upload/13138_ file.pdf [accessed 14 October 2013].

V&A. 2006. Shhh ... Sounds in Spaces. Exhibition Gallery Guide. Available at: http://www.vam.ac.uk/content/articles/n/national-art-library-catalogue [accessed 14 October 2013].

V&A. 2011. "The V&A's Computer Art Collections." Available at: http://www.
 vam.ac.uk/content/articles/t/v-and-a-computer-art-collections [accessed 14
 October 2013].

Chapter 9
Collecting Experience:
The Multiple Incarnations of
Very Nervous System

Lizzie Muller

David Rokeby's *Very Nervous System* is an interactive installation in which the audience's movements are translated into a complex, responsive soundscape. Rokeby has been exhibiting the installation since the 1980s and it is now seen as a classic media artwork. It has been written about extensively, awarded several prizes, exhibited frequently all over the world, and acquired for the permanent collection of numerous museums. But what exactly is *Very Nervous System*? Over its 30-year life, the work has had many incarnations. Its hardware, software, physical configuration, and sonic output have all changed. The technological core of the system has been used as the substrate for many of Rokeby's other works and has also been packaged, sold, and extensively used as a tool by other artists.

The mutability, celebrity, and longevity of *Very Nervous System* all pose interesting questions about the documentation, conservation, and contextualization of media artworks over time and through processes of change. These questions are compounded by the emphatically experiential nature of the work. As a physical installation, *Very Nervous System* is basically an empty space – a zone of potentiality that is activated by the participation of its audience. The work exists in the multiple individual experiences that have brought it to life in its many configurations over three decades. In 2009, the Ludwig Boltzmann Institute for Media.Art.Research commissioned Caitlin Jones and I to create a documentary collection for *Very Nervous System* based on its presentation in the exhibition *See This Sound* at the Lentos Art Museum in Linz (Jones and Muller 2010). Caitlin Jones is a curator and archivist who played a key role in developing the Variable Media Network approach to conservation, and our approach to this collection followed a model that we describe as an Indeterminate Archive: a collection of materials that provides multiple perspectives on an artwork. Through extensive interviewing with both artist and audience, this model seeks to capture the relationship between audience experience and the artist's intent or, as we have framed it, "between real and ideal" (Jones and Muller 2008b). This strategy acknowledges the fundamental importance of audience experience to the existence of new media artworks and creates a place for the audience within the documentary record.

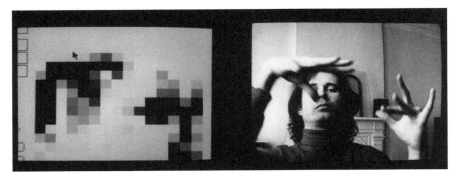

Figure 9.1 David Rokeby as seen by *Very Nervous System*, Toronto, 1990. Image courtesy of David Rokeby

In this chapter, I argue that one of Rokeby's primary reasons for creating *Very Nervous System* was to draw attention to the *experience* of interacting with computers. Understanding the changing nature of the audience's experience is therefore a key part of understanding the way this artwork expresses and explores the changing relationship between humans and technology. Through an examination of the materials in the Indeterminate Archive, I investigate here the shifting connections between the artwork, the artist's intent, and audience experience over the 30-year existence of *Very Nervous System*.

Audience Experience and Artist's Intent in the Indeterminate Archive

The documentary and conservation challenges of media art are by now well rehearsed. The lack of a stable and discrete "object," the rapid obsolescence of technology, the reluctance of museums to collect media art works, and the challenge of audience interaction – all of these issues have prompted a wealth of interesting discussions and practical initiatives over the past decade (Jones 2008). In the absence of a stable artifact, the cornerstone of many preservation strategies for new media works is artist's intent. Perhaps pre-eminent amongst contemporary approaches is that of the Variable Media Network, the key principle of which is to record information about the essence (or "kernel") of an artwork independent of the media in which it manifests (Depocas et al. 2003). This should allow future conservators to emulate the work's essential characteristics when its original technological ingredients are obsolete. These characteristics may be the work's behavior, its external appearance, or any number of other factors *as defined by its creator*.

Documentation of artist's intent is crucially important, but as this chapter will show, intent is not necessarily more stable than the artwork it produces. The Indeterminate Archive developed by Caitlin Jones and myself is based on recognition of the archival value of both the artist's intent *and* the audience

experience of the work. Audience experience is a vital ingredient of any artwork, but its importance is magnified where a work itself is mutable, or based on a process or interaction. As I have argued at length elsewhere (Muller 2008, 2010), media art theory emphasizes the role of participants, but descriptions of their experiences in their own words rarely appear in the documentary record. The Indeterminate Archive seeks to address this gap.

We developed our first Indeterminate Archive in 2007 for another of Rokeby's works, *The Giver of Names*, at the Daniel Langlois Foundation in Montreal (Jones and Muller 2008a). We have described our methods and the rationale behind them in detail elsewhere (Jones and Muller 2008b), but a summary here will help the reader to understand the structure and materials of the Archive. It combines a lengthy artist interview with numerous audience interviews, backed up by technical information, links to other exhibitions, and a bibliography. The artist interview is based on techniques drawn from the Variable Media Network questionnaire (which focuses on the relationship between the conceptual and technical aspects of the work), with additional questions that encourage the artist to describe the work as closely as possible in terms of audience experience. The audience interviews draw from techniques in Oral History and Experience Design to elicit rich, descriptive accounts of artwork encounters that move from perception, through action to cognition and critique. Essentially, the interviewer encourages the participants to describe their experience as closely as possible before they begin to evaluate the work or their own actions.

This approach seeks to capture rich and vibrant oral accounts that bring the work to life in all its variety and complexity. The Archive draws attention to the dialog between artistic intent (or the "ideal" version of the artwork) and the audience experience (or "real" instantiation of the work). It is important to be clear that whilst the Indeterminate Archive uses the audience experience as companion and, sometimes, even counterpoint to artist intent, it does not aim to show that the artist is wrong or that the work has failed. Rather, the dialog between real and ideal is intended to create a valuable indeterminacy, which captures the work's mutability and contingency.

The invitation to create a second Indeterminate Archive for *Very Nervous System* offered a compelling opportunity for two reasons. First, *Very Nervous System* provides an unmatched demonstration of the importance of experience in media art. Second, its celebrity and longevity make it a fascinating focus from the point of view of the relationship between real and ideal. The work is, for many, one of the first successful artistic experiments in gestural, embodied interaction. A large number of texts have been written about it (a bibliography of which is included in the Indeterminate Archive) and many curators and critics of media art have read about it without ever having experienced it themselves. As Erkki Huhtamo has argued, *Very Nervous System*'s fame "may have perpetuated some fixed ideas about its nature and prevented critics from appreciating some of its dimensions" (Huhtamo 1998). This begs the question of how the "real" individual experiences of the work in 2009 relate to this powerful and long-lived ideal.

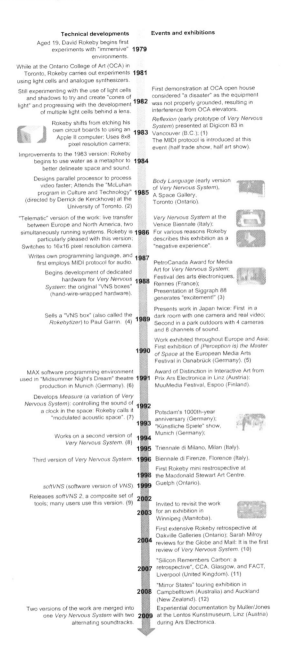

Technical developments

Aged 19, David Rokeby begins first experiments with "immersive" environments. **1979**

While at the Ontario College of Art (OCA) in Toronto, Rokeby carries out experiments using light cells and analogue synthesizers. **1981**

Still experimenting with the use of light cells and shadows to try and create "cones of light" and progressing with the development of multiple light cells behind a lens. **1982**

Rokeby shifts from etching his own circuit boards to using an Apple II computer; Uses 8x8 pixel resolution camera; **1983**

Improvements to the 1983 version: Rokeby begins to use water as a metaphor to better delineate space and sound. **1984**

Designs parallel processor to process video faster; Attends the "McLuhan program in Culture and Technology" (directed by Derrick de Kerckhove) at the University of Toronto. (2) **1985**

"Telematic" version of the work: live transfer between Europe and North America, two simultaneously running systems. Rokeby is particularly pleased with this version; Switches to 16x16 pixel resolution camera. **1986**

Writes own programming language, and first employs MIDI protocol for audio. **1987**

Begins development of dedicated hardware for *Very Nervous System*: the original "VNS boxes" (hand-wire-wrapped hardware). **1988**

Sells a "VNS box" (also called the *Rokebytizer*) to Paul Garrin. (4) **1989**

1990

MAX software programming environment used in "Midsummer Night's Dream" theatre production in Munich (Germany). (6) **1991**

Develops *Measure* (a variation of *Very Nervous System*): controlling the sound of a clock in the space: Rokeby calls it "modulated acoustic space". (7) **1992**

1993

Works on a second version of *Very Nervous System*. (8) **1994**

1995

Third version of *Very Nervous System*. **1996**

1998

softVNS (software version of *VNS*). **1999**

Releases *softVNS 2*, a composite set of tools; many users use this version. (9) **2002**

2003

2004

2007

2008

Two versions of the work are merged into one *Very Nervous System* with two alternating soundtracks. **2009**

Events and exhibitions

First demonstration at OCA open house considered "a disaster" as the equipment was not properly grounded, resulting in interference from OCA elevators.

Reflexion (early prototype of *Very Nervous System*) presented at Digicon 83 in Vancouver (B.C.); (1) The MIDI protocol is introduced at this event (half trade show, half art show).

Body Language (early version of *Very Nervous System*), A Space Gallery, Toronto (Ontario).

Very Nervous System at the Venice Biennale (Italy); For various reasons Rokeby describes this exhibition as a "negative experience".

PetroCanada Award for Media Art for *Very Nervous System*; Festival des arts électroniques, Rennes (France); Presentation at Siggraph 88 generates "excitement!" (3)

Presents work in Japan twice: First in a dark room with one camera and real video; Second in a park outdoors with 4 cameras and 8 channels of sound.

Work exhibited throughout Europe and Asia; First exhibition of *(Perception is) the Master of Space* at the European Media Arts Festival in Osnabrück (Germany). (5)

Award of Distinction in Interactive Art from Prix Ars Electronica in Linz (Austria); MuuMedia Festival, Espoo (Finland).

Potsdam's 1000th-year anniversary (Germany); "Künstliche Spiele" show, Munich (Germany);

Triennale di Milano, Milan (Italy).

Biennale di Firenze, Florence (Italy).

First Rokeby mini retrospective at the Macdonald Stewart Art Centre, Guelph (Ontario).

Invited to revisit the work for an exhibition in Winnipeg (Manitoba).

First extensive Rokeby retrospective at Oakville Galleries (Ontario); Sarah Milroy reviews for the Globe and Mail: It is the first review of *Very Nervous System*. (10)

"Silicon Remembers Carbon: a retrospective", CCA, Glasgow, and FACT, Liverpool (United Kingdom). (11)

"Mirror States" touring exhibition in Campbelltown (Australia) and Auckland (New Zealand). (12)

Experiential documentation by Muller/Jones at the Lentos Kunstmuseum, Linz (Austria) during Ars Electronica.

Figure 9.2 Timeline of David Rokeby's *Very Nervous System* by Caitlin Jones and Lizzie Muller. Image courtesy of Ludovic Carpentier and the Daniel Langlois Foundation

The Lifespan of *Very Nervous System* (1983–?)

One of the characteristics of new media artworks is the appearance of a date range rather than a single authorial date to signify the ongoing making and remaking of the work. *Very Nervous System* is a particularly striking example of this phenomenon. Its date range is not only long but also unstable. The work appears with different start and completion dates in different catalogs, and there are even two different date ranges given on Rokeby's own website (1982–91 and 1986–90).

In the Indeterminate Archive our strategy for addressing this long and varying lifespan was to produce a timeline that fleshed out the history of the work. The timeline charted the major technical developments of the work and mapped these onto significant exhibitions and moments in its life. We created the timeline during a conversation with Rokeby in which he told the "story" of *Very Nervous System* in as much detail as he could. Whilst there are necessarily gaps and omissions in this story, it reveals what seemed important to Rokeby about the work as he looked back on it in 2009. In the Indeterminate Archive we acknowledge the contingency of this version of the artwork's life by including the original hand-drawn timeline alongside the formalized version that contains links to additional information (videos, texts, excerpts from interviews, and technical documents) connected to the events that appear (Figure 9.2).

The variable start dates given for the work reflect the different decisions by Rokeby as to whether to include in the date span other works, which in retrospect appear to be early versions of *Very Nervous System*. The timeline shows how *Very Nervous System*, as a fully-fledged work, grew from Rokeby's aim between 1979 and 1982 to create an "immersive environment." In 1983 there was a work-in-progress showing of Rokeby's ongoing project, at which point he introduced an Apple II computer and gave the work a name: *Reflexions*. He suggests that this exhibition is probably the most accurate start date of *Very Nervous System* (Rokeby 2010). This is therefore the date we have used when referring to the work in the Archive, but the timeline makes clear that 1983 is in fact just one moment in a process that has no clear beginning.

The timeline not only tells the story of *Very Nervous System* but also offers insights into the history of media art as an emerging form and of David Rokeby's own career. Early showings at Digicon (which Rokeby refers to in the timeline as 'half trade-show half art show') and SIGGRAPH '88 reveal the close relationship between the nascent community of new media artists in the 1980s and the academic and industrial research base in computing. As the work gains reputation, it is shown in the burgeoning international scene of specialist media art venues and festivals such as Ars Electronica, Linz, and the European Media Arts Festival, Osnabruck. The work begins to garner awards, and by the 1990s, it is shown increasingly at mainstream events like the Venice Biennale in 1996 (see Figure 9.3).

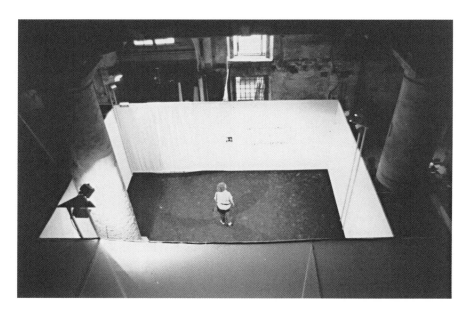

**Figure 9.3 *Very Nervous System* at the Venice Biennale in 1986. Image
 courtesy of David Rokeby**

In the 2000s, when Rokeby was recognized as a significant artist, the work
is shown in retrospectives, where it is accorded a privileged position as his
defining achievement.[1]

The technical developments of the work over 30 years offer a glimpse into
the history of creative computing. Rokeby notes the release of the MIDI protocol
at the same event as the first official showing of *Reflexions* in 1983 and the
emergence of MAX MSP in 1991 – both hugely significant tools for artists
working with computers. These developments in creative computing intersect
with *Very Nervous System*'s double life as both artwork and creative tool.
The timeline shows how the "suite of tools" called "VNS" emerged from the
artwork – first appearing as custom hardware, the "VNS box" or "Rokebytizer"

1 Rokeby did not mention the various acquisitions of *Very Nervous System* during
the creation of the timeline perhaps because he did not believe they related to significant
technical or conceptual developments in the life of the work, but the list of organizations
that have bought the work offers an insight into the vital role of science museums in
collecting and preserving media art. It has been acquired by five institutions, all with an
interdisciplinary science/art emphasis: Technorama Schweiz in Winterthur in around 1993;
Citta della Cienza in Naples in around 1994; COSI (Columbus, Ohio Science Museum)
in 1995; Technopolis, near Brussels in around 1999; and the Clay Center (a science and art
center), Charleston, West Virginia in 2002.

(which was first sold to Paul Garrin, the video installation and interactive artist, in 1989). The software version (*softVNS*) was released in 1999 and *softVNS 2* followed in 2002. Rokeby estimates that around 100 users purchased this version (Rokeby 2013). Numerous other histories spring from VNS's adoption as a tool. In particular, it has played a significant role in the field of technologically mediated performance (see, for example, Winkler 1997). It has also been used as a tool for rehabilitation in medical and therapeutic contexts (Rokeby 1991, 1998). Rokeby's desire to make the system available to others as a tool was motivated by the same spirit of curiosity that drives his own art practice. In 2006 he explained this in an interview with the curator Peter Ride:

> One of the things that is a key part of my engagement in this stuff is a love of the generation of possibilities and developing software is a very powerful way to produce possibilities ... I'm fascinated when I see people use these things in ways that I hadn't imagined. (Rokeby in Ride 2006)

In order to understand the constant making and remaking of *Very Nervous System* over 30 years, the work must be seen not only as artwork and tool, but more fundamentally as an *ongoing* live process of artistic enquiry. As Peter Ride has pointed out, *Very Nervous System* is not only the technological substrate of Rokeby's oeuvre, it is also its conceptual base layer: a set of ideas and questions that has fueled his practice. As an artist, Rokeby uses the process of making or remaking works as a way of engaging with the computational medium, the nature of interaction, and questions of human and machine perception. Whilst finished artworks may emerge from this process, there are no clear "end" points:

> My practice, in some ways, is better framed as a research practice. I rarely start with an absolutely clear end point in mind when I'm working on a project, so how can I know when I am done when I don't have a coherent goal? (Rokeby in Ride 2006)

Understanding *Very Nervous System* as a process of ongoing exploration allows us to understand its documentary and conservational challenges more richly. *Very Nervous System* is a mode of engagement and enquiry. As such, it does not fit easily within a museological culture dominated by objects, scarcity, and a conception of authenticity that forces inauthentic borders around intellectual and creative processes.

The various end dates given for *Very Nervous System* indicate moments when Rokeby believed that the process of research embodied in the work had come to an end. By 1991, *Very Nervous System* had reached a point of technical and conceptual maturity and stability, and it received an Award of Distinction for Interactive Art at Ars Electronica. At this point, Rokeby claims he had exhausted his interest in what *Very Nervous System* could tell him (Rokeby 2010). The year 1991 could have been (and was for a while) a plausible point to end the

Very Nervous System date range (notwithstanding conservational "tweaks" to hardware and software), until 2003, when Rokeby accepted an opportunity to revisit the work and make substantial changes for an exhibition in Winnipeg. At this point, he created a new sound palette and a new behavior paradigm in which sound responses were located spatially around the installation. According to him, the 2003 version "looks back" to the earliest 1981 version of the work where sounds were also arrayed in space (Rokeby 2013). In light of the 2003 remake of the work, it is probably most realistic to say that *Very Nervous System* cannot be given a reliable end date whilst Rokeby himself is still alive.

Caroline Seck Langill (2009) has investigated the conservational challenges brought about by this lifelong link between artists and technological artworks. Because of the difficulty inherent in any staging of a complex media work, she suggests that it is inevitable that "as long as [media] artists are alive, they will essentially fulfill the role of conservators of their own work." In responding to the possibilities of new technologies, artists will "upgrade" their work, often fundamentally altering it for each exhibition. In doing so, she argues that artists, unlike museum conservators "are less concerned with the original components of the work, with the result that its historical context and original intentions may be lost." She also states that artists' "self-emulation" through continual upgrades obscures an important aspect of the work's historical narrative, which "acted as evidence of what was happening on the frontier of new technologies and situated the work within the limits of available platforms and computer language."

There is a tension at the heart of any attempt to conserve, document, or exhibit *Very Nervous System*. On the one hand, it is vital to recognize the fundamental nature of the work as a medium of exploration, which must change over time. On the other hand, it is important to document, or if necessary excavate, these changes in order to articulate the historical context and significance of the work. David Rokeby has written of himself: "I'm an interactive artist, I construct experiences" (Rokeby 1998). He sees his artworks not only as machines for creating certain kinds of experience but also as machines which create a space for *reflection on experience*, and particularly on the impact of computers on our experience of the world. The lifespan of *Very Nervous System* has seen the ascendance of the personal computer, the World Wide Web, the mobile phone, surveillance technologies, and computer game culture. How different would the experiences of audiences have been in 1983, 1993, 2003 and 2013?

In the Indeterminate Archive we have attempted to capture evidence of these experiences in 2009. Whilst the voices of audiences from previous decades cannot be recovered, we are not completely without evidence as to their nature. Rokeby's own practice is so focused on audience experience that, as the following section demonstrates, it is possible to trace, within his own reflections on experiential esthetics over the past three decades, the changing relationship between his own intentions, the audience's experience, and technological change.

David Rokeby's Experiential Esthetics

There is an anecdote that appears frequently in Rokeby's interviews and writing: in preparation for the exhibition of *Reflexions* at Digicon 1983 (the "first" public exhibition of *Very Nervous System*), he spent many intense hours programming and preparing the work. When it was installed, he was surprised to discover that despite reacting perfectly to his own movements, it would not respond to visitors. Later, watching a video of himself within the installation, he realized that his own movements had become jerky and unnatural. He had slowly, over his intense period of creation, adjusted his own behavior to the system rather than adjusting the system's behavior to his own.

This formative experience made a deep impression on Rokeby. First, it persuaded him of the immense power of the interface to shape human behavior (a theme that occurs frequently in his work and writing) and, second, it demonstrated to him the importance of watching audiences interact with his work and adjusting it based on their experiences. In this sense, *Very Nervous System* is a deeply interactive artwork – not only does it create an open system that responds to participants in real time, it also responds to (or learns from) the experience of those participants through the intervention of its maker over time.

This has interesting implications from the perspective of experiential documentation. Rokeby becomes a close observer of audience experience and publishes the results of his "free form research" (Rokeby 1998) into the esthetics of interactive experiences in several essays (see, for example, Rokeby 1990, 1996, 1998). This means that despite the absence of first-hand audience accounts of the work over its 30-year life, we are still able to gain an insight into the changing nature of audience experience and its relationship to Rokeby's own intentions through his critical reflections.

Rokeby's experiential esthetics are grounded in a fascination with perception and the immense complexity of the relationship between human beings and the world. Much of his work uses the medium of the computer to reveal or examine this complexity through comparison, simulation, reduction, or augmentation of perceptual processes. *Very Nervous System* was an attempt to create an esthetic experience that would "draw as much of the universe's complexity into the computer as possible" (Rokeby 1998). In the early days of the installation, Rokeby was motivated by a desire to create an immersive and visceral experience (Rokeby 1991, 2010). *Very Nervous System* began as a phenomenological enquiry and in the 1980s, he claims, the audience experienced the installation as a "phenomenon":

> There was no [textual] explanation when the work was displayed in 1983, and people had no experience of computers at all. People were experiencing it completely fresh. It was a phenomenon. (Rokeby 2010)

According to Rokeby, audiences in the 1980s reacted to the installation as a whole space or an environment rather than as a technological system. He believes that there was a sense of magic about the installation that was later lost. He remembers with particular fondness the work being described as "the room that sings" (Rokeby 2010). He describes dancers reacting instinctively and viscerally to the work, and responding as if the room itself was "spirited" when technical interference produced unexpected effects.

In the late 1980s and early 1990s, as people became more familiar with interactive technology, Rokeby believes there was a period of time where "the question of how it works was overtaking the experiential" (Rokeby 2010). He noticed the emergence of a particular kind of behavior, which he describes as "the first test of interactivity" (Rokeby 1998). Participants would enter the work and repeat a single gesture two or three times as a kind of enquiry to the system. If the work responded the same to each repetition, the participant's demeanor would change and they would repeat the gesture, this time as a command. Frequently, he claims, the installation would not respond to this command gesture, which would unwittingly betray the user's change in motivation through different physical dynamics.

This audience tendency towards trying to control the system was, for Rokeby, a distraction from the main intention of the work. He explains that the question he wanted the installation to provoke was "how do I work – not how does the system work" (Rokeby 2010). The crucial question of control became incredibly important to him and figures prominently in his writing over the next 20 years. One of the fundamental reasons he cites for creating the work was to cede some creative power to the audience (Rokeby 1990); however, the nature and degree of that power is the focus of ongoing critical reflection throughout his career.

Rokeby's written text accompanying *Very Nervous System*'s entry to the Ars Electronica Festival in 1991 gives a fascinating insight into his thoughts about the work at a pivotal moment in the work's life. He created *Very Nervous System* chiefly, he claims in this document, to counter the dominant characteristics of the computer and allow people to experience Human-Computer Interaction differently. For Rokeby, since the prevailing interactive paradigm was of control and mastery, *Very Nervous System* became instead "a zone of experience, of multi-dimensional encounter" (Rokeby 1991). The 1983–2003 versions of the work (unlike other movement-based interaction systems) sense overall movement within the space, and analyze and respond to that one variable in complex and unpredictable ways (see Figure 9.4). As a result, the feedback from the system to the interactor is both immediate and vague. There is no clear evidence of cause and effect, but rather a sense of an emerging relationship. For Rokeby, this experience of complex and unpredictable interaction between human and computer leads to an evolving dialog in which "the notion of control is lost and the relationship becomes encounter and involvement" (Rokeby 1991).

In 1991, after a decade of intense work with the *Very Nervous System*, the Ars Electronica document makes it clear that a tension is emerging for Rokeby between

the seductive, visceral, and immersive experience that "informed a lot of the initial development of the work," and a desire for a more critical and reflective experience, which makes the nature of interaction more visible to the participant. During the late 1980s and early 1990s, Rokeby claims that the hype around interactivity led to a loss of criticality: "the level of enthusiasm was picking up and the level of criticality was falling down" (Rokeby 2010). As a result, his desire to make more critical and reflective experiences grew. His published writings from the mid- and late 1990s reveal an increasingly polemical position about the social and political role of interactive art in countering the unconscious and unquestioning adoption of computer technology in all areas of life.

In his 1998 essay "The Construction of Experience," Rokeby argues that the interface between humans and computers is not an inert means for controlling an interactive system, but "by defining a way of sensing and a way of acting in an interactive system the interface defines the 'experience of being' for that system" (Rokeby 1998: 31). Since such interactive systems are pervading all areas of our lives, the interfaces we design will necessarily begin to transform our ways of being in the world – from our sensory and physical experiences to our social attitudes and belief systems. This becomes a problem, he argues, when we, as users, are unable to *see* these transformations: "When an interface is accepted as transparent, the user and his or her world are changed; the transforming characteristics of the interface … are incorporated into the user and the user's world-view" (Rokeby 1996: 153).

In his essay "Transforming Mirrors: Control and Subjectivity in Interactive Media" (1996), Rokeby argues that technological artworks have a special role to play in drawing attention to the way interfaces construct our experiences of the world. All interactive technologies, he argues, reflect the consequences of our actions and as such can be seen as mirrors. Part of their allure exists in the pleasure of seeing oneself reflected and augmented. The esthetic impact of interactive artworks, however, lies not only in their ability to reflect but also to "refract" images of the self – to act as "transforming mirrors" that offer insights into our relationship to ourselves, our technologies, and the world around us (Rokeby 1996). For Rokeby, the difference between reflection and refraction is strongly related to his recurring interest in control. An interactive technology producing too direct a reflection – where the interface appears transparent and control over the technology seems absolute – creates a "closed system" in which the participant becomes entranced and stupefied. Conversely, "to the degree that a technology transforms our image in the act of reflection it provides us with a sense of the relations between this self and the experienced world" (Rokeby 1996).

In *Very Nervous System*, the refracted images of the self are expressed and experienced in the complex and indirect relationship between sound and movement. This emphasis on relationships explains the peculiar fact that Rokeby says comparatively little in his texts about the actual sounds that *Very Nervous System* makes. In 1990, he wrote that: "The music of the *Very Nervous System*

installations is not so much in the sounds that you hear but in the interplay of the resonances that you feel as you experience the work with your body" (Rokeby 1990). The sounds made by *Very Nervous System* are not intended to be listened to, he continues, but to create a kind of physical presence that the body can relate to: "sound has a sculptural presence, both as an extension of the body and as a physical reality which one encounters with the body" (Rokeby 1990).

In our 2009 interview, Rokeby reflected on what he describes as his "awkward relationship" to the sound of *Very Nervous System*, caused by the fact that "it was not designed to be great music, but designed to be a great marker, a great artefact to enable interaction, to encourage movement" (Rokeby 2010). The sounds of the work are the area of human experience that he finds most opaque: "I really don't know how it's heard," he said. His ambivalence to the sound throws into question two commonly repeated descriptions of the work in catalogs and articles: first, that it is a sound installation; and, second, that it is a kind of gestural instrument.

Given the close relationship between *Very Nervous System* and technological change, it is impossible not to question its continued relevance 30 years after its first appearance. Attitudes to interactivity have changed drastically over three decades, as Rokeby pointed out in his interview within the Archive: from the wonder of the 1980s and the feverish enthusiasm of the 1990s to a point in the 2000s where unencumbered interaction becomes "something that we experience everyday" (Rokeby 2010). In some ways, he believes, this familiarity with interactive technology allows contemporary audiences to experience the work with some of the directness of audiences in the early 1980s. Crucially, for him, the continued relevance of the work remains in its complex treatment of control:

> The more we have tools that can control things, the more we have to ask what an appropriate control relationship to the things around us is … I don't think that stops being important. And I don't think our relationship to our body stops being important. So there are some basic grounded human questions that remain in the work and remain accessible. I think that means it stays relevant.

Asked to describe his ideal experience of *Very Nervous System* in 2009, Rokeby acknowledged his own shifting position over the years:

> There are a million ways to answer that question, here's how I choose to answer it today: The work is about stereoscopic proprioception … In an ideal experience in the slippage between your own sense of movement and the feedback you are getting from the system there's energy, depth, another dimension, a possibility to understand something new about your body. (Rokeby 2010)

Rokeby's concept of "stereoscopic proprioception" reconciles the tension between the experiences of visceral immersion and critical reflection. It unites two different, simultaneous perspectives on the self: an immediate sensory experience and a transformed or refracted reflection. He hopes that the combination of these two

different perspectives will offer the participant an insight into their relationship to the world around them. What light can the *actual* experiences of audiences in 2009 shed on this mutable and powerful ideal?

2009 Incarnations

In 2009, *Very Nervous System* was shown in Linz (Austria) at the Lentos Art Museum as part of the exhibition *See This Sound: Promises in Sound and Vision*. This exhibition examined the relationship between image and sound in contemporary and historical artworks, with a particular emphasis on media technology[2]. Partly because of the historical nature of the show, Rokeby showed a combination of the "old" (1983–91) version of the work and the "new" 2003 version of the artwork.[3] The switch between the two versions was triggered by a period of stillness followed by new activity. This meant that most often the versions would change between one participant leaving and another participant entering the installation.[4] From a historical perspective, Rokeby felt that this combination of the two versions gave a better insight into the nature of *Very Nervous System*. He also thought it was "helpful to show two completely different kinds of sonic relationship to demonstrate that the music is not really an aesthetic decision" (Rokeby 2010).

Linz is a particularly interesting place in which to document audience experiences of a media artwork. The city has been home to the renowned Ars Electronica Festival since 1979 and the Ars Electronic Centre since 1996. The population of Linz therefore has had an unusual level of exposure to media art for the past 30 years. The interviews were conducted during the 2009 Festival, so they include a relatively high number of media arts professionals. Twelve interviews were collected and they include a range of different levels of knowledge of the *Very Nervous System* – from first-time encounters to reunions. The interviewees have a wide spread of ages and levels of experience with technology and art.[5]

2 The exhibition was organized by the Ludwig Boltzmann Institute for Media.Art. Research (the commissioners of the Indeterminate Archive for the *Very Nervous System*) in collaboration with the Lentos Art Museum, Ars Electronica 2009, and Linz City of Culture 09. An extensive archive related to the show can be found at: http://www.see-this-sound.at.

3 The dates given in the exhibition catalog for *Very Nervous System* are, however, 1986–91, demonstrating the ongoing challenge of accurately dating the work.

4 The installation was exhibited as an enclosed space of around 4 x 5 m, with solid white walls. For full technical details, images, and video of Rokeby interacting with both versions, see the online archive at: http://www.fondation-langlois.org/html/e/page.php?NumPage=2186.

5 The majority of the interviews were conducted in English and include a mixture of native English and German speakers. There are some obvious drawbacks to conducting interviews about personal experience in a foreign language and some interviewees struggle

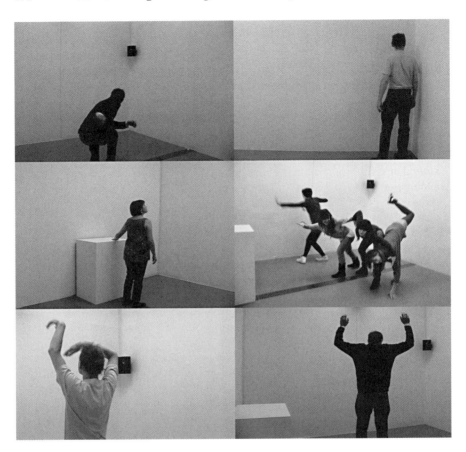

**Figure 9.4 *Very Nervous System* at the Lentos Art Museum, Linz, 2009.
Image montage by Katja Kwastek courtesy of David Rokeby**

I will focus here on a few particularly interesting interviews that offer insights into the relationship between audience experience, artist's intent, and technological change.

Perhaps the most interesting interview from a historical perspective is with a professional musician called Günther. Günther, a Linz local, plays the theremin and has a great deal of experience in art, technology, and gestural interaction. When he enters the installation, he recalls that he previously experienced *Very Nervous System* many years ago. Whilst he is not sure of the date, he believes that

to explain themselves clearly in English. In the transcriptions used here some of the original grammar and phrasing has been altered for the sake of comprehension. All interviewees are referred to in the archive by their first name.

he saw the work at Ars Electronica and it seems likely that this experience was at the 1991 exhibition.

Günther remembers that the first time he saw the work, he did not enjoy it. He felt that its responses were too unpredictable and that it was impossible to trust that it was really interactive. This time, he experiences the 2003 version and feels that it is much more responsive. He spends time trying to work out how the installation reacts to various movements and then he explores, with very small movements of his fingers, how sensitive the system can be. He describes it as "an instrument that I can control very precisely."

Günther's experience offers an interesting counterpoint to Rokeby's strong aversion to direct control. In contrast to Rokeby's intention to create a sense of complexity, which, like reality, is beyond total comprehension, Günther describes his satisfaction at discovering that "I'm in a Universe that is governed by laws that are very understandable." For him, the increased sense of control that he feels between the previous and the current versions makes the experience much more engaging. This time, he says, he feels he can "trust" the work.

Günther, as a theremin musician, is perhaps more attuned than most to the potential of the installation as a controllable instrument. His sense of the increased sensitivity raises some interesting questions about how the work has changed over time. In the Archive interview, Rokeby acknowledges that refinements in camera technologies and processor speeds over the past 20 years have made the work more sensitive. In a classic instance of conservational emulation (where the behaviors of former technologies are replicated in newer systems in order to preserve an important aspect of the work), Rokeby says he has purposely prevented the sensitivity from reaching the (now technically possible) point where every finger twitch or eyelash flutter elicits a response. For him, the important sensitivity threshold is that the work reacts when you move and is silent when you are still. The increased sensitivity and controllability experienced by Günther, however, raises the possibility that Rokeby's intense interest in the limitations of and alternatives to the experience of direct control resulted, to some extent, from the imposed limitations of technological possibilities. It is at least clear that over time, the level of control has changed from being in part technologically determined to being authorially driven.

Günther, on the other hand, raises the interesting possibility that it is not the work that has changed, but himself. In the intervening years, he claims, he has had lots of experience of touch and gestural interfaces, all of which make him more able to "engage with the work." In an insightful comment, which goes to the heart of the nature of *Very Nervous System*, Günther points out that if the audience has changed, then, necessarily, so has the artwork:

> **Interviewer**: Your feeling is that the work is different now or that your relationship to it is different now?

Günther: My relationship is definitely different, the work itself I assume is objectively the same, but again where does this work exist outside of myself, outside of my own experience?

Another interviewee with a long relationship to the *Very Nervous System* is the curator Peter Ride. In 2005, Ride organized a major Rokeby retrospective that featured *Very Nervous System*. In Linz he happily played within the installation, saying it was like meeting "an old friend." Ride, who has installed the work himself three times, finds the installation at the Lentos Art Museum physically ugly and uninviting:

> It's really ugly, and I think that's a real issue. It's like it's been stuck in the corridor to the cleaner's cupboard. There's nothing about it that's inviting. It's one of those conundrums of participatory art and new technology pieces that lots of things that people will think about with other objects – the aesthetics – aren't being brought into play here.

Ride believes that this physical ugliness would be off-putting for many gallery visitors and the work in this format would not "give people permission to participate." Ride's experience is a useful reminder that, whatever changes have occurred to the hardware and software over 30 years, *Very Nervous System* remains essentially an empty room. A great deal of the audience experience has nothing to do with the technology, but instead is to do with curatorial decisions, production values, and contextualization. Of course, these are elements which Rokeby is well aware of, but to which he has a very open attitude. The work has been shown in all different configurations – light, dark, private, and public. Rokeby describes instances where he has made the technology disappear as much as possible, and others where he has made certain elements of the apparatus fairly obvious. Whilst he has opinions about the way in which it works best, he allows a great deal of input from the curators whenever the work is displayed; *Very Nervous System* is necessarily site-specific (for better or worse) and this is part of its inherent openness.[6]

Almost all the interviewees are surprised to see an empty room when they enter the installation. Even though sound was the focus of this exhibition, interviewees often still searched for something to look at. The visibility of the technical infrastructure in this case (a fairly noticeable camera, speakers, and box containing the computer) attracted a great deal of attention from many of the interviewees. One frequent response was to attempt to find the edges of the interactive area and to avoid interacting by staying in parts of the installation where the system could not "see" you. Susanna, a middle-aged chemistry teacher with a keen interest in art,

6 I have direct experience of Rokeby's openness in this regard, having installed *Very Nervous System* myself twice as the co-curator of the exhibition *Mirror States* in Sydney and Auckland (2008).

describes this experience: "I tried to find the space where there is no interaction – in this corner and along the walls I did not produce any sound. Somehow it was the feeling that Big Brother is Watching You, so I am looking for a space where I am not observed." Susanna's experience suggests that the increase in camera-based surveillance over the past 30 years has had an important impact on the way in which audiences react to the camera-tracking technology of *Very Nervous System*.

Several of the interviewees' responses support Rokeby's instinct that people do not "listen" to the sounds, but experience them relationally through their body. Günther suggests that the sounds are rather "80s," but he doesn't think that is important as "any sound is potentially interesting." Elfi, a middle-aged arts professional, likes the sounds of the 2003 version, which she likens to rubbish, metal, stones, and keys. Music, she thinks, "would be weird," but fundamentally her experience of the sounds is neither positive nor negative; it is simply "something you can relate with."

Claudia, a 61-year-old woman working in a publishing house, reminds us that media art is still an unfamiliar and challenging form for many audiences. For Claudia, who has a great interest in art and whose husband is an artist, the exhibition *See This Sound* was a disappointment as they had come expecting to see paintings. She remarks that she is not at all familiar with this kind of art and she feels that "older people can't understand very much about technics." Unexpectedly, however, she enjoys *Very Nervous System*. When she enters the space, she runs rapidly around the edges of the room and then begins to move very slowly. The installation, she says, gave her "a motive to move," and though her desire was to move fast, the work influenced her to slow down. It made her think it would be good to slow down not only physically but "also in life." She describes the piece as "meditative" and "moving," and says that it helps you "contemplate." Claudia shows no interest in how the work functions technically. Her description is close to Rokeby's 2009 ideal of "stereoscopic proprioception," in which the felt experience of movement combines with the feedback from the system to give her an insight into her relationship to movement and her way of being in the world.

The experience of another interviewee, Alexander, shows that this sense of joyful and immersive exploration does not rely upon technical naïvety. Alexander is a young software engineer. He has a moderate knowledge of art and a great deal of knowledge about computers. He experiences the pre-2003 version of the work and quickly understands that it is responding to his movement. His description of his own reaction to the work eloquently evokes Rokeby's ideal notion of a dialog of mutual influence:

> **Alexander:** It gave me a sort of joy, because it is me being a part of this art piece … It was as if a kid opens up a new toy and is playing with it … I was triggering the art, and without me it is just a few loud speakers and a camera. As I moved in there, the artwork adapted to me, and not me to the art object. Here there was a possibility to act outside of myself and the art piece interacts with me.

Interviewer: Do you mean that you had more control?

Alexander: Not control, but influence.

For Alexander, the "joy" of the work is that he feels *involved* in the art. This is, he thinks, unusual and rewarding, as "art is usually static." His experience is an important reminder that even in 2009, when daily life is dominated by human-computer interaction, interacting with an artwork remains an unusual, and potentially deeply pleasurable, esthetic experience.

There are many more experiences recorded in the Archive, all of which provide unique and partial views of the *Very Nervous System*. It is tempting to think of all these partial perspectives as the parable of the blind men and the elephant, where each person grabs a different part of the creature. But in this case and, I would argue, in the case of any artwork, there is, in fact, no elephant. *Very Nervous System* does not exist anywhere as a complete, or fully knowable thing, but as a process of investigation on the part of the artist and a cumulative collection of experiences on the part of the audience. I hope that this chapter demonstrates that paying attention to and documenting where possible these experiences can offer valuable insights into the ongoing process that is *Very Nervous System*.

Conclusion

This chapter demonstrates that the history of *Very Nervous System* contains within it countless different and sometimes contradictory stories. Apart from its many "real" incarnations in the bodies and memories of the individual participants who have experienced it, there are multiple "ideal" images of the work, as Rokeby himself has acknowledged, in the mind of its creator. There are also, of course, countless possible critical and historical interpretations of the work, of which the argument presented in this chapter is only one.

The approach I have taken – of tracing the shifting relationship between audience experience and artist intent – is made possible through a painstaking process of recording and listening to audience's descriptions of their own experiences. Whilst I passionately advocate the value of documenting experience, the chapter concludes with a cautionary postscript. Such dense audiovisual documentary collections require significant resources both to produce and to maintain. Developments in technology – including social, portable, and locative media – offer new opportunities for the audience's voice and opinions to be documented. However, high-quality experiential documentation will always need significant hands-on production and curation in order to be searchable and usable. Since the creation of the Indeterminate Archive for *Very Nervous System*, the commissioning agency (the Ludwig Boltzmann Institute for Media.Art.Research) has closed and the hosting organization (the Daniel Langlois Foundation Centre for Research and Documentation) has "dematerialized." Whilst the Daniel Langlois

Foundation (DLF) web presence remains active and well maintained (meaning that the Indeterminate Archives can still be accessed), its physical archive has been accessioned by the Cinémathèque Québécois.

It is likely that the greatest value of the Indeterminate Archive will be realized in the future, when *Very Nervous System* is 50 or 100 years old, when David Rokeby himself is no longer able to provide upgrades and explanations, and when our current relationship to computers and gestural interaction seems as antiquated as the telegraph. It is therefore important to remember that the digital archives created to preserve the fleeting experiential aspects of new media art share with those works a fundamental instability.[7] The traditional meaning of the term "to curate" – as a duty of eternal care – emerges strongly, in the face of these shifting sands, as an ongoing responsibility for all curators, researchers, and artists involved with new media art.

References

Depocas, A., Ippolito, J. and Jones, C. (eds). 2003. *Permanence through Change: The Variable Media Approach*. Montreal: Daniel Langlois Foundation; New York: Solomon R. Guggenheim Museum.

Huhtamo, E. 1998. "Silicon Remembers Ideology, or David Rokeby's Meta-interactive Art," in *David Rokeby: The Giver of Names*, edited by A. McPherson and D. Esch. Ontario: MacDonald Stewart Art Centre, 16–30.

Jones, C. 2008. "Surveying the State of the Art (of Documentation)." Available at: http://www.fondation-langlois.org/html/e/page.php?NumPage=2125 [accessed 14 October 2013].

Jones, C. and Muller, L. 2008a. "David Rokeby, *The Giver of Names* (1991–) Documentary Collection." Available at: http://www.fondation-langlois.org/html/e/page.php?NumPage=2121 [accessed 14 October 2013].

Jones, C. and Muller, L. 2008b. "Between Real and Ideal: Documenting New Media Art," *Leonardo*, 41(4), 418–19.

Jones, C. and Muller, L. 2010. "David Rokeby's *Very Nervous System* (1983–) Documentary Collection." Available at: http://www.fondation-langlois.org/html/e/page.php?NumPage=2186 [accessed 14 October 2013].

7 One solution to this problem is to include audience experiences within the interpretation and publication strategies surrounding exhibitions. Since the creation of the Indeterminate Archives, I have worked with the Museum of Contemporary Art in Sydney, Australia to produce a "Living Catalogue" for a survey exhibition of the work of Anish Kapoor (MCA 2013, Muller 2013). Like the Indeterminate Archive, this multimedia publication for tablet computers includes interviews with the artist and with both professional and general audience members. The wide distribution of this publication means that these experiential documents are not reliant on a centralized archive for storage and access.

Langill, C. 2009. "Self-Emulation: Upgrades in New Media Art and the Potential Loss of Narrative," *Convergence: The International Journal of Research into New Media Technologies*, 15(3), 347–58.

MCA (ed.). 2013. *Anish Kapoor ePublication*. Sydney: MCA Publications. Available to download at: http://www.mca.com.au/apps/mca-publications/anish-kapoor-epublication [accessed 14 October 2013].

Muller, L. 2008. "Towards an Oral History of Media Art." Available at: http://www.fondation-langlois.org/html/e/page.php?NumPage=2096 [accessed 14 October 2013].

Muller, L. 2010. "Oral History and the Media Art Audience," in *Archive 2020: Sustainable Archiving of Born-Digital Cultural Content*, edited by Annet Dekker, Amsterdam: Virtueel Platform, 71–9.

Muller, L. 2013. "Experiencing Anish Kapoor" in *Anish Kapoor ePublication*, edited by MCA, Sydney: MCA Publications. Available to download at: http://www.mca.com.au/apps/mca-publications/anish-kapoor-epublication [accessed 14 October 2013].

Muller, L. and Jones, C. 2009. "An Indeterminate Archive for David Rokeby's *The Giver of Names*." Paper to the Re:live Media Art Histories Conference, Melbourne, 26–29 November.

Ride, P. 2006. "Interview: David Rokeby in Conversation with Peter Ride," in *The New Media Handbook*, edited by A. Dewdney and P. Ride. New York: Routledge, 217–25.

Rokeby, D. 1990. "The Harmonics of Interaction." *MUSICWORKS*, 46.

Rokeby, D. 1991. "Very Nervous System Installation Details and Requirements." Submitted to Ars Electronica Festival 1991. Available at: http://www.fondation-langlois.org/pdf/e/VNS-Project-Description.pdf [accessed 14 October 2013].

Rokeby, D. 1996. "Transforming Mirrors: Control and Subjectivity in Interactive Media," in *Critical Issues in Electronic Media*, edited by S. Penny. Albany: State University of New York Press.

Rokeby, D. 1998. "The Construction of Experience: Interface as Content," in *Digital Illusion: Entertaining the Future with High Technology*, edited by C. Dodsworth Jr. New York: ACM Press, 27–47.

Rokeby, D. 2010. "Interview with David Rokeby," in C. Jones and L. Muller, "David Rokeby's *Very Nervous System* (1983–) Documentary Collection." Available at: http://www.fondation-langlois.org/html/e/page.php?NumPage=2187 [accessed 14 October 2013].

Rokeby, D. 2013. Unpublished personal communication from David Rokeby to Lizzie Muller.

Winkler, D. 1997. "Creating Interactive Dance with the Very Nervous System." Paper to the 1997 Connecticut College Symposium on Arts and Technology. Available at: http://www.iar.unicamp.br/lab/luz/ld/C%EAnica/dan%E7a/creating_interactive_dance_with_nercous_system.pdf [accessed 14 October 2013].

Chapter 10

Murky Categorization and Bearing Witness: The Varied Processes of the Historicization of New Media Art

Sarah Cook

Introduction

> You can't save the spirit of a new media work by fixing it in time or place, anymore than you can save a life of a butterfly by pinning it to a wall. (Ippolito 2011)[1]

Curators like to believe that the activity of curating art – which sometimes (but not necessarily) includes the collection of art – is the necessary precursor to the historicization of art. Before you study something, you have to be able to look at it; to look at it, you have to have found it, and hopefully, if you aren't the first to have found it, someone has already noted its name and description down somewhere, and put it in a recognized category of "things." So far, so taxonomically true. The chapters in this book have addressed questions of how the subsequent process of the collection of artworks is managed from the perspective of the museum, its audiences, and its conservators. It has been suggested that roles overlap between the early-stage tasks of finding, naming, and showing to the latter-stage tasks of filing and preserving (more here in the field of new media and digital arts than in other contemporary arts). Yet what if instead of looking backwards – assuming those named things which are collected (pinned like dead objects onto boards and filed in drawers, later to be written about) are the subject of art history – we look forwards, to how the early stages of curatorial activity (the finding, naming, and showing) inform what, from the wide world, is to become a possible subject for art history in the first place?

This process – *historicization* – is complicated when dealing with live and changing things, never mind emerging forms or things not yet named and categorized. Consider Charles Darwin's fascination with insects and beetles, which he observed live in their natural habitat and collected feverishly to study

1 With due acknowledgement for Ippolito's important work under the rubric of the Variable Media Initiative, I will continue with this metaphor of pinning insects to boards (see also Ippolito 2008).

later.[2] Insects, in many cases, have short lifespans, so conjecturing about their evolution, species modification, and diversification across generations was possible for Darwin using both methods of study – observing the live thing in its context and considering the dead thing in its file drawer. Art historians, when addressing currently alive art and the newest of art forms, need similarly multiple methodologies and opportunities for analysis. Art history is currently stuck in an ever-widening rift between its modes of scholarship (how it studies the dead thing) and contemporary artistic practice, which includes curating (and therefore the near-impossibility to be at any critical distance from the thing in its live habitat). The more that contemporary practice and curating entail context-led temporary event structures and increasingly fragmented global outputs, the more the rift widens.[3]

While art historians continue to use mostly the same old methodologies – considering the artist's biography or the close reading of the discrete object of art, separated from its context – artworks continue to evolve, using new technologies, new tools, and enjoining new audiences in their production and dissemination. The field of art history has struggled to take into account the evolving and technical nature of the contemporary work of art, and the fact that it is not a static, fixed object (though it may seem to be so in a photograph). Methods of analysis based on understandings of the artwork as autonomous object are inadequate for addressing art forms which are created collaboratively in multidisciplinary teams, which are ever changing in their appearance and behavior (the work might be generative or algorithmic) and which rely on a continual flow of development of technology, with all its social implications.

The problem of art history's (lack of) consideration of new media art – which Edward A. Shanken has been trying to rectify (2005) and Claire Bishop has now brought to wider attention through her own acknowledged ignorance as much as anything else (2012) – is very likely related to the collection of that art. Are there not enough dead insects in files to study, or not the opportunities to study live insects in their habitat … or both? In his research paper for the London-based Tate Gallery's research project "New Media Art and the Gallery in the Digital Age," art historian Charlie Gere writes:

2 Darwin wrote: "I must have observed insects with some little care, for when ten years old (1819) I went for three weeks to Plas Edwards on the sea coast in Wales, I was very much interested and surprised at seeing a large black and scarlet Hemipterous insect, many moths (Zygaena), and a Cicindela which are not found in Shropshire. I almost made up my mind to begin collecting all the insects which I could find dead, for on consulting my sister I concluded that it was not right to kill insects for the sake of making a collection" (Smith 1987).

3 This "crisis" facing the field of art history has been well documented over the last 25 years. Art historian Hans Belting (1997) has written of "the end of the history of art," which when taken alongside the work of Arthur C. Danto (1998), suggests that in the twentieth century there has been a demise in the idea of artistic development as progress through history which can be understood meaningfully; namely, the postmodern end of art as we know it. And yet art has not ended, although the boundaries of what the term encompasses are continually shifting, as are the contexts in which it is understood.

> The most cursory comparison between the history of post-war art and the Tate's holdings will demonstrate that, for all its intentions to represent, as best it is able, art of that period, there are many forms of practice it has failed to engage with completely or at best only partially or belatedly. These include: Cybernetic Art, Robotic Art, Kinetic Art, Telematic Art, Computer Art and net. art. (Gere 2004)

This list of categories of missing art already seems woefully out of date. And yet, as the other chapters in this book show, these collections are one of the first points of call for art historians.

So what if instead of looking backwards, we look forwards: how might curating, as a practice which has kept pace with new media art, interrupt the formation of a canon or reshape art history in relation to these collections and object-oriented histories?

What Might Go in the Collection (Hindsight)

Curator Laurence Sillars outlined to me in conversation the rationales for art acquisition, in part in reference to the Tate Liverpool, where he worked from 2004 to 2009. He indicated that often what informs the acquisition of a work – for curators and trustees alike – is what it might connect to that is already in the collection (one might imagine 10-year-old Darwin exclaiming "Ah, I don't have that bug yet!").[4] For new media art, as Beryl Graham's chapter notes, this may be simply a problem of taxonomy – the category of the new work might not connect to any of the existing categories listed in the museum's collections-management database. The reason that new media artworks are not in the collection may be that there is not anything in the collection to connect it to or, moreover, that those connections haven't been thought through by the curators yet:

> You need both an existing art history and the distance of time to find the position of [a] new work within the trajectory of art history. When museums are collecting things one of the first questions is, "well what can we show it with? What would be an interesting pairing?"

4 To quote Darwin again: "But no pursuit at Cambridge was followed with nearly so much eagerness or gave me so much pleasure as collecting beetles. It was the mere passion for collecting; for I did not dissect them, and rarely compared their external characters with published descriptions, but got them named anyhow. I will give a proof of my zeal: one day on tearing off some old bark, I saw two rare beetles, and seized one in each hand; then I saw a third and new kind, which I could not bear to lose, so that I popped the one which I held in my right hand into my mouth. Alas! it ejected some intensely acrid fluid, which burnt my tongue so that I was forced to spit the beetle out, which was lost, as was the third one" (Smith 1987).

> So with new media art how do you categorise it and make those value judgments
> and say, "well if we buy it we could do this great display pairing it with this
> person, this person and this person?"

> People still think in boxes, even if we are all utterly interdisciplinary now. But
> if a collection has been in existence for 20, 50 or 100 years, you still have those
> divisions. Mapping a new work into a pre-existing territory, which was defined
> long before this new trajectory was made, is difficult. (Sillars 2013)

Institutional collections will have clearly defined mandates and acquisition
policies, which, as commented on by Beryl Graham in this book, might not
mention media art because their institutions cannot agree on what it is. One useful
definition of media art from the Alberta Media Arts Alliance Society (AMAAS)
(AMAAS 2012) is "artist initiated and controlled use of film, video, new media,
audio art, and related media." This agreement on definitions, and shared interest, is
what defines a public collection. So, for instance, Tate has acquisition committees
based specifically in areas of special shared interest, such as Latin American Art,
or photography (because they recognize that they missed the early period of that
art form) (Morris 2012). These areas of interest are therefore just as likely to be
geographic as medium-specific, and collecting is often based around a regional
basis – considering how artists are important in relation to their local contexts.

This might be entirely the wrong paradigm for networked new media art which
is collaborative across time and space, and which is based on variable media,
or intermedia, and ever-changing elements. Then again, as in the words of Jean
Gagnon, formerly curator of media arts at the National Gallery of Canada, in the
case of Canadian new media art, it could be just the right paradigm:

> being the National Gallery of Canada and Canada as a country having certain
> fictions – national fictions under the flags of [media theorists] [Harold] Innis,
> [George] Grant, [Marshall] McLuhan – about or rooted in certain ideas of
> communication technologies, therefore making it fruitful to defend a certain
> idea of art, technology, and national identity. So in a way I thought that the role
> of the Gallery was also to participate in the development of artists' works using
> those communication technologies. (Gagnon 2001)

The work Gagnon undertook at the Gallery stands as an anomaly in institutional
histories of the curating of new media art (Cook 2003, 2004). In addition to
supporting new work in new media art through commissions and acquisition,
he also excavated older works already in the collection and re-presented them in
exhibitions, adding to the history of technology-led art practices in Canada, as was
the case with Toronto-based artist Norman White. Gagnon pointed out that the
curatorial effort to acquire a work because it connected to something already in the
collection, or other contemporaneous art practices, was, however, at the expense
of an appreciation of that work on its own technological terms:

The case of the three electronic sculptures by Norman White is quite indicative of a number of factors with regards to the curators' functions in relation to their acquisitions. These three works were purchased around 1972–1974 from the Electric Gallery in Toronto – a gallery that ceased existing soon after. The works themselves are all from 1970–1972 – if my memory is good – and they show early examples of electronic works with integrated circuits and custom-made electronic circuitry. So after the purchase they were shown and then they went back into the vaults up to 1993, when I brought them out. Obviously when we plugged them in, they didn't work. In the curatorial files I found nothing on the technical aspects of the piece. This shows you that most curators had very little concern for these aspects of technological works. They were not trying to care for these and they were mostly concerned with the works' relevance to the collection, to the current practices and the placement of the work in certain narratives of art history. But fortunately, in this particular case, Norman White was (and is) still alive, so he came to Ottawa and worked with the restoration department and repaired the pieces and installed them. But before he left the gallery he left technical drawings of the circuitry that are now in the curatorial files. Basically this time, we documented the piece as an after thought. (Gagnon 2001)

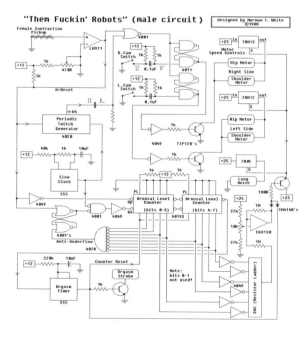

Figure 10.1 Norman White, *Them Fuckin' Robots (Schematic)*, 1988. Image courtesy of the artist and Jean Gagnon © Norman White

Figure 10.1 shows a later work than those in the collection of the National Gallery of Canada, but one which has been in danger of being lost to art history; the work exists only in the form of documentation, including schematics, notebooks, photographs, and video of a performance of the work, all in the artist's own collections.

This anecdote reveals the driving impetus in the collection of artwork – acquiring because the content of the work might relate to current practices or particular narratives. This tactic has often meant that a new and emerging "medium-led" category – such as electronic or digital arts – has been overlooked. Or are new media artworks there in the collection, just not "tagged" as such? Recent museological studies (including the research in this book) are now asking if there exist media art collections that currently aren't described as such.[5] Being able to identify what is in your collection is the first step, as the 2011 AMAAS study suggests:

> The process of establishing media art collections necessarily involves the strategic development of standard definitions that will result in a common understanding of *what* constitutes a media art collection, both within artist-run culture and institutions. Can you quantify your collection? How so – Do you have an organized, searchable database? Do you know what formats all of the work is on? Can you search for media artworks by format, by artist, by title? Is your database accessible online? Do you know the date range for the works in the collection? Are they all copyrighted works; if so, do you know how to contact the copyright holder? (Wozny 2011: 74, emphasis in original)

These questions to curators imply that the physical accessibility and control of the collection (its storerooms, the formats of the work within it) are as important as its intellectual accessibility and control (the naming, category or definition, the copyright, the catalog). If your curatorial work is concerned with the finding, naming, and showing, then acquisition might not just be a question of what category to put the work into, but of what new category might be required.

5 For example, curator Darko Fritz has been funded by Fonds BKVB, Amsterdam and the Mondrian Fond, Amsterdam to research early media art collections in the Netherlands. From this he curated the exhibition *Nature and Early Visual Computer-Generated Art in the Netherlands (before 1980)*, including the work of artists: Compos 68 (Jan Baptist Bedaux, Jeroen Clausman, and Arthur Veen), Michael Fahres, Lambert Meertens, and Leo Geurts, Samuel Meyering, Herman de Vries, and Victor Wentink, all as part of Coded Perception, organized by SETUP, Utrecht, the Netherlands, October 27–November 18, 2012. The exhibition announcement prompted Bruce Sterling to describe Darko Fritz as a "one-man tech-art history machine" (Sterling 2012).

What Could Go in the Collection (Foresight)

A story from the American Museum of the Moving Image (AMMI) in New York from the very early days of the browsable web (c. 1998) is interesting to cite at length on the question of agreeing an acquisition policy and trying to predict what future categories of artistic practice might emerge as technologies change. What follows are the words of then curator (now executive director) Carl Goodman:

> we began unknowingly collecting digital media. The museum collects; their mission was founded in the idea of collecting the material culture, movies, television, or video ... but we're also collecting the stuff that's involved in the process of making, marketing, and exhibiting. It's that attitude of being really focused on the process – that is the idea that there may be no fixed finished work. That is what we collect. The context of the work includes how it is received and its impact on audience prior to collecting it, where perhaps the impact on society of that work is something that will happen later ... When looking at new media, these attitudes have helped situate us quite nicely. We can look at some of the problems that there are in collecting, let's say, a website, CD-ROM, or dynamic audiovisual media of some sort, which may depend on a particular platform for it to be experienced – but, in a sense, could be persistent in some way where there is no fixed identity of the work and it changes over time. In some sense, it's defined in relationship to what it's linked to, what it links to, and what it's linked from ... The idea that it has ceased to be in any way interesting once it's no longer new is still something we're very, very interested in. Some of the naiveté present in technology-based work many years down the road is really, really wonderful, and it's important to preserve that as well. (Goodman 1998: 869)

In 2005, Steve Dietz and I curated an exhibition called *The Art Formerly Known as New Media*, which was based on the notion that the newness of new media art was not its most interesting categorization. Included was a work which was being cared for, though not yet entirely fully acquired by, the Museum of the Moving Image[6] – Michael Naimark's *See Banff!* The work is a modern reworking of a kinetoscope, based on travelogues and stereoscopic views of the landscape. The museum was very interested in the work's digital restoration and its future exhibition possibilities from the point of view that the work would remain relevant for how it addresses, in its conception if not in its technology, the mediated ways in which we see the world. *See Banff!* has since been highlighted as a direct precursor, in terms of viewing experience, to the contemporary technology of Google Street View.[7]

6 AMMI (or MOMI as it is now known, having dropped the "American" from its title) – for more information, see its website at http://www.movingimage.us.

7 For more information about precursors to Google Street View, see http://www.computerhistory.org/atchm/going-places-a-history-of-google-maps-with-street-view.

Thinking outside of the existing categories, imagining how artworks might read in the future and identifying what new categories are needed are all challenging aspects of a curator's remit.

What You Want in the Collection (Insight)

As Beryl Graham has noted in her introductory chapter, many collections of new media art are not actually of art but of documentation of art or other ephemera. With the rapid spread of content online and the many possible digital manifestations of a single idea or work, actually trying to collect a work must, to some curators, feel like a Sisyphean task, or like *Hand Catching Lead*, Richard Serra's 1968 16 mm film – even when you've caught the fast-moving thing, it's not long before you've lost it again. Certainly, my own personal new media art archive is an inadvertent collection amassed through my own practice as a curator, not a collector (and even the failings of my practice). It is comprised of the detritus and context surrounding networked practices, from invitation cards and exhibition press releases to correspondence with artists, small print-run leaflets, stickers, CD-ROMs, and digital files and free downloads (such as artist-written software or browser plug-ins). There is likely, in most curators' collections of ephemera, "exhibition copies" – executable files or burnable video images used to run projections or installations in a gallery or classroom. These usually come with instructions from the artist that the files are to be destroyed at the end of the presentation/exhibition, but for whatever reason have yet to be.[8] As with the fragility of other intermedia practices, such as Fluxus, one has no way of knowing if, pending accidental safekeeping, such multiples and ephemera, if excavated, systematized, and cataloged, could prove more useful to art historians than what is already in the national public collections.

As the famous essay "Unpacking My Library" by Walter Benjamin ([1931] 1969) attests, the acquisition process is key to the work's personal value – in my case as a reminder of a curatorial activity. In private collections, monetary value is accrued by the circulation of your collected works or how long you keep them hidden before selling them on. This is not necessarily the way that works of media art accrue value – exhibition and documentation is patchy, it is not always your "unique" copy (original or not) which is exhibited but simply another version; the information about the work stands to accrue more value than the work itself. Moreover, most technology-savvy art collectors are collecting art to seem cool and to be associated with the cutting-edge manifestation of technology's playful or political aspects, not out of an interest in having the only copy of the original thing (Gamerman 2013). The proliferation of copies is not to be railed against,

8 Alana Kushnir has written "When Curating Meets Piracy: Rehashing the History of Unauthorized Exhibition-Making," an interesting article concerning showing artists' works without the artists' permission (Kushnir 2012).

but without an agreed manifestation of value – a critical scale against which to judge the manifestation of the work – there is little impetus on the part of art historically minded collectors, such as museums and national bodies, to invest in new media art if they are primarily concerned with its exhibition value as a unique object.[9] This aspect of art's engagement with media technologies was predicted by artist Les Levine in an article he wrote in response to the *Information* exhibition shown at the Museum of Modern Art in 1970:

> Collecting art has been a way of socially identifying oneself ... the problem of collecting art objects is that the information reads out more about having money and power than it does about being aesthetically involved or concerned with art ... the only step left now would be for the collector to become an artist. He must be directly involved in art production. He could do it by selecting various groups of art and showing them in a similar way to that in which the curator of the Museum of Modern Art put on the "Information" show. (Levine 1971)

The *Information* exhibition featured a number of systems-based and conceptual artworks in which the idea of the work trumped its physical manifestation (which in some cases could be enacted by anyone). With systems-based art and art made using executable files in new media, with infinite variations and reproductions, as well as work which responds to its own time and place, this makes all the more sense. It could be argued that this is the new normal when it comes to the "collection" and display of "works" online. Are Pinterest boards or tumblr blogs the *Information* shows of today?

Categories (Oversight)

This question of how information and documentation relates to the work of art – and that of the categories, whether geographic or formal, used to describe or tag it – is murky when sifting through the miasma of online material. But rigorous categorization, the provision of considered contextual information, and good documentation is what distinguishes curatorial practice from other informal remixing/reblogging activities. To that end, it may be that the newest forms of media and technology-led practices can be questioned as to whether they are best understood as art. Often practitioners might tag their works under the varied categories of image or lens-based, data-driven experiments, research, design, or activism. As Lev Manovich has said, "today's post-digital makers don't call themselves visual artists, they are processing artists or info architects" (Manovich 2013).

9 Beryl Graham's Chapter 1 in this volume suggests that this is one reason that commercial dealers and private collectors are increasingly becoming commissioners of art. In the case of museums, this is perhaps more complicated.

An informed awareness of murky categorization provides a good opportunity to change art history though clever curating, as Laurence Sillars found when organizing a comprehensive retrospective exhibition of the late artist Robert Breer, whose works include animation systems and kinetic sculptures which appear to float across the gallery floor:

> Because [Breer] is known primarily as an experimental filmmaker those boundaries are very prevalent and very divisive. Experimental film only exists in certain collections – it is a niche – but he was making innovations that were fundamental to art history as well as responding to it … I wanted to inject him into something he'd been forgotten from … People to date had really only done media-specific shows – so there had been the sculpture show, the film show and, very early on, the painting show. But I absolutely felt that you couldn't understand his floats without experiencing his paintings from the '50s. So seeing listings and a bit of documentation made it all the more apparent how much there was something absent from those presentations. (Sillars 2013)

Artworks are often exhibited or enter collections at moments when the discourse has been frozen around them – that is, categorized as one specific thing in order to fit a thematic show or justify their acquisition – and then those works are forever associated with that one medium or category. This is particularly problematic for interdisciplinary practice. For instance, many artists working with data visualization might have their works acquired by a particular collector, but that might be only one aspect of their practice – the bit that is trendily collectable at that moment – and not a true representation of that artist's work over time. Inclusion of documentation of Marius Watz's work on James Brindle's "New Aesthetic" tumblr blog, for instance, might forever mean that artist's work is understood as exemplary of that emerging paradigm or "meme."[10] In fact, Watz works with software programs to generate his works so that they have the possibility of being ever-changing even if they often are manifest as rapid-prototyped objects or print series.

New media art history is still an emerging field of practice. It draws from international sources, as new media art is dispersed across networks, and the practice of art history is generally not a localized practice. Within the field of new media art, those who are engaged in writing its art history tend to be the artists and curators engaged in the work themselves. After all, most of the bugs are still very much alive – many more are scuttling about in their own contextual landscapes than are pinned to the board in the drawer. As a result, the material which can be drawn upon to develop this history are those brief written-down descriptions – blog postings, exhibition catalogs, short collected anthologies, press releases, exhibition announcements online or in print – identifying what works have been produced and shown, not career-spanning retrospective exhibitions with *catalogues raisonnées*.

10 See Marius Watz's work at http://mariuswatz.com. See James Bridle's tumblr at http://new-aesthetic.tumblr.com/about.

Many of the key components of discourse in the field of art history – such as conferences and trade publications – have until very recently ignored new media art or have tried to subject it to populist approaches ("Hot Lists" of websites rather than investigations into the creation of network-based art, for instance). There are scantily few monographs of new media artists and they are not widely distributed. Publications that include new media art within art history have tended to be illustrated introductory volumes by publishers such as Phaidon and Thames & Hudson (particularly its World of Art series). These short anthologies with titles such as *Digital Art, Internet Art, New Media Art, Art of the Digital Age*, or *Art and Electronic Media* overlap in content, many citing the same small group of artists' works, but the categories are not firm and the boundaries between different types of technology-based artworks are very confused. Thankfully, however, they are often translated into other languages, extending the discourse broadly if not deeply.

As many new media curators and writers, such as Christiane Paul, have pointed out, these art works are so new and oftentimes intangible (computer code, an intervention, a new use of an old tool) that they are at serious risk of being entirely forgotten from the history of art altogether without strengthening the contextual writing around new media art. Edward A. Shanken characterizes the problem of historicizing new media art as follows:

> One can see that the task is bound up in at least two other issues: 1) the problem of defining a method for interpreting artworks on the basis of technology and creating a comprehensive history of art and technology; and 2) the problem of gaining canonical recognition that technology always has and always will play an integral role in art-making. (Shanken 2005)

But how do you do that when you are standing in the waters rushing around you, those same waters which you are supposed to be observing and critically reframing?

What we have in the field of new media art is a mishmash of, on the one hand, what could be called "instant historicization" in which there is little to no time lag between a work's presentation (posted online) and its critique (commented, re-posting, tumblring), and, on the other hand, "self-historicization," in which the artists are the ones recontextualizing their own works into art histories of their own making. Examples of this would include Lynn Hershman Leeson writing her own reviews of her work under a pseudonym as no one else would write about it (2000) and Vuk Ćosić curating a new separate group show of net.art practices, and publishing an anthology about the exhibition of art and technology to accompany his own inclusion in the Venice Biennial (Cook and Graham 2010). This is no bad thing. In fact, this self-awareness around the historicization process is even manifest in new media art itself. As Jon Cates writes, the remixes of Olia Lialina's classic piece of net.art, *My boyfriend came back from the war* (1996–), "function as a form of archiving and preservation in that they extend the life of the work by reworking this now historical New Media Art project" (2009).

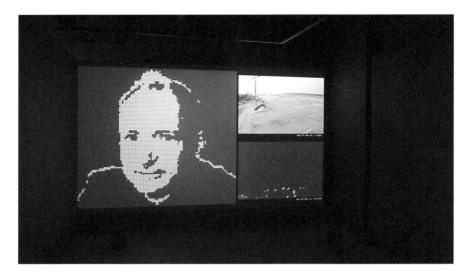

Figure 10.2 Jon Thomson and Alison Craighead, *A live portrait of Tim Berners-Lee (an early warning system)*, 2012. Installation view of digital projection from online sources. Courtesy of the artists and Carroll/Fletcher

Commissioning (Farsight)

As others in this book have pointed out, commissioning new work can usefully contribute to a more varied art history, alongside collection and good curating practice. Commissioning draws press attention, assuring more reports and reviews of the work (though this may be more true of the more prevalent publicly sited works rather than gallery or museum-based commissions). New media art also offers the opportunity for curators and audiences to be involved in the conceptualization, production, delivery, and lifelong maintenance of a work, giving the work a better chance of being remembered.

A very much alive example of this is *A live portrait of Tim Berners-Lee* (2012) by UK-based artists Thomson and Craighead.[11] Commissioned by the Media Museum in Bradford, this work is in the museum's collection, although it might not be possible to have it on permanent display. It is sold by the artists' commercial gallery, Carroll/Fletcher, in a short-run edition. A number of issues concerning the work's collection and historicization are raised in the work, which uses live webcams in the construction of its image, which is projected into a black box gallery space.

11 See http://www.thomson-craighead.net/docs/tbl.html.

The first set of questions that this work poses in terms of its own historicization concerns obsolescence and the artists' own responsibility to its ongoing preservation. It is likely that the webcams that are acceptable for this work will eventually disappear, which suggests that technical decay is a consideration, in the sense of the work one day being too "fragile" to exhibit. This is, in fact, an intent on the part of the artists, given the content of the work being about the founder of the World Wide Web; the work reflects both his and his creation's possible lifespan. To mitigate for this, or to make the work appealing to potential collectors, a 24-hour film accompanies the work when it is sold. This film is a digitized version of the work, which can be projected in place of the live version. In this way, the work's longevity is assured. In the words of gallerist Steve Fletcher, the film "acts as a simulacrum of the original" (Fletcher 2012).

This raises a question particular to the commissioning and collection of new media art. It is common, and increasingly commonly understood, that for the exhibition of new media works, artists might, where possible, remake an element of the original work (upgrading technology or perhaps even improving the experience of the work, for instance, through facilitating interaction). In cases where an edition exists based on criteria and technical standards established at the outset of the lifespan of the work between the artists and a commercial gallery, does this still mean that the artist cannot remake a piece (when technology improves later) or that he or she is simply freed up from the time-consuming work of having to constantly technically maintain his or her earlier works? Again in the case of the work of Thomson and Craighead, Steve Fletcher replies with the following questions:

> Is it artistically interesting for them to complete another version? How might this impact the work that has already been produced? We are giving a work a longer life by capturing it in another way; it is not that we are creating a replacement or alternative. The film would only be used if the live version were no longer available. This is a conservation issue that bears witness to the work. (Fletcher 2012)

This question of different editions of works complicates the task of both the curator and the art historian in considering which work to show and whether the documentation of earlier works accurately represents the intent of the work or merely that particular exhibition manifestation.

So we find ourselves with a quandary. Is art history better served by very good and well-documented exhibitions or by the artwork – in whatever version – getting into the collection? How might exhibition histories inform art history and what is the task of the curator in creating those exhibition histories? Again, Laurence Sillars comments:

> You have to do both. Artists are often the worst people at presenting their work, that's why I find it so vital to understand what they want to do and then put my

own interpretation or make a new thing as a result. But then many curators are bad at making that interpretation, or put too much of their own ideas in so that the original idea gets diluted. And exhibitions are a result of social and financial economies – you might not get the three crucial loans for the exhibition that really make the point that needs to be made just because the lender won't loan the work for exhibition or you can't afford the crate for the shipping. There are so many forms of mediation in an exhibition that get lost in their histories. To think of them as definitive things is something that I struggle with. Do you believe the artist or the art historian or the curator? I think they are all pretty dodgy on their own. (Sillars 2013)

Conclusions (the Long View ...)

Art historians and curators have to ask themselves the same questions that collectors do. Who are you collecting for? Is it for the sake of the artist or creator (what is called contemporary preservation) or for the audience or end-user such as the art historian (legacy archiving)? Are you studying the insects while alive, or killing them yourself (or having someone else do it, as Darwin later did),[12] or waiting until they are dead to collect them?

In art history, the canon (or canons) is agreed upon only if works in it have enough exposure. Canons represent the works that most readily come to mind, but perhaps not in a way you might want to see them exhibited. Their documentation in the canon might not be telling the whole story.

> If I was an art historian and I was studying an artist the outcome might be an essay, a chapter in a book or a paper, and I would like to think that exhibitions are an equivalent that you can stand inside and walk around and have the luxury of comparing three works in not a strictly linear way but in a physical way and navigate between them. An exhibition is another outcome of research. But just as if anyone researching an artist in detail wouldn't look at one source, they would compare different voices, people don't just look at one exhibition when they are recording and going back into an artist's history. (Sillars 2013)

This is a fair view from an institutionally affiliated curator on the subject of curating the work of an artist then nearing the end of his life, with 30 years or more of output to consider. But do we have that luxury with new media art? There was, after all, only one *Cybernetic Serendipity* exhibition. When works are prototypes or experimental commissions, they might not get shown more than once; if they are, it is likely not to be the same work, and certainly not in the same context.

12 Darwin's colleague John Herbert recalls that Darwin "armed me with a bottle of alcohol, in which I had to drop any beetle which struck me as not of a common kind" (Smith 1987).

New media art history needs to find new modes of analysis besides consideration of the single unique object and a reliance on institutional exhibition documentation:

> There is very little documentation of Ernest Edmond's shows, and I have never seen a show of Ernest's work apart from one piece in a group show which was terribly installed. Poor installation of media art can utterly devalue its creative content and make it seem throw-away and irrelevant. (Sillars 2012)

The historicization of art is then closely tied to curatorial activity. The form of the exhibition, its place and time, its intent, and its connection to its audience are all going to affect the reading of the work, whether it is eventually collected and preserved or not. Curators would be advised to continue, in these fast-moving waters, to still try and take the long view, and generate, through exhibition and the provision of critical context, connections between artworks, on both a technological/medium level and on a content/subject level:

> So for me, in a way, the definition of what it means to curate new or old media art would go like this: it is to document the present; to prepare the future so that we can have a past. (Gagnon 2001)

References

AMAAS. 2012. *Raison d'être | Alberta Media Arts Alliance Society*. Available at: http://amaas.ca/?page_id=6 [accessed 14 October 2013].

Belting, Hans. 1997. *The End of the History of Art?* Chicago: University of Chicago Press.

Benjamin, Walter W. [1931] 1969. "Unpacking My Library: A Talk about Book Collecting," in *Illuminations: Essays and Reflections*, 241(2). New York: Schocken, 59–67.

Bishop, Claire. 2012. "The Digital Divide." *Artforum* (September). Available at: http://artforum.com/inprint/id=31944 [accessed 14 October 2013].

Cates, Jon. 2009. *MediaArtHistories*, April 2, 2009. Available at: http://media arthistories.blogspot.co.uk [accessed 14 October 2013].

Cook, Sarah. 2003. "Towards a Method for Curating New Media Art," in *Beyond the Box: Diverging Curatorial Practices*, edited by Melanie Townsend. Banff, Canada: Banff Centre Press, 169–82.

Cook, Sarah. 2004. "The Search for a Third Way of Curating New Media Art: Balancing Content and Context in and out of the Institution." PhD dissertation, University of Sunderland.

Cook, Sarah and Graham, Beryl. 2010. *Rethinking Curating: Art after New Media*. Cambridge, MA: MIT Press.

Danto, Arthur C. 1998. *After the End of Art: Contemporary Art and the Pale of History*. Princeton: Princeton University Press.

Fletcher, Steve. 2012. Unpublished notes from the conference Born-Digital Art at the Van Abbemuseum with Baltan Laboratories, December 2012.

Gagnon, Jean. 2001. "Production, Distribution, Consumption." Available at: http://www.crumbweb.org [accessed 14 October 2013].

Gamerman, Ellen. 2013. "The New High-Tech Patrons," *Financial Times*, February 28, 2013. Available at: http://online.wsj.com/article/SB10001424 127887323384604578328121811415726.html [accessed 14 October 2013].

Gere, Charlie. 2004. "New Media Art and the Gallery in the Digital Age," Tate Research papers. Available at: http://www.tate.org.uk/research/tateresearch/tatepapers/04autumn/gere.htm [accessed 14 October 2013].

Goodman, Carl. 1998. "Curating, Conserving New Media," in *Euphoria & Dystopia: The Banff New Media Institute Dialogues*, edited by Sarah Cook and Sara Diamond. Toronto: Riverside Architectural Press and the Banff Centre Press, 867–71.

Ippolito, Jon. 2008. "Death by Wall Label," in *New Media in the White Cube and Beyond: Curatorial Models for Digital Art*, edited by Christiane Paul. Berkeley: University of California Press, 106–33. Also available at: http://thoughtmesh.net/publish/11.php [accessed 14 October 2013].

Ippolito, Jon. 2011. "Proliferative Preservation." Paper presented as part of the panel New Media Archives – new intelligent ambiances, *ISEA Istanbul*. Available at: http://isea2011.sabanciuniv.edu/panel/new-media-archives-new-intelligent-ambiances [accessed 14 October 2013].

Kushnir, Alana. 2012. "When Curating Meets Piracy: Rehashing the History of Unauthorized Exhibition-Making." *Journal of Curatorial Studies*, 1(3), 295–313.

Leeson, Lynn Hershman. 2000. Notes from conference presentation, EAT, Sins of Change conference, Walker Art Center, Minneapolis, April.

Levine, Les. 1971. "The Information Fall-Out," *Studio International*, 181(934), 265–6.

Manovich, Lev. 2013. From my notes taken from his talk on the OSXXI panel, organized by Claire Bishop at the CUNY Graduate Centre, New York, February 13.

Morris, Frances. 2012. Notes from her talk and the Q&A period at the Contemporary Art Society's *Curators and Collections* conference on collecting, held at the Burrell Collection, Glasgow.

Paul, Christiane (ed.). 2008. *New Media in the White Cube and Beyond: Curatorial Models for Digital Art*. Berkeley: University of California Press.

Shanken, Edward A. 2005. "Historicizing Art and Technology: Forging a Method and Firing a Canon." Paper delivered at *Refresh! The First International Conference on the History of Media Art, Science and Technology*. Banff Centre, Canada. Available at: http://www.mediaarthistory.org/refresh/Programmatic key texts/pdfs/Shanken.pdf [accessed 14 October 2013].

Shanken, Edward A. 2007. "Historicizing Art and Technology: Forging a Method and Firing a Cannon," in *MediaArtHistories*, edited by Oliver Grau. Cambridge, MA: MIT Press, 43–70.

Sillars, Laura. 2012. [email]. From: Laura Sillars, Site Gallery. Subject: Re: questions about ernest edmonds show. Date: 2 November 2012, 10:47:39 GMT.

Sillars, Laurence. 2013. [email]. From: Laurence Sillars Subject: Re: questions about breer. Date: 8 January 2013, 13:21:27 GMT. Also from an unpublished interview (conducted in person at BALTIC, January 17, 2013).

Smith, Kenneth G.V. 1987. "Darwin's Insects: Charles Darwin's Entomological Notes, with an Introduction and Comments by Kenneth G.V. Smith." *Bulletin of the British Museum (Natural History) Historical Series*, 14(1), 1–143. Available at: http://darwin-online.org.uk/content/frameset?pageseq=1&itemID=F1830&viewtype=text [accessed 14 October 2013].

Sterling, Bruce. 2012. "Wired: Beyond the Beyond," October 29. Available at: http://www.wired.com/beyond_the_beyond/2012/10/nature-and-early-visual-computer-generated-art-in-the-netherlands-before-1980 [accessed 14 October 2013].

Wozny, Michele. 2011. *Alberta Media Arts Collection Research Study*. Calgary: AMAAS – Alberta Media Arts Alliance. Available at: http://amaas.ca [accessed 14 October 2013].

Index